W9-AKI-663

Tricking Power into Performing Acts of Love

PRAISE FOR *TRICKING POWER INTO PERFORMING ACTS OF LOVE*

Tricking Power into Performing Acts of Love weaves together delightful stories of mischief from famous tricksters. Some of them—like Muhammed Ali—cast such a long shadow in history that their trickster nature was somehow obscured. Thanks go to Shepherd Siegel, who illuminates that and tells even more fascinating tales and timeless techniques we too can use to "float like butterflies and sting like bees."

MIKE BONANNO
of *The Yes Men*

Tricking Power explores a buried historical current of people who use creativity and play to challenge authority and envision new possibilities—through music, comedy, writing, visual arts and politics. Siegel traces their influences back to classic trickster stories and forward as they echo to the present. I don't know if these tales will help lead us out of harsh times, but heeding their lessons will definitely make the journey more fun."

PAUL LOEB
Author of *Soul of a Citizen and The Impossible Will Take a Little While*

Shep Siegel has written a brilliant book about the small minority of trickster people in the world. Tricking Power is for the vast majority who don't understand them and must if things are going to change for the better. Read this book!

ELLIOT WASHOR
Co-Founder of Big Picture Learning, Author of *Leaving to Learn: How Out-of-School Learning Increases Student Engagement and Reduces Dropout Rates* and co-author of *Get Real: Your Future Depends on It!*

I was thinking of Shep as I took a stroll after dinner with my three-and-a-half year old daughter. She made up all these games to play with me. She can imagine new games forever. Usually, I don't have the time or patience for it, but we didn't really have to be anywhere, so I said why not. Our objective was simply moving along the sidewalk. First we raced. Then she started making up games whose logic I could not follow at all. Bend down. Jump. Raise one hand. Then grab something in one hand. Wave it around. Run down the street with both arms in the air. Then one arm. And so on. She could have done this for hours.

Dr. Siegel knows of what I speak. He knows play, he knows his tricks and tricksters. Profiling such provocateurs, posers and pugilists as Mae West, Lord Buckley, Muhammad Ali, Sun Ra and many more, Siegel shows their playful pranks and how their dances amuse, irritate and stimulate. And how they just might illuminate humanity's path forward. *Keep moving, keep changing* might be Siegel's motto and of many of the artists he loves. At a time when too many people take themselves and their times too seriously, Siegel shows the benefits of treading lightly but skillfully, and with a grin.

ALEX MARSHALL
Author of *How Cities Work and The Surprising Design of Market Economies*

Siegel provides many outstanding examples of why tricksters appeal to our collective imagination, and none better than Muhammad Ali. Not only did Ali have "speed, grace, strategy and intelligence" as Siegel writes—he was a natural born prankster. When Muhammad Ali tricked George Foreman with an ingenious tactic, which he coined "rope-a-dope," Ali not only conned Foreman, he conned the entire world. No one saw it coming - especially George Foreman. "The Rumble in the Jungle," as Ali called the fight in Zaire, was a brilliant, unforgettable comeback victory. Siegel's book explains how Ali's disruptive tomfoolery and playfulness made him "the Greatest" and a legend loved the world over.

JOHN CRANE
Filmmaker, Executive Producer of *The Official Make-A-Wish Story:*
Batkid Begins

Tricking Power tells stories rich with insight, humor, and warmth. Each poetic tale reveals and awakens a new appreciation for the purpose and power of Tricksters young and old. Siegel's playful, creative force helps to reconstruct how we think about Tricksters and the way they contribute to advancing society to a higher state of being and functioning (and boy do we need that now!), ultimately to a happier and heathier, a more enjoyable and love-filled world. This is a provocative and lovely book!

WALTER F. DREW

Play Advocate and co-author of *Self Active Play: Awakens Creativity, Empowers Self-discovery, Inspires Optimism*

PRAISE FOR *DISRUPTIVE PLAY: THE TRICKSTER IN POLITICS AND CULTURE*

Shepherd Siegel's *Disruptive Play* is a must read for anyone who thinks we need to build a movement that goes beyond challenging this or that politician to reorganize the direction our world is going. In a beautiful integration of scholarship and passionate advocacy, this former rock musician and engaged academic opens up to the reader the liberating role that irreverent and playful challenges have played in undermining oppressive social and cultural structures in history and today.

Siegel both defines and extolls what he means by "disruptive play" with stirring descriptions of the victories and defeats of tricksters in history. In a world where even children's play is increasingly regimented and ultimately repressive, this exciting book allows the reader to recapture the joys of youthful free play and experience or re-experience those joyous moments of real community in the midst of serious political struggles and deadening cultural conformity. More importantly, it makes a compelling argument for integrating disruptive play in all of our political and cultural work and daily lives.

MIKE ROTKIN

UC Santa Cruz lecturer, former five-time Mayor of Santa Cruz. In the sixties, Rotkin was refused induction into the military, who'd decided he posed a "security threat" to the US

SHEPHERD SIEGEL, PhD

TRICKING POWER

INTO PERFORMING ACTS OF LOVE

HOW TRICKSTERS THROUGH HISTORY HAVE CHANGED THE WORLD

NEW YORK

LONDON • NASHVILLE • MELBOURNE • VANCOUVER

Tricking Power into Performing Acts of Love

How Trickster's Through History Have Changed the World

© 2022 Shepherd Siegel, PhD

All rights reserved. No portion of this book may be reproduced, stored in a retrieval system, or transmitted in any form or by any means—electronic, mechanical, photocopy, recording, scanning, or other—except for brief quotations in critical reviews or articles, without the prior written permission of the publisher.

Published in New York, New York, by Morgan James Publishing. Morgan James is a trademark of Morgan James, LLC. www.MorganJamesPublishing.com

Proudly distributed by Ingram Publisher Services.

Morgan James BOGO™

A **FREE** ebook edition is available for you or a friend with the purchase of this print book.

CLEARLY SIGN YOUR NAME ABOVE

Instructions to claim your free ebook edition:
1. Visit MorganJamesBOGO.com
2. Sign your name CLEARLY in the space above
3. Complete the form and submit a photo of this entire page
4. You or your friend can download the ebook to your preferred device

ISBN 9781631957307 paperback
ISBN 9781631957314 ebook
Library of Congress Control Number:
2021943929

Cover Design by:
Megan Dillon
megan@creativeninjadesigns.com

Interior Design by:
Christopher Kirk
www.GFSstudio.com

Morgan James is a proud partner of Habitat for Humanity Peninsula and Greater Williamsburg. Partners in building since 2006.

Get involved today! Visit MorganJamesPublishing.com/giving-back

PG | **PARENTAL GUIDANCE SUGGESTED**
SOME MATERIAL MAY NOT BE SUITABLE FOR CHILDREN
CONTAINS SOME MILD LANGUAGE

ILLUSTRATIONS

Lawrence Ferlinghetti: Photo by Brian Garrett, 1980. Used by permission

Anne Hathaway: PictureLux / The Hollywood Archive / Alamy Stock Photo

Lord Buckley: Michael Ochs Archives / Stringer

Buster Keaton: Sueddeutsche Zeitung Photo / Alamy Stock Photo

Marx Brothers: Photograph from Ralph F. Stitt, Rivoli Theatre. New York World-Telegram and the Sun Newspaper Photograph Collection (Library of Congress)

Mae West: A.F. ARCHIVE / Alamy Stock Photo

Katharine Hepburn, Sylvia Scarlett: Moviestore Collection / Alamy Stock Photo

David Bowie: Mary Evans / STUDIOCANAL FILMS LTD / Alamy Stock Photo

Jerry Lewis as Julius Kelp: Paramount Pictures / Alamy Stock Photo

Jerry Lewis as Buddy Love: CBS Photo Archive / Contributor

Petitioning Papa Legba at the Crossroads: Art by Rick Jacobi, https://www.rickjacobiart.com. Used by permission

Muhammad Ali: Peter Morgan / Alamy Stock Photo

Dennis Rodman: Shutterstock

Sun Ra Returns to Saturn. Wood Construction by Steve Soklin. somekindofart.com. Used by permission

Regina King: HOME BOX OFFICE (HBO) / Album/ Alamy Stock Photo

Baubo statue: bpk Bildagentur / Staatliche Museum / Johannes Laurentius / Art Resource, NY

Nine-Tailed Fox: H. O. Havemeyer Collection, Bequest of Mrs. H. O. Havemeyer, 1929; Metropolitan Museum of Art, New York

Yoko Ono: © 1968 Paul McCartney / Photographer: Linda McCartney. All rights reserved

Bugs Bunny: Pictorial Press Ltd / Alamy Stock Photo

Bill & Ted: A.F. ARCHIVE / Alamy Stock Photo

Sacha Baron Cohen as Ali G.: AA Film Archive / Alamy Stock Photo

Sacha Baron Cohen as himself: Stills Press / Alamy Stock Photo

Sacha Baron Cohen as Borat: Francis Specker / Alamy Stock Photo

Shepherd Siegel: Photo by Laura Anders

SONG LYRICS

Gangster of Love, Words and Music by Johnny Watson, Copyright © 1978 VRIJON MUSIC and BOOTY OOTY MUSIC, All Rights Controlled and Administered by SONGS OF UNIVERSAL, INC., All Rights Reserved. Used by Permission. *Reprinted by Permission of Hal Leonard LLC*. **Signifyin' Monkey** is in the Public Domain. **Room Full of Mirrors,** written by Jimi Hendrix, © Experience Hendrix, L.L.C., published by Experience Hendrix, L.L.C. Used by permission. All Rights Reserved.

FOOTNOTES AND ENDNOTES

Bottom-of-page Footnotes add commentary. Endnotes cite sources only.

Photo by Brian Garrett, ©1980. Used by permission.

Remembering Lawrence Ferlinghetti (1919-2021), who wrote . . .
The poet by definition is the bearer of Eros and love and freedom
and thus the natural-born non-violent enemy of any police state.[1]

and

I really believe that art is capable of the total transformation of the world,
and of life itself, and nothing less is really acceptable.
So I mean if art is going to have any excuse . . .
beyond being a leisure-class plaything—it has to transform life itself.[2]

CONTENTS

ACKNOWLEDGMENTS

I would like to thank and protest dear friends who contain my outlandish claims and stop my mind from wandering where it will go: Marian and Darrell Donly; Marla and Dan Barrett; Alan and Sandi Armstrong; John and Kathryn Littel; Ron and Jane Weed-Pomerantz; Bob Huven and Howard Leonard; Tom and Tammy Massey-Long; Mike Rotkin; Kevin and Kirsten Halloran; Elliot Washor; Walter Drew; Eli Siegel and Mary Smith; Daniel Siegel; Gary Pernell; Kerry and Paul "Pazzo" Mehling; Daniel, Sam, Jim Fair and Celeste Tell; Janice and David Roach; Joanne and Steve Dicker; Carol Pyes; Harvey and Lois Pyes; Matt, Deb, Adah, and Nathan Siegel; Phil, Ruth, Daniel, and Joel Moser; Ruth Weinstein; Bruce Greeley; Natalie Siegel; Brad, Meredith, Emerson, and Adelaide Shatto; Bruce, Donna, Nathaniel, and Sarah Masumoto-Brown; The Alavi-Sniders; Joseph Butler; Dean Smith; Jane Chadsey; Linda Jurca; Brian Graham; Laura Custer; Kari Furthur; Jeremy Carey; Patrick, Tracy, Torin Record-Sand; Alex Marshall; Lynda Collie-Johnson; Michael Perez; Dan Eisenberg; Dan and Anna Beederman; Rick Jacobi; Steve Soklin. To my writing buddies and critics Paul Luczak, Carla Janes-Heneghan, Vicki Barbosa, Brian Overland, Stan Barnes, Elaine Dale, and Pam McWethy. And the team complicit in bringing the crimes of *Tricking Power* before the public: Beth Jusino, Katie Mulligan, Kathy Burge, Kris Ashley, Pete Garceau, Stefanie Hartman, David Hancock, Jim Howard, Taylor Chaffer, Emily Madison, and David Litvak.

INTRODUCTION

IN THE MOOD

You can still fart when you're dead.

—Brian Posehn, *Grandpa Metal*[3]

I gotta say, Mr. Samuels, sometimes I think folks in this town don't really understand the power they have. Movies don't just show us how the world is, they show us how the world can be, and if we change the way that movies are made—you take a chance and you make a different kind of story—I think you can change the world.

—Ryan Murphy and Ian Brennan, *Hollywood*[4]

Tricking Power into Performing Acts of Love makes a different kind of story, a story of human nature we assume to be fixed but is shown to be changeable. Tricking Power is about the role of the Trickster in opening our eyes to the real possibility of advancing a more perfect and playful society.

The attributes that go into making personalities and cultures draw on a mix of archetypes—part Warrior, Caretaker, Magician, Fool, Mother, Hero, Sage—and Trickster. This book is about how grown-ups who have retained the ability to be playful as they were when a child view and behave in the world. Such a grown-up will consciously or unconsciously engage with the Trickster,

1

and *Tricking Power* is about what that looks like, and what could happen if society made more of that animating force.

The persistent question is: Where is Trickster energy today? Does it have to be embodied in a person or character, or can it be a cultural sensibility?

I wrote this book while we were knee-deep in the hoopla of the first third of the twenty-first century, so *Tricking Power*, implicitly and explicitly, also warns of the nasty trouble that comes with Warrior infatuation and the dilemma of how best to respond to it before a lot of people get hurt and killed. It's time for Tricksters to have their say in the matter.

There is a timeless prank, popular with a certain age group, I'm thinking eight-to-fourteen-year-olds. It goes like this: You put a pile of doggy doo into a brown paper bag, set the bag down on your target's front doorstep. With the acceleration of a little lighter fluid, you take a match to the bag, and as the fire begins to blaze, ring the doorbell, and run. From your hidden vantage point, you watch the unsuspecting resident answer the door, experience shock at the burning fire, try to stomp it out, and voilá, punchline delivered, or as we say in French, *fait une farce*.

To fully appreciate the humor and beauty of the joke, you have to remove as much context as possible. Consider that the prank is pulled as neither provocation nor revenge, just strictly for laughs and the elevated mood laughs bring. The only point, if there is a point, is the look on the dupe's face.

The meanness of the prank is slight enough. The humiliation is significantly less than that suffered by most cartoon characters, where dynamite explosions and mile-long plunges off cliffs are commonplace, yet the poop-on-fire prank transports us mere mortals into a real-life version of those same iconic celluloids from the golden age of animation. The energy of these classic cartoons can be sensed almost anywhere you look in that carnival of errors known as society.

The trickster just sets out to have fun, and somebody *might* get hurt, but the intentions are never to deliberately hurt others. In fact, quite the opposite: this book is about the role of the trickster (human), and the Trickster (demigod, archetype), in opening our eyes and our minds to the tangible possibility of a more perfect and playful society, a utopia if you will.

Yes, the silliest of pranks are exactly why playfulness, and why the Trickster archetype, are at least clues, if not keys, to how society itself might someday transcend our self-inflicted miseries, might learn to laugh. If we lived for the fun of it, we'd have less time or effort for the real harm that so-called civilization has inflicted on the world.

The pure heart of the trickster, the headstrong commitment to fun and laughing, are always conditions worth considering, understanding, and even experiencing. It need not be at someone's expense, yet tricksterism does trade in the pratfall, and slapstick often fuels its jolt. Slapstick's ability to connect the play of the child with adult concerns makes it key to understanding the trickster in politics and culture.

Throughout my research, whether into the Trickster gods and goddesses of China, West Africa, the Americas; the global folklore of women; hipster culture; or Black America, I have found themes of deliverance and changes in human nature—the language of utopias and messiahs—recurring again and again. The reader will find more than traces and less than prophecy in this volume.

Consider what a discussion of utopia must be (courtesy of Cornel West):[5]

- Understand what drives the cynic without succumbing to cynicism.
- Appreciate the childlike fantasies of the sentimentalist without yielding to the childishness of sentimentalism.
- Enact melancholic yet melioristic indictments of misery without concealing the wounds inflicted or promising permanent victory.[i]
- Stay in touch with the everyday realities of ordinary people and highlight our peculiar wrestlings with appearance and reality, opinion and knowledge, illusion and truth—of beauty, love and the collective struggle for a decent society.
- Lead us through our contemporary inferno with love and sorrow, but not cheap pity or the promise of ultimate happiness.

i Advocate for optimistic solutions to social problems and acknowledge the wounds that need healing, without making unrealistic promises.

And if we're all going to just get along, does that mean that everyone has to be good? Or just that the planet and life on it thrive? I think that figuring out good and evil is really difficult, so I've only ever proposed and sought after a more perfect world that's lots of fun. I think if we all have lots of fun, we're gonna be okay. So to build a society that's fun, the first thing we gotta do is get along with Nature, right? Because 99 percent of scientists have been warning us that we've over-messed with Nature, which will destroy the planet as we know it. Before Earth, before people, there was Nature, on Earth and in space, right? Here are two astronauts talking about it:

> Amelia: That's what I love. You know out there [in space], we face great odds. Death, but not evil.
>
> Coop: You don't think Nature can be evil?
>
> Amelia: No. Formidable. Frightening. But not evil. Is a lion evil because it rips a gazelle to shreds?[ii]

—*Interstellar,* Jonathan and Christopher Nolan

So we're not so sure about good and evil, you're looking at me kind of funny on the whole "fun" thing, but we can agree that Nature is neither good nor evil. And we need to get along with it. So in a bit of reverse logic, nature being neither good nor evil frees it up to be playful. This begins the case for defining the Play Society as one that is in harmony with Nature.

And since the human race has drifted away from Nature, the most powerful tool we have for renegotiating that relationship is our consciousness, which includes our heart, mind, soul, and whatever bonus features came with the package. Change consciousness, change behavior.

We are face-to-face with the imperative that we figure out how to live in concert with Nature and the life it provides. Or we die. Serious stuff. Yet this

ii *Interstellar,* directed by Christopher Nolan (Hollywood, CA: Paramount Pictures, 2014), film. Is the name for the character Anne Hathaway plays, Amelia Brand, a double homage to Amelia Earhart and Stewart Brand? Matthew McConaughey plays Joseph A. "Coop" Cooper.

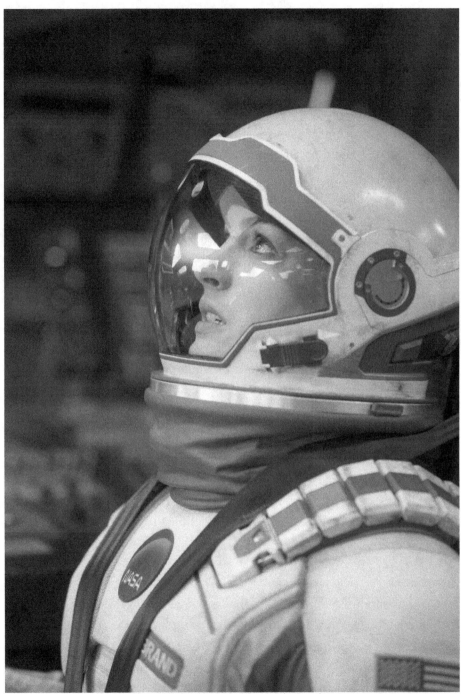

Anne Hathaway as astronaut Amelia Brand.

book is about play, about *not* taking things seriously. Stop looking at me funny and keep reading. Please.

A goodly part of our consciousness has left Nature and brought on the threats of environmental catastrophe and extinction, which has finally gotten our attention. Lousy economic systems, lousy education, lousy doctrines, lousy political systems, lousy people got our planet into this mess. Abuse of power has an awful lot to do with it, and far too often, power gets away with it.

Let's review. The above dialogue between two astronauts, from the Christopher Nolan film *Interstellar,* illuminates, a bit, the amorality and irrationality of the universe. Amelia Brand witnesses it, loves it, seeks to understand it. Yet Western discomfort with the idea of moral indeterminacy, like a helpless reflex, jumps right in, and we wonder along with Coop, *can Nature be evil?* The example is one designed to get a rise: a lion killing a gazelle. Not evil, natural. Likewise, we should not jump to the false conclusion that because a lion mother plays with her cubs, because playfulness sparks joy, Nature is good. Beautiful, necessary, inspirational, playful, and fun, **and** dangerous, formidable, and frightening. But neither evil nor good. When we play, truly play, we enter that joyful, amoral part of Nature.

So a gross simplification of our mess is that we've let other archetypes dominate cultural consciousness, a consciousness that lends itself to the accumulation and abuse of power. And by not fully exercising our playful selves—a way of living connected to Nature and its amoral grace—we've wandered farther and farther away from the utopian, playful life and beautiful, peaceful planet we were born to live in and love.

We can measure that distance by what happens when playfulness enters arenas of power. When play cannot resist mocking power, when it refuses to take power seriously, the resulting fray is dangerous, formidable, and, in all likelihood, bloody. Such disruptive play comes from human tricksters who are most offended by the harms of power. Like war, for example. War is power's admission of failure. Tricksters who just want to have fun discover morality when they stumble into a position of being antiwar, because war is the least fun thing that humans do.

The beauty of tricksterism is that Trickster can beat the bad guy without necessarily being the good guy, thus dissipating any tendencies towards hero or warrior worship and instead opening the door to a leaderless consensus that banishes malicious evil without making any doctrinaire declaration of good. This is pretty much where art has been heading for over a century. And great art is a lot of fun.

Through hapless and hilarious and morally indeterminate adventures, tricksters bent on just having fun make that journey from moral indeterminacy to moral discovery.

Hang on, my phone's ringing.

Shepherd: Hello? Oh, Groucho, is that you?

Groucho: Sounding kind of dour and fatally serious there, Skip, shall I send a hearse? Or maybe a his?

Shepherd: Ha ha. You're the one who's dead. And it's Shep.

Groucho: Ha ha, you're the one who's dying up there on stage. Could you maybe make this simpler, so a child of four could understand?

Shepherd: All right, give me a chance. And run out and find me a child of four.

Groucho: Hey, that's my line.

Shepherd: Hey, this is my book!

When we watch a film or read a novel, the actor's or the narrator's job is to make us believe that they are just who they say they are. In Marx Brothers films, we typically learn in the first scene that they are imposters, pretending to be whatever role they are mocking—college presidents, stockholders, dictators, business managers, hotel managers, explorers, or a veterinarian posing as a doctor. Or rather, they are not imposters, as they are always authentically the Marx Brothers. As Alan Dale says of Groucho, "stepping out of character becomes his character."[6] He breaks the fourth wall and winks at the audience, we are in on the joke.

In *Monkey Business* (1931),[7] all four Marx Brothers enter as stowaways on a luxury liner. Yet within the first few minutes they shape-shift, pretend-

ing to be coffee brewers, the ship's band (they even get applause), older women under blankets resting on the deck, and passengers. Groucho impersonates the captain, and in a true-to-form trickster ploy to gobble food, brazenly orders the captain's lunch for himself. When they all sit down to dine, we see this classic routine, one endlessly riffed on and replayed by Elmer Fudd and Bugs Bunny:

Chico & Groucho:	We're a couple of big stockholders in this company.
Captain:	Stockholders? You look like a couple of stowaways to me.
Chico:	Don't forget that the stockholder of yesteryear is the stowaway of today.
Captain:	Well, you look exactly like them.
Chico:	What do they look like?
Captain:	One of them goes around with a black moustache.
Groucho:	So do I. If I had my choice, I'd go around with a little blonde.
Captain:	I said, one goes around with a black moustache.
Groucho:	You couldn't expect a moustache to go around by itself. Don't you think a moustache ever gets lonely, Captain?
Chico:	Sure, it gets lonely.

Transpose this crazy mockery into the political arena and you get the Yes Men, led by Jacques Servin and Igor Vamos, two American Yippie activists. Like the Marx Brothers, their primary tactic is to impersonate, acting out the motto "Lies can expose the truth." Only this time it's real.

One of their most successful pranks was to pose as executives from Dow Chemical on the tenth anniversary of the 1984 tragedy in Bhopal, India. The company's fertilizer plant had blown up, resulting in eighteen thousand deaths and countless children born with birth defects in its aftermath.

The Yes Men put up a fake website proclaiming their bona fides as Dow Chemical VP's. When a bankers association fell for the ruse, they were invited to give the keynote at a London conference. On BBC Radio and at the confer-

ence, the Yes Men took an absurdly big swing, promising full reparations to Bhopal's victims. Big because they claimed that they would liquidate the company in order to make things right in Bhopal. Absurd because corporate greed and capitalist dicta would never allow such a thing.[iii] Their prankster activism exposed criminal neglect and gave Dow Chemical the opportunity to do the right thing. And in case you're wondering . . . Dow did not.

The Marx Brothers reveal soon enough that they are imposters, liars—the play is more fun if you get caught—and that is also part of the Yes Men's method. In fact, they usually manage to get the discovery of their hoaxes on camera so as to make their point.

The Yes Men's means are all in the trickster mode, and the magnificent satire of the Marx Brothers bursts with Trickster spirit. Their oeuvre, *The Cocoanuts* (1929); *Animal Crackers* (1930); *Monkey Business* (1931); *Horse Feathers* (1932); *Duck Soup* (1933); *A Night at the Opera* (1935); and eight other films, provide the theory. The Yes Men put that theory into practice, into a political context. What they do is consummate disruptive play.

Marx Brothers films always feature some thuggish, powerful bad guys, but they are a caricature of threat, positioned as easy targets for mockery and pranks. They are not to be feared. They are part of the problem, the wrongheaded exercise of power. And the closer we get to the minimal yet just exercise of power—first by prank and eventually by wise governance—the closer we get to power's dissolution. An essential tool of human progress, then, is to be found through expressions of the Trickster archetype, through those who refuse to take power seriously and mock it to its face.

Human beings can be called a lowercase *t* trickster but cannot BE a capital *T* Trickster archetype. Archetypes are more like demigods, perfect-ish manifestations. Zeppo, Groucho, Chico, and Harpo are only human, but when experienced as a four-headed trickster creature, they push the stratospheric limits of what is humanly possible. This begs the question of definition. The distinction

iii The Yes Men did an interview sharing their fake announcement with BBC News and three hundred million listeners. For the short time that the news media bought the hoax and spread the news, Dow Chemical's stock lost $2 billion in value, dropping over 4 percent in less than a half hour. Why the big stock sell-off? Investors knew that in a case where a corporation behaves altruistically but not profitably, they would be punished.

between the archetypal Trickster and the human version is one of the ten attributes of the Trickster.

So by all means, read on. After all, that elephant's made off with your pajamas.

Ha HA! The Marx Brothers put themselves out there as freaks on the outside of society striking a satiric pose of those on the inside. And this is consistent with tricksters' marginal status. But they are white men in a patriarchy that enveloped the world of entertainment, where white men got all the good lines and most of the money. And I'm sure Groucho's woman-hungry sexist quip above did not go unnoticed.

What of other marginal voices, of women and their historic oppression? Of Black and indigenous Americans, whose voices have been shuttered by the formalized oppressions of slavery, Jim Crow, and genocide? To strike a trickster pose and yet bear the legacy of these oppressed states is to be twice marginalized. This adds a dimension to the trickster tale that makes it all the more profound in its messianic possibilities, and all the more essential to human liberation. Oppression is the one word that best summarizes political history, and the fulfilment of Trickster's utopian promise cannot be realized until oppression ends, until marginalized voices are heard and integrated into a unified whole.

This book has two beating hearts. The first is a suite of three chapters that comprise *The Triumph of Eshù Elégba* and how that West African Trickster god presents perhaps the world's most complex and complete Trickster persona. The journey of enslaved people from that West African spiritual milieu to the founding of a Black American literary tradition and soulful expressions of humanity throughout the Western arts is one of struggle, demand for justice, and triumphant beauty, a collective spiritual energy that lights the path to liberation.

Likewise, female tricksters have never had the luxury of the carefree, cartoonish, ribald, and rib-tickling trickster adventures that populate much Trickster mythology and folklore and genres like slapstick. As the oppressed sex, they enter the fray of human politics with a variation on the Trickster that comes equipped with the moral prerogative to right the wrongs of sexism. This second beating heart, *A Million Years of Fifty Trickster Women,* bears a title

inspired by the sexy and victorious poses of Nancy Archer in 1958's *Attack of the 50 Foot Woman* and Loana in 1966's *One Million Years B.C.,* played by Allison Hayes and Raquel Welch, respectively. And evolved by the twenty-first-century version of the immortal *Wonder Woman,* played by Gal Gadot. In the freeing air of speculative science fiction, these women sacrifice none of their sexual appeal[iv] and dispense with the stereotype of helplessness that more typically shackles them. Indeed, female tricksters more frequently combine with hero and warrior personae than do males. Most profoundly, female tricksters raise the possibility of tricksterism and governance.

Which makes discernment a complicated task. Getting ahold of the feminine in Trickster is itself tricky, as the case can be made that Tricksters are all genders and genderless all at once. The journey of a single individual, Yoko Ono, is one of female Trickster energy obscured by a publicly conflicted life. Those conflicts—power struggles—surround her playful, loving, liberated, and trickster-esque self. She proclaims her art/life amidst the chaos of a society that can't handle the truth.

Tricking Power into Performing Acts of Love integrates the tectonic paradigm shifts of the 2020s. Here in the twilight of the patriarchy, I hope to share a perspective less blindered by biased legacies.

Any writer, including this one, is limited by their exposures and where their querying path leads. In *Disruptive Play,*[v] I shared stories and examples from the West, from European folktales to dada and World War I; from the Beats, hippies, Yippies and the Vietnam War to *The Simpsons* and Burning Man. To tie a bow on that hipster angle, *Tricking Power into Performing Acts of Love* includes a profile of Lord Buckley, whose colossal contribution to countercultural tricksterism has been overlooked by too many for far too long. The original hipster and proto-beatnik, Lord Buckley offers a tangible example of a human with whom the Trickster force is strong.

iv A privilege that male tricksters can now share.
v Shepherd Siegel, *Disruptive Play: The Trickster in Politics and Culture* (Seattle, WA: Wakdjunkaga Press, 2018). Other trickster types profiled in *Disruptive Play* include Marcel Duchamp, Alfred Jarry, Andy Kaufman, Abbie Hoffman, Anonymous, and Burning Man.

Slapstick, though a slippery critter, with and without the banana peel, offers fascinating opportunities for hilarity and Trickster spirit. Its universal appeal (little kids get slapstick!) performed by the likes of Buster Keaton, the Marx Brothers, Beatrice "Bea" Lillie, and Mae West, ensured Trickster's flourishing in Hollywood and all visual entertainment since that golden age. Finally, some thoughts on time travel and a prognosis for the rest of this tumultuous century conclude *Tricking Power*.

* * * * * * * * *

The essence of Trickster energy is not chaos, but antistructure: "His relentless willfulness is not some archaic version of laissez-faire, but a passionate entry into the rawness of precultural relationships to reclaim and restore their potencies, to make them available for new patterns of order."[8] Just as the opening quote from *Hollywood* calls out hope that if we can make a different story, we can change the world.

And isn't it ironic that some of the most different stories are some of the oldest? The Ashanti Trickster god Ananse, manifesting as a spider, fools an entire village. Ananse tricks the villagers into believing that they have killed what was an already rotting corpse. They thought that the dead body was sleeping, and they beat it to get it to stop its flatulence. Because, as we already know, you can still fart when you're dead. With this trick, Ananse upended the social order of the village, and the high god Nyame rewarded him with rulership.

The elusive pieces of the trickster fall into place, at least for a moment. The play state is ethereal and fleeting, a glass hand dissolving, like fizzy candy or an Erik Satie *Gnossienne,* or even that thought you just had but seems to have flitted away. Yet as this prototypical force comes partially into focus, *Tricking Power into Performing Acts of Love* fulfills its purpose, which is to propose life without purpose, but with great meaning. And to extrapolate that to society at large: The Play Society, where art reigns, where commerce and consumerism are held to a low simmer. Instead of the frantic and oppressive urge to consume that's been saturating us, squelching our playfulness, and destroying the planet and our souls for generations; instead of a commercialized society that

includes art as an accessory, *Tricking Power* suggests an artistic society that relies on only the most necessary and just-sufficient mechanisms of commerce and consumption. Such a revolutionary rearrangement frees our creative and playful and classless selves. So the tricking part happens with some regularity. But tricking power into performing acts of love proves to be rare. Still, political and corporate figures gain and lose power through trickery, and it is during the transcendent moments of the trick that taking that next step—redistributing wealth, for starters—enters the realm of possibility.

When the realities of optional employment hit, when we get the planet back on a natural path, one that includes the survival of humanity and whatever species remain, when we eliminate poverty and war . . . it's gonna be time to play and play more. *Tricking Power* invites you into its time machine, for its message to the universe, its message of love! Oh wait, I think I smell something burning. Is that your doorbell?

COME PLAY

THE TEN ATTRIBUTES OF THE TRICKSTER

What does matter is that we come to recognize that playful-
ness, as a philosophical stance, can be very serious, indeed;
and, moreover, that it possesses an unfailing capacity to
arouse ridicule and hostility in those among us who crave cer-
tainty, reverence, and restraint. The fact that playfulness—a
kind of divine playfulness intended to lighten man's existen-
tial burden and promote what Joseph Campbell called "the
rapture of being alive"—lies near the core of Zen, Taoist,
Sufi, and Tantric teachers, is lost on most Westerners: working
stiffs and intellectuals alike.

—Tom Robbins[9]

Like the trickster who limps and wanders between two worlds, in *Stum-
blin' In*[10] Suzi Quatro sings about vulnerability, stumbling and foolish-
ness…and love. And so we begin. We clean off our shoes and commence
the journey, to envision and create a more perfect and playful society. The quest
compels three questions, the first being: what is this thing called play?

Play scholars have identified at least 308[11] forms of play; a more modest
count yields 131.[12] But we shall concern ourselves with a mere three. The first,
original play, is that substance found in all life forms. The universe offers it.

It's been described as rough-and-tumble play, and it is physical, yet we see it in that most fragile of critters, the human infant. No hitting, no biting, no scratching, no grasping, nothing sexual, but by all means, full physical contact, rolling around on the ground, wrasslin', starting games that dissolve as quickly as they begin, all of us can engage in original play and enter that state of grace. That kind of playfulness also has a cerebral corollary, most commonly manifested in art, but it can take many forms.

When original play develops into games with winners and losers, with competition, even competition against oneself (i.e., scorekeeping to attain a "personal best"), then original play becomes what is in many ways its opposite, *cultural play*. In cultural play, we compete, we achieve, we seek titles, we defeat competitors, we win or we lose. Though these two kinds of play are opposites, in each lies the seeds of the other. The spirit of original play can be embedded in cultural play. Consider the example of, say, Michael Jordan in one of his many superlative games with the Chicago Bulls basketball team. While on the outside he is competing in and winning a game that is clearly cultural play, he is also "in the zone" and experiencing the flow of original play.

Both forms can be fun; both forms are essential to our society and the enjoyment of life. My only caveat is that we have become overly obsessed with cultural play, and when grown-ups squelch the original play of children with more structured and achievement-oriented cultural play, those children become grown-ups who would seem to have lost their ability to be original players, lost sight of the joy original play brings. And in our obsession with cultural play, with playing the warrior and seeking victory and another's defeat, when we fail as a society to moderate cultural play, fail and are seized by scenarios where cultural play escalates, we find ourselves in its most toxic form, war.

Short of war, political disagreements are not settled through debate and collective inquiry, but through a need to attack and defeat. And a saturating commerce regularly defeats our resistance to consumption; it permeates and invades our daily lives, interrupting our access to original play. So yes, we need cultural play, but we're overdosing.

The third form of play is *disruptive play*. Quite simply, when original play (we play in order to keep on playing) is introduced into the arena of *cul-*

tural play (we play to win and bring the game to its conclusion), it disrupts the game, provokes the cultural players, lays bare a primordial conflict in the interest of letting love and fun overcome power, and opens the door to the possibilities of the Play Society. Thus the underrated human proclivity for the prank. Whether streaking naked onto the field of an NFL game or protesting war by attempting to levitate the Pentagon three hundred feet off the ground, disruptive play is the thing.

The Warrior archetype informs cultural play. The Child, original play. And the Trickster thrives on disruptive play.

The second question is: what happens when grown-ups retain the ability to be playful the way they were as children and continue original playing? Consciously or unconsciously, what happens is that they are going to engage with the oldest archetype known to humanity, the Trickster, a powerful demigod who appears all over the world.

Studies of Trickster gods from various cultures turn up consistencies and patterns. I've been able to distill ten recurring attributes that that characterize the Trickster.

To answer the most-asked question and set the table, consider the first attribute, that a person cannot be a Trickster if we are talking about the capital 'T' Trickster archetype. Yet humans are very much a part of the conversation. So think of it the way *Star Wars* casts the Hero Warrior. The Force animates the Hero Warrior archetype. No human, not even a Jedi, can *be* the Force, but the Force can be strong or weak with a person.[vi] Likewise, the Force of Trickster energy can be stronger with some than others. Some humans have quite a lot of it, some not, but everybody's got some. So understanding these attributes yields a lens through which one can develop a sensibility about tricksterism as it manifests—in folklore, fiction, art, music, consciousness, politics, culture, theater, mythology, and the like.

1. The first attribute we have just reviewed. The Trickster is an archetype, thus a human being cannot *be* a Trickster . . . but we all embody,

vi Or other sentient alien race, Jedi—or not.

to varying degrees, a mixture of archetypal influences. The Trickster force can be strong with a person.

2. Secondly, a Trickster never met a boundary they didn't relish crossing. For example, they might first appear as male but frequently spend time as females too. This gender fluidity reminds us that the nonbinary approach to gender has been around for at least as long as people have been telling each other stories, and the current movement to challenge cultural dictates around gender announces a rebirth of something ancient. But the point here is that Tricksters compulsively test, challenge, and cross boundaries and transgress when it suits them.

3. Tricksters tend to be loners. Lonerism[vii] makes wandering easier, and they like to wander. Lonerism means autonomy, and so harebrained schemes that work, as well as the ones that backfire, get executed as no one else needs to be consulted. And their aversion to lasting connections complements the image of the wandering loner. Yet it is the transcendence of this attribute—the intriguing, ephemeral possibilities of the collective, of communal connection—that, paradoxically, Tricksters seek.

4. Tricksters are not evil, but neither are they good. They are ruled by moral indeterminacy. They just want to have fun. Trickster amorality/ indeterminacy is, in the case of the infant, simply pre-moral. In trickster grown-ups, moral ambiguity restarts a process that invites a fresh stab at figuring out what morality is. Thus, think not of amorality as necessarily evil, as many do, but as the pause that refreshes.

 By embarking on adventures with no greater intention than having fun, tricksters eventually discover values, order, and morality anew. These adventures regenerate the urge to human progress. And trickster tales are part of a cycle, a cycle that begins free of morality and ends with moral discovery.[13]

5. Tricksters play tricks. But they get tricks played on them, too, and sometimes they play tricks on themselves. Embracing the risk of back-

vii "Lonerism is a state of being alone embraced by mostly schizoids, weirdos, outcasts, loners, ninjas, shaolin heroes, and geeks." Yadsendew, "Lonerism," in online Urban Dictionary, posted June 7, 2011, https://www.urbandictionary.com/define. php?term=lonerism.

fire and the near-guarantee of guffaws, being willing to play the fool for the sake of enlightenment, or peace, or a good laugh, performing whatever it takes to grow the party—this is the essential fifth attribute of the Trickster. It's important to consider this self-effacing attribute when looking at politicians and applying the label. Folks whose lives are about power rarely display this humble and sacrificial quality.

A favorite trickster tale comes from the Winnebago tribe, where Trickster Wakdjunkaga tricks a buffalo with straw men, making the buffalo think he's surrounded. He thus captures the buffalo and skins him using his right arm. His left arm becomes jealous and tries to usurp the right arm and take over the skinning. The result is some nasty self-mutilation of the left arm by the right. It is this kind of silliness, innocuous intentions, and backfiring of tricks that distinguish Trickster from villains or sadists. The trickery can bounce in any direction, including back at Trickster.

6. Trickster tales typically feature fart and poop jokes. And sometimes pee. And at this point, the reader may wonder whether the author is stooping to cheap tricks to sustain attention or whether he is really on to something.

The theory of disruptive play connects the playfulness of the infant, of animals, to political liberation and a utopian vision. Thus the import of how the scatological brings our consciousness back to core functions inevitably emerges. In other words, when you were a little kid learning your first jokes, was *anything* funnier that poop and fart jokes? I daresay not. The Bavarian Trickster Till Eulenspiegel is particularly obsessed with scatology, but these jokes and poop plot devices show up throughout folklore, and even in Western art. Marcel Duchamp—the Force was strong with him!—provoked impressionist and cubist art dealers by submitting a men's urinal into a prestigious art competition. And female tricksters outwit men who fear the menstrual cycle.

7. Tricksters are liars. And saviors. While many people will have the initial response of looking askance at such a trait, they should also consider that if one envisions a world far more beautiful, just, prosperous,

and fun than the one we currently inhabit . . . is that messianic inspiration or lie? Mischievous trickery can be in service to a savior-like quality. Amongst indigenous tribes of the North American Northwest, Raven lies and tricks the Chief into relinquishing the sun, the moon, and the stars into the world and, in another tale, rebuilds the world after the flood.[14]

8. We are living through difficult times. By that very term "living through," we attach our existence to the forces and circumstances of the present, forces that oppress us, that bind us to the moment. Examples abound, from our environmental catastrophe to the exploitation of the poor, from any of our personal tragedies and trials to the Tower of Babel that best describes the state of public discourse. If Trickster consciousness is to work its magic of perspective, lightheartedness, and optimistic vision, it must be granted the ability to escape the current moment through a tunnel, and Tricksters use that superpower. Tunnels are the first tool in the trickster's toolbox. Whether it's the Zulu weasel, Native American coyote, Bugs Bunny, Dennis Rodman, a hipster subculture, or *Watchmen's* Doctor Manhattan, tunnels show up as escape routes, traps, a gimmick for a trick, a metaphor, or a means to understanding.

Tricksters can tunnel through time, detach from a moment so as to connect histories past to speculative futures. We see it in trickster types who anticipate the future, like Lord Buckley or Alfred Jarry. We experience it in the fictional worlds of Shakespeare's King Lear and in Warner Brothers' Bugs Bunny. Thus the eighth attribute of the Trickster is about a transit system for crossing boundaries and connecting distant points. In other words, tunnels and time travel.

9. When Tricksters are powerful, from whence do they draw their power? Sometimes they attain power through trickery—no surprise there—when biblical Rebekah helps Jacob steal the birthright from Esau or when West African Èshù Elégba contrives with the chief god Ifa the day before a contest to receive the blessings of Àshe. Or, as in the cases of Norse god Loki and Northwest Raven, they're born that way;

their power is a first principle. So Tricksters do not assemble armies. They do not conquer through war. This is not to say that Tricksters cannot be lethal or dangerous or powerful, but their nature is to mock power, not to amass it.

10. Raven is the Trickster god whose tales span Northern California, the Pacific Northwest, British Columbia, Alaska's Aleutian Islands, and Siberia. And the word *raven* has Old English, Norse, Danish, Dutch, High German, and even Greek roots that tie the raven to the crow. Now tricksters and hedonists are not the same thing. But that's not to say that tricksters don't have an enormous appetite for as much food and sex as they can possibly get. They do. Rare is the trickster tale where food or sex or both are not a major aspect or plot device, and these appetites are, naturally, frequently described as *ravenous!*

So consider these ten attributes as a roadmap to the rest of this book, to help us notice and sort out Tricksters and Trickster energy as they appear and just as quickly fly away.

And what of the third question . . . quite simply, what happens when this playful grown-up, an original player, gets involved in culture and politics, politics being the most competitive arena there is? Here disruptive play takes its shot at breaking the game and making time and space for better lives, for playful living. Despite the sweet accolades draped on play in popular culture, disruptive play, until it clears the path to the Play Society, is a bloody and difficult affair. This first chapter inches closer to the cliff's edge from whence we leap into an exploration of that third question.

And so we delve into the playground where elusive demigods meet provocative gadflies, where we catch a peek at the influence of the Trickster archetype, shrouded in mystery for too long. And we ask the truly serious question: can a deeper understanding of Trickster and a fuller integration of Trickster consciousness make the world more fun?

Tricksters! Demeaned, dismissed, disregarded. Demonized, confined, even punished. But as Lewis Hyde has warned us throughout his book, *Trickster Makes This World,*[15] if we suppress Trickster, Trickster energy will eventu-

ally blow up in our face. Because Trickster cannot be destroyed. And Trickster is everywhere. In both this and my previous book, *Disruptive Play*, I connect Trickster to politics and culture, to the state of society and how Trickster energy lights the way to a better one. In this volume, I get closer to that utopic vision and to identifying those forces of feminism and sexual liberation, of antiracism and universal civil rights, and of fascinating changes in the precepts of humor, which must all be accounted for in a movement for a better, safer, more prosperous, just, and fun world.

PRANKS

Fun? When prankster Boyd Rice[viii] answers the phone and it's a wrong number, he jumps on the opportunity, and instead of telling the caller that they got the wrong number, he'll say things like, "Hang on, I'll see if Jack's here. Who's calling?" And then "I'm sorry, Jack doesn't want to talk to you. Jack is still very angry with you, and he doesn't want to discuss it."

Tricksters pull pranks, and the liberating energy of pranks is explained and celebrated in the shimmering literature of the RE/Search group out of San Francisco:

> Obedience to language and image must continually be challenged, if we are to stay "alive." The best pranks research and probe the boundaries of the occupied territory known as "society" in an attempt to redirect that society toward a vision of life grounded not in dreadful necessity, but rather, *continual poetic renewal*. (A society whose *exchange value* consisted in poetic images and humor rather than dollars can barely be *imagined* at this stage of world evolution.) Pranks function to evoke the parallel *Land of Make Believe*, that realm of perpetual surprise and delight where endless possibilities for fun

viii There will be more on Mr. Rice later, but suffice it to say, he's "an American experimental sound/noise musician using the name of NON since the mid-1970s, archivist, actor, photographer, author, member of the *Partridge Family Temple* religious group, co-founder of the UNPOP art movement and former staff writer for the now-defunct *Modern Drunkard* magazine." Wikipedia, s.v. "Boyd Rice, last modified May 16, 2021, 15:30, https://en.wikipedia.org/wiki/Boyd_Rice.

and pleasure depend upon circumvention of habit and cliché. From their Shadow-world, pranks cast their Funhouse Mirror reflection of our workaday world. Ultimately, the territory signposted by pranks may represent our single supremely tangible freedom.[16]

Editor A. Juno of RE/Search says,

The police . . . know how to deal with real criminals, but somebody who puts eggplants on sticks [in front of a shopping center]—you're making a mockery of their social order, and that's worse than what most criminals are capable of doing. By doing something incomprehensible, you place yourself outside their magic, and then they lose control. And authority needs control with a simple set of uniforms and buzz words."[17]

This is just the smallest sampling of stories told by people who live and love to prank and do so from a piercing political analysis and point of view. RE/Search documents everything from Joey Skaggs, who got NBC to cover his fake house of prostitution for studding out dogs, to Mark Pauline, who built a three-legged "walking machine" contraption and trained his guinea pig to drive it. Pranks like these and notable pranksters like Timothy Leary, Abbie Hoffman, John Waters, John Cale, Karen Finley, Frank Discussion, Kerri Kwinter, Earth First! are all featured in RE/Search's defiant publication, *Pranks!*

West Africa's Eshù Elégba pranks and, to get the blessings of *Àshe* from God, played a trick on his competitors, making his sacrifice a day ahead of them. As one of the world's most complex and developed Trickster gods, Eshù Elégba infuses much of Afro-Atlantic culture. He shows up rich with insight. Eshù's spirit can aid in the resolution of America's original sin of racism and slavery. Prankishness enlightens.

Which brings us to the present . . . except that "the present" is equally slippery, as time travel is in Trickster's quiver, and a Trickster might evaporate from the present. Just when we think we've got them figured out, they slip

from our grasp. But there is hope. The whole confounding thing of indeterminacy is that it is the crack in the forces that oppress us.

Here's a glimmer: Before Zeus, symbolized by the Warrior Eagle, took over Mount Olympus and became the reigning king of the gods, the heavens were "ruled" by Cronus, symbolized by the Crow, a cousin of the Trickster Raven. Cronus ruled in what was called the Golden Age, an anarchist utopia of the past. There was no need for laws or rules, everyone did the right thing . . . thus Cronus led by following, until he was killed by his Warrior son.

And here is where hope begins: acknowledging the difference between the way it's *always* been and the way it's been for a long, long time. But "things do not have to be the way they are."[18] Giving Tricksters their seat at the table, combined with a retreat of Warriors to a less dominant role in our society, just might reveal a new societal vision. At the heart of the Trickster cycle is the journey from moral indeterminacy to moral discovery, and the idea that morality is best attained through experience, again and again if need be, rather than through the adoption of any particular liturgy or doctrine. This is how it happens.

CHAPTER TWO

LORD BUCKLEY: THE HIP MESSIAH PERFORMS THE TRICKSTER[ix]

Is it not written in the Talmud? "Who will bring redemption?
The Jesters."

— As told by Bart and Lisa Simpson[x]

Comedy is the only thing I've been able to take seriously. [19]

— Lord Buckley

 as anyone ever enjoyed being alive more than Lord Richard Buck-
ley did? His whole life was lived in perpetual answer to the trickster
question, *Wouldn't it be fun if ___?* and he took that mischief trait a

ix Author's Note: Because Lord Buckley (1906-1960) was the same character on and off
the stage, it's utterly fitting that his definitive biography *Dig Infinity!* by Oliver Trager
should be a compilation of reminiscences made by those who knew him, folks who can
tell the stories of his wild trickster persona, usually from firsthand accounts. While this
chapter relies heavily on *Dig Infinity!,* the original sources are the recollections of over
one hundred of Buckley's closest friends.

x *The Simpsons*, directed by Jeffrey Lynch with Brad Bird, season 3, episode 6, "Like
Father, Like Clown," aired October 24, 1991, on FOX. The quote from the Talmud
(Taanit 22a) is "We are jesters, and we cheer up the depressed. Alternatively, when we
see two people who have a quarrel between them, we strive to make peace. It is said that
for this behavior one enjoys the profits of his actions in this world, and yet his reward is
not diminished in the World-to-Come.

step further, playing with group dynamics and starting a movement to explore *What unexpected magic could happen when people gather?* All the while he's preaching, "I'm a people worshiper. I think people should worship people. I really do."[20] He was deeply loved by his close followers and friends, the Royal Court, and admired for his creativity throughout show business. And this was accomplished in the midst of what might be considered his mission quest: how much pranking can one guy get away with? For someone who played tricks that might be marginally mean and still be so beloved is itself a trick, and a paradox.

Buckley was perhaps the greatest influencer of popular culture in the 1940s and '50s and beyond. He was a comedian. And a troubadour, visionary monologist, gadfly, prankster, con man and hero. He was the original hipster, a mooch, philosopher, outlaw, griot, recording artist, ladies' man, proto-hippie, proto-beatnik, proto-New Ager. A hustler, pothead, healer, drunk, evangelist, loser. Lord Buckley was a performance artist, father, husband, and a guru in his own mind . . . an inveterate rascal and a trickster writ large.

Buckley's our human who most resembles Trickster as archetype, for the Force is strong with him. Beyond being a prime example who checks more boxes than most, Buckley's tricksterism inspires those of us who seek to lubricate the joints of an arthritic society, to make it a better, nimbler, funner place.

To that end, we get familiar with the evidence left in Dick Buckley's wake, his performances and the legendary tales his friends tell. Following that is an attribute-by-attribute profile of the man as his life aspires and correlates to Trickster. In his own way, Buckley defies the categories, and they tend to overlap, but that's apropos of the messy, tricky, slippery ways of the Trickster. Enjoy the ride. We look at how his jazz artistry and the substance of his monologues were relevant to race in America in the forties and fifties. And we ultimately come to appreciate the enormous influence Lord Buckley has had on American consciousness, imagination, language, style, and utopianism.

* * * * * * * * *

It's been said that Alfred Jarry (1873-1907) invented dada about fifteen years before it happened. He'd been dead for nine years when it blew onto

the scene. And it can be said that during the 1940s and '50s, Lord Buckley invented the sixties and did a lot of what the hippies would do years after his life was spent.

Did he affect a British-styled accent and aristocratic air while at the same time introducing Black vernacular to white audiences? He did. Did he help to invent "jazz comedy" that incorporated the rhythms of jazz in a stream-of-consciousness storytelling style? He did. Did he take antiracist stands and draw attention to ongoing racist practices when such messages were unwelcomed? He certainly did. Was he the first hippie and an inventor of Beat consciousness? Yeah, could be. In short, Lord Buckley personified the Trickster archetype.

Like Sun Ra, like Marcel Duchamp, Mae West, Alfred Jarry, Yoko Ono, Abbie Hoffman, Carolee Schneeman, Neal Cassady, and Andy Kaufman, Buckley's life was his art. The more tangible products, his records and his few videos, simply residue, embellished by the memories of those who knew him. Buckley was a great experimenter, leading a radically imagined and radically loving life right in the midst of "real" society? So nonconformity in his case is not a performance that is against convention, but one that proposes new directions.

Dick Buckley was born in 1906 in the rural town of Tuolumne, California, 150 miles east of San Francisco and between the Stanislaus National Forest and Yosemite National Park. Trickster scatology, tales that feature fart and poop and pee and toilet jokes come into play from the get-go: "I had a very auspicious beginning. I was attended by a midwife and, because I was very slippery, they made a grab for me and missed, and I hit the john—BOOM! They fished me out and wiped me off. I don't think it's harmed me any."[21]

He never stopped being slippery either.

The seventh son of a seventh son,[22] he and one of his sisters would busk in the streets from a very early age. His talent for acrobatics and mimicry and his ability to hold an audience's attention developed early.

And he was a beautiful liar. Buckley's eldest brother, Robert, was tragically killed, decapitated by a passing beam while riding up a miner's elevator. Buckley's version of the story claims that Robert was laughing at a joke his little brother Dick was telling him, threw back his head in laughter, and . . .

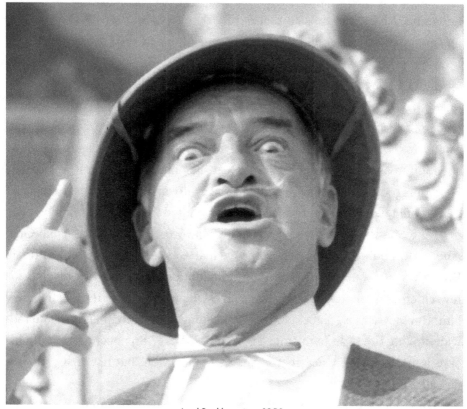

Lord Buckley, circa 1958.

This tale, based on truth (the decapitation), embeds a trickster lie, as Lord Buckley was only three years old at the time. Makes a good story, though!

In his youth, he worked as a lumberjack, known for his physical abilities and thus could take on the most challenging role of tree topper, and as a prankster, take target practice from the forest heights, spitting tobacco juice onto the heads of his coworkers.

But by the mid-1930s, he'd found his way to Chicago, working as an emcee in dance marathons, called walkathons. In these Depression-era competitions, couples would dance until they dropped, and the last ones standing would win the prize money. The film *They Shoot Horses, Don't They?* (1969) is set in a walkathon.

Buckley's job was to keep the audience entertained as they watched the dancers shuffle on the floor and eventually collapse from exhaustion. He

worked ten-hour shifts and so had time to develop his improvisational skills and gimmicks. Drawing on his lumberjack experience, Buckley would swing from a rope over the audience and pelt them with eggs.

But this was only the beginning. He was also performing in vaudeville and gangster-owned night clubs. In fact, he was Al Capone's favorite comic. Capone loved him so much he bankrolled a nightclub for him, Chez Buckley. On opening night, Buckley realized he hadn't prepared. Capone is there with his henchmen and their molls. Drunk and making it up as he goes along, Buckley collects the fur coats of all the girlfriends, just to borrow them for a moment, makes a pile in the middle of the stage, douses them with lighter fluid, and burns them all. He hightails it out the back door and gets on the next train to New York . . . and that's how his first residency in Chicago ended. Capone thought it was hilarious and bought everyone new coats.

He claimed that he wanted to "make it" conventionally, but Buckley's compulsive aversion to playing the game would win out; his self-destruct button was always on. Later in his career, when he was given his last chance to perform on Broadway, he showed up drunk, fell unconscious and into the orchestra pit, crashing through the drums and cymbals, and was carried out on a stretcher. The more he was told to, the less he would take anything seriously. This approach can work but is generally better for true archetypes like Bugs Bunny, who can survive all kinds of accidents and calamities.

Buckley presided over vaudeville's demise, becoming its biggest act just as it entered its death throes . . . and he took delight in that. A 1946 attempt to resuscitate the genre with a long-gone competitor to the Ziegfeld Follies, The Passing Show, utterly failed.

In the final days of its run at the Palace Theater in New York, Buckley met up with a friend, Harry "the Hipster" Gibson, during intermission. As they were sharing some reefer, Buckley said, "Hey Hipster, this is the end of vaudeville and I just killed it. So let's forget about it. I'll go into the nightclub business like you."[23] He kept on walking and never looked back, though his vaudeville chops would serve him well. Buckley never played the game. He always played *with* the game.

On this seam of vaudeville's danse macabre, Buckley mediated vaudevillian qualities into the emerging bebop jazz, hipster, and beatnik movement. He danced with time; he mourned the death of vaudeville not at all but used what he learned there to inform what became his main act. Previously, he'd been the biggest star in one of the most miserable of genres, the long-gone, unmourned walkathons. So when vaudeville died, Buckley popped up out of its coffin and declared himself ready to pounce on the now. During the Second World War, Buckley formed a lifelong friendship with Ed Sullivan, joining him for numerous USO tours, entertaining the troops, and taking his act to the next level.

Following the war and before rock and roll captured the American zeitgeist, the cultural juice flowed in the nightclubs, where a new generation of jazz musicians and comedians were holding forth, moving culture and consciousness on. And these were the settings where Buckley developed the strongest material for which he is known.

HIS ART

The monologues he performed on record really should not be cordoned off from who he was, nor should they be thought of as sufficiently defining him. But it's a good place to start. With Buckley, his orations are the closest we get to the conventional.

His manner of delivery will remind you immediately of Robin Williams, who took much from Buckley's cadences. Williams and also Richard Pryor shared and were influenced by Buckley's ability to perform lightning-fast changes of voice, odd sound effects, and skits with multiple characters. While known mainly for his faux English accent, booming delivery, and use of Black vernacular, Lord Buckley had a toolbox brimming with characters and voices to draw from. His own life, the Bible, film, literature, sex, history, animal stories, political commentary, children's stories, and Atomic Age anxiety were all fair game for topical exploration.

Besides his *Amos 'n' Andy* reenactment, using four audience members the way a ventriloquist uses his dummies, and his spot-on impersonation of Louis Armstrong, Buckley had a deep repertoire of routines and monologues. He was most proud of having invented what he dubbed "hipsemantic," which was

taking a classic story, like from Shakespeare or the Bible, and transliterating it into hipster language. Here's a summary of his best-known routines:

- **The Raven/The Bugbird.** A hip retelling of Edgar Allen Poe's most famous poem.
- **Willie the Shake.** A tribute to Shakespeare.
- **The Hip Einie.** Buckley's take on Albert Einstein and the consequences, good and bad, of his theories and discoveries.
- **The Hip Gahn.** The story of Mahatma Gandhi and the spiritual jazz he blew.
- **H-Bomb.** A short piece ranting and laying out the trickster principle that humor is fun and "our great ally" and that "a spear of humor" can deflate the threat of nuclear war, the least fun activity ever devised.
- **The Train.** A celebration and sonic re-creation of a train, a swinging creation of the kind of rhythms most associated with rap, the influence on Robin Williams apparent. A newscaster reporting deaths from a train crash impassively, thus heightening, à la Hitchcock, an audience response of horror.
- **Marc Antony** (Hipsters, Flipsters, and Finger-Poppin' Daddies). The famous speech from "Willie the Shake's" Julius Caesar told in hipsemantic.
- **Chastity Belt.** Whereby the inventor convinces the king, who must leave his queen to go conquering, of the belt's value, followed by the king tricking his wife into wearing it.
- **Gettysburg Address.** The hipsemantic version and the piece Buckley and his most ardent fans considered his strongest.
- **Jonah and the Whale.** A retelling of the Bible story, and we don't escape it or the whale before Jonah lights up some grass in the big fish's belly.
- **Scrooge.** The lesson he takes from the Dickens novel: "You can get with it if you want to—there's only one way straight to the road of love!"[24]
- **The Nazz.** As in Nazareth, the story of Jesus and maybe Buckley's most famous routine. Jesus, the hippest cat around with The Word: "To

stay cool means to believe in the Magic Power of Love" and "Make it, Jude" and "Dig, and Thou Shalt be Dug! Drag Not, and Thou Shalt not be Drug" and "Dig Infinity!" all come from this routine. Buckley a Christian.[25]

- **The Bad Rapping of the Marquis de Sade.** The shadow side of The Nazz?, Buckley's description of the Marquis's ways with women and disputation of the bad rap he gets.

- **Murder.** Buckley the humorous storyteller, more a monologist than a comedian, so usually no punchlines, excepting this misogynistic Hitchcock or Poe or Dostoyevsky husband-kills-wife tale, including the inner voice of the plotter, he grabs you in the end: "I killed her because . . . I LOVED HER!"

- **The Gasser.** Shines light on the less-well-known but fascinating Spanish conquistador Cabeza de Vaca, who led the first European exploration of North America's interior, from the Dakotas to Texas and the Southwest to Mexico City.

- **Governor Gulpwell/Governor Slugwell.** Buckley's presentation of a Huey Long/Donald Trump-type politician trying his best to come off in more of a Norman Rockwell vein and transparently failing.

- **Georgia, Sweet and Kind and Black Cross.** Buckley softly singing the standard "Georgia On My Mind," alternating it with a narrative depicting the Southern lynching of a Black man; a statement of horrifying parody that expresses Buckley's stand in alliance with Black America.

Black Cross is a recitation of Joseph Newman's similarly titled 1948 poem.[xi] Lynching and its contemptuous justification is confronted. These are his two most politically intentional pieces. He wants you to be uncomfortable, he's making it as terrifying as he can, and he wants you to feel the disparity of events that are airbrushed out of our culture using the beautiful and softly sentimental song of "Georgia" and the hillbilly humor of "Black Cross" to make

xi Joseph Newman was Paul Newman's uncle. On a couple of bootlegs of early performances (e.g., *Bonnie's Songs*), you can hear Bob Dylan do a pretty good cover of Buckley reciting Newman's poem.

his point. Buckley invades the serenity with the harshest of news bulletins: we live in a society poisoned by racist practices.

Before one of his performances for the liberal Beverly Hills/Hollywood crowd, his friend pleaded with him not to perform *Georgia, Sweet and Kind* for fear of offending the audience. Of course, it was the first thing Buckley did when he got on stage. Understand what a radical act it was to be performing these bits on race in the late '40s and 1950s. More than once, it so antagonized rednecks in the audience that Buckley had to make a run for it.

The San Francisco Renaissance produced art that emerged from radically unconventional lifestyles, just as the bohemian lifestyles of Montmartre went hand in hand with impressionism's break from tradition. Joseph Jablonski, a critic, friend, and Buckley aficionado, commented that "the key to Lord Buckley's alchemy was undoubtedly his . . . technique of inflation that allowed him to both valorize and satirize Great Men like Gandhi, Jesus, and Cabeza de Vaca, while contriving somehow to diffuse their mythical, miraculous gifts within a spirit of bop egalitarianism and universal aristocracy of the free."[26]

What made Kerouac, Ann Charters, Joyce Johnson, Ginsberg, Burroughs, Diane di Prima, and other Beat writers unique was that they were more influenced by the jazz rhythms of Lester Young, Dizzy Gillespie, Charlie Parker, Miles Davis and John Coltrane than they were by the authors and poets who preceded them.[xii] Beat poetry grabbed jazz rhythms, most notably in San Francisco's North Beach. Thus the significance of Lord Buckley being the first and only successful jazz comic can get lost in the misty, lovely mess of Beat.

Buckley defied category. One of many indicators was the inability of stores to find the right bin for his records. There were no comedy records at the time his first releases appeared in 1955-56, as if that would even be the right place to file him.

And even writing about him missed the mark. Newspaper reporters retreated into their own clichés: "it's a sin to summarize . . . a bit [The Hip Gahn] like this on paper because everything that's good about it gets lost in the translation. The timing, the phrasing, the irresistibly funny sound of Lord

xii Of course it wasn't just jazz that influenced these writers. There were Asian and
 European influences, and Thoreau, Melville, Whitman, Emerson, et al. also inspired the
 Beats.

Buckley's voice—none of it comes across [in prose description]. The basic message is one of joy and ecstasy."[27]

There are many recordings of Buckley and, regrettably, few filmed performances. YouTube features a few selections, Oliver Trager's biography comes with a CD, and the persistent hunter may be able to track down his twenty-plus releases.

Think of Lenny Bruce, with whom Buckley did a long residency at Strip City in Los Angeles and who joined the Royal Court for a time, as his shadow figure. Bruce was the more cynical satirist, while Buckley's humor seeks a positive resolve of social problems.

With one foot in the protectiveness of cool and the other loose and fancy-free, flouting the conventional, Buckley and his pals put a trickster spin on the very concept of society. His ignominious tall tale regarding his birth connects to the scatological. Beyond the poop and pee jokes, this next section puts Buckley to the test on the other key attributes of the Trickster archetype, from the ridiculous to the sublime.

TRICKSTERS TIME TRAVEL

He made his final tour in a red Volkswagen microbus. Though he died in 1960, he invented the hippie life whenever he could and a Yippie approach when confronted with authority. Buckley lived amongst and led a communal tribe of followers and friends, the Royal Court.

His Lordship anticipated the love generation. As early as 1956, Buckley's shows time traveled to the mid-sixties. In one of them, his Hollywood-beautiful wife, regally crowned and adorned, could be found selling tickets on the sidewalk in front of the theater in true flower power fashion. His followers and roommates, the Royal Court, built the set and painted the backdrop during the show, while the great R & B artists Roy Milton and Little Willie Jackson led the band. A happening, the original be-in.

British writer Francis Newton first saw him come on stage at two thirty in the morning at the Gate of Horn in Chicago. "He looked like a colonel cashiered from the Indian army in 1930."[28] He went on to comment that unlike his contemporaries—Lenny Bruce, Mort Sahl, Shelley Berman—one could

imagine Buckley "fitting in" with the cabaret society of the belle époque period (1871-1914). And in his *Nero* routine, two hipsters, the original Bill & Ted, travel to the first century CE. But Buckley's greatest time traveling feat was to live in the utopian regions of the sixties a decade or two before they dawned.

Buckley's reborn by the mid-1950s, spreading his gospel of love for all humanity. He moved to L.A.'s Topanga Canyon in 1954. It was inexpensive; Will Geer and Woody Guthrie took refuge there as well. Buckley and the Royal Court joined Bob DeWitt, a local artist, who was holding artists' parties, preaching love, live music, Buckley events, and even a very early version of a light show.

Kerouac defined Beat[xiii] in *On the Road,* an instruction manual for youths' idealism and nihilism in the fifties. While Kerouac was of the moment, Buckley's timeless glow made him some kind of oracle. Minstrelsy and vaudeville, Beat, and forgotten pasts launched Buckley, like a pebble from a slingshot, into the future.

He invented a beatnik/hippie version of antimaterialism.[xiv] He gained ontological momentum, from his birth in the shadow of Yosemite through his long runs of gigs in Chicago, Hollywood, Las Vegas, Miami, the Mojave Desert, and New York City . . . ultimately being claimed most lovingly by San Francisco.

TRICKSTER IS AN ARCHETYPE

We know that a human being cannot be an archetype . . . but they can try! Buckley flew close to that divine wind.

Jerry Garcia called him "the hipster of the heart."[29] His sum total was completely unique. The way he blended jazz with wordcraft, the way he predicted and even leaped beyond the incipient beatnik scene bespoke a supernatural talent.

Buckley elevated everyone around him, addressing them as lords and ladies, counts and countesses, dukes and duchesses. One story has it that he

xiii For a riffing compendium of Jack Kerouac's various definitions of *beat,* see
 Shepherd Siegel, *Disruptive Play: The Trickster in Politics and Culture* (Seattle, WA:
 Wakdjunkaga Press, 2018), 142-143.

xiv . . . and thus Buckley was constantly in debt.

was touring a circus and from an elephant (the king of the jungle) he took the regal-looking hanging that would otherwise drape the animal and enrobed himself in it . . . and was Lord Buckley from that point on.

By adopting Lord as a title, he at once identifies with the royal siblings: King Oliver; Duke Ellington; Count Basie; King Pleasure; Lady Day; Ella Fitzgerald, the Queen of Jazz; Bessie Smith, the Empress of the Blues. So his gaze is on high, but he's making fun of it at the same time. Tricksters take nothing seriously, but Buckley didn't need to be told that.

He was a devout believer in love and chose it always above success, never hurting a friend in the interest of his own advancement. This quality hints at the savior-like attribute that makes Trickster more than what a human can be.

It was said that success eluded him because he used up all his luck just staying alive. But luck, he had a bunch of it. Getting away with your life when Al Capone is your number one fan would seem to have a godly air about it.

Despite the titles, which must be taken as satiric, his political talks decried colonialism and the idea that us common folk should ever look to any form of royalty to solve our problems. So instead, through his riffing on Jesus in The Nazz, he takes us to God. Yet that pathway releases us from royalty worship just long enough for him to preach his gospel that we should worship each other. And thus he founded the Church of the Living Swing. At one of its early services, he shared the bill with a couple of belly dancers, and the short-lived venture has the distinction of being the only church to have been raided by the vice squad. Some say that Buckley himself phoned in the tip. Only a trickster could master the spiritual juggling of leading people to God, to each other, in total sincerity and then pull the plug on the whole thing in an act of self-and god mockery.

His holiness came through his humility, his refusal to treat any fellow human poorly, and his ability to gather believers around him. He felt a spiritual connection with animals, performing Jonah and the Whale and his versions of many of Aesop's fables (The Dog and the Wolf, The Mouse and the Lion, The Grasshopper and the Ant, and The Lion's Breath.)

Buckley's proximity to archetype status might best be summarized by his daughter, Laurie: "It was always a highly stimulating atmosphere, musi-

cians, artists, actors and actresses, always a collection of interesting, interesting people. He just had such tremendous insights into lives and souls, he had kindness and compassion and he never put people down. . . . He could identify the negative in people but he never used it against them."[30] This striving to be more—the willingness to cross boundaries one would expect only of a supernatural being—takes Buckley into the stratosphere where he rubs shoulders with the divine.

TRICKSTERS RELISH CROSSING BOUNDARIES

Just the fact that Buckley was billed and made his way as a comedian, when his so-called jokes had no punch lines, crossed the Borscht Belt boundaries that defined stand-up comedy in the 1940s and '50s. Buckley's wife, Lady Elizabeth Buckley, said, "The worst thing he did was to tell people the truth. Lots of times people don't like that."[31] Once he told an audience that they had too much money and didn't know what to do with it. He had to exit by the back door. Another time, an insulted audience member jumped onstage with a knife and threatened him.

After a gig in upstate New York that did not go well, Buckley, Lady Elizabeth, and his close friend Larry Storch stopped in an out-of-the-way rural bar, drank, and then Buckley started lecturing the clientele on Communist China. In the course of the lecture, he insulted a woman in the crowd, whose husband approached Buckley menacingly. Buckley gathered his crew together for a hasty retreat. "Easy, Lord Storch," said Buckley. "We're not going to pay the bill on this one even though we've had our drinks . . . they're like sharks and monkeys: they can smell blood. Don't let them sense fear. Back out slowly . . . we'll have to kick our way out of this if need be."[32] And they hightailed it out of town.

After smoking some pot with a friend at the Central Park Zoo, Buckley noticed a crowd looking at a lion. Not to be upstaged, Buckley got down on all fours and impersonated the lion, roaring and throwing dirt up in the air. He pulled in the audience and did a friendly cutting session with the lion.

In 1955, on the national television program The Steve Allen Show, Buckley improvised a tumbling and handstand free-for-all with bandleader Skitch

Henderson, guest Andy Williams, techies on the set, and audience members. By the end of the sketch, Buckley's in his underwear.

Speaking of which, he was seen by the great bassist and photographer Milt Hinton walking down Broadway with a woman on each arm and wearing a beautiful new tuxedo that had everything except the pants.

"O God, the whole world has turned against me!" Buckley cried out in his booming voice when taken before the judge the morning after a house detective busted him in his hotel room for having reefer and alcohol and a possibly underage woman. The judge, seeing the kind of troublesome defendant before him, immediately dismissed the case.

Buckley shenanigans that were not performed out in public took place in the several homes, both majestic and tumbledown, where he and his Royal Court took up residence. Robert Mitchum came by for a visit only to see that Buckley had cowed all of the guests under chairs, and he was lion-training them with a whip. They had to perform in order to earn their way to freedom.

During his stint with Lenny Bruce, the famous comic turned the tables on Buckley, hiding out above the stage's ceiling in the rafters. The prank went wrong, and Bruce came crashing down through the ceiling on top of the good lord.

One of Buckley's big chances was following Frank Sinatra at New York's Copacabana. After the opener and the headliner, these third acts were hired to "play to the haircuts" and help the club sell more drinks as the audience was getting up and leaving, in this case having seen and heard Sinatra. Buckley came on stage, pulled out a saw, said "It's hard to follow Frank but here's a little something to make you think" and proceeded to begin sawing his foot off, enough to make the foot spurt blood and some in the audience to faint. "Thank you, now you know when you leave here that there's only one name on your lips and it's mine!" Sinatra was impressed, and they became friends. However, when Buckley led sixteen naked folks through the lobby of the Royal Hawaiian Hotel where he was performing, he got a phone call: "That's the funniest thing I ever heard," said Sinatra, "just don't ask me for any more favors."[33]

But being driven by libido is intrinsic to Trickster. A friend is taking some of his friends to meet Buckley in his hotel room. Not one to have his coitus interrupted, Buckley answers the door stark naked and invites them to have a seat and a drink while he finishes making love with his other guest.

For an important meeting where he could have gotten a contract doing television ads for Coca-Cola and made more money than he ever had before, he showed up over a half hour late with two prostitutes, whose services he offered to the advertising executives at the table. Neither the contract nor relations with the women were consummated. I think he was making a political comment.

Speaking of sex/gender, Buckley gave titles to all in his Royal Court. To comic Tubby Boots, who performed in drag, he gave the name Princess Lil . . . such would be common today but was radical back then.

One live recording has Buckley leading the audience in a group re-creation of the sounds of sexual ecstasy. And it is with these moves, beyond the individual prank, that the idea of an entire group getting in on the action shows up. The magic of what can happen when people gather happens. And the veil is lifted ever so slightly on utopian possibility.

One could say that the movement of hippies heading out to the country to live and celebrate communally was initiated by Buckley. At one point in the early 1950s, the Royal Court took up residence on the outskirts of Las Vegas. They came upon a bunch of mattresses that the army had dumped, and they made a huge U-shaped couch with them and built a fire in the center . . . and they gathered and enjoyed life and each other out there in the desert. In 1959, he led a three-day Thanksgiving party at Lake Arrowhead, eighty miles east of Los Angeles. Legend has it that Buckley got up and improvised monologues, holding the audience in rapt attention for thirty-six hours. It should not go unsaid that Buckley was an early experimenter with LSD, and . . . he was tripping.[xv] But more to the point are the possibilities of such gatherings. And it was at this celebration that Buckley first addressed his audience with a line for which he

xv In fact, his during-the-trip observational notes under the supervision of Dr. Oscar Janiger were part of some of the earliest research on the drug.

became known: "Would it embarrass you if I were to tell you that . . . I love you? It embarrasses you, doesn't it?"

TRICKSTERS JUST WANT TO HAVE FUN

Of all the friends and acquaintances with all their stories that populate Trager's biography, Mel Welles, who collaborated with Lord Buckley on the writing of many of his routines, seemed to know him the best, and he makes this pithy and to-the-point comment: "Everything was done just to have a good time. There was nothing serious about anything."[34] Indeed, tricksters are ruled by indeterminacy and avoid anything, including moral strictures, that would get in the way of having fun. So begins the way of the Trickster cycle, free of morality, a cycle that completes with moral discovery[35]

Buckley may have begun performing in the streets of Tuolumne as early as age three. At age three, a toddler's pre-moral state hasn't quite worn off, and the attention and money that Buckley and his sister earned, and the fun they were having, could serve only as encouragement. So Dick Buckley kept on doing the things that got him attention, and some of the pranks already mentioned—spitting tobacco juice on lumberjacks, throwing eggs at an audience—must appear mean and if not evil, at least bad. Bad boy! When constructing his Amos 'n' Andy routine, Buckley stumbled into the dilemma of American racism, yet at the time, all he knew was that it got audience attention and approval and it was fun. As fate would have it, this was the shtick Ed Sullivan would insist he perform on national TV, right up to his ninth and final appearance. Yet by wading into this predicament from a morally indeterminate standpoint, Buckley was able to grapple with the issues it uncovered, contemplate and reckon, and become an antiracist and a champion of civil rights for Blacks, gays, all people. He thus presents a sterling example of the Trickster cycle and its value—that just having fun will eventually lead us to construct morality anew, not through pedagogy, doctrine, or liturgy, but through experience.

Even in adulthood, though, the temptations of fun could still override moral considerations. There is a great story about how, on the MGM movie lot, Buckley convinced the keeper of the prop department that he was work-

ing on a film and he needed a safari jacket, jodhpurs, and pith helmet, symbols of British imperialism Buckley was only too eager to satirize. He faked his way into procuring the items and made his escape wearing the outfit. Hidden in plain sight, he stood up in the convertible his recording engineer and friend Nick Venet was driving and tipped his hat to the security guards at the gate. They saluted as they drove through the gate, and the safari outfit became one of his calling cards. He appears in the pilfered garb on the cover of more than one album.

Once he told his children, who were only five and six years old at the time, to show a guest their room. It was the pitch-black middle of the night, and Buckley had the children running down a rickety staircase, urging them to go faster and faster. He turns to his guest and in a stage whisper says, "Don't worry, they're heavily insured."

When working and recording live gigs for World Pacific Records, the owner sent Venet, who was teaching himself recording technique, to the sessions, not so much to run the equipment, but mainly to make sure that Buckley wouldn't sell it.

Sunset Boulevard in Los Angeles was home to the Club Renaissance, whose owner, Ben Shapiro, would allow artists who had lost their cabaret cards to perform under the radar. Buckley needed the opportunity and joined Wavy Gravy, Stan Getz, Lenny Bruce, Jimmy Witherspoon, and others who found themselves in the same jam. These cabaret card outlaws formed something of an underground association. But the whole cabaret card racket, in Los Angeles and New York, was all about police graft. You would bribe the cops to get your card back. It had seriously hurt the careers of Billie Holiday, Thelonious Monk, Lenny Bruce, and many others.

Bob Dylan sings "to live outside the law you must be honest."[36] Holiday, Monk, Bruce, Buckley, these are artists who trade in big truth, real honesty. Working without your cabaret card is, according to the system, a lie, outside the law. This is an elementary example of telling a lie to expose the truth, a trickster maxim (See the Yes Men; see Rebekah and Jacob). Sometimes rule-breaking is the breaking of unfair rules. The transgression plants a seed of moral insight to be harvested later.

TRICKSTERS PLAY TRICKS AND ARE ALSO DUPES

Buckley's main cowriter Mel Welles believed that the hagiography of Buckley missed the point, that he was, in the final analysis, a loser. Jablonski concludes that "Like many of his routines, Lord Buckley's own life was a hectic and chaotic parody of grandiosity."[37] All trick, if you will. The Trickster's willingness to risk humiliation and the messianic implications of that are aptly stated by TV actor (from The Munsters) "Grampa" Al Lewis in his interview with Trager: "Buckley was like Baudelaire—a junkie gone intellectually berserk. Flying so high that people laughed and applauded out of curiosity not out of understanding. It's like Baudelaire's poem about the albatross the sailors nail to the deck of the ship and laugh at while it wildly tries to get away."[38]

Even Buckley's appearance was something of a trick. Robin Williams described him as looking as if Salvador Dali and Coleman Hawkins had a kid, and that "calling himself 'Lord' Buckley was self-elevating and, at the same time, self-mocking. Giving yourself status and simultaneously making fun of that status."[39]

That's not always a beautiful thing. For late-night TV host and comedian Steve Allen, dealing with a man who was never out of character made it difficult for him to form a friendship with the lord. But oh, his tricks had some memorable wonder to them. When shopping with Lady Elizabeth, they would bring their invisible dog, who would bark as they went in and out of stores and under the table at the restaurant where they dined. This ventriloquized pantomime would fool many and delight all (okay, except Mr. Allen).

At New York's Waldorf Astoria, he walked in on an orchestra rehearsing for a benefit that was to be emceed by Ed Sullivan. He rehearsed several cues with the orchestra for a good forty minutes. It wasn't until the evening's performance that the musicians figured out he wasn't even on the bill.

His Royal Court was holding forth with a party loud enough to summon a visit from the police. Buckley met the officers at the door, and before long they had fallen for his Jedi mind tricks and accepted his invitation to come into the house for a couple shots of whiskey.

Aspects of the following anecdote conform to patterns of abuse. But if anything, Buckley was satirizing. By all reports, his treatment of women was

always respectful. Lord Buckley's surviving wife and partner, Lady Elizabeth Buckley, said, "He was a very handsome gentleman with impeccable manners and dress. . . . He was very eloquent, and he knew exactly how to treat a lady and make her feel very comfortable no matter where he went."[40]

His motivation, in this instance, was to pull a fast one on the cops, and he set a scene of domestic violence in service to that motive.

In his memoir, From Birdland to Broadway, Bill Crow recounts how "[Buckley] once threw open his front window and pushed his wife out over the sill, clutching her by the throat and waving a butcher knife in the air as he screamed, 'I'll kill you, you b****!' When the police arrived, the door was open. Inside, they found the Buckleys dressed in evening clothes, listening like staid British royalty to a recording of a Mozart quartet while sipping tea. . . . They politely inquired 'What disturbance, officers?'"[41]

This small fraction of the tricks Buckley was constantly playing are matched by the ones where he was his own or even someone else's dupe. Or the dupe of circumstance. He drove his brand-new car onto trolley tracks on Chicago's State Street. On purpose. For fun. The tracks were still under construction, though. He took his hands off the wheel, letting the dug out traces do the steering, right up to the point where the car rolled into a ditch.

Buckley exhibited athleticism on and off stage, but it didn't always go perfectly. He once tried to steal the spotlight in a show with one of his famous leaps, this one from the audience to the stage. But someone grabbed for him in midair, and he fell and broke his arm.

His last home was in San Rafael, California. It was mildly decrepit and perched precariously above a canyon, seemingly in midfall. Buckley strung Christmas tree lights that would shine through cracks in the walls, giving the house a fascinating glow, but it seemed that the house itself was playing the trick.

TRICKSTERS ARE LIARS. AND SAVIORS.

Enough with the lying, the cheating, the pranking, and o the cruelty. I think we got that. In concert with his trickster compatriots—Marcel Duchamp, Carolee Schneeman, Mae West, Andy Kaufman, Alfred Jarry, Groucho, Yoko Ono, Abbie Hoffman, etc.—Buckley most deliberately reached for the divine, for

the mythical, the archetypal. In matching his life to Trickster attributes, the idea of trickster as savior resonates utmost. He even called himself the Hip Messiah. Once I learned that, when out sailing, Buckley would take off all his clothes, stand at the bow, and howl at the moon, I was ready to join the fold. But that's just me. Of course, there's more to the story.

As early as 1943, his shows were promoted in the papers as "New! Different! The Audience Makes the Fun!" And this philosophy, whereby the audience *does* make the fun, comes through in his own words. Buckley Though some of his pranks may seem mean or morally indeterminate, Buckley would complete the Trickster cycle early on and enter the moral discovery phase. Um, the ends justify the "mean." This is the path he took to a visionary and innocent idealism. He said things like this:

I'm a people worshiper. I think people should worship people. I really do.

I don't give a d*** what people say: love is love. That's the point I want to make to you. Never be unkind to anyone. Never join people in laughing at people. Join all the people laughing with people. Join them. See, when you're not informed through life, you've got to carry a lot of remorse with you.

Humor should be used for beauty, not for ridicule or other cruel purposes.

The flowers, the gorgeous, mystic, multi-colored flowers are not the flowers of life, but people, yes people are the true flowers of life. And it has been a most precious privilege to have temporarily strolled in your garden.

Buckley paraphrased the closing scene from the 1958 Alec Guinness movie, *Horse's Mouth,* based on a novel by Joyce Cary. The dying protagonist is visited by a nun who can't understand why he's laughing. "Mr. Jimson, at a very serious time like this, don't you think you should laugh a little less . . . and pray a little more?" He speaks his final words: "But it's the same thing, Mother."

Whatever martyrdom might be read into Buckley's death, it was, like the rest of his life, not a joke, but a good story with a greater truth to share. And it's the story of entertainers and artists, and of his family. In late 1960, he was pulled off a New York stage by the vice squad in the middle of his act for lack of a cabaret card. The city had taken it away fifteen years afore over a drunken fight. Buckley was trying to get it reinstated but had run into a lot of red tape.

Things had just been looking up; reinstatement seemed imminent, but he was despondent. He quoted to his most fervent advocate, Doc Humes, his pseudonym for Poe's *The Raven*, "I've got to find help somewhere, they're bugging me to death. In fact I got the Bugbird in me right now."

A few days later, Buckley was dead. Much mystery and numerous theories surrounded his demise—from poisoning to suicide by vodka and peyote, to stroke or heart attack, to being beaten—which make the story intriguing, but the through-point, the simple algebra, can be found in his own words: he once said that a performer who couldn't perform might as well be dead.[xvi]

His sacrifice, in the name of entertainment and free expression, was evinced by the uprising of artists and a movement his sad end inspired. Luminaries including Norman Mailer, Quincy Jones, Nina Simone, and Frank Sinatra all filed lawsuits or refused to get cabaret cards. They exposed the corrupt government harassment, the police raids on clubs, and the indignities the scam foisted on artists. It took another seven years, but in 1967, the cabaret card system was abolished, and credit for starting this movement must be given to Lord Buckley and his sacrifice.

BUCKLEY AND RACE

Children of the sixties bask in the glow of their passionate progressivism. Stances against the war in Vietnam and for the civil rights movement advanced the Left's commitment to antiracism, exposing hateful policies that were oppressing Native Americans, the Vietnamese people, and Black Americans. Though the American Left of the sixties was rife with sexism in its leadership, in its behavior, and in the misogyny of the so-called sexual revolution, the movement was nonetheless important in raising consciousness and awareness and moving ideas forward. So it was with Lord Buckley, whose abstract vision of a world based upon love went beyond his best efforts to make that vision real. And best efforts, as well as the flaws and limitations of those best efforts, are what we need to acknowledge and learn from. Millennials and Generation Z have put forth a deeply considered and aware vision of what it means to live

xvi To escort him beyond this life, Cannonball Adderley played at his funeral, which was paid for by Ed Sullivan. In Trager, 351.

in a space liberated from sexual and racial prejudice. Yet we will always be a work in progress, always paying for the sins of our forebears. The residual effects of sexism clung to the fabric of sixties liberation movements; it wasn't ready to be residue, as the wave of feminism that came into play in the 1970s ably insisted upon and proved. Thus, if we believe in the advancement of progressive ideals, there will always be, even for Generation Z and on beyond Zebra,[xvii] further correction required. I try to acknowledge such advancements and take note of their shortcomings.

Buckley's relationship to African American culture may be complicated, but what stands out most are its intimacy, its utter respect, and the courage with which he took antiracist stands in public before the modern civil rights movement and before any white person would venture such statements in public. Two of his main routines, *Black Cross* and *Georgia, Sweet and Kind*, depict the lynching of a Black man by hateful and bigoted mobs playacting a feigned innocence. He performed these routines not to elicit laughter from his audience, but to share his horror at the atrocities people were inflicting on others.

I should think that a child is born free of racism but, in a society drenched in it, comes to accept it as the way things are, or even acts it out reflexively. Such may have been the case with Lord Buckley. His chosen field of entertainment brought him in close contact with Black jazz, dance, and comedy artists, many of whom became close friends. And in these nightclubs, the evening's entertainment most often alternated a comedian with the jazz musicians, so Buckley's exposure was extensive. Thus, his *Amos 'n' Andy* routine, the one Buckley first became known for, was an act of doubling. It both honored and demeaned, depending upon which mirrored reflection one sees. Buckley himself came to reject that routine but continued to perform a hefty portion of his others using Black vernacular for certain characters. Many who knew him through radio broadcasts and records initially thought that Buckley *was* Black. And as Black jazz critic and author Al Young explained:

> The spirit of Lord Buckley was not malicious, hostile or in any way exploitive. That was the language that was around in

xvii I wrote this before the Dr. Seuss book by the same name was discontinued.

the world that he inhabited. Everybody talked like that . . . His language was poetic, and the effects he achieved were poetic effects. And he had a sense of rhythmic development that not all monologists have. He also had the ear of a musician. . . . He did not do anything substantially different from what Mark Twain did. Lord Buckley is from that grassroots, populist, anarchist American tradition that was a force for so long in this country and, for a while there, made it great.[42]

In fact, he is more often credited with making Black vernacular acceptable and beautiful to white audiences than he is accused of prejudiced appropriation.[xviii]

Such language demonstrated the intimacy and vulnerability that Buckley was willing to own. Being "the first and only successful jazz comic in the history of American show business"[43] makes comparisons impossible. But when Buckley took influence and inspiration from Black culture, it was to honor and not to offend, and to advance art, as did white jazz greats like Bix Beiderbecke, Django Reinhardt, Stan Getz, Phil Woods, and Bill Evans. Their use of a jazz phrase first played by a Black jazz artist was never questioned. When we are in the realm of the arts, we're more likely to experience an artist under the influence than we are to witness appropriation. There is not, and I should hope never will be, an official arbiter of which is which.

Buckley's epiphany on racial justice may have come when he developed The Gasser, his routine on Álvar Núñez Cabeza de Vaca. Buckley picks it because during this conquistador's first exploits in the New World (1526-1536), Cabeza de Vaca came to realize that the enslaved and conquered indigenous people were deserving of equality, dignity and respect, and the right to not cede their land to Spain. Cabeza de Vaca went rogue on his mission from King Ferdinand and for a time became a faith healer amongst the tribes.

Possibly the most important Buckley routine, The Gasser mirrors his own revelation and love for cultures of the oppressed, in particular Black culture,

xviii According to Charles Tacot, "Lord Buckley wound up meaning more to the language from the standpoint of bringing hip jargon into respectability than he did as a comic. He did more for the English language in bringing the black idiom into favor than anyone else before him." In Trager, *Dig Infinity!*, 58.

and it serves as an exposé of the fairytale version of European imperialism that was taught in American schools. In his tale, the moment of revelation is thus spoken: "And The Gasser say, 'Well, I'll go in here and sound the Chief and get a couple of boxes of acorns. Say, we might not find out where we is but we liable to find out who we is, that'll help a little bit. . . . I found out on this Expedition that there is a GREAT POWER WITHIN which when used with Purity, Unselfishness and Immaculate Thought can Cure, Heal and Cause Miracles. When you use it, it Spreads like a Magic Garden, AND WHEN YOU DO NOT USE IT, it recedes from you."[44]

And again, Buckley expresses in his own words that he was not exploiting a culture to get some easy laughs, rather that he had been blessed to drink from the well of indigenous, Spanish, and Black culture:

> Well I came by the language in association with the beauty of the American Beauty Negro and the sacred association with the field of music and its growing volume which has had a fantastic renaissance here in the United States. . . . They got themself a zig-zag way of talking and I think eventually became the intimate social language of the American Beauty Negro. It has a fantastic sense of renewal that'll take any old and revered movement and swing it right up to the pounce of the now and the meaning and it is sparkled with the magical beauty of the American Negro for which the United States should be tremendously grateful for many many other things: the brotherhood of the Negro race. Because, going up against the granite walls of stupidity, they have, as a consequence, at the other end of the pendulum, have dug out their wells of humor to such a point that it turned into a spring. It spread by a spring that is so deep because they had many many times to laugh at a number of things that weren't funny and laughed at them anyway. And, as a consequence, in the law of conversation, they wound up with a very very deep sparkling humorous well of beauty.[45]

So Buckley's life not only resists any racist tag, but he can even be seen as a New World version of griots, the West African itinerant storytellers and sages.

No group is monolithic, and whatever criticism or resentment was thrown at Buckley for using Black idioms, it was overwhelmed by his acceptance and adoration by heroes of Black jazz culture such as Dizzy Gillespie, Ornette Coleman, Cannonball Adderley, Amiri Baraka, and Charlie Parker. Did Buckley profit financially from his integration of Black vernacular into his act? Buckley lost hundreds of thousands of dollars more than he earned. When he was in the money, he gave it away and surely enjoyed himself.

Buckley pulled a final trick, this one from the grave, that showed how his use of Black vernacular opened doors for Black artists. Near the end of his life, he got a voice part playing Go Man Van Gogh in the children's cartoon show *Beany and Cecil*. When Buckley died, Black musician and actor Scatman Crothers was recruited to take his role.

HIS INFLUENCE

Lord Buckley never made it big, and in seeming acts of self-defeat, he repeatedly refused to play the game. Merely a pebble on the Big Rock Candy Mountain of celebrity? Or maybe the ripples of a pebble dropped in a still pond make a better metaphor for Buckley's influence. Indeed, trickster types like Marcel Duchamp, Mae West, and Andy Kaufman, along with the multitudes of the unfamous, chafe under whatever game the star-making machinery foists on their art or politics. While there are notable exceptions, such rankling can ruin their chances at success and garner dismissive responses to their notoriety. Thus Buckley is famous for famously screwing up opportunities that would have made him famous.

But what a beautiful paradox Buckley's esoteric fame yet incomparable influence makes. What's the lesson in that? Perhaps that a culture steeped in celebrity for celebrity's sake obscures artists who perform in the interest of making a better world. Tracing Buckley's immense influence begins with those who rippled and riffed in close contact with him or publicly proclaimed their love or made direct reference. Just a few of the many close friends, unfamous but who have influenced the arts and American culture include, beyond the

already mentioned Hollywood beatnik Mel Welles and drag comedian Tubby Boots: composer, musician, author, farmer, David Amram; road manager and the first to write about him, Charles Tacot; musical collaborators and close friends Dick "Prince Owl Head" Zalud and Millie "Lady Renaissance" Vernon; puppeteer and admirer Paul Zaloom; and cofounder of The Living Theatre, Judith Malina. Then there was the woman in her eighties, Lady Curl, who let Lord Buckley and the Royal Court move into her famous Hollywood home— the Castle, they dubbed it—and live and party there for several months.[xix] All of these folks are important, not for being famous, but for extending the notion that when we gather and optimize fun, our potential for living better together manifests. Fame may have eluded Buckley, but the fun he made happen, his reflexive generosity, and his uncanny sense of freedom drew people to him wherever he went. And they joined in his true purpose, a communal search for more fun and rewarding ways to live together.

Buckley and Lenny Bruce were probably the two most controversial comedians of the 1950s. Bruce was more famous but, while not afraid of pulling the occasional prank, embodied the Trickster persona less consistently than Buckley. But Bruce's notoriety brings an important comparison into relief. Lenny landed very specific punches on organized religion, the cops, sex and so-called obscenity, dirty politics, hypocrisy, etc. He could be loved or hated for his opinions, but Buckley's monologues lent themselves to more open-ended questions on these same topics, thus making his art more complex.

Buckley's influence and talents are manifold, but it's his unique cadences that bring audiences under his storytelling spell. You hear that immediately in Robin Williams's style, and also in Gilda Radner's Roseanne Roseannadanna character, in Whoopi Goldberg's comedy, and in some of the lines Chris Rock delivers, to name just a few examples.

Buckley's kind of funny but very intentional and profound monologues could be heard in nightclubs and coffee shops, on TV and radio, in vaudeville, or even on Broadway. He played *with* the conventions of those settings to deliver whatever message of free-thinking he thought most valuable. He was

xix He and the Royal Court were eventually asked to leave after Buckley started selling her furniture to pay off his debts.

the first to deliver an on-air satiric take of the daily news, which has become de rigueur for everything from *That Was the Week That Was*[xx] to Saturday Night Live's *Weekend Update, Full Frontal with Samantha Bee, Last Week Tonight with John Oliver,* and *The Daily Show.* He was one of the first observed LSD experimenters. He challenged the mores of friendship and the dictates of sexual and social relationships. Among his closest friends was Charlie "Bird" Parker, the first genius of bebop jazz. As Buckley affected Black vernacular, Parker often took on the spoken airs of a British aristocrat.

Was Buckley's art comedy, or was it jazz? He broke taboos of whether and where we could talk about race. And he preached unabashed love, something that all these years later is still more accepted in the context of a church than elsewhere, though much rock and roll and pop music has followed Buckley's lead.

Buckley treated all friends and acquaintances as lords and ladies, setting an example of unrestricted love of our fellow women and men. But what makes influence substantial? Does it matter that some of the more famous but not yet mentioned big fans and friends influenced by Buckley include Ken Kesey, George Harrison, Anita O'Day, o', Phil Schaap, Studs Terkel, David Bowie, Jack Kerouac, Jon Hendricks, Sammy Davis Jr., James Coburn, Richard Fariña, Frank Zappa, Miles Davis, Tom Waits, Benny Carter, Eric Bogosian, James Taylor, Jimmy Buffett, Redd Foxx, Billie Holiday, James Dean, and many more? Consider the immense influence of these folks and that Buckley's influence may be even greater. These associations matter only to the extent that Buckley's influence inspired boundary-crossing and fun that advanced social progress. He forged a subculture in tunnels of free-spiritedness away from the spotlight of celebrity. That was his mission, his moral discovery.

* * * * * * * * * *

One of the more precious beauties of Western democracies is that they allow artistic freedom, artists who take to the streets and test the limits of that freedom, cross boundaries. Still, some artists threaten the state simply by virtue

xx *That Was the Week That Was* ran 1962-63 on the BBC, and in the US, 1964-65 on NBC.

of their race (Black blues, jazz, folk, hip-hop) or their more liberal approach to sex or drugs or life itself (e.g., Chuck Berry, Robert Mapplethorpe, Andres Serrano, Elvis Presley, Jim Morrison, Prince, Karen Finley, Mae West, Lenny Bruce). Buckley's outrageousness came from a different perspective, from the great questions he posed and acted out: What can happen when people gather? What are the untried possibilities?

His quest commenced early on, when he had to hang on to an audience during the painful and painfully boring walkathons. He was fascinated then by the question in a purely amoral, fun way; later in life, he fascinated by the answer, the search for utopian possibility.

To say that Lord Buckley was a playful character would be quite the understatement. Onstage and off, his persona did not change. His rapid-fire, loud, rhythmic, satiric declarations of love for humanity put him in the camp of the messianic trickster. If we can accept the idea of messiah as a type of person instead of "the one, the only, the all-powerful" and avoid phonies and exploiters, we may find that the human race has more going for it than we thought.

Buckley was a trickster in so many ways, though not a typical loner. He seemed to be always around people, guiding the Royal Court with a spontaneous, creative, radical model of communality—royalty only in the sense that *everyone* was treated with the respect royalty takes for granted. He was a loner in his iconoclasm and individual risk-taking, but he transmuted that lonerism into a renewed quest for what a community could look like—against the grain of a bustling postwar America more concerned with industrial efficiency than community. Through these rebellious experiments in communal living, Buckley sought to fulfill the utopic prophesies of tricksterism.

Though Buckley self-identified as an entertainer, he was always exploring that deeper question of communal possibility. Thus, his life and the lives of those in his audience, his Royal Court of lords and ladies, were all part of an experiment. What if we just found someone to take us in and then lived in their house for as long as they would let us? What if the only rules we lived by were love for one another and, above all, have fun? What if the default attire in our home was to wear none at all and receive our guests in the buff? And within the structures of performance, what if his monologues were comedic and funny

but delivered a message instead of a punchline? What if he confronted racism from the stage when no one else would? What if his modus operandi was one of flouting authority, yet maintaining an abiding respect and gratitude for the police officer? What if there were regular references and squeals of appreciation for sex when such a thing was taboo? What if he introduced the rhythms and sensibilities of jazz to the spoken word?

But perhaps the strongest influence came in the decade following his death, in the thousands and millions of free-thinking and free-living folks we'll call the hippies and idealists of the sixties who took his cue to dare to dream. Lord Buckley scouted out the terrain and reported back to us from the future: this is what you might be able to get away with . . . have fun!

When all is said and done, the trickster attribute that rises to the top is that Lord Richard "Dick" Buckley was a savior type. He is the original modern believer in love above all else, and he sought out love, beyond race, beyond class, beyond political views, beyond vocation.

SLAPSTICK: THE CATAPULT AND CATALYST OF DISRUPTIVE PLAY

Until the law of gravity is repealed, the pratfall will never be replaced.

—Alan Dale[46]

Sennett[xxi] used to hire a "wild man" to sit in on his gag conferences, whose whole job was to think up "wildies." Usually he was an all but brainless speechless man, scarcely able to communicate his idea; but he had a totally uninhibited imagination. He might say nothing for an hour; then he'd mutter "You take . . ." and all the relatively rational others shut up and wait. "You take this cloud . . ." he would get out, sketching vague shapes in the air. Often he could get no further; but thanks to some kind of thought-transference, saner men would take the cloud and make something of it. The wild man seems in fact to have functioned as the group's subconscious mind, the source of all creative energy. His ideas were so weird and amorphous

[xxi] Mack Sennett was one of the first great studio heads. Known as the King of Comedy, his productions originated much of slapstick. He claimed that the only gag he really invented was pie throwing.

that Sennett can no longer remember a one of them, or even how it turned out after rational processing. But a fair equivalent might be one of the best comic sequences in a Laurel and Hardy picture. It is simple enough—simple and real, in fact, as a nightmare. Laurel and Hardy are trying to move a piano across a narrow suspension bridge. The bridge is slung over a sickening chasm, between a couple of Alps. Midway they meet a gorilla.

—James Agee[47]

On the western front in World War I, Belgian Private Paul Bergot can't shoot straight. Firing several rounds per second from a mounted machine gun, the targeted tin can survives his onslaught. Played by Harry Langdon in the 1926 film *The Strong Man,*xxii the frustrated Bergot pulls out his slingshot. Now his native marksmanship comes to the fore, and he obliterates the can on the first volley. Great, but there are German soldiers to contend with, and one in particular is taking shots at the private, ripping at his uniform with near misses. Once again raising his slingshot, Bergot befuddles his enemy with pieces of biscuit so hard they hurt and then completely overwhelms the Boche by sling shooting chunks of raw onion at his face, making him tear up, put on his gas mask, and flee. It's a tour de force of disruptive play that mocks power and the instruments of war—playfulness in the face of conflict, defusing the fight, the game, and replacing the bitter pains of war with the playfulness of the child. It's not *who's gonna win?* It's *wouldn't it be funny if . . .?*

Of all the grown-ups, the slapstick artist may most resemble the playful child and thus be the most susceptible to the blessings of the Trickster. The retention of childlikeness (not to be confused with immaturity) invites the Trickster archetype in.

xxii Langdon is the forgotten superstar of slapstick, whose popularity rivaled Charlie Chaplin's, Harold Lloyd's and Buster Keaton's in the 1920s. He frequently evoked an overgrown child in his mannerisms, cherubic yet pre-moral. *The Strong Man* was also Frank Capra's directorial debut.

Slapstick segues abstract play into narrative. Though plot is often the weakest part of slapstick films, that is their virtue. Too much plot would distract us from the more concise snap of the synapse that makes us laugh when Harold Lloyd, for example, dangles from a clock above a busy Los Angeles street in 1923's *Safety Last!* or as Charlie Chaplin turns a passed-out drunk into a puppet *(A Dog's Life,* 1918). Groucho and Harpo Marx do sidesplitting imitations as each other's mirror, a routine famously reprised by Lucille Ball with Harpo himself. This genesis of physical humor in film is even embodied in Buster Keaton's first name, synonymous in vaudeville with a "fall."

Consider our definition of original play, the play of animals and infant humans—the giggly, noncompetitive frolic on offer to all life forms. If you make the leap of faith to a cerebral version of original play, then phenomena as disparate as dada, Anonymous, the Yes Men, Yippies, Andy Kaufman, and Burning Man become exemplars of disruptive play. During these historic sparks, their childlike playfulness—abstract, nonverbal, and physical—was introduced into the grown-up world of conflict and contest, oft mediated by language.

I should like to suggest that slapstick functions as a missing link, a bridge across that leap from the abstract fun an infant has in nonverbal playfulness, frolic, and laughter to the grown-up playfulness that projects that fun into the narrative idiom. It's not an easy concept, its paradoxes a bit like moving a piano across a narrow suspension bridge and running into a gorilla.

SLAPSTICK, PLAYFULNESS THAT SPARKS LIBERATION

The physical humor of slapstick puts the very young child on equal footing with the grown-up—pratfalls and pies in the face, stupidity, surprises, and the like can be understood and enjoyed from a very young age. That, plus the starring role gravity plays in many slapstick gags, makes it a form that approaches universal understanding and appreciation.

Slapstick migrated from sixteenth and seventeenth century commedia dell'arte in Italy to Britain's *Punch and Judy* puppet shows—Punch being the evolution of the Italian trickster figure Pulcinella—and then to music halls, burlesque, vaudeville, circuses, and limbo. Such entertainment appeals to children and does not mince the violence and meanness that can be found in

trickster tales, though it avoids villainy by adopting the subservient mode of court jester.

This irrepressible energy morphed into modern slapstick at a unique historical moment. At the outset of World War I, antiwar art movements like dada represented Trickster's jailbreak from Western constraints, which coincided with the Golden Era of silent films. But antiwar sentiment was not exclusive to dada, it also characterized silent film comedy, which did not hesitate to mock war.

Slapstick played a major role in defining humor in the film medium. Before sound, with only the visual available, its masters pulled off a coup. Taking two steps forward and one step back, slapstick stars made a headfirst lurching leap from the vaudeville stage to the silver screen—but they lost their voice, literally. The circumstances of silent film compelled the development of an art form so pronounced, so exaggerated, so obvious, so primal, that it could slip its dance of hilarity into the lives of folks of all ages without the so-called advantage of sound. Even a two-year-old could understand a pratfall, a dangle, or a pie in the face and laugh. Slapstick on film achieved the new by rediscovering something quite old.

Silent film slapstick is at once as exaggerated and obvious as puppet shows, but through the trickery of filmmaking, more abstract. In a medium that also produced adventure, drama, romance, comedy, horror, action, and science fiction, slapstick introduced the play of the child into the general cultural narrative. It's the unruly rascal kid testing the limits of convention, of genre itself.

* * * * * * * * *

Willson Disher says that there are only six kinds of jokes—falls, blows, surprises, knavery, mimicry, and stupidity. Alan Dale elaborates:

> In their iconic form, the fall is caused by a banana peel, and
> the blow is translated into a pie in the face. Thus the essence
> of a slapstick gag is a physical assault on, or collapse of, the

hero's dignity; as a corollary, the loss of dignity by itself can result in our identifying with the victim."[48]

The slapstick film stars brought their vaudeville backgrounds to the silver screen, brought their gags. In silent films, where all the power of the gag had to be conveyed visually, with the occasional title cards, gags spoke in the more culture-free language of the physical. Part of their appeal came from their meaninglessness. Slapstick gags rarely advanced the story line, they simply made the narrative funnier. In a nutshell, the falls and stumbles and clumsiness that set up slapstick gags are all about the character either failing or finessing tricky challenges in the physical world. Thus slapstick opened a portal to the inspiration of the Trickster and, once on the streets, smuggled tricksterism into the modern narratives of film.

What would have happened if the antics of Chaplin, Keaton, Colleen Moore, Beatrice Lillie, Margaret Dumont, Katharine Hepburn, Harold Lloyd, Bebe Daniels, Jobyna Ralston, Martha Raye, Harry Langdon, and Lucille Ball, as well as Mack Sennett's and Hal Roach's productions, had been given even freer rein to see where, left to their own devices, physical slapstick comedy might have gone? Un Chien Andalou (1929), the surrealist film made by Luis Buñuel and Salvador Dali, provides a clue. It's slapstick in its use of physical displacement and unreality (few ever forget the razor blade slicing open an eyeball). It has no plot, jumping in time and place without rhyme or narrative, instead using dream logic, perhaps to induce dream and free our minds.

Slapstick's essence, "a rupture in the expected link between physical effort and result" and "a physical assault on, or collapse of, the hero's dignity"[49] had just such potential. This misfortune of humiliation is a permanent fixture of the human condition and raw material for the artist, a tool for inciting imagination.

It would be almost fifty years before disruptive play's antinarrative influence reemerged in the fragmented plot of David Lynch's not-so-funny Eraserhead (1977). But let's first jump back to some of the cornerstones of slapstick comedy, where if the performers themselves weren't revolutionary, the implications of their playful feats (and playful feet) were.

BUSTER KEATON, THE SILENT SPOKESPERSON FOR DISRUPTIVE PLAY

Buster Keaton's[50] first name gets right to the point. Legend has it that it was given to him by his father's partner, escape artist Harry Houdini, who used the vaudeville word for a fall—buster. While still an infant, Keaton took a bad tumble down a staircase and popped right up. Houdini cried out, "That was sure some buster!" And the name, so prescient, stuck. Keaton went on to film an unmatched abundance of falls.

Joseph Francis "Buster" Keaton first wandered onto the vaudeville stage when he was eleven months old. By age three, he was performing with his parents as one third of The Three Keatons. His schtick was to disobey his father, who would retaliate by throwing young Buster into the scenery, the orchestra pit, or even the audience.[xxiii] In fact, a suitcase handle was sewn into his clothing to make him easier to toss. Keaton was anything but fragile—quite the opposite—but like any of us, he did have human vulnerabilities and risked his life more frequently and at a younger age than anyone. This sort of rambunctious play was bound to affect his perspective on life, but this gained him a deeply developed intuition around movement in the physical world.

Discussing silent films, Keaton once said, "The average picture used 240 title cards, that was the average. And the most I ever used was fifty-six. . . . We eliminated subtitles just as fast as we could if we could possibly tell it in action. . . . We had to stop doing impossible gags, and what we called cartoon gags. We lost all of that when we started making feature pictures. They had to be believable, or your story wouldn't hold up."[51]

If fiction is a realm where gods real or imagined can roam, then cartoons take full advantage of such liberty. The cartoon format welcomes the Trickster persona. With their ability to portray animal and human characters interacting and playing with each other, committing impossible physical feats, and making instant comebacks from lethal explosions, falls, drownings, cannon shots, etc., cartoons routinely defy physics, biology, and realism. Thus it is beyond poignant that the vault, the library, the treasure, or, better yet, the candy store for the supernatural whacks, pratfalls, stunts, and gags in cartoons is to be found

xxiii Joe Keaton was arrested several times but never convicted for child abuse. Apparently, Buster didn't bruise easily.

in the oeuvre of the very human, though seemingly indestructible actor and director Buster Keaton. After all, by the age of four. he was famous as "The Little Boy Who Can't Be Damaged."[xxiv]

Coming at us from the live popular theater of medicine shows, minstrelsy, Wild West shows, circuses, and then burlesque and vaudeville, it's righteous that one of silent film's greats would be a lifelong performer who made his bones, and maybe broke some, in vaudeville.

After an apprenticeship with Roscoe "Fatty" Arbuckle—where he learned the ropes of filmmaking—a stint with the infantry in World War I, and appearances in others' films, Buster gained enough artistic control to take his vision to the big screen. He made two-reelers, the very popular twenty-minute shorts that were shown in theaters before the feature, a perch from whence cartoons would later roost. Today, commerce has usurped that time slot, and we sit through endless advertising as we wait for the film to begin. Note the movie theater prelude went from twenty-minute shorts to seven-minute cartoons to an endless stream of two-minute commercials.

Taking over Charlie Chaplin's old studio, Keaton directed, wrote, and starred in nineteen two-reelers between 1920 and 1923, among *them One Week, Neighbors, The Scarecrow, The Haunted House, The Playhouse, The Boat, Cops!, The Blacksmith, The Frozen North, Day Dreams,*[xxv] The Balloonatic, and The Love Nest. Besides his supernatural physical abilities, Keaton developed a signature face and was nicknamed "The Great Stone Face." He never smiled but could express a wide range of emotions through his eyes and his creative physicality.

Gags that became cinematic tropes, especially in cartoons, especially in Warner Brothers cartoons, pervade Keaton films. In his first release as producer/director, *One Week* (1920), a jilted lover sabotages the prefabricated house Buster buys for his wife (the jilter). Once built, it ends up as a house of comic horrors: it leaks, its second-story rooms open into thin air, it rotates and spins, it's slanted, it's smashed by a train.

xxiv It would be unfair to over-mythologize and omit that Keaton took a real beating throughout his life, cracking and breaking bones and being otherwise interrupted in his work by injury.

xxv In *Day Dreams* and *The Playhouse,* we see Keaton performing in drag, adding gender fluidity to his already high score of trickster attributes.

And this is only the beginning of the cartoon reality Keaton crafts in subsequent shorts. We see him getting hit in the face with a hefty hammer, hitting himself with that hefty hammer,[xxvi] outrunning a landslide of boulders, getting stuck headfirst in the ground, getting hit over the head with a vase, striving unsuccessfully against a stiff wind, sliding down a stairway that folds right beneath his feet, having a car completely disassemble and collapse when going over a bump, lighting a cigarette with a live fuse attached to a bomb, walking up a down escalator (seemingly forever), and grabbing on to a moving car and flying in the breeze. When he dives but misses his swimming pool, he drills into the ground and is shown years later with his adopted family in China. Silly? Funny to little children? Like a cartoon?

With his more surrealist eye and camera expertise, he and his crew created cinema unfettered by cultural reference and thus could convey the pure fun of original play, where a very young child could sit through and understand this two-reeler and a grown-up could reconnect to their own sense of original playfulness. Other comedies relied more heavily on the conventional presentation of a setting with real life as its straight man. Keaton felt no such obligation to reality. It's a Western; it's a chase; it's a train. It almost doesn't matter. Keaton establishes scenes just long enough to get him to the next gag, as in cartoons.

And it wasn't just the cartoonists who helped themselves to sweets from Keaton's candy store. He was brimming with ideas that other filmmakers stole. He had lampooned the mechanization of daily life in *The Scarecrow* where in a one-room efficiency house, salt, pepper, toast, sugar, and the like are conveyed by labor-saving Rube Goldberg-esque contraptions (see *Wallace and Gromit);* broken the fourth wall and jumped into and out of the movie screen (see Woody Allen's *Purple Rose of Cairo* and Mel Brooks' *Spaceballs* and *Blazing Saddles);* lifted up a car with a balloon; tried to kill himself in front of a train, only to be foiled by it stopping in time; and rescued a damsel in distress through physical daring.

In *The Playhouse* (1921), the screen was filled with multiple Buster's when in one sequence he played every role (see *Being John Malkovich).* He

xxvi A gag first pulled by Wakdjunkaga, the Winnebago trickster, sometime around 500 BCE.

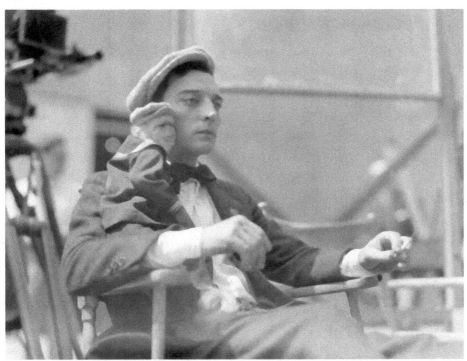

Buster Keaton with monkey 'Chicago' on his shoulder in a scene from 1928's *The Cameraman*, directed by Buster Keaton and Edward Sedgwick.

stood on the head of a brontosaurus (to get a good view), stood proud and stoic on the prow a boat that sinks on its launch. And he originated the most copied gag of all where the wall of a house falls on the comedian, who is spared by just happening to be standing where the open doorway is (see *The Simpsons;* *"Weird Al" Yankovic's* "Amish Paradise" *video; Jack*** Number Two;* Jackie Chan; *Shrek The Third;* etc.)

These gags and feats of impossible acrobatics are the toolbox of the Trickster. Their absurd funniness has a certain kinesthetic illogic to it, as all pratfalls and slapstick do, but they are characterized by plot in only the most rudimentary fashion. This opens psychic space for new possibilities—to be born, to breathe, to spark our imaginations.

Like any pure art form, slapstick stays true to the playfulness of the child and resists commercialization. But, as the Hollywood villain likes to say, resistance is futile!

THAT WAS SURE SOME BUSTER

Keaton's best contributions, 1920-28, defied convention by portraying a comic hero who did not have to look like the weaker guy. He always stood up to his adversaries. In this way, he personifies a Trickster god, his sometimes meek appearance a trick.

He would advance the art of film editing, evoke dream realities, break the fourth wall, and bring countless other innovations to the screen. And Buster Keaton *is* the special effect. He never used stuntmen or doubles. Indeed, many of his stunts tested the limits of human capacity, and many of his cinematographic experiments tested the limits of film technology. He's begging the gods to take him, either to his death or to immortality.

Except for *The General* (1926), all his major films were pretty much improvised by him and his crews. Like the gang that put together the Trickster Bugs Bunny cartoons, Keaton's films were a group effort, where he worked with the same cinematographer, Elgin Lessley, and technical director, Fred Gabourie, throughout, not to mention the crew and gagmen who brought their ideas and antics to the film lot. We all have our trickster heroes, but the spirit flows most splendidly when from a collective milieu, a lesson for disruptive play politics as well as for art. And in his shorts, Keaton approaches that magical under-twenty-minute running time closer to cartoons and trickster tales than feature-length films.

Here's a great example of the improvisational climate at Buster Keaton Studios. A stunt goes wrong while filming his first feature, *Three Ages* (1923). He is jumping from one building to another, and he misses, falling into a safety net—but he uses it. With his superhuman acrobatic and film editing skills, in the film's release he leaps, misses, falls through three awnings on his way down, grabs a downspout that bends and tosses him through the second-story window of a fire station where he is hurled across the floor and onto the fireman's pole, down the pole he goes, onto the back of the fire truck, and he's off, silent sirens wailing.

The finale to Keaton's *Steamboat Bill, Jr.* (1928) delivers a punchy example of gag prevailing over plot. Buster as Bill Canfield Jr. helps his father break out of jail. Junior's coat gets caught in the jail door, and he knocks about and

contorts himself free. But he's too late; the delay results in Bill Sr.'s recapture. Bill Sr. gets bopped on the head by the sheriff and sent off to the hospital. Just for this moment the slapstick gag at the jail door actually serves the plot; it's the reason Junior's dad gets caught.

But wait. Storm clouds are gathering, and it's a doozy. Piers are blown apart, setting steamships adrift. Everyone is taking shelter. On the way to the hospital, Keaton falls out of the car and wanders down the street, ending up at the hospital anyway. When patients later flee the hospital amid the storm, Keaton is left behind. The wind takes down walls, and the bedridden Keaton, with buildings collapsing around him, is blown into a horse stable, where he gets passing notice by about eight horses, and then careens beyond into the heart of the storm. Peering out from hiding under his hospital bed, the wall of a house falls on him, but he's spared as he happens to be standing right where a window opening comes down. He flees, buildings collapsing all around him, and then tries to run headlong into a torrential wind that keeps him at inhuman slanted angles, knocks him over, and puts him in the line of fire of a truckload of boxes blown off the back of a truck. He seeks shelter in a ravaged theater but gets caught by the pulley and rope of a curtain weight, and the sandbag falls and, when released, drops Keaton on his head. He's spooked by an abandoned ventriloquist's puppet. He falls through a trap door. The falling wall gag is repeated. He's blown into a doghouse where he gets bitten on the butt. Escaping to a field, yet another house falls on him, at an angle, but he's unscathed still.

Get the picture? This hilarity goes on for another eight minutes and eventually ties up the plot in a tidy but conventional way (boy gets girl). But that is hardly the point. Keaton knew funny. These gags convey danger escaped through trickery, fun, and humor. And lack of plot is part of his genius. The story is simply an excuse for the gags. Such disruptive play introduces original play—the gags—into conventional narrative, the cultural play of conflict and resolution. His artistic daring drew praise from none other than Salvador Dali, who maintained that the works of Keaton's films were pure poetry, "anti-artistic" filmmaking.[52]

The loss of dignity that comes with slapstick gags tie it to the Trickster archetype, even as that loss itself is a trick. Freedom from dignity means free-

dom to reach for the seeming defiance of the laws of physics, comically super-human feats, and falling-down-funny lurches towards the divine. Such actors, appearing as fall guys (pun intended), aspire to become superhero demigods. Slapstick gags are funny, and excepting the most elaborate ones, animate a crude humor akin to Trickster spirit. That's why little kids get it! A slapstick gag is neither good nor evil, it's just fun; it's just funny.

James Agee comments in his seminal 1949 LIFE magazine article:

> When a modern comedian gets hit on the head, for example, the most he is apt to do is look sleepy. When a silent comedian got hit on the head he seldom let it go so flatly. He realized a broad license, and a ruthless discipline within that license. It was his business to be as funny as possible physically, without the help or hindrance of words. . . . The still more gifted men [the best silent comedians] . . . simplified and invented, finding out new and much deeper uses for the idiom. They learned to show emotion through it, and comic psychology, more eloquently than most language has ever managed to, and they discovered beauties of comic motion which are hope-lessly beyond the reach of words.[53]

"Slapstick is a fundamental, universal, and eternal response to the fact that life is physical."[54] And life, when presented with slapstick, nips the magic from the film and connects original play to the larger stages of community and society at large.

* * * * * * * * *

The industrial system of making movies at MGM, under Irving Thalberg's leadership, would not allow the improvisational style that Keaton and his team had perfected. The studio insisted on formulaic and conventional storytelling, written by staff writers, and would portray Keaton as an awkward rube, as in Parlor, Bedroom and Bath (1931), where he looks ten years older than he

is but is given the lines of a schoolboy. Thus ended Keaton's revolutionary approach and divine reach. The Marx Brothers, Laurel & Hardy, and Abbott & Costello suffered similar fates at MGM. Keaton's decline signals an egregious and important case study of commerce killing artistic freedom, killing play.

Perhaps Keaton had the last laugh, turning commercialism on its head by appearing in, and offering much more humor than they deserved, many TV ads from the sixties: Northwest Orient Airlines, Ford Econoline vans, Smirnoff Vodka, Levy's Real Jewish Rye Bread, Kodak Instamatic cameras, Shamrock Oil, Simon Pure Beer, Alka-Seltzer, and more. And one of the funnier episodes of The Twilight Zone from 1961 featured Keaton, along with a Richard Matheson (The Twilight Zone's finest writer) script, "Once Upon A Time."[55] The episode is replete with gags and pratfalls. Keaton, as Woodrow Mulligan, time-travels[xxvii] from 1890 to 1962—without his pants.

What we need to take away from this is that the early stuff bursts with energy, expresses an imagination that was pointing us to some greater reality—but in pursuit of commercial potential, Keaton's producers fumbled the ball as they filled their bank accounts.

What makes silent film slapstick different from infant and animal play is that it is dragged kicking a screaming into the context of a story, and thus the leap is made, from the most abstract forms of play to stories of playfulness that make fun of, mock, and deflate dignity. But then, in circular fashion, it is also like child's play in that it reproportions reality. As you are watching Margaret Dumont being ridiculed by Groucho Marx, for example, you are invited back into your own early childhood where the laugh you get from Groucho's wise-cracking remarks are just as important, perhaps even more so, than the larger drama or story into which it is placed.

Slapstick filmmaking was also joined at the hip with cartoons, trading inspiration with animators like Tex Avery and Chuck Jones.[xxviii] You could almost define slapstick film as humans reaching for the physical impossibility (surviving being hit over the head with a hammer or falling off a cliff or tall building) that could be achieved only by demigods or cartoon characters. It's

xxvii Time travel is one of the ten Trickster attributes.

xxviii Animators of the classic Warner Brothers *Looney Tunes* and *Merrie Melodies,* from 1935 into the sixties.

as if the slapstick stars were exerting efforts to get as close to Trickster divinity as they could. Think of their vocation as the extreme sport of the time. Jim Carrey's The Mask not only defines itself as homage and appendage to Tex Avery cartoons, but it is loosely based on the Norse Trickster god of mischief, Loki.[xxix] So when the talkies showed up, they tethered the madness of the abstract, the surreal, the fantastic of the Keaton or Chaplin or Langdon silent film gag. It would take three or four brothers with that kind of zany in their blood to steward such playfulness into the talkies.

THE MARX BROTHERS, A FOUR-HEADED HYDRA OF TRICKSTERISM

> …a foundationless world collapsing toward entropy but never
> approaching stagnation—nothing is constantly happening[56]

Have you ever noticed how pictures of the Marx Brothers—movie posters, cartooning, photos—bunch them together. They often look like they're growing out of a single trunk, giving new meaning to the term joined at the hip . . . or the heart, or the head, or the funny bone. In fact, in the American Film Institute's list of the twenty-five greatest male stars of Classic Hollywood, Chico, Harpo and Groucho[57] are inducted as one. At the conclusion of *Horse Feathers* (1932), Thelma Todd, who had been courted by Zeppo, ends up marrying the other three brothers all at once. They're a three-or-four-headed Hydra[xxx] of Tricksterism—as close as humans get to demigodliness: Harpo the id-ish child; Chico the hustler; Groucho who ridicules the game; and Zeppo who won't even play it. While a human cannot *be* an archetype, if you get four geniuses, each with a different trickster strength, all knocking on heaven's door in concert, well, that's about as close as humans are likely to get to that divine state. We should pay attention.

The four Marx brothers started out as children. A vaudeville singing act, to be specific, the faux angelic Four Nightingales, who were presented by their mom, Minnie. As they grew through their adolescence, lost innocence made

xxix And Jerry Lewis's *The Nutty Professor* (1963).

xxx Hydra, also called the Lernaean Hydra, in Greek legend, the offspring of Typhon and Echidna, a gigantic water-snake-like monster with nine heads (the number varies), one of which was immortal. Britannica, s.v. "Hydra," retrieved May 18, 2021, https://www.britannica.com/topic/Hydra-Greek-mythology.

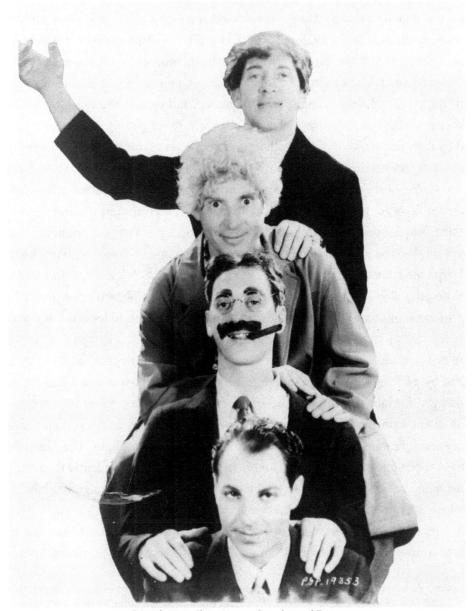

Top to bottom: Chico, Harpo, Groucho, and Zeppo

it harder to get bookings. They fought off looming adulthood by developing a comedy act where they never had to grow up. Their vaudeville career launched in 1905. By 1923 their fame had grown to where they could take their show *I'll Say She Is* to Broadway, where audience love and laughter propelled their

second and third live shows—*The Cocoanuts* and *Animal Crackers*—from the stage to the screen, in 1929 and 1930, respectively. But whether it was Harpo's virtuosity on the harp or Chico's on the piano; spoken routines between Groucho and Chico or Groucho and Margaret Dumont; physical slapstick acts of running, jumping, miming, impersonating, falling and the like—the point was never the story, always the gag, always about getting laughs. Though they doth protest, the Marx Brothers were trickster revolutionaries, anarchists mocking seriousness and its dour institutions at every turn.

Harpo best represents the pre-moral child state and was always the children's favorite. He is also the Marx Brothers' historical marker. Harpo plays mute, never speaking, reminding audiences of the silent film tradition that yet infused the early talkies.[xxxi] During a chase scene on board a luxury liner, Harpo interrupts the action to take over a *Punch and Judy* kiddie performance. When the ship's officers catch up to him, he escapes aboard a toy train. In profound intuitive knowledge of early childhood, Harpo hides from his pursuers under a rug, but only his head—if I can't see them, they can't see me![58] In brilliant capture of the trickster personality, Harpo is neither good nor evil, and by performing without speech, offers one of the most abstract and therefore precise human depictions of Trickster spirit.[xxxii] James Agee, commenting on silent comedy, concurs that "[The best silent comedians] simplified and invented, finding out new and much deeper uses for the idiom. They learned to show emotion through it, and comic psychology, more eloquently than most language has ever managed to, and they discovered beauties of comic motion which are hopelessly beyond the reach of words."[59]

In a *Horse Feathers* gag, we get a taste of how this Brother refused to lose to the power structure: A cop starts writing him a traffic ticket. Harpo

xxxi It's an interesting twist of fate, or perhaps a deep insight into Harpo's artistic intentions, that he was part of the very wordy Algonquin Round Table, a group of New York writers, critics, actors, and public intellectuals who met daily and, through newspaper columns, amused and educated the nation from 1919 to 1929. Alongside Harpo were members Dorothy Parker, Robert Benchley, George S. Kaufman (who wrote the Marx Brothers' best screenplays), and Noël Coward.

xxxii An apt demonstration of Marcel Duchamp's declaration that "there is absolutely no chance for a word ever to express anything. As soon as we start putting our thoughts into words and sentences, everything goes wrong." In *Duchamp, A Biography* by Calvin Tomkins (New York: Owl, 1997), 65.

pulls out his own pad and writes the cop a ticket. Rather than running to escape, he tricks the cop and locks him up in his dogcatcher's wagon. Government by clown.

Harpo could suck in air and blow up his face to look like he's painted on a balloon—silly and innocent like a child but always some menace and larceny to his character as well and, like a Trickster demigod, impetuously drawn to women and sex; the beauties are rarely on screen for more than a second before Harpo commences pursuit. Overall, his id-like behavior signifies that dimension of the trickster. As the guy whose crazy is too tough to corral, Harpo paced the Brothers, maybe like the way drummer Keith Moon could both manage and incite the rock and roll chaos of The Who.

When they migrated from Paramount to Metro-Goldwyn-Mayer, the four Marx Brothers became three, but Zeppo had completed the fully formed Trickster archetype they evoked. As the original straight man, he mocked the mockers by refusing to play the game. We kept expecting some kind of jokes to get voiced by Zeppo, but save his impersonation of Maurice Chevalier in *Monkey Business,* his trick was to be the part of the trickster personality that did not play tricks. Was he just a straight man, or did he complete some strange cycle? Was he mocking the mockers? Perhaps he reminds us that the personality that refuses to take anything seriously may be delivering a very serious, or at least significant, message.

If Harpo made his statement with no voice, Chico couldn't shut up, and he employed a merry-go-round of accents, of many voices: German, Irish, Eastern European, Italian. Silent Harpo remade physical gags. Chico destroyed language with his mispronunciations, malapropisms, and puns. He's responsible for the signature line "Who you gonna believe, me or your own eyes?" (*Duck Soup*). And with Groucho the straight man, the signature "Why A Duck?" routine (*The Cocoanuts*). Chico was never not playing tricks, whether he was cheating at cards, cheating Groucho in a negotiation, conning hotel guests, or "cheating" on his piano technique. Both he and Harpo were able to build jokes into their musical performances, through puppeteering with their fingers, speeding up, slowing down, and inserting quotes from other songs. Nothing, not even music, was safe from Marx Brothers humor.

In *Horse Feathers*, Chico's selling bootleg liquor from a speakeasy. Regardless of whether scotch or rye was ordered, the customer got the same rotgut poured from the same jug. In the middle of this transaction, he's summoned to guard the entrance door. Now we see his wordplay as Groucho knocks on the speakeasy's window:

Chico: Who are you?

Groucho: I'm fine, thanks. Who are you?

Chico: I'm fine, too, but you can't come in unless you give the password.

Groucho: Well, what is the password?

Chico: Oh, no. You gotta tell me. I tell you what I do. I give you three guesses. (Whispering It's the name of a fish).

Groucho: Is it Mary?

Chico: Ha ha. That's no fish.

Groucho: She isn't? Well, she drinks like one. Let me see, is it sturgeon?

Chico: Eh, you crazy. Sturgeon is a doctor who cuts you open when you sick. Now I give you one more chance.

Groucho: I got it, haddock.

Chico: That's funny. I got a haddock too.

Groucho: What do you take for a haddock?

Chico: Well, sometimes I take aspirin. Sometimes I take a calomel.

Groucho: I'd walk a mile for a calomel.

Chico: You mean chocolate calomel.[xxxiii] I like that, too, but you no guess it. (He closes the door. Groucho knocks again. Chico opens again). What's the matter? You don't understand English? You can't come in here unless you say "swordfish." Now, I give you one more guess.

xxxiii Calomel was a medicine popular during the Victorian period and was widely used as a treatment for a variety of ailments during the American Civil War. "I'd walk a mile for a Camel" was the long-standing slogan for Camel cigarettes. And in a third turn, Chico mangles the word again to mean *caramel*.

Groucho: (mulling) Swordfish, swordfish. I think I got it. Is it swordfish?

Chico: That's it. You guess it. (He opens the door.)

Groucho: Pretty good, huh?

Chico: Fine. You guess it. (Groucho goes in, locks Chico out. More antics ensue.)[xxxiv]

Groucho's humor uses wordplay as well, puns and smart-ass comebacks, but while Chico's working to get a laugh and undermine convention, Groucho's schtick skirmishes with politics, and the barbs are specifically directed at whatever powerful figures the thin plot has propped up for him to undermine. The audience is already set up through the obvious pompousness of the power figures, and Groucho satisfies the wise-guy pranking saboteur in us all. As Andy Kaufman was to take the conventions of comedy itself as his plaything, so Groucho fools with film convention, refuses sensible plot, and challenges narrative itself, thus freeing playfulness. He has great comic physicality, and no one dances as funny as Groucho. But he reaches slapstick rapture through verbal jiujitsu. A genius like Buster Keaton surprises with his physical gags; Groucho gets to you with one-liners.

Verbal slapstick necessarily enhanced the form, keeping pace with the progress of filmmaking and, just as importantly, with America's rapid urbanization, where in big cities everything is happening at once. Rapid-fire dialogue branded screwball comedies, expanding comic opportunities to those less willing or able to take a fall. As the banter races ahead of an audience's ability to keep up, it provokes an urban displacement from reality, invoking the surrealist dream world, something Alfred Jarry[xxxv] might imagine, disordering and blowing up narrative. But you had to dig beneath the prevailing situation comedy narrative to find this invocation of dream.

What makes silent film slapstick *different* from child's play is that it happens in the context of a bare-bones story, but a story nonetheless, and thus the leaps from the most abstract forms of play to the playfulness that dips its toe into storyline as it makes fun of, mocks, and deflates dignity.

xxxiv Harpo shows up and gives the password by pulling a big dead fish out of his clothes and slides a sword down its throat.

xxxv Jarry (1873-1907), the absurdist playwright, poet, rascal, and enfant terrible of Paris whose work anticipated dada and surrealism.

But then, in circular fashion, it is also *like* child's play in that it reproportions reality. As you are watching a lemonade vendor being ridiculed and tricked by Harpo,[60] you are invited back into your own early childhood where the laugh you get from the slapstick gag, which is always based on some form of disrespect, is just as important, perhaps even more so, than the larger drama or story into which it is placed. You're in the middle of a story, but the gag is so funny you're momentarily cut loose from it.

Reality is further messed with when Groucho undermines the illusion of the movie, breaking the fourth wall, stepping out of character, deflating sentimentality, and tricking power into bringing on its own demise: ridiculing a society matron in *Animal Crackers*, impresarios and divos in *A Night at the Opera*, a ship's captain in *Monkey Business*, and dictatorial leaders in *Duck Soup*. In fact, Groucho mocks law itself, in song, of course: "These are the laws of my administration: No one's allowed to smoke or tell a dirty joke. And whistling is forbidden." Chorus: "We're not allowed to tell a dirty joke."[61]

THE MARX BROTHERS VERSUS THE BORG

The Marx Brothers' humor extends beyond absurd power figures, and in the mode of disruptive play, they target power itself. Alan Dale summarizes Marx Brothers anarchy, and incidentally defines trickster, when he describes how they transpose onto the screen not only the riotous energy of vaudeville but also of cathartic festivals of transgression,[62] be they Mardi Gras, Brazil's Carnaval, or ancient traditions of collective ecstasy:

> Groucho . . . presents *himself* as ridiculous . . . the Brothers demolish various upper-crust institutions and figures . . . and stand tall in the rubble, having freed, in the manner of the older holiday festivals, "the vitality normally locked up in awe and respect" of their supposed betters . . . the Marx Brothers . . . follow in a long tradition of "festive abuse" that isn't so much aimed at a target as released and left free to radiate in all directions, even back on the clowns themselves.[63]

Charlie Chaplin would also trade in the preposterous, make slapstick grand. Without breaking the fourth wall, Chaplin conveyed the fantastical and unbelievable; he knows we know it's all a show. Though generally more attracted to narrative, and that is where his later efforts went, the Trickster characteristic of distancing and lonerism would show itself when the Tramp would scamper away from entanglement. Likewise, Groucho's line "the audience doesn't believe us anyway" serves as the structural principle of the Marx Brothers' movies: they mock dramatic structure and theatrical affect by invoking them with exaggerated, stylized lack of conviction.[64]

This is the opposite of sentimental.

To some extent, Groucho mocks antisemitism and, through ridiculous casting, uses it as a means of unearthing the absurd. In a 1930s society accepting of antisemitism, who would believe that a Jew would even be a fearless explorer invited to a Long Island estate party *(Animal Crackers)*, a university president *(Horse Feathers)*, the leader of a European country *(Duck Soup)?* And what made it funny, what made it revolutionary, was not how preposterous it would be to imagine a Jew in these roles, but a Jew as outrageous as Groucho, at which point the point of religious bigotry is transcended by the film's promotion of an imposter who, from a position of power, sabotages power.

Of course, every scene of every Marx Brothers movie lampoons convention, mocks power. As the most poignant brother, the one who pretends to explain the Marx Brothers to the audience, Groucho begins to bring disruptive play's lens into focus.

* * * * * * * * * *

Whether inspecting dada, rock and roll, rhythm and blues, Banksy, Jarry, Buckley, Baubo, or impressionism, the tension between art and commerce, between play liberated and play confined, has been our theme. The Marx Brothers' career maps one of the more fascinating cases.

Groucho, Zeppo, Harpo, and Chico brought the playfulness of vaudeville and slapstick to the movies when the movies were still figuring out what

movies were.[xxxvi] They imported these values into their films with the same intentions that they had on stage: to get a laugh, to entertain, to have fun doing it, and yes, to make some money. But note the omission: they were less interested in telling a story. Like all great slapstick, plot took a back seat to gags. They were in it more for the playful moments than the narrative that connected them.

Marx Brothers' humor was frequently physical, and they managed to pull off plenty of visual gags and wordplay. But they were not acrobatic in the way that Chaplin, Keaton, or Lloyd were. All of these film stars were antiauthoritarian, but the Marx Brothers in particular emphasized mockery of the laws of men more than the laws of gravity and physics.

From *The Cocoanuts* (1929) to *Love Happy* (1949), they reigned among the greats of the burgeoning film industry. Ironically, the Marx Brothers' greatness was built on ridicule of what movies were becoming. As tricksters, they mock an industry that profits off of clichés, sentiment, stereotypes and stale plots. Marx Brothers movies satirize these very tropes of film culture and its characterization of our society.

But the story of their transition from early films of innovative anarchy to conventional and contrived comedy is a classic case of commerce containing and confining (even killing?) the exuberance of the authentic playfulness first brought to the screen by slapstick.

By his own assessment, Groucho Marx said, "I think our earlier films were funnier than the later ones, but they didn't gross as much as those in which we dragged in a story and a love interest or 'messages.' We just set out to try and be funny. It seems we succeeded in being funny and making a little money."[65]

The story of how commerce conquered their art is also related by Groucho:

> I remember the first time we met Irving Thalberg. Chico, as usual, had arranged the meeting over a bridge game. Thalberg said, "I would like to make some pictures with you fellows. I mean real pictures."

xxxvi Their earliest film was the lost silent reel *Humor Risk* (1920).

I flared up. "What's the matter with *Cocoanuts, Animal Crackers* and *Duck Soup?* Are you going to sit there and tell me those weren't funny?"

"Of course they were funny," he said, "but they weren't movies. They weren't about anything."

"People laughed, didn't they?" asked Harpo. "Duck Soup had as many laughs as any comedy ever made, including Chaplin's."

"That's true," he agreed "it was a very funny picture, but you don't need that many laughs in a movie. I'll make a picture with you fellows with half as many laughs—but I'll put a legitimate story in it and I'll bet it will gross twice as much as Duck Soup."

It's a good thing we didn't bet. Our first picture was A Night at the Opera, and it doubled Duck Soup's gross.66

But how do you make a movie with a legitimate story featuring stars whose act consists of blowing up legitimate stories?[67] The Marx Brothers are about translating their signature energy onto celluloid. Thalberg is about a lucrative product. And of course, in neither case are the movies purely one or the other. But while *The Cocoanuts, Duck Soup*, or *Monkey Business* make you feel like you've stumbled into an explosively out-of-control party where anything can happen, *A Night at the Opera* and its successors make you feel like you're watching a movie, and each one was a little bit worse than the last. Hollywood dilutes the Brothers' genius with plot, romance, obvious good guys and bad guys, and other gimmicks and devices of the mid-1930s. The beauty of their early films was that they were able to bring down the bad guys without portraying themselves as the good guys. Which pretty much describes the great contribution of Trickster in the political arena.

Certainly, with big studio money behind them, the gags became more high-tech, like when in *A Night at the Opera* Harpo is yanked up and then dunked by the rigging and hoists of the ship where they've stowed away. But Chico is made a more lovable good guy; where's his mischief? Only Groucho's irreverence bridles at the chains of convention. And the pace is slower, which makes

it easier for audiences to follow the story but takes the shine off their rapid-fire humor. Eventually, the Brothers become a gimmick in service to otherwise schlocky movies instead of the playful firecrackers that they are. What really took the air out of the balloon was the way the MGM films injected sentimentalism—anathema to the Marx Brothers and tricksterism—into every scene.

Somehow, the anarchic energy of the Brothers breaks free in the final half hour of *A Night at the Opera.* The stowaways pose as famous aviators, thus beginning a chase. They repeat their great gag of escaping through multiple doors and moving furniture around to confuse the cops. A romantic episode intercedes, and the plight of the thwarted lovers is compounded when Groucho, who, as Otis B. Driftwood, had been contracted to manage the opera company, loses his job (and his elevator privileges!). All is lost! Down on their luck, the Brothers scheme to upend the evening's performance of Verdi's Il Trovatore. They knock out the villain[68] with a cartoonish mallet, then Harpo revives him with smelling salts, but only so he can knock him out again.[xxxvii] Onstage with the orchestra, they wreak havoc during the performance: Harpo tries to play the trombone with a violin bow; with Chico, they also conduct, to rile the musicians; this develops into Harpo engaging in swordplay with a violin bow and threatening the maestro; they change the sheet music to "Take Me Out to the Ball Game." Later, Chico and Harpo cross-dress as gypsies on stage; the stage scenery gets switched; police chase the Brothers around the opera house. Harpo does acrobatics with the set pieces and the rigging and pulls the plug on the lighting; ultimately, the villain tenor is replaced with our hero and his love interest. They triumph as lovers and stars. Yawn. But the film is rescued by the sudden outburst of the Brothers' subversive anarchic humor. They reprise the contract gag from early in the story, and their second-highest grossing film concludes.

This is the point. I don't recommend living life through YouTube, but buried beneath our oversaturated, instantly gratified, bored, and jaded twenty-first century life is the genuine urge to experience reality, fun, and a playfulness that transcends narrative and story. So we go to YouTube and cue up

xxxvii Bugs Bunny would do the same to Elmer "Doc" Fudd a few years later in *Elmer's Candid Camera* (1940). Shepherd Siegel, *Disruptive Play: The Trickster in Politics and Culture* (Seattle, WA: Wakdjunkaga Press, 2018), 56.

just the good parts, just the gags, just enough for us to get the joke and have a laugh. Again, despite the hazards of vapidity that YouTube oozes through your laptop, comedy like that of the Marx Brothers, since the point of plot is so secondary, is made for the viewing of just the good parts, just the parts that make us laugh . . . although the films are so chock full of them, one might as well watch the films in their entirety.

And today's independent films experiment with forms of nonnarrative and lovingly mangle cliché. But film itself is not the point, disruptive play is. Can we possibly experience a state of mind that is liberated from narrative, and what does that tell us about the human condition, about the kinds of beings we might be, about the kind of society that infers? Dale quotes C.L. Barber, that "festivity signals the realization that we belong in the universe," and

> the Marx Brothers' carryings-on signal the realization that they belong in American culture. . . . But the "release" of the one festive day "was understood to be a temporary license, a "misrule" which implied rule . . . *A Night at the Opera* shows this seeming contradiction: it features them as scroungers who don't fit into high society but was in fact their bid for the big time, and it worked. It was their number one hit and by consensus the movie that ensured that they and their funnier but less profitable Paramount pictures would not be forgotten.[xxxviii]

What if *Duck Soup* had been a hit at the time, and the Marx Brothers had stuck with the instincts that steered their first four films? What if film, a typically narrative art form, had been taken over by comedy acts that minimized, dispensed with, ridiculed, upended, and challenged the attachment to narrative? If we are to imagine a society with the characteristics of the playful child—well, you can't throw that party without inviting the Marx Brothers.

xxxviii Dale, *Comedy Is a Man in Trouble*, 158-159. The quotes by Dale are from Barber, *Shakespeare's Festive Comedy*, 99, 10. After *A Night at the Opera* and *A Day at the Races,* the Brothers did a stage tour comprised of the best gags from the movies. Studio writers attended and took notes on what gags worked best, planning their future flicks.

They may protest the label of anarchist, but art gives the anarchist safe haven. And in challenging conventional narratives, the anarchist artist leads us down the path to a more utopian society. It's up to us to merge such art with reality.

Before long, the Hollywood machine, addicted to the lowest common denominator of audience and the demands of commerce, would kidnap slapstick and paste it into the screwball comedies that, while admirable and funny in their own right, follow formulas later milked to death by television, most notably the situation comedy.[xxxix] Slapstick was absorbed by the film industry and made profitable, but its essence threatens convention and the precepts of commercialization.

SLAPSTICK WOMEN

The major opportunities in slapstick came to men, white men in fact. Though it's fair to assume that talent is distributed widely and evenly, we cannot pretend that there was equal opportunity. Not just the film industry, but Western society at large and the structure of capitalism and the molding of popular taste—what sells—are all complicit in patriarchy's hegemony. What we can point out, though, is evidence and comical examples of women in slapstick who broke glass ceilings and enriched the genre. Some of what held women back was patriarchy and fear of breaking norms. Some of what held women back when it came to representing trickster personality was the clash between what that personality calls for and what women were allowed to do and tended to experience.

Powerful women who rebel against stereotype have been with us always, though sometimes one has to search them out. Jobyna Ralston played against Harold Lloyd as a romantic interest, yet his films seem stuck in his constrained and adolescent concept of romance. Bebe Daniels broke free of Lloyd's typecasting, appearing as early as 1917 in two-reelers as a "belt-hitching tomboy who scratches her shoulder blades against a telephone pole, punches a masher, grabs Luke's (Lloyd's) loot, and outruns him. . . . [She was] a more aggressive pretty-girl character than any other."[69]

xxxix The characteristics of this form are abundant leisure, childlike nature, male frustration, physical comedy, and parody/satire. The scripts peddle mistaken identity, the struggle to put two romantic leads together, beating the bad guy, harmless deception, inadvertent heroics, and the like.

Beatrice "Bea" Lillie made the move from stage revues to film and starred in 1926's silent comedy *Exit Smiling.* She plays Violet, the bit player and gofer for a traveling theater troupe, doing all the dirty work as they tour their miserable too-long play, *Flaming Women.* Violet's also the understudy for the star, waiting for her to be too drunk to perform so that she can get her big break. That's the initial gag, as Violet is thwarted when the star shows up late, shows up drunk, but shows up.

Lillie had alluring and engaging looks, but not the kind of starlet beauty Hollywood had already begun to favor. As trickster star, Lillie uses slapstick to blow up typical female roles. She's a great actor who, in *Exit Smiling,* plays the role of a bad actor. Besides being shoved aside from the main stage, she's further duped by circumstance. She doesn't realize that the guy she's fallen in love with, Jimmy, has a girl waiting for him. So she plays the Flaming Women vamp role in real life to rescue Jimmy from a criminal trying to frame him for embezzling. This is sentimental stuff, but Lillie puts it in service to a broader comic, trickster-esque, slapstick play with very original female gags such as The Klutz: rehearsing a scene with Jimmy at a farm, she makes her dramatic entrance but, in doing so, releases the pigs from their pen. The Jester: she tries on a hat five different ways, slinging it from one look to another with a flick of her neck. The Backfire: she puts on her feather boa to dress up, but the attempt flops, and she walks off looking like she has a tail. The Switch: when serving lunch to the theater troupe and a selfish player takes all the bacon, she takes his plate when he's not looking and converts it into the serving platter for everyone else. The Cover-up: she burns a shirt she's ironing and then carefully folds it before tossing it into the fire to destroy the evidence. The Gender Bend: when Jimmy must avoid being seen when the troupe comes to his hometown, she has him feign sickness, and she goes on stage as a man, playing his part. The Backfire, Part 2: she sneezes on stage, and her fake moustache falls off and is askew from that point on. And true to trickster's loner destiny, she saves the day as the unsung hero who doesn't get the guy.

But more typically, women in these early films are idealized romantic interests, revered as lovers and mothers, who might catalyze slapstick action but stay clear of the line of fire. On the other hand, Chaplin, Arbuckle, and the

Marx Brothers would cast heavy-set overbearing wives and society matrons as acceptable targets of slapstick gags, but not perpetrators. Exceptions include Phyllis Allen, the overwhelming wife in *Pay Day* (1922), a gorgon; Edna Purviance, the melancholy, flighty society mistress in *A Woman of Paris* (1923), who doesn't get her man; Paulette Goddard, the spirited street urchin in *Modern Times* (1936), who is presexual; and Martha Raye, the hard-nosed and unkillable intended victim in *Monsieur Verdoux* (1947), who is something of a goon. None of these costars are mothers or lovers; thus, at least according to the rules of popular culture of the time, this makes them eligible for trickster mode and gets them onto the slapstick playing field. The woman must be liberated from the serious demands of motherhood in order to come out and join the male tricksters in disruptive play.[70]

Tricksters cross boundaries, and tricksters lie. Usually to make the most of a moment, always because it's fun, maybe to signify. Norse Trickster god Loki was called the father of lies.[71] The Yes Men promote their progressive agenda with the motto "Lies can expose the truth."[72] Other dimensions of the human personality—greed, career, shame, what have you—can also be the motive behind a lie, so, unless it's coming from a demigod, being a human complicates the lie.

Mae West represents trickster well. She riffs off of slapstick, teases it if you will, without resorting to full-blown pratfalls. Her verbal antics scream trickster as loud as the Marx Brothers, Andy Kaufman, or Lord Buckley. And to the extent that her persona also defined her off stage and off camera—wow, no one could cross boundaries or lie like she did.

Depending upon who she was having conversation with, her religious affiliation could be Catholic, Lutheran, Jew, or Allergic. It's true that she lifted weights, but not that she could press five hundred pounds as she claimed. The gender-bending trickster force was strong with her, as she took inspiration for her act from Bert Savoy, a vaudeville female impersonator of the late teens and early 1920s. And she would dress as a man as part of her act as well. For some reason, critics started calling her "America's greatest female impersonator." Tricksters are described as being perpetually sexually aroused, usually described in phallic terms. Mae put that gender-centric myth to rest, as she

famously took daily satisfaction in congress with a long list of men. More to the point of her genius, she wrote her own scripts, was a true auteur.

Mae West gives a bravura performance in 1940's *My Little Chickadee*. Her commanding presence overshadows even the comic genius of W.C. Fields. As she plays trickster, she revels in moral ambiguity, and we're teased into thinking she's the heroine in one scene, the villainess in the next. Once she's dumped Fields, who plays charlatan Cuthbert J. Twillie, West leaves the audience wondering as she refuses to commit to either the good guy or the bad guy suitor—she's already had dalliances with them both.

West doesn't perform physical gags so much, but her sexual swagger animates her banter, where she matches Groucho Marx as a master of verbal slapstick, exhibits a libido worthy of Harpo, and, though fashioned in her signature style, schemes as cleverly as Chico. Rather than avoiding sexuality through wholesomeness or playing the stereotypical romantic interest, West goes beyond innuendo, represents sex incarnate with the same lack of inhibition as comics like Groucho and Harpo. Like Groucho, her every line is a quip; like Harpo, she radiates sexual desire; and like any comic great, almost every line is pretty darn funny.

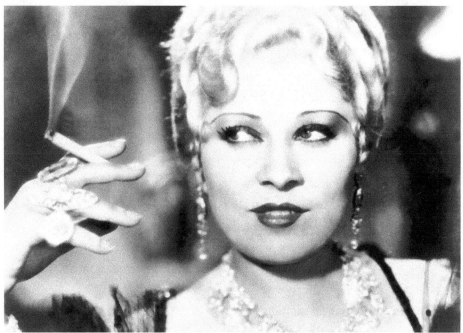

Mae West in a scene from 1933's *She Done Him Wrong*.

In *Night After Night* (1932), George Raft, Constance Cummings, and the other costars do a good enough job setting up the drama of a lovable gangster falling for a mysterious femme fatale. The film is about to run out of gas midpoint, when West (as Maudie Triplett) appears with her raucous and uncensored charm and upends everything that had gone before. The trickster trait of not taking things seriously is on full display. "Goodness, what beautiful diamonds you have," chirps the coat-check girl. "Goodness had nothing to do with it, dearie," retorts Maudie.

Yet Mae West never comes off as a woman degraded by loose morals, more as a woman in charge, who has resisted the patriarchy armed with sex and won each battle with no more than a sideways glance, a quip, and a dare. Mae West, modern prototype of the female trickster, raises her lantern high, proving that women can embody trickster traits as well.

* * * * * * * * * *

Screwball comedies, the commercially successful genre that succeeded slapstick, tamed its ebullient anarchy but did open up more possibilities for women. And a woman as talented as Katharine Hepburn, in *Bringing Up Baby* (1938), took full advantage of the broadened palette and was able to work in a few pratfalls of her own playing millionaire heiress Susan Vance, who explores the wacky possibilities that come with having a leopard as a pet. Hepburn appears to be scatterbrained and disorganized yet is actually in charge the whole time. She deftly manipulates Cary Grant into romance with her (she does get the guy). She manages some great slapstick gags: the back of her dress accidentally rips off when walking away, compelling stooge Grant to cover her up; she keeps the leopard handy on a leash; she takes a fall into a creek during a nighttime search for a dinosaur bone.

It didn't hurt that Hepburn was a lifelong feminist, her mother a suffragette. She often preferred men's clothing and close-cropped hair—and did so without compromising her powerful appeal. In *Sylvia Scarlett* (1935), Hepburn embraces playing an ambiguously gendered character, being mistaken for a man by some, eventually revealing that she is a woman but not sure in which

guise she gets the better deal. The premise in this George Cukor film is that she impersonates a man in order to help her debt-ridden father. In fact, David Bowie circa Young Americans mimics Katherine Hepburn's Sylvia Scarlett, looking like a woman who's dressed up to look like a man. With this dizzy trick, Hepburn successfully rebels against the Hollywood factory model of a star. In fact, she leaps over railings, in and out of windows, runs like the wind, and does a pratfall or two; not a slapstick film, but slapstick spirit lives on in Hepburn's physical performances.

In real life, she chose to not have children because her career was so important to her. Society's imposed duties of motherhood frequently shape a woman's life and leave little room for trickster potential. Conversely, the stereotype of the male playboy conforms to many trickster characteristics. Hepburn deftly finessed this conundrum in Bringing Up Baby. And in her subsequent career picked and chose moments to pull out her bag of trickster in films like *The Philadelphia Story* (1940), *Adam's Rib* (1949), *The African Queen* (1951), and *On Golden Pond* (1981).

Wrestling with the conventions of the time, the women with access to tricksterism and slapstick protagonism were bad, sexy, sexually active, and funny. Prohibited from such fun were women who were good, marriageable

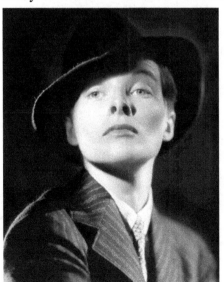 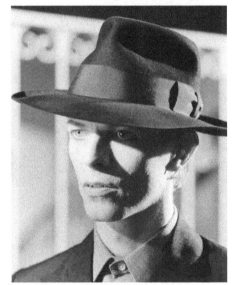

Katharine Hepburn in a scene from 1935's *Sylvia Scarlett*
and David Bowie in a scene from 1976's *The Man Who Fell to Earth*.

(virgins), sweet, nice, and like your mother. Lillie had to sacrifice romance in order to gain entrée into the boys' club of slapstick. Hepburn was a more modern woman ready to have it all—a true leading person—and she took it without looking back.

CHAPTER FOUR

SLAPSTICK LURCHES ON!

Old friend, there are people—young and old—that I like, and people that I do not like. The former are always in short supply. I am turned off by humorless fanaticism, whether it's revolutionary mumbo-jumbo by a young one, or loud lessons from scripture by an old one. We are all comical, touching, slapstick animals, walking on our hind legs, trying to make it a noble journey from womb to tomb, and the people who can't see it all that way bore the h*** out of me.[73]

—John D. MacDonald

Screwball comedies—*The Front Page; It Happened One Night; Bringing up Baby; His Girl Friday; The Lady Eve; The Palm Beach Story,* etc.—opened up opportunities for women, but the genre also stuffed slapstick into its formulaic compartments. It could have banished Trickster from the movies. But one more comedian with a vaudeville background was able to revive slapstick in a wholly new context.

JERRY LEWIS, MIDWIFE TO THE MODERN

Jerry Lewis and his films ensured that slapstick and the Trickster spirit would, amidst trips, falls, and lurching stumbles played to the tune of crashing cym-

bals, make the transition from silent films to talkies. As a performer, he caught the tail end of vaudeville and took his schtick to the nightclub circuit, where his live performances catapulted him into film. Notably, not silent film.

Chaplin's spoken voice falls flat, so drab compared to the lightning flash triumphs of his physical humor and voiceless expressions. Jerry Lewis, on the other hand, belly flops onto the screen with a voice that is an aural pratfall: two-year-olds will laugh at a Jerry Lewis line, even if they don't understand the words. He has a funny, whiny, silly slapstick-ish voice! So if we lost the (really little) kids when the silent films gave way to the talkies, Jerry Lewis got them back with his aggressive energy, undisguised silliness, and manic voice.

True to the tenets of playfulness, Lewis, with his partner Dean Martin, honed improvisatory ad-libbing in the lively and live atmosphere of nightclubs. Even the pair's orchestra, led by Pupi Campo, would get in on the act, riffing off of the banter. Martin and Lewis took some inspiration from Laurel and Hardy and added Martin's sexy crooning to feed the changing tastes of American audiences.

Lewis's movie persona presents an important variation of the trickster character. In an inversion of the trickster plays tricks but is occasionally tricked himself, Lewis foregoes the protagonist role and instead exaggerates that essential trickster characteristic of being the victim, the dupe, the stooge. In fact, his characters tend to be well-intentioned, and the tricks he plays on others are often inadvertent. He seems to be missing that particular scheming and sometimes mean quality of trickster as agent of mischief.

But the mean side won't be repressed, and it's as if he's aware of the imbalance. In *The Stooge* (1952), Lewis as Ted Rogers is the just-glad-to-be-here, clumsy-but-lovable foil for Bill Miller's (played by Martin) rise to stardom on mediocre singing talent. But in the film's climax that features two Martin and Lewis routines, Lewis shows swagger and confidence, as if to tell the audience "I was just acting. I'm still funny, but I'm a mature and talented Hollywood star." He seems to be trying almost too hard to prove himself, to overcome the exaggerated sad sack, naive, loyal, innocent, butt-of-the-joke qualities of his Ted Rogers character, a dynamic he stretched even further as Stanley in *The Bellboy* (1960).

When the aggression comes out in *The Stooge,* you see that even though he's playing the part, he's no longer the stooge, and the whole movie has been about him growing out of that role. But it's such an original screenplay that Lewis had few models upon which to base his character, so we see the man and the act that had been honed in nightclubs. The stature that his slapstick clumsiness undermines he later grasps for tenaciously. Lewis sold this basic narrative to the adult moviegoing public without fully losing that all-important child audience.

This trickster course correction doesn't work in the long run. Lewis is also known for his arrogance and bitterness. He created a character based on not being taken seriously, and he was thus provoked, piqued, and irritated when in real life he wasn't, when his fans approached the character and not the man. He was this complicated mixture of trickster and trickster target. Though Trickster gods don't take themselves too seriously, the point and paradox are that Trickster is a powerful god who doesn't take power seriously either. Lewis corrected his self-victimization with a desperate reach for power, to be respected. This self-correction goes further askew in *The Nutty Professor.*

In this, his later masterpiece, Lewis uses the Jekyll and Hyde plot device, where the alter ego unleashes just that kind of mean. Schlemiel chemistry Professor Julius Kelp is transformed by his formula into Buddy Love, a parody of sexy but mean Frank Sinatra. In musical numbers placed to show off his talent, Lewis sings "That Old Black Magic," "We've Got a World That Swings," and "I'm In the Mood for Love." But he doesn't need anyone to tell him what a great singer he is, and he's likely to insult anyone who does. This trickster persona also falls short, for though Buddy Love instigates tricks, his meanness and vengefulness—Buddy punches out a student who had humiliated Kelp—don't fit the profile. Tricksters tend to dodge attacks and are thus motivated by fun, even mean fun, but not revenge.

In *The Bellboy* (1960), Lewis plays bellboy Stanley, in a tip of the bowler hat to Stan Laurel. And actor Bill Richmond has multiple cameos playing Stan Laurel, whom Lewis admired.

The movie dispenses with plot, which opens the door wide for Trickster to enter. Filmed at Miami Beach's luxury hotel[74] Fontainebleau, *The Bellboy*

Jerry Lewis as Professor Julius Kelp and as Buddy Love in 1963's *The Nutty Professor*.

sets the stage for the kind of sight gags that would populate TV sitcoms for years to come.

An obese woman comes to the hotel for spa treatments and a weight-reducing regimen. She attempts to leave the hotel, now a svelte starlet, but in eating a gift box of chocolates while waiting for the limo to take her to the airport, she regains all the lost weight. Stanley is tasked with setting up chairs for a few thousand in the main ballroom. His coworkers are about to laugh at his expense as the herculean labor should take many hours, but he somehow gets it done in minutes (innocently reversing a trick that was played on him). He loses a battle with the steam press while trying to iron the pants of a guest, and they end up like cartoon cardboard. In one of the more physical gags, he insists on helping a disgruntled guest with his luggage. Refusing the refusal, Stanley latches on to the suitcase and is dragged across the lobby and into the departing taxi with the guest. Though just as frequently sight gags as physical slapstick, *The Bellboy* achieves the plotless apex of trickster play. Notably, bellboy Stanley utters no lines until the very end of the movie.

Lewis aspires to trickster divinity, commenting "I appeal to children who know I get paid for doing what they get slapped for. . . . I flout dignity and authority, and there's nobody alive who doesn't want to do the same thing."[75]

But when Lewis plays a trick, one senses an undercurrent of revenge that is absent from the more authentic "just for fun" trickery of the trickster.

Lewis couldn't incorporate the Trickster archetype into a single character, but his slapstick antics and whiny delivery—understood or misunderstood as immature and not worthy of an adult audience—are genuine imports of the child's playfulness into an adult body, and a vehicle for Trickster spirit.

Alan Dale writes "Americans in the twentieth century have perennially gone for manic nonchalance, from the Marx Brothers to Hope and Crosby to Martin and Lewis to *Animal House*; we love to see the old routines reupholstered with the latest in humor, music, sex, and topical targets."[76] But the more joined to parody a comedy is, the fewer the opportunities for disruptive play, freed from plot, to flourish. Both are critical: satire and parody can make us feel smarter than the usual idiom—they provide insights into so-called reality—but play must disrupt even further if it is to enlighten. Credit Lewis and Martin for making fun of sentimental phoniness. Sixties TV sketch comedy show *Rowan & Martin's Laugh-In* would use this, coming on to the audience as if there is a prepared and straightforward act and then demolishing it with interruption, ad-lib, slapstick, and pokes at piety.

Chaplin made dynamism fabulous. As if loss of dignity could stoop any lower, through his aggressive and desperate demands for laughs, Lewis managed to devalue the kind of humiliations suffered by Chaplin's Tramp. Then Woody Allen recaptured the fabulous, using Lewis-type slapstick moves—say, the famous sneeze on hundreds of dollars' worth of cocaine in *Annie Hall* and the numerous pratfalls of *Play It Again, Sam*—but in the context of defeat and his ever more complex narratives of love and relationships.

Narrative, however, obscures the irrationality of original play.

Though not a fully formed trickster personality, Lewis forged new pathways of possibility for film and pop culture. He opened the door to characters like those portrayed by Jim Carrey (as Ace Ventura, Lloyd Christmas, Andy Kaufman, The Cable Guy, Stanley Ipkiss) or Robin Williams (as Genie, Mork, Mrs. Doubtfire, Parry, King of the Moon, "Patch" Adams, Armand Goldman), where plot is secondary to pranks and tricks, where characters sniff out the tricky path of disruptive play.

THE TRUTH IS OUT THERE

While slapstick in film—the conveyance of the child's amoral playfulness into a medium anchored in narrative—has yet to incite the revolution it suggests, its influence is nonetheless widespread. There are countless talkies beyond the Marx Brothers films where slapstick is on full display, and many that illustrate disruptive play. The ones I've selected embed the hope that the wonder of a Play Society will take shape in more minds, more lives, and society at large. I seek these examples out because I believe in their potency, that art can change minds, and changed minds can change the world.

* * * * * * * * * *

Throw a stone at a pile of movies, and you're going to hit one where slapstick has sneaked in under the tent flaps. Directors and actors with obvious influence include Wes Anderson, Jackie Chan, Bill Murray, Lucille Ball, Amy Poehler, Gilda Radner, Carol Burnett, Joan Davis, Melissa McCarthy, Leslie Jones, Penny Marshall and Cindy Williams, Amy Sedaris, Peter Sellers, Chris Farley, Cary Grant, Pedro Almodóvar, Terry Gilliam, and George Roy Hill, just to name a few. Films such as *M*A*S*H*, *Raising Arizona*, *Beetlejuice*, *Little Miss Sunshine*, *The Mask*, *Kingpin*, *Women on the Verge of a Nervous Breakdown* all incorporate slapstick; again, this is but a small sampling. In the cases of Buster and the Tramp, you could get away with saying *everyone's* been influenced; both are considered among the greatest film directors of all time.

I've shared examples that resonate for me and merit comment. They touch Trickster magic and inform the collective consciousness.

In the foreword to *The Three Stooges Book of Scripts*,[77] comedian Whoopi Goldberg observes "I hear some people say that the Stooges' comedy is violent, but their violence, if you can call it that, is fun and hysterically funny; sorta like an animated cartoon with real people." And in this, she solves the seeming paradox between an acceleration of vaudeville and comedy's flirting with the crude and a sacred reaching to the divinity of a demigod archetype. Cartoons and The Three Stooges aspire through so-called violence to reach

the elasticity of fantasy, animation, and folklore, where the character suffers lethal attacks without dying, or is injured, but only for the few seconds it takes to get a laugh. Human beings cannot be archetypes, in this case Tricksters, but they can sure try and, in that trying, cast a light and take a buster. The universe sent us The Three Stooges because it was looking for volunteers to see how much screen violence real humans could endure. Thank you, Moe, Shemp, Larry, and Curly. The Three Stooges' influence is as a resource, a mosh pit of a database: file under *Physical Assault That Makes You Laugh.* They did not summon the Trickster so much as provide spare parts for the trickster dance.

While our focus has been on the physical, and the Stooges rely on it the most, there is the playfulness that comes out of Marx Brothers dialogue, most notably Groucho's. Groucho was physically agile, a fabulous and very funny dancer, but he is remembered more for his quips. Groucho's and Mae West's verbal slapstick had its own iconic, illogical logic and, in that, kinship to the way Buster Keaton redesigned the physical world with his own spatial illogical logic.

Butch Cassidy and the Sundance Kid[78] is just one example of how Trickster consciousness hovers over us. In William Goldman's script and Paul Newman's acting (as Butch), Groucho humor is channeled to both serve the narrative and refuse to serve the narrative. This comedic tragedy keeps us laughing all the way to the gallows. It recounts the saga of the end of the horseback bandit as a more modern form of law enforcement laid their tricks to waste. The law eventually nails these clever bandits, for whom the audience is rooting all the way.

Butch's wisecracks unsettle. He jokes and philosophizes and raises the question of whether crime and love and life-and-death struggles need be taken seriously. Goldman plants the irrationality of play as acted out in slapstick into the more conventional form of the plot-based film.

Robert Redford as the Sundance Kid is trickster-like in his inability to form a durable love connection with Etta Place (actor Katharine Ross), while Butch looks on and never even finds a mate.

The deep value of Groucho's verbal slapstick was not lost on Goldman. Newman's lines are lifted straight out of his smart-aleck mind and deliver

wisecracks that both move the plot forward and, without ever straying, none-theless expose the boundary that would take the film into the nonsense of play and irrationality.

Just check out these Butch lines and imagine them being delivered by Groucho. When Sweetface, one of their pals, misdirects a posse looking for Butch and Sundance:

Butch Cassidy: I swear, if Sweetface told me that I rode out of town ten minutes ago, I'd believe him.

And later:

Butch: (to Sundance) Boy, I got vision, and the rest of the world wears bifocals.

When scouting out banks to rob:

Butch: What happened to the old bank? It was beautiful.

Guard: People kept robbing it.

Butch: Small price to pay for beauty.

Sundance: No. Swimming isn't important. What about the banks?

Butch: Very easy. Easy, ripe, and luscious.

Sundance: The banks or the women?

Butch: Well, once you get one you get the other.

During a scene where they are lost in the Bolivian desert:

Sundance: Which way?

Butch:I t doesn't matter. I don't know where we've been, and I've just been there.

And to bring us full circle, from *Duck Soup*:

Chico: Hello? No, not yet. Alright, I'll tell 'im. Goodbye. Thank you. (Hangs up phone.) That was for you again.

Groucho: I wonder whatever became of me. I should have been back here a long
time ago.

Josh Heald, Sean Anders, and John Morris, the screenplay writers of 2010's *Hot Tub Time Machine*,[79] create a complex character in Lou, played by Rob Corddry. Lou animates Trickster energy as he vacillates between off-the-charts hedonism, punchline nihilism, and trickster-esque amorality. Yet through repeated humiliations—the dark slapstick of getting your ass kicked over and over again—he completes the Trickster cycle and refreshes his moral compass by choosing to stay in the time-traveled past and give life a second chance. But you'll miss it if you blink: he exploits his knowledge of the future for financial gain, keeping the comedy comic in the stoner tradition and stopping short of any message of enlightenment.

For pure physical laughs, the sad-sack Buster[xl] Bluth character in the cable TV series *Arrested Development*[xli] cannot be beat. The pratfalls and physical gags prove that this form of playfulness done well has a timeless humor to it. After a seal bites off his left hand, slapstick ensues: first, with his prosthetic hook, he gashes his uncle when he attempts to give him a shoulder massage, then he goes on a rampage and with said hook destroys a living room. Later the gag evolves with a wide array of prosthetics, for example, a "Terminator" hand and another one that gets caught in an elevator door. His several allergies, military enlistment, need for frequent naps, unhealthy attachment to his mother, and immature jealousies add to the humor. His childish and socially awkward insecurity misses the mark of the mischievous trickster, but he performs the best slapstick the twenty-first century has yet to offer.

While slapstick can be featured in a narrative form, by itself it rarely makes a satirical or dramatic point. The Trickster demigod who inhabits slapstick will not allow it. In conversation with Gouverneur Morris, Charlie Chaplin defended "the form [*The Kid*] was taking, keying slapstick with sentiment." Morris replied, "It won't work. The form must be pure, either slapstick or drama; you cannot mix them, otherwise one element of your story will fail."[80]

xl Played by Tony Hale. Is the name "Buster" in homage to Keaton?
xli Created by Mitchell Hurwitz, *Arrested Development* ran on Fox from 2003-2006, with
 additional seasons on Netflix, 2013, 2018, and 2019.

Slapstick was eventually refined by the likes of Chaplin when it injected more sentimentality and pathos. But in its origin soup of amorality, Chaplin as Tramp is more of a cad and a prankster, his slapstick a chaotic and wild party of pranks, pratfalls, clobberings, and chases. Such cinematic moments are more to the pointless point. Expanding the two-reeler shorts to feature length and reifying the myth of the little guy against the big bad guy steered slapstick away from true trickster nature.

The transition from silent films to talkies coincided with Hollywood, in the interest of profit, glomming on to sentiment, stereotypical heroism, occasional satire, and convention. For slapstick, it was an awkward step taken at the expense of its artistic essence and playful potential. The Trickster and the slapstick artist both mock power but satirize it only in passing, which is not to say that slapstick doesn't share some of satire's ulterior motive in deposing power. Early Chaplin has that beauty. The Tramp is an amoral character who would just as soon prank the good guy as the bad. Witness his bad boy behavior as a frankfurter thief in *A Dog's Life,* stealing from a working-class stiff, escaping from the pursuing cop, and avoiding arrest and debt. To the audience, it seems harmless enough, and we become endeared to this trickster more drawn to mischief than satire.

As great as *The Great Dictator* (1940) is, it's a transition to conventional narrative where the slapstick, also great, is tacked on to the plot, not really woven into it. Its flaws do not detract from its cinematic achievement, but as far as furthering Trickster consciousness, it's a frustrating cul-de-sac. The radio microphone that dances with Chaplin, the signature prank of pouring water into his ear and having it come out of his mouth, and even the jousting with the Mussolini-esque Jack Oakie (as Benzino Napaloni, dictator of Bacteria) comprise some of film's most famous slapstick, but in these moments, as always, the gags are unrelated to Chaplin's intended political satire and not really part of the narrative.

The virtue of early slapstick films was that flimsy plots were just excuses for gags. Chaplin courageously sought more substance, but the arithmetic just didn't pencil out. Such plots cannot integrate gags, which become merely ornaments.

But there are redeeming features in the film where tricks quite shrewdly do serve the narrative. When the Barber realizes that he's been mistaken for the Hitler character, Hynkel, he embraces the opportunity and makes a speech in favor of freedom and against fascism. Ta dum, baby! This trick serves as a blueprint for the kind of Yippie pranks the Yes Men would become known for in the late twentieth century.[81] This is disruptive play at its finest, tricking power into performing acts of love. But Chaplin chose to stop short of "raising the political calamity of fascism to the level of nonsense"[82] and instead dropped all humor and made a serious speech. Those were, in fact, serious times.

We admire Chaplin for making the broader point of (almost) never losing your sense of humor, especially during the dark onset of Nazism and World War II. And to return to the basics of satire, slapstick, and class struggle, Chaplin makes the cardinal point that it's funnier to drop ice cream from a balcony onto a rich person than a poor one. Some claim that the comic trickster's anti-authoritarianism is not political, but how can it not be?

Chaplin, and for that matter Keaton, also failed to deliver slapstick's message into sound because their spoken voices were not as funny as Groucho's, Chico's, and ultimately Jerry Lewis's. Chaplin confessed as much to Groucho Marx when he said, "I wish I could talk on screen the way you do."[83] So the torch was passed to new comics who safeguarded the flame of fun-ness, using Groucho's illogical verbal slapstick as the cornerstone of the new era.

But just because slapstick's full potential wasn't realized in the plot-driven *Great Dictator* doesn't mean it can't be. Terry Gilliam's *Brazil*[84] does more than incorporate, it integrates slapstick with the narrative. *Brazil* is generally referred to as satire, but I believe that it takes satire to a whole other level; the film performs a slamming takedown of power. *Brazil's* protagonist, Jonathan Pryce as Sam Lowry, is a victim caught in an ever more menacing vortex of victimization; Chaplin as the Barber played a victim who wakes up to find himself in power.

When Lowry misses his bus as those exiting stampede him, it's pure Chaplin. In this case, though, it's not a piece of candy tossed in, it contributes to the portrait of Lowry as the emasculated victim of the state. He later hangs on to

the front of a semitruck, slapstick as satire on the hero's quest for love. The truck is being driven by Kim Greist as Jill Layton. Jill is the real-life version of Pryce's fantasized dream girl, and instead of the yielding princess, she's a hard-assed feminist resister of the state, and in no mood for Lowry's romantic cravings. The slapstick of him clinging to the truck's grille as it speeds away from and towards more danger fits the character and plot perfectly.

Unsurprisingly, in this dystopian world, Lowry works at a desk. Chaplin and Keaton would both applaud the scene where it moves back and forth through the wall as Lowry and the guy next door play tug-of-war—the one desk is supposed to serve two closet-sized offices. There is a nod to the scatology of the trickster when two government workers, through an act of sabotage, have the worst kind of sewage pumped into their sealed hazmat suits. And then there is a more modern act of slapstick violence performed on the face of Lowry's mother, played by Katherine Helmond with dark comic brilliance, as she submits to multiple plastic surgeries, each bringing more bizarre results than the last, until she becomes a cartoonish version of herself.

Besides the generous helpings of classic slapstick, the film pays homage to Alfred Hitchcock, as if Gilliam is signaling the strength of narrative and the weaving of slapstick into its fabric. Lowry, often from a distance, evokes in his gray suits and demeanor Jimmy Stewart. His manner of dress and his timid voice portray an everyman who is eventually aroused to heroism, as Stewart is in *Vertigo* or *North by Northwest.* And when he dreams of his romantic love, the soft focus put on Jill Layton as intoxicating lover reminds us of Hitchcock as well. *Brazil* actually achieves what Chaplin was reaching for in *The Great Dictator:* performing slapstick and making it work in service to a narrative that confronts power with physical hilarity. In this case, the politics are more radical, the script more sophisticated. Trickster writers Gilliam and Tom Stoppard mock film convention itself: the hero, in this case, is doomed.

Slapstick is a permanent fixture of storytelling. There are hundreds of examples, I've chosen these. An authentic expression of the human condition, slapstick ignites the playful spirit. K.J Dover offers a description of Aristophanes's[xlii] insolence, an impulse central to comedy. It correlates almost per-

xlii The Greek playwright (c. 446-c.386 BCE) known as "The Father of Comedy."

fectly with the Trickster archetype and leads us to greater understanding of the political bent of Trickster: "Devaluation of gods, politicians, generals and intellectuals may be taken together with ready recourse to violence, uninhibited sexuality, frequent reference to excretion and restricted vulgarity of language, as different forms of the self-assertion of man against the unseen world, of the average man against superior authority, and of the individual against society."[85]

Though I made *Brazil* my strongest example of slapstick's power to liberate, the film is a tragedy where the state wins and the hero suffers the most painful of defeats: he is punished with inflicted insanity, his utopia is only in his mind. To put together a vision of victory, of liberation, of the Play Society, Western culture makes essential contributions but, as controlled and interpreted by a white male patriarchy, just can't fully compose it, and certainly can't compose it alone. The participation of women in the odyssey of the Trickster, the monumental achievements of African culture on the Atlantic coasts of the Americas, and the influence of the West African Trickster god Eshu, or Eshù Elégba[xliii] offer some of the missing pieces that complete that vision.

xliii "The names for Trickster god Eshu vary around the world: in Yorùbáland, Eshu is *Èṣù-Elegba* or *Laolu-Ogiri* Oko; *Exu de Candomblé* in Candomblé; *Echú* in Santería and Latin America; *Legba* in Haitian Vodou; *Leba* in Winti; *Exu de Quimbanda* in Quimbanda; *Lubaniba* in Palo Mayombe; and *Exu* in Latin America." Wikipedia, s.v. "Eshu," retrieved February 18, 2020, https://en.wikipedia.org/wiki/Eshu.

THE TRIUMPH OF ESHÙ ELÉGBA

CHAPTER FIVE

ORIGIN STORY

Esu is the sole messenger of the gods . . . he who interprets the will of the gods to man; he who carries the desires of man to the gods. Esu is the guardian of the crossroads, master of style and of stylus, the phallic god of generation and fecundity, master of that elusive, mystical barrier that separates the divine world from the profane.

—Henry Louis Gates Jr.[86]

Eshù Elégba, one of the more notorious, complex, and revered Trickster gods, earned his position as intermediary between the big God Ifa and mortals through trickery. On the day before Ifa was to choose his messenger, Eshù Elégba made a sacrifice and asked Ifa what he needed to do to win. Taking God's cue, he put on some style. His esquire hat, and/or feather, and/or phallus made him appear red when viewed from one angle and black from another. Eshù Elégba's striking getup stood out, and he nailed the audition.

The Trickster's greatest play is to bend towards a future both predictable and changeable. Such indeterminacy signifies Tricksters' savior-like, redemptive peculiarity.[87]

* * * * * * * * *

No American issue looms larger than race and the four-hundred-year struggle of African Americans for freedom, justice, and equality. Serious stuff for a book about play and tricksters, plopped down in a twenty-first century where American racism yet persists.

But Trickster god Eshù Elégba plays a part in the New World experience of enslaved Africans, just as Trickster Wakdjunkaga does for the Native American Winnebago tribe. And just as Tricksters Til Eulenspiegel and Bugs Bunny influence Western culture. Playfulness and Trickster spirit have deep roots in all cultures and are especially prominent in the Afro-Atlantic (the southern United States, the Caribbean and Brazil).

This is no comprehensive accounting of the Afro-Atlantic, but it is the author's hope to explore, within African American culture, that complex archetype, the Trickster, and Trickster's universal message and blessings of magic, power, fun, magnificence, and mischief. Comments on these significant dimensions of world cultures are made in resistance to any associations with racist stereotypes or biases.

* * * * * * * * *

Abolition released a torrent of pent-up intelligence, power, skill, talent, creativity, and leadership that slavery had suppressed and cast new light on Afro-Atlantic folklore. We should not forget, if we ever knew, that the African American contributions to the world are not limited to athletics, politics and law, community organizing, religion, music, dance, comedy, film. and drama, as impressive as that list is. In *The African-American Century: How Black Americans Have Shaped Our Country,* Henry Louis Gates Jr. and Cornel West burst the stereotypes and set the record straight. Twentieth-century African Americans distinguished themselves with historic accomplishments in literature (Toni Morrison, Ralph Ellison, James Baldwin, Octavia Butler, Richard Wright, Maya Angelou, Alice Walker, Langston Hughes, Chester Himes, Jean Toomer), exploration (Matthew Henson), painting and sculpture (Jacob Lawrence, Henry Ossawa Tanner, Romare Bearden, Martin Puryear), enterprise (Madame C.J. Walker, Robert Smith, Booker

T. Washington), feminism (Ida B. Wells-Barnett, Mary McLeod Bethune), agriculture (George Washington Carver), military (Benjamin O. Davis Sr. and Benjamin O. Davis Jr.), entomology (Charles Henry Turner), history (Carter G. Woodson), aviation (Bessie Coleman), biology (Ernest Everett Just), medicine (Charles R. Drew), and any other field of endeavor one could name.

And we've been blessed with countless heroes in the fight for social and economic justice, among them Frederick Douglass, abolitionist and champion of the Fourteenth Amendment; Ida B. Wells-Barnett, cofounder of the NAACP; Black Panther Party leader Huey P. Newton; womanist Mary McLeod Bethune; voting rights activists Stacey Abrams and Fannie Lou Hamer; as well as authors Ta-Nehisi Coates and James Baldwin. Add Sherrilyn Ifill, Rosa Parks, Muhammad Ali, Angela Davis, Martin Luther King Jr., Thurgood Marshall, Malcolm X, and Shirley Chisholm to this endless but important list.[xliv]

In a nutshell, "American life is inconceivable without its black presence. The sheer intelligence and imagination of African Americans have disproportionately shaped American culture, produced wealth in the American economy, and refined notions of freedom and equality in American politics."[88] These champions comprise a no-nonsense, serious, engaged movement whose demands are as sturdy and defiant as they are simple and straightforward: full equality under the law, educational and economic opportunity, and an end to racism. But simple is a far cry from easy.

Hard times and this dangerous, risky struggle go hand in hand with the magic of humor, the respite and finesse of not taking things too seriously, or of laughing to keep from crying. It seems that the more painful the struggle, the more uproarious the joking about it. Despair, discouragement, and the frustrations and suffering of the Black experience become the stuff of the comedian's punchline, and declarations of racial pride can energize and electrify an audience. Trickster gave Black America a shot at redemption, and Black tricksters took it. Here's an example from Richard Pryor:

xliv These people are more than their race. We consider them together as Black contributors, but they are each unique. They share a Black ancestry that only partially defines who they are.

We come from the first people on the earth. You know, the first people on the earth were Black people. 'Cause anthropologists, white anthropologists (so the white people go "that could be true, you know"), yeah, Dr. Leakey and them found people remains five million years ago in Africa. You know them mother******* didn't speak French. So Black people, we're the first people that had thought, right? We were the first ones to say "Where the f*** am I? And how do you get to Detroit?"[89]

Pryor gets deep into Trickster magic in *Richard Pryor: Live in Concert*,[90] taped in 1979 at the Terrace Theater in Long Beach, California. Pryor enacts getting revenge on the tree from which he had to pick a switch for his grandma to whip him with. The hilarious tale conjures the most ancient of Trickster myths, those of the Winnebago god Wakdjunkaga, who had his own frustrating confrontations with blameful trees.

Pryor narrates the murder of George Floyd forty years before it occurs. He states a raw, painful fact of racism decades before the general American population began its reckoning with it...he states truth to power in the context of a joke and the safe space that surrounds the jester comedian. He tricks power so as to psychologically and politically prepare Americans for power's act of love.

Pryor describes how, in drunken anger and distress over his wife leaving him, he shot his .357 Magnum at his own car. And here's the no-joke joke:

Then the police came. I...went in the house. 'Cause they got Magnums too. And they don't kill *cars*. They kill *n***-gars.* [loud applause]
Police got a choke hold they use out here, though. Man, they choke n***as to death. That mean you be dead when they through. Did you know that? Wait, n***as goin' "Yeah, we knew." White folks, "No, I had no idea." Yeah, two grab your legs, one grab your head, and snap. [Cop voice]: "Oh, s***. He broke. Can you break a n*****? Is it okay? Let's check the

manual. Yep, page 8. 'You can break a n*****.' Right there, see?" [laughter and applause].

Why does this mostly white audience laugh so? Not because the murder of Blacks by cops is funny, but because it's so wrong, absurdly wrong, and that's what Pryor's signifyin(g). Pryor's performing Trickster magic, knowing that the laughing crowd is now with him and that a cessation of such treatment of Black people is the act of love Pryor is preaching. Ten years later, Spike Lee drove the point home with a graphic enactment of a choke hold murder in *Do the Right Thing.*

Thus opens the portal. Trickster enters. Says Henry Louis Gates Jr: "On a deeper level, Black reflections on the human condition in this land of sentimental aims and romantic dreams injected tragicomic sensibilities into the American experience."[91]

* * * * * * * * * *

Taking on the responsibilities and opportunities of newly gained citizenship, inspired by their unique history and the cultural and spiritual gifts of African roots, women and men freed from slavery set about reinventing America. In the midst of the unfinished struggle for equality and justice, and through those gifts—the Trickster Eshù Elégba among them—liberation and triumph came into view.

The story of the Signifying Monkey is the story of tricking power into performing acts of love, or at least tricking power into reversing itself. The Signifying Monkey's origin stories take place in the jungles of Africa, yet he emerges on the other side of the Atlantic, in the Afro-Atlantic. He's the New World cousin to the West African Trickster god Eshù Elégba, or Esu.[xlv] He embodies enough trickster characteristics to be called one, and can be under-

xlv He is called Esu-Elegbara in Nigeria and Legba among the Fon in Benin. His New World figurations include Exú in Brazil, Echu-Elegua in Cuba, Papa Legba (pronounced La-Bas) in the pantheon of the loa of Vaudou of Haiti, and Papa LaBas in the loa of Hoodoo in the United States, i.e., New Orleans. Gates settles on Esu and Esu-Elegbara; Robert Farris Thompson and this author use Eshù or Eshù Elégba.

Petitioning Papa Legba at the Crossroads, art by Rick Jacobi. https://www.rickjacobiart.com.

stood as a stand-in, but the Signifying Monkey is distinct from Eshù. His true origin and relationship to Eshù Elégba is lost in the mists and cover-ups and dispersions of the Middle Passage.[xlvi] Today, that mystery nurtures and suffuses Trickster legend.

The Signifying Monkey's obvious virtue is his ability to "signify." Henry Louis Gates Jr. coins the term "signifyin(g)" as belonging to African American vernacular and literary style. The unique spelling is to distinguish it from the standard English signifying, which carries an opposite meaning. Standard English uses forms of the word signify to make an idea or statement more precise. The Black vernacular and literary usage of signify adds doubt, ambiguity, layers of interpretation, and thus the opening of more, not fewer possibilities. Thus they are two different words with two different spellings. Gates' distinguishing use of "signifyin(g)" is adopted here, except in the title The Signifying Monkey. And here's the tale:

xlvi The Middle Passage was the stage of the triangular trade in which millions of Africans were forcibly transported to the New World as part of the Atlantic slave trade.

The Lion thinks that he's the king of the jungle, but really, it's the Elephant. The Monkey, a natty dresser with (what in the day Black vernacular would call) his own pimp roll and gassed hair, conked beneath an esquire hat,[xlvii] knows that he cannot beat the Lion, but the Elephant can. So he taunts the Lion. He convinces him that the Elephant's been talking smack, low-rating him behind his back. The Lion falls for it. Angered, he goes after the Elephant and demands an apology. The Elephant refuses—after all, it was a lie—and trounces him. For two days nonstop. The Lion realizes he's been conned by the Monkey, and bedraggled, broken, and defeated, he heads back. He thinks he's going to give the Monkey a beating. But the Monkey's climbed up high in a tree, out of the Lion's reach. Still, the Lion can hear the Monkey signifyin(g), adding insult to injury, reveling in his little victory:

> Now the Lion come back more dead than alive,
> That's when the Monkey started some more of his old signifying.
> He said, "King of the Jungles, ain't you a b*****,
> You look like someone with the seven-year itch."
> He said, "When you left [me earlier], the lightnin' flashed and the bells rung.
> You look like something been d*** near hung."
> He said, "Whup! Mother******, don't you roar,
> I'll jump down on the ground and beat your funky ass some more."
> Say, "While I'm swinging around in my tree,"
> Say, "I ought to swing over your chickens*** head and pee."
> Say, "Everytime me and my old lady be tryin' to get a little bit,
> Here you come down through the jungle with that old 'Hi Ho' s***."[92]

But then the boasting Monkey gets a little careless, slips, and falls to the ground. The Lion's got him! Like Bugs Bunny fake-pleading with Elmer Fudd, the Monkey begs for mercy and apologizes. The Lion's not angry about the con or the beating he took from the Elephant—he's furious that he got signified.

xlvii This site has an image of how one artist renders Eshù Elégba as Papa Legba: https://www.mooremetal.com/paintings?lightbox=image_7pt.

> Monkey, I'm not kicking you're a** for lyin',
> I'm kicking your hairy a** for signifyin'.[93]

Now this sample of signifyin(g) is full of insults and is associated with the origins of the street game Playing the Dozens. But signifyin(g) is not merely that, it's a fully formed and complex means of discourse and trickster god-consciousness. It can be the ability to talk with great innuendo; to carp, cajole, needle, and lie; to talk around a subject, never quite coming to the point; to make fun of a person or situation; to speak with the hands and eyes; to employ the language of trickery; to be the Monkey (the signifier) or the Lion (the signified). Signifyin(g) even includes honoring the signified. Gates proposes the Signifying Monkey tale as the basis of African American literature, its *Robinson Crusoe, Don Quixote, El Periquillo Sarniento, Epic of Gilgamesh,* its *Beowulf,* or *The Iliad* and *The Odyssey.* As such, it plants the flag of an independent and unique literary origin . . . and it's a trickster tale.

A partial list of the trickster's signifyin(g) qualities includes "individuality, satire, parody, irony, magic, indeterminacy, open-endedness, ambiguity, sexuality, chance, uncertainty, disruption and reconciliation, betrayal and loyalty, closure and disclosure, encasement and rupture."[94]

When John Coltrane takes a particularly sentimental and almost silly Broadway tune, "My Favorite Things" (all apologies to Rodgers and Hammerstein), and turns it into a tour de force of celestial revision, improvisation, and reinterpretation, that's signifyin(g).[95] When Rudy Ray Moore in his film *Dolemite* retells the tale of the Signifying Monkey in a parking lot to a group of admiring brothers, that's signifyin(g). When Octavia Butler takes the racist raping of Black women and transmutes it into a science fiction playground where extraterrestrial species crossbreed with humans, that's signifyin(g). When the gospel preacher's rhythms find their way into a hip-hop dressing down, boast, or call to solidarity, that's signifyin(g).

Folks tend to focus on the insult and boast as predominant, but the coming examples show that signifyin(g) comprises an entire vernacular of discourse. Eshù Elégba contains multitudes, all of these characteristics plus more; "taken together, they only begin to describe the complexity of this classic figure of

mediation and the unity of opposed forces."[96] The signifier can impersonate, improvise, ad-lib, persuade, use wordplay—and master Black Signification.

* * * * * * * * *

Where I have previously discussed the archetype, I characterized Trickster as *amoral*, neither good nor evil. Gates, in *The Signifying Monkey: A Theory of African-American Literary Criticism,* improves on that, using the term *moral indeterminacy* to define Eshù Elégba.[97] He constructs his theory of African American literature as a meshing of oral and written text that continues that state, a state whereby the moral indeterminacy of Eshù Elégba creates more than it resolves moral dilemmas.

* * * * * * * * *

Ifa is the main god in the Yoruba belief system. Ifa decrees *Fa*, what each person needs to know on a daily basis so that they can fulfill their destiny for that day. But to connect with Ifa, his emissaries and the major gods remind us that Trickster Eshù Elégba, Ifa's crucial intermediary, must be worshipped, because he knows all the languages and thus can channel and interpret. But he's going to mess with you too.

And then, somehow, when Eshù Elégba shows up in the New World he's got the Signifying Monkey at his side, whose badass way of talking and making mischief is the source of African American vernacular and rhetorical discourse. Gates distinguishes Eshù Elégba from the Signifying Monkey. Eshù Elégba can play with language, manipulate meanings, and play linguistic tricks. As such he is the key to understanding Pan-Africanist literature, while the Signifying Monkey originates the Afro-Atlantic oral tradition. This dichotomy mediates the indeterminacy between oral and written traditions.

Ifa, Eshù Elégba (Esu), and the Monkey come together to "speak a new word and to disclose a deeper grammar"[98] that makes for a narrative tradition not beholden to Western culture, but one that—even in its stirrings and blendings with the European-based cultures of the New World—stands on

its own, in literature, dance, music, comedy, performance, daily life . . . in a word, culture. And so, in the Afro-Atlantic, the Signifying Monkey, born of Africa, born of Ifa and Eshù Elégba, born of the Middle Passage, acts out the trickster persona.

> While we lack archeological and historical evidence to explain the valorized presence of the Monkey in Cuban mythology, in the textual evidence . . . we commonly encounter Esu with his companion, as depicted even in visual representations . . . As Alberto del Pozo writes, "Echu Elegua frequently has a monkey . . . by his side." If we examine the general characteristics of Esu . . . the Signifying Monkey emerges from his mysteriously beclouded Afro-American origins as Esu's first cousin, if not his American heir. It is as if Esu's friend, the Monkey, left his side at Havana and swam to New Orleans. The Signifying Monkey remains as the trace of Esu, the sole survivor of a disrupted partnership. Both are tropes that serve as transferences in a system aware of the nature of language and its interpretation.[99]

Discussion of this intriguing and enormous influence is complicated and disturbed by racist epithets of the African American as a monkey. Such racism obfuscates and hobbles a shared appreciation of the Signifying Monkey as, ironically, the cleverest challenger to racism and Western hegemony. To get beyond this trap is to approach the threshold of the Signifying Monkey's paradoxical tricks, divinity, aporetic misdirection, and indeterminacy that mean nothing less than the ascendency, transformation, indeed the very definition of New World culture and the triumph of Eshù Elégba.

Yet the agonizing struggle of Black Americans to attain dignity, political power, and their share of New World prosperity persists. If there were some greater purpose to be fulfilled via the European enslavement of Africans in the New World—"not the conviction that something will turn out well, but the certainty that something makes sense"[100]—was it for Africans to be European-

ized or for Europeans to be Africanized? We should not have to choose either dynamic so long as we acknowledge both. And in giving both their due, we open ourselves to a world where we behold the most sophisticated representation—signification if you will—of the Trickster archetype and its potential benefit to society.

Eshù Elégba is "a term of (anti) mediation, as are all trickster figures, between two forces he seeks to oppose for his own contentious purposes, and then to reconcile."[xlviii] Eshù is the great translator, interpreter, speaker of all languages. He reveals a portal to transformed and magical worlds.

* * * * * * * * *

In his 1975 film *Dolemite,* which the *New York Times* called "the 'Citizen Kane' of kung fu pimpin' movies," Rudy Ray Moore is at once trying to help create a genre—kung fu pimpin' movies—while at the same time signifyin(g) on the existing genres of gangster and martial arts films. He is delivering parody and heartfelt intent at the same time. Here's his street-language version of the Signifyin' Monkey tale:

> Way down in the jungle deep,
> The lion stepped on the signifyin' monkey's feet.
> The monkey said, "Mother******, can't you see?
> You're standing on my god*****d feet."
> The monkey lived in the jungle in an old oak tree,
> Bull*******" the lion every day of the week.
> Every day before the sun go down,
> That lion would kick his a** all through the jungle town.
> But the monkey got wise and started usin' his wit,
> Started sayin' I'm gonna put a stop to this whole a**-kickin' s***.
> So he ran up on the lion the very next day,

xlviii Tricking the Lion into tangling with the Elephant. Gates, *The Signifying Monkey*, 61.

He said, "Oh, Mr. Lion, there's a big bad mother******coming your way.

And he's somebody that you don't know,

He just broke a-loose from the Ringling Brothers show."

Said "He talked about your people in a h***uva way,

He talked about your people 'til my hair turned gray.

Well, Mr. Lion, you know that ain't right,

So whenever you run up on the elephant, I want you to be ready to fight."

The lion jumped up in a h***uva rage,

Like a young man smokin' some gage.

He ran up on the elephant talkin' to the smile,

He said, "All right you big bad mother******, it's gonna be you're a** or mine."

The lion jumped up and made a faster pass,

But the elephant sidestepped him and knocked him dead on his a**.

He f***** up his jaw, messed up his face,

Broke all four legs and knocked his a** out of place.

They fought all night and all the next day,

Somehow the little lion managed to get away.

He drug his a** back to the jungle more dead'n alive,

Just to run into that little monkey and some more of his signifyin' jive.

The little monkey said, "Look here, partner, you don't look so swell,

Look like to me like you caught a whole lotta h***."

Said "Your eyes is red, and you're a** is blue,

But I knew in the first place it wasn't s*** to you.

But I told my wife before you left,

I shoulda whipped your a** my mother******' self.

Shut up, don't you roar,

Cause I'll jump out of this tree and whip your dog-a** some more.

An' don't look up here with your sucker-paw case,

Cause I'll piss through the bark of this tree in your mother******'
face."
The little monkey started halfway jumpin' up and down;
His feet missed the limb, his a** hit the ground.
Like a ball of lightnin' and a streak of white heat,
That lion was on his a** with all four feet.
Dust rolls and tears came in the little monkey's eyes,
Nothing he could see and nothing he could hear.
But he knew that was the end of his bull*******' and signifyin' career,
And signifyin' career.[101]

* * * * * * * * * *

His penis is perpetually erect, and through sex, he travels back and forth
between two worlds. In Melville Herskovits's anthropological work, *Dahomey,*
we read, "His organ was always to remain erect, Mawu had herself decreed
such conduct for him. That is why, when Legba dances, he tries to take any
woman who is at hand."[xlix] Paradoxically, he also presents a unity of male and
female. Eshù exists in all genders.[1]

xlix Melville J. Herskovits, *Dahomey: An Ancient West African Kingdom, Vol. II,* (New York:
J.J. Augustin, 1938), 205-6. Harpo Marx plays out this sexual insatiability in his version
of trickster as well.

1 Eshù's indeterminant gender presents a path to resolving sexism. In Gates, *The
Signifying Monkey,* 29, he quotes Ayodele Ogundipe, a Nigerian scholar, who writes
that Esu 'certainly is not restricted to human distinctions of gender or sex; he is at once
both male and female. Although his masculinity is depicted as visually and graphically
overwhelming, his equally expressive femininity renders his enormous sexuality
ambiguous, contrary, and genderless.'" And on 34-35: "Fon and Yoruba discourse is
truly genderless, offering feminist literary critics a unique opportunity to examine a
field of texts, a discursive universe, that escaped the trap of sexism inherent in Western
discourse. This is not to attempt to argue that African men and women are not sexist, but
to argue that the Yoruba discursive and hermeneutical universes are not. The Fon and the
Yoruba escape the Western version of discursive sexism through the action of doubling
the double; the number four and its multiples are sacred in Yoruba metaphysics. Esu's
two sides 'disclose a hidden wholeness;' rather than closing off unity, through the
opposition, they signify the passage from one to the other as section of a subsumed
whole. Esu stands as the sign of this wholeness.

He limps; his legs are of different lengths because one is in the realm of the gods and the other in our world. Thus his trickery transcends the banal and becomes a principle of the universe.

Eshù Elégba, Papa Legba, Esu, in all his appellations, represents indeterminacy, that even though every person's fate is preordained—it's not! There is a "way out"—through worship of Eshù Elégba. This exception to the rule, this ability to change fate, is the "trick" that can give credibility to the prospect of a better society. If you are enslaved and you see no hope for a happy life, Eshù Elégba and his Signifying Monkey give you hope through their mastery of the chaos and contradictions of creation. Popular culture notions of Louisiana Voodoo or Haitian Vodou mistakenly frame this ability to change the future as superstition. But it's more. Enslaved people in Brazil revered Exú as their political liberator and the enemy of the enslavers. Eshù Elégba's Ashanti counterpart Ananse the Spider symbolizes slave resistance through trickery, mostly in Jamaica and Haiti.

The symbolism in such tales is of the little guy overcoming the big guy with his wits—basic tricks. Ananse (Akan for spider, and also known as Kwaku Ananse, Anancy, Ba Anansi, Kopa Nanzi, Nanzi, Nancy, Aunt Nancy, and Sis Nancy) bargains with Nyame the sky god to purchase all the stories of the world from him. Nyame sets before Ananse herculean tasks: capture and present Onini the Python, then the Mmoboro Hornets, Osebo the Leopard, and the Fairy Mmoatia. Ananse adds his mother to the bargain and proceeds to trick each of these targets, all the while boasting of his cleverness, signifyin(g) on his quarries. Ananse's tricks, involving pits and gourds, wagers and sticky gum, all succeed, and this Trickster spider-god becomes the keeper of all stories.[102]

Standard English *signifying* relies on eliminating ambiguity and is about making a precise statement that expels all the conscious, subconscious, unconscious associations that the statement might suggest. Afro-Atlantic *signifyin(g)* turns that definition on its head, invites and encourages ambiguity and all possible associations, and does a dance around Standard English. To put it in terms of the language of the subjugated versus the colonizing slaveholder and racist: *If I play your game, you will always win. But If I can make parody of your*

linguistic game, refusing to play it by your rules, throwing aside and laughing at your concept of precision, dance my signifyin(g) dance up and down and all around your signifying, then the game is thrown asunder, and we've created a new playing field, perhaps one without winners and losers. Or at least one that destabilizes your game, gives me a fighting chance, and asserts my humanity. In the meantime, I'm making culture.

Black-white differences of meaning come simultaneously exposed in sharp relief and wrapped in beclouded mists: "The most poignant level of black-white differences is that of meaning, of 'signification' in the most literal sense. The play of doubles here occurs precisely on the axes, on the threshold or at Esu's crossroads, where black and white semantic fields collide. We can imagine the relationship of these two discursive universes Parallel universes, then, is an inappropriate metaphor; *perpendicular* universes is perhaps a more accurate visual description."[103] And evokes crossroads.

And thus we approach this deliberately and deliciously ambiguous playground, signifyin(g) as a way of dancing on the boundaries:

- between the realm of the gods and our human world, in the way that Papa LaBas limps with legs of different lengths.
- between being an "untainted African" enslaved, and an articulate African American versed in Western European traditions.
- between kidding and seriousness in a signifier's oratory.
- between male and female.
- between the written and the oral as rhetorical strategies.
- between Standard English and Black vernacular.
- between the dictionary definition of the word and an invented new meaning.
- between intent to inform and intent to persuade.
- between Western and African modes of music, as in jazz.
- between politics and art, as an artful way to practice politics or a political way to make art.

CHAPTER SIX

FOR YOUR PLEASURE

The trickster . . . opposes the gods and mocks the shamans. In seeking this mastery of the world and the creation of a secular sacredness, the trickster often fails. In his failures he becomes a joke, yet in laughing at him men are set free, for "they are laughing at themselves. He endures their ridicule like a suffering savior, and in the end he saves them, through their laughter."

—Robert D. Pelton[104]

I used to live in a room full of mirrors,
All I could see was me.
Well, I take my spirit and I crash my mirrors,
Now the whole world is here for me to see,
I said the whole world is here for me to see.

Jimi Hendrix[105]

Where in the African American experience does Trickster show up and work magic? The Afro-Atlantic is defined by the most violent and painful of boundaries, slavery. Boundaries and tricksters who dance on them predate slavery. But slavery's outsized insult and brutality imparts a ubiquitous and self-evident boundary, a universe of opportunity for the Trickster spirit to dance.

It would seem that the battle for equality is so grave, so imbued with anger, the suffering so extreme, that the Black voice—whether coming from Martin Luther King Jr., Malcolm X, Angela Davis, Michelle Alexander or W.E.B. Du Bois, Patrisse Cullors or Booker T. Washington, Stacey Abrams or Jesse Jackson—is a serious voice, without signifyin(g) humor, and generally searing in its analysis and evisceration of the institutions of white supremacy—heartfelt, direct, and defiant in its calls to action.

The same might be said of Black literature, where authors struggled for acceptance, acknowledgement, and audience. Highbrow pretensions in the literary establishment, lack of representation in the publishing industry, and low literacy rates amongst the Black populations made Black authors' task of finding their audience all the more difficult.

But in American comedy, oral tradition found a medium where the comic delights in elastic meanings that make artful, enlightening, and funny connections. Comedy trades in the boundary-dancing contradictions that help folks laugh through their hardships. Comedy can convey political realities sharpened by the ambiguities and double meanings of trickster signifyin(g). Just as slapstick made humor dance on the boundary between uprightness and the pratfall and cartoons exaggerated slapstick into supernatural realms, Black humor used race relations—or the lack of them—as the foil for comic prancing.

COMEDY, LITERATURE, FILM, AND THE TRICKSTER

In Spike Lee's *The Original Kings of Comedy*,[106] four comedians who are at the top of their game and popular with Black audiences—Bernie Mac, Cedric the Entertainer, D.L. Hughley, and Steve Harvey—share their year 2000 routines. Race and African American culture are pervasive themes, are ninety-nine percent of the axis around which their jokes revolve. And consistently, unsurprisingly, with a frankness initiated by Redd Foxx, Dick Gregory and Godfrey Cambridge and carried on by Richard Pryor and later Eddie Murphy, Chris Rock, and the Wayans brothers, these comics harp on the differences between Black and white culture. The way white folks do things compared to the way Blacks do.

D.L. Hughley, on getting fired from a job, says, "How come you didn't call me at home? You knew I was fired yesterday. Making me burn up all my god*** gas." Or quitting a job: "I'm announcing it right now, giving two minutes notice"—as opposed to white people who give two weeks' notice. Or Cedric the Entertainer on why we could never have a Black president: "We got Clinton, that's close. . . . We can't handle no Black president. 'Cause, you know, what's the deficit, like six trillion dollars or something, you know? You know Black people, we don't deal with debt like that. That'd be too much pressure for a Black president. Six trillion dollars, man. He'd be sittin' in the White House . . . Hey, dawg. I ain't got it." Or driving a car: "Y'all know the only time we turn our music down is when we gotta parallel park. That's the only time we gotta concentrate." Or that, in the streets, if there is any sign of trouble, white folks walk right into it; "Blacks start running and find out what it was they was running about later."

Or having someone take your reserved seat at a concert. If a white person is late to a show, they hope that no one took their seats and that there won't be trouble. If a Black person is late and a white person takes their seat, they could have the thrill of a power reversal and eject the interlopers. Richard Pryor and Cedric the Entertainer both riffed on this in their routines.

In all these cases, the perspective is the same. They lampoon the somber institutions that white folks, or the dominant not-play society, hold sacred and expect others to take seriously—work, career, respect for customs like reserved seats, "responsible" handling of debt or driving habits. That's the game that a rebellious and trickster-esque Black culture won't play, choosing instead to signify upon it.

These jokes, this sensibility, is not solely a function of being oppressed or being poor, though these are critical factors. But consider that just as Puritanism penetrates the ethics, behaviors, and attitudes of American white folks, the African ethos survived the Middle Passage and slavery, despite efforts to extinguish it,[li] and created culture anew, embraced the playful Trickster spirit of Eshù Elégba, and absorbed Eshù's celebratory qualities, passing them on

li Thompson and Gates are just two of the many scholars who make this case. Robert Farris Thompson, *Flash of the Spirit: African and Afro-American Art & Philosophy* (New York: Vintage, 1983). Henry Louis Gates Jr., *The Signifying Monkey: A Theory of African American Literary Criticism* (Oxford: Oxford University Press, 1988).

from generation to generation. As surely as white Protestant ascetics revel in the European traditions of pursuing their calling, showing up on time, working hard, not wasting time, might not Black people have just as crucial a connection to a Trickster spirit of being playful and having a good time? If Trickster occurs in all cultures, this contrast exemplifies one culture that suppresses and demonizes tricksters and another that celebrates them.

And isn't comedy a sweet spot from which these differences can assert, celebrate, and, subtle or not, illuminate the regions of cultural justice and equality that go beyond the letter of the law? In this way, the savior aspect of the Trickster archetype is called upon to suggest a better way for us to get along. And from the perspective of playfulness, the dance of the comedian allows us to appreciate the differences between cultures without ranking them, because in a world that plays, we know that we are not different from one another.

In this refreshing air, I should like to suggest that one of the most precious and powerful gifts from many African cultures has been the retention of our innate capacity for play, at all ages. And that gift has informed New World cultures that sustain play. Black culture thus verges on making its ultimate contribution to the larger American culture. With full acceptance, equality, and justice will come a reorientation that is more honoring of play. May comedy herald this new age! This is the triumph of Eshù Elégba.

* * * * * * * * * *

Film at first magnified prejudice but was later able to play a liberating role. Film was accessible but for decades would portray stereotypes as defined by white Hollywood.

In *Da 5 Bloods* (2020), an elegy for the Black Vietnam vet, Spike Lee gleefully appropriates Hollywood's storytelling tropes, from the death-delivering helicopters of *Apocalypse Now* (1979) to *The Treasure of the Sierra Madre* (1948), a tale of gold treasure and greed as old as the hills.

Lee puts Hollywood's best devices to use and recontextualizes them into Black history, from slavery to Muhammad Ali's opening retort of "No Viet Cong ever called me n*****." This adherence to traditional filmmaking makes

it easier for the audience to follow Lee into a heart of darkness different from *Apocalypse Now*. And then boom, in this supposedly serious narrative, Eshù Elégba makes a critical cameo appearance that endows the entire drama with an air of the magical, with cosmic pranks in the midst of pain and loss, with mockery of greed.

The five Black Vietnam vets return to 'Nam to recover a treasure of gold bars they'd discovered during the war and hidden. After encounters with land mines, thieving interlopers, gunfire, and betrayal, Paul, the most guilt-ridden and post-traumatic of the vets, takes his booty, leaves his brothers, and heads back alone. After a nasty snake bite, he trips and stumbles and loses his backpack to a high tree branch. The pack contains his share of the gold bars. He lays on the ground, looks up at the lost treasure, considers all the effort—years of secrecy and planning, thousands of dollars, numerous lethal risks—now gone to waste, laughs at his own fate, cries out, "God, you're a trickster! O God. You're a trickster!"

Indeterminacy flags the neither-good-nor-evil trickster character. And though an entirely serious person, Jean Toomer wrote the most playful and experimental novel of the Harlem Renaissance, *Cane* (1923). But instead of leading the movement of Black literature, he renounced his race, or as he put it, "There are seven race bloods within this body of mine. French, Dutch, Welsh, Negro, German, Jewish, and Indian. . . . One half of my family is definitely colored. For my own part I have lived equally amid the two groups. And I alone, as far as I know, have striven for a spiritual fusion analogous to the fact of racial intermingling. . . . Viewed from the world of race distinctions, I take the color of whatever group I at the time am sojourning in."[107] To transcend racial lines is the kind of spiritual pursuit one expects of a trickster, and in so attempting, Toomer dances on the boundaries between races, and the boundary surrounding the Harlem Renaissance, which hurled him into obscurity for decades, until his rediscovery in the sixties.

But Black literature as a whole is deserving of a deeper analysis than this overview. Many of its luminaries, these important voices, cannot go unmentioned. Even with the Signifying Monkey tale as its basis, rising into notice, respect, and active dialogue with their audience has been a challenge

for Black authors. Their story is well told by Gates in *The Signifying Monkey*, and in other sources. Suffice it to say that music, comedy, dance, film, and literature all forge different pathways and gain different levels of access and leverage for African American culture makers, and literature has presented unique challenges.

MUSIC AND LITERATURE: FANFARE FOR THE DEMIGOD

Music is the most accessible art form; some would say the most magical. Is music mythic ephemera, or is it substance? Bandleader and icon Sun Ra answers yes to the question of whether music can be a means of interstellar transport, transcending those categories.

There is perhaps no greater testament to the power of music, and of West African music in particular, than the rhythms, timbres, and melodies that survived the Middle Passage and became the driving force for Afro-Atlantic (American, Caribbean, and Brazilian) music. American music mingles the folk, popular, and art music of Europe, Africa, and the Americas. We should never deny the multiple influences in music, nor should we deny Black/African music as a global force, and as the main driver of American genres.

Jazz, an African American tradition, is considered America's premier original art form. There are many talented American non-Black jazz musicians, composers, and songwriters, but the foundations, innovations, influences, and demographics of American music are decidedly mostly Black. From Congo Square in New Orleans to the Delta, from the northern migrations to Memphis, Chicago, Kansas City, New York, Philadelphia, and eventually Los Angeles and San Francisco—in blues, jazz, R & B, rock and roll, soul, hip-hop, Black is king. Writer, musician, and producer Greg Tate goes as far as to say that "It is our music, especially jazz, which confronts Western culture with its most intimidating and improbable Other: the sui generis black genius."[108]

West African culture had already adapted and integrated Arab and Islamic culture, dating to the eighth century.[109] But its life in the New World is another matter. In antebellum America, music of the oppressed served as a reminder of a distant home, a lost freedom, a lifeline of relief from the agony of slavery, agony that magnified music's redemptive power. Because of the deliberate

breaking up of tribes by slaveholders, because of no notation, verification of West African influence is almost impossible to come by. But we get a glimpse through the recordings in *Roots of Black Music in America* (1972),[110] an anthology assembled by musicologist Sam Charters, and in the field recordings of Alan Lomax, Chris Strachwitz and other ethnomusicologists.

Listen to the music: the Ewe tribe in Ghana; a New York street band, whose music is flavored with the sounds of New Orleans, Puerto Rico, indigenous America, and the West Indies; the Wolof tribe from Gambia and Senegal; and the highly isolated Andros Island in the Bahamas, to name but a few. The correspondences between these and the thirty-seven other selections just in the Charters anthology alone—a sliver from a vast catalog—unmistakably connect West African music to that of the Afro-Atlantic. That influence is more than evident; it defines New World music, from prison hollers to hip-hop.

Music's intrinsic elasticity meant that Black artists could integrate European-influenced folk and popular music and define American music with less contorting or constraining to fit European formal structures. Literature's rules had much less give. In their profile of Langston Hughes, the most prolific Black writer from 1926-1967, Henry Louis Gates and Cornel West write that "He knew where the real basis of his creativity lay. He returned constantly to the life-affirming folk tradition of the black masses: 'After all the deceptions and disappointments, there was always the undertow of black music with its rhythms that never betray you, its strength like the beat of the human heart.'" Gates and West continue, "Hughes' genius lay in expressing black consciousness, interpreting to the people the beauty within themselves, and in raising the racial folk form to literary art. He used the incredibly creative poetry of black language, blues, and jazz to construct an Afro-American aesthetic that rarely has been surpassed."[111]

In Gates's *Signifying Monkey*, much of his argument is devoted to the story of how, in the field of literature, the freed slave from Africa had to prove first his humanity; second, his intelligence; third, his ability to learn the European skill set and traditions of literature; fourth, his ability to write and publish and to tell a story that could not be easily dismissed as imitative and lacking gener-

ative creativity. And even then, he was set aside, commented upon, and viewed from a perch of superiority by the white establishment. Black writers, male and female, were confined to a seemingly endless effort to prove themselves as writers worthy of membership in literature's ivory tower. This lineage began with authors from the eighteenth century like Ukawsaw Gronniosaw (1705-1775)[lii] and continued on as the respected and acknowledged works of Zora Neale Hurston, Frederick Douglass, then Richard Wright and Ralph Ellison, James Baldwin, Alice Walker, bell hooks, Octavia Butler, Maya Angelou, and many others. They created and debated various stances of the Black writer in America. This consuming struggle eclipsed the presentation of the trickster in Black literature, for when confronting the suffering and oppression of slavery and the ongoing insult and injury of Jim Crow, the African American spoke directly and with raw truth. Humor and trickster were evident, but not prominent. There is neither trick nor humor, misdirection, or indeterminacy to be found in the pain of oppression and the demand for justice.

Music was different. Here the Black artists' ability to master genres, to invent new ones, to immediately show plentiful talent, creativity, and appeal would define Afro-Atlantic music. And you can dance to it.

In music, Blacks were not seeking acceptance at the gates of a white art form. No, in this case, they could find audiences on the nearest street corner. Their threat was not a haughty literary establishment, more a parasitic music industry. The Black artists struggled to protect their musical treasure from white theft of authorship, recordings, copyrights, royalties, fair compensation, and full recognition. But their mastery, from Delta blues to Duke Ellington, was never in question. And in an enslaved society that prohibited literacy, music could find its audience with less interference from the state or the enslaver.

This entire chapter voices a debt owed to Black artistry, humanity, spirituality, and fellowship. To wit, Jeff Tweedy of the alternative rock band Wilco strikes a repentant note: "The modern music industry is built almost entirely on Black art. The wealth that rightfully belonged to Black artists was stolen outright and to this day continues to grow outside their communities. No one

lii Also known as James Albert, Gronniosaw was an enslaved man and is considered the first published African in Britain.

artist could come close to paying the debt owed to the Black originators of our modern music and their children and grandchildren. As an individual I have recognized the unfairness of the life I live in relation to the deprivation of people whose work mine is but a shadow of. I've tried to compensate for those inequities in both my public and private life."[112]

SPORTS: EVENTUALLY

In American professional sports, the barriers to Black athletes were even more rigid than those of literature. But when those barriers broke, there was no stopping the achievements of Black athletes, in whatever sport they were allowed to join. On April 15, 1947, Jackie Robinson broke baseball's color line, starting at first base for the Brooklyn Dodgers. But there was a spiritual ceiling as well, the ceiling imposed by the game itself.

What happens when playful persons, those who play to keep on playing instead of playing to win, find themselves on an international stage of competitive sports, where winning is everything? To compete fiercely and win, yet also rise above the game, to transcend it. To beat your competitors and then to beat the game itself takes us into the realm of Trickster spirit, Trickster magic, Trickster vision of the divine. Eshù's spirit releases an energy beyond the game.

MUHAMMAD ALI

In a prophetic nod to a core trickster trait—the fart—young Muhammad Ali née Cassius Clay was nicknamed Gaseous Cassius. With speed, grace, strategy, and intelligence, Ali became the greatest boxer of all time. Three times he won the heavyweight title. Consistent with the paradox of tricksterism, he brought beauty to that most primal and brutal, some would say ugly, sport. But he was more than just an athlete. Sports Illustrated's Richard Hoffer makes it clear: "His legacy as a global personality owes more to that glint in his eye, to his capacity for tomfoolery, to his playfulness. He was a born prankster, giddy in his eagerness to surprise, and the world won't soon forget his insistence upon fun."[113]

Our psyches are comprised of blends of the different archetypes. The Hero is oft conflated with the Warrior, but they differ. Some, like basket-

ball great Michael Jordan, are more warrior, not necessarily hero. For some others, the hero predominates, and the warrior must be subdued. Jackie Robinson had to rise to great heights of heroism. His achievement required athletic greatness, sure, but also a strength of character and willingness to suffer racist attacks in order to survive as the first Black man to play on a Major League Baseball team. And we're also witness to baseball players white and Black and brown, who personify both hero and warrior, like Roberto Clemente, Ted Williams, Willie Mays, Bob Gibson, Satchel Paige and Lou Gehrig. The rarity that is Muhammad Ali combines strains of the Warrior, the Hero, *and* the Trickster.

Ali accomplished the daunting feat of taking on power with unapologetic bravado and Black pride. He embodied not just athletic excellence, not just a defiant political stance, but also great humor. Dramatically unlike the racist Stepin Fetchit caricature framed by popular culture, Hollywood, and white authors, Ali created a new and liberated angle on humor and Black pride. His jokes did not self-deprecate or diminish the seriousness of racism in America or the wrongness of the Vietnam War. With rhyme and comedy that just plain made sense, Ali signified all over Uncle Sam, and for that matter, on every white supremacist who doubted his supremacy in the ring.

Ali competed in the most serious and dangerous of sports arenas. The more fraught the situation, the more playful his antics. His unmatchable wit, his ability to dance, to float like a butterfly and sting like a bee, created something never before witnessed. He fed the public's imagination and sprouted trickster glory as he won one championship after another and created the phenomenon of the media star. His trickster greatness was not only demonstrated in the ring but in his ability to make the media itself his plaything. Norman Mailer sized Ali up like this: "Being a black heavyweight champion [in a period marked by decolonization, antiwar movements, and revolt] was not unlike being Jack Johnson, Malcolm X, and [gangster] Frank Costello all in one."[114]

Like quicksilver, tricksters make sudden changes in direction. Soon after Ali won the championship, defeating Sonny Liston, he confounded white

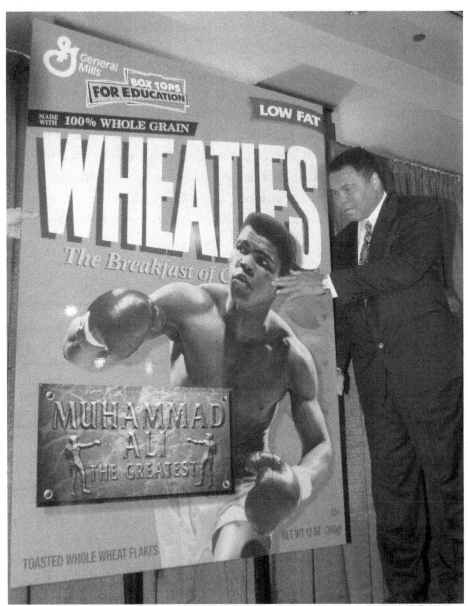

Three-time heavyweight boxing champion Muhammad Ali poses with an enlarged copy of a Wheaties cereal box adorned with his photo. New York, February 4, 1999.

America's starmaking machinery by converting to Islam.[liii] The politics of his conversion overtook the sports narrative, and one of the two major boxing

liii Not to infer that he was deliberately playing a trick. Ali took his conversion and his new identity as a Muslim seriously.

associations immediately stripped him of his title. The Islamophobic punishment continued. In prelude to his full exile, Ali was banned from the US and had to fight matches in Canada and Europe.

Before a scheduled fight in 1966, he became the most famous of draft resisters, refusing induction after the draft board reclassified him as eligible. He recalls that moment on camera a decade later, and the footage sets the tone for *Da 5 Bloods:* "My conscience won't let me go shoot my brother, or some darker people, or some poor, hungry people in the mud, for big, powerful America. And shoot them for what? They [the Viet Cong] never called me n*****. They never lynched me. They didn't put no dogs on me. They didn't rob me of my nationality."[115]

Converting to Islam while one of the most famous people in a fearful and bigoted America. Serious. Refusing induction into the armed forces. Serious. Being convicted for that refusal of conscience. Serious. Losing his title and being barred from boxing during what would have been the prime of his career (three and a half years the world was deprived of his talents). Serious. And Ali went through a very public divorce. Serious, serious stuff.

The triumph of Eshù Elégba, the triumph of Muhammad Ali, was to confront these most serious of events all the time knowing that the powers that rained down punishing blows were not to be taken seriously—he could take a punch—and time has proven him and the resilience of his Trickster spirit to be bigger than power.

Tricksters are antiwar. War, the most reprehensible spilling of blood and expenditure of power, is an opposite of fun. Fun is bigger than war and the main thing to which tricksters are loyal. Muhammad Ali knew how to have fun. Through the very serious dramas of heavyweight boxing, religious conversion, draft resistance and subsequent arrest and conviction, Ali never lost his sense of humor.[liv] Most quotable, Ali exercised the trickster privilege of speaking truth to power, even making fun of his own career, calling himself the greatest when he had yet to establish that fact. He showed his willingness to call the game and walk away from it for the sake of the larger

liv This primacy of trickster fun over persecution is a not-so-subtle quality of Ali's personality that Will Smith can't quite capture and is lost on director Michael Mann in the biopic *Ali* (Columbia Pictures, 2001).

issues of war in Vietnam and persecution of people of color. After beating big, bad Sonny Liston, perhaps the only greater opponent was the US government itself.

The confidence which infused his humor rubbed his critics the wrong way, but he was playing with them, playing *with* the games of professional sports and celebrity, and often using his mouth to signify on his opponents. Some of his best lines[116] would seem to come straight out of the Signifying Monkey tale. In the run-up to his first title match against Sonny Liston in 1964, whom he called "the Bear," Ali delivered what some consider the greatest trash-talk line of all time: "Liston even smells like a bear. After I beat him, I'm going to donate him to the zoo."[117] Here's more of that signifyin(g), much of it boasts:

- I'm young; I'm handsome; I'm fast. I'm pretty and can't possibly be beat. They must fall in the round I call.[118]
- It's hard to be humble when you're as great as I am.
- If you even dream of beating me, you'd better wake up and apologize.
- Braggin' is when a person says something and can't do it. I do what I say.
- I am the greatest, I said that even before I knew I was.
- I should be a postage stamp. That's the only way I'll ever get licked.
- I shook up the world. Me! Whee!
- At home I am a nice guy: but I don't want the world to know. Humble people, I've found, don't get very far.
- If they can make penicillin out of moldy bread, they can sure make something out of you.
- He's [Sonny Liston] too ugly to be the world champ. The world champ should be pretty like me!
- I am the astronaut of boxing. Joe Louis and Dempsey were just jet pilots. I'm in a world of my own.
- I've wrestled with alligators, I've tussled with a whale. I done handcuffed lightning and thrown thunder in jail. Only last week, I mur-

dered a rock, injured a stone, hospitalized a brick. I'm so mean I make medicine sick.

- It's not bragging if you can back it up.
- I'm not the greatest, I'm the double greatest.
- It's just a job. Grass grows, birds fly, waves pound the sand. I beat people up.
- Hating people because of their color is wrong. And it doesn't matter which color does the hating. It's just plain wrong.
- Live everyday as if it were your last because someday, you're going to be right.

And finally, Ali's belief in unlimited achievement lifts the tent flap on utopic possibilities:

- They're all afraid of me because I speak the truth that can set men free.
- Impossible is just a big word thrown around by small men who find it easier to live in the world they've been given than to explore the power that they have to change it. Impossible is not a fact. It's an opinion. Impossible is not a declaration. It's a dare. Impossible is potential. Impossible is temporary. Impossible is nothing.

Ali's verbal trickery brought signifyin(g) to its largest stage yet. He was the most famous person in the world. He both crossed and transcended boundaries, taking social issues seriously yet keeping his sense of humor throughout. When he defended himself against his critics, he did it in the name of fun. In a twist and a trick on his own citizenship, Ali defined himself not as an African American, but as an African. Indeed, he was a Pan-African hero with great love for the continent, a love they returned.

One could conjure a modern folktale, where Ali is the reemergence of Eshù Elégba in the New World. Drew "Bundini" Brown, Ali's hype man, did the signifyin(g) along with Ali, at his side rhymin' and signifyin(g) like the Signifying Monkey. In a press conference, Bundini even referred to Joe Frazier as a "Geechee."[119]

Geechee refers to the Gullah, a group of African Americans semi-isolated in the Lowcountry of South Carolina and Georgia. The Gullah are known for preserving more of their African linguistic and cultural heritage than any other African American community in the United States.[120] The heavy juju[lv]—the term "juju" can be used to refer to magical properties dealing with good luck—was always going down.

So in savior mode, Ali inhabits Eshù Elégba and makes his triumphant return to Mother Africa in the "Rumble in the Jungle," a championship match in Zaire (now the Democratic Republic of Congo). At that match, Ali/Eshù unveils his newest trick, the one that will carry him through the final stages of his fighting career. And that exile kind of ends with a punch line. Past his physical prime and no longer able to command the swift footwork that elevated him above his competition, he tricked the game with the "rope-a-dope" strategy of playing defense, taking his opponents' punches until he wears them out and then attacking in the late rounds. This is how George Foreman went down and the hopes and aspirations of millions of Africans were raised up.

He raised millions of dollars, too, and made numerous goodwill visits throughout Africa, notably Cote d'Ivoire, Ghana, South Africa, Nigeria, Kenya and Egypt.[121] Ali's popularity and adoration in Africa compares best with the scale of Elvis Presley's or The Beatles' in America.

Tricksters in the sports world don't just play the game, they play around *with* the game. In Ali's case, he rose above heavyweight fighting throughout his career, but in this late-career event, reported as an embarrassment at the time, he performed Trickster magic. On June 26, 1976, Ali participated in an unscripted exhibition bout in Tokyo against Japanese professional wrestler and martial artist Antonio Inoki. After Ali's death, the *New York Times* declared it his least memorable fight,[122] and boxing commentators demeaned it. Yet today it is considered by some to be one of Ali's most influential acts as it fore-

lv From Wikipedia: "Juju or ju-ju (French: *joujou*, lit. 'plaything') is a spiritual belief system incorporating objects, such as amulets, and spells used in religious practice in West Africa especially the people of Nigeria and Cameroon. The term has been applied to traditional African religions. In a general sense the term 'juju' can be used to refer to magical properties dealing with good luck." Wikipedia, s.v. "Juju," accessed June 30, 2020, https://en.wikipedia.org/wiki/Juju.

told the arrival of the very popular mixed martial arts. The match has become legend among MMA fighters.

DENNIS RODMAN

When it comes to immodesty, competitive juice, and confidence in one's own athletic abilities, Ali's got nothing over the former star player for the NBA's Detroit Pistons and Chicago Bulls,[lvi] Dennis Rodman. With Rodman on the team, Detroit won two championships. During his 1995-1998 run with that legendary Chicago team, they won the championship every year. "You know, you got the great Michael Jordan, the great Scottie Pippen, the great Phil Jackson, but if you take me away from this team, do they still win a championship? I don't think so."[123] This signifyin(g) boast is supported by facts. A deep analysis of Rodman's statistics proves him to be the greatest rebounder and one of the greatest defensive players of all time and, based on those stats, more valuable to his team than even Michael Jordan.[124] Jordan has six rings. Rodman has five. But the reason Rodman's teams always win a lot of games is because his defensive strategy is to attack. Not the basket where his team scores, but the opponent's basket, to make it impossible for them to score. So the warrior force is strong in him too.

The Weasel of Zulu folklore, the Coyote of Native American, the Bunny of the Brothers (Warner, that is), all these Tricksters have at least one plaything in common: tunnels. Dennis Rodman tells a story from his childhood of very carefully walking five miles through a Dallas sewage tunnel so that he and his friends could sneak into the state fair. Right out of folklore and into cartoon hilarity, they of course remove the manhole cover and emerge from their stinky five-mile trek right in the middle of the fairgrounds. From the time he was fourteen, he would repeat the journey every year until college. Why go through that? In Rodman's own words, "It was d*** fun."[125] And tunnel is the imagery he uses to describe his entire life journey. "I walked through a lot of tunnels . . . In a lot of ways I'm still that same little kid, crawling through that tunnel on my way to the state fair."

lvi He also played briefly for the Los Angeles Lakers, San Antonio Spurs, and Dallas Mavericks.

Transgressive for the sake of transgression might describe any number of trickster types, but such boundary-crossing seems particularly apt when it comes to Rodman. Trickster "happens" to people who are able to retain a good dose of childlikeness.

One of the main highways by which a person reaches out to the Trickster god Eshù is through that pre-moral child state. *Sports Illustrated* writer Michael Silver put it this way: "Dealing with Dennis is like dealing with your best friend when you're 10 years old. There's nobody better. You love that guy. It's beautiful. But sometimes when you need to have an emotionally developed interaction or a logistically important interaction, it's like, *I'm dealing with my best friend when I'm 10*." Silver further writes:

> Rodman emerges wearing a shiny tank top, metallic hot pants and a rhinestone dog collar, his guests ooh, aah and gawk in amusement. "Dennis is in one of his transvestite moods," says Rodman's friend Amy Frederick, rolling her eyes. Were it not Rodman, a man who dreams of playing his last NBA game au naturel, this behavior might be a bit shocking.[126]

And in an article by Chris Ballard, Rodman's friend Dwight Manley says: "It's the classic case of a boy who grew up without a strong male role model. He is learning manhood on his own, and he's learning it with no one to tell him no. He can get away with anything. No one stops him. When you're raised without boundaries, you have to find them for yourself."[127]

Silver concludes: "Rodman's eyes are glistening, but he is not laughing. I ask him if he thinks about dying young. 'Sometimes I say I'm going to play basketball and go-go-go until I drop dead,' he says. 'I'm not afraid of dying at all. It's just the next boundary.'"[128]

One can fault episodes of Rodman's career and public life, but he's earned his place in the pantheon of the greatest basketball players. His outrageous behavior and friendship with Kim Jong-un gets him snubbed. He did not get voted into the basketball Hall of Fame until his sixth year of eligibility. Though still left off many top-fifty lists, he was one of only six players to have played

on two of the top ten teams in NBA history, the 1988-89 Detroit Pistons and the 1995-96 Chicago Bulls. He was crucial to both teams' success.[129] Many consider him the greatest defensive player of all time. And according to the numbers, he is the greatest rebounder of all time. By a long shot. Ironically, the politics of sports is not playful, and playful trickster characters are not welcomed.

Like Ali, Rodman sought an identity beyond the game. Though he's misfired in the political arena, he's also played a liberating role. In 1995, he fashioned his haircut with an inset dye of an HIV/AIDS awareness ribbon.[130] This on a nationally televised playoff game in a time when homophobia was common among players.

The playfully titled article in the *New Yorker*, "Playing Dennis Rodman," describes his trickster traits well:

> About eccentric basketball star Dennis Rodman . . . Unclassifiable—"the most unique player in the history of the NBA," according to Chuck Daly, who coached Rodman's first pro team, the Detroit Pistons, to two consecutive NBA championships. . . . Not exactly a forward, guard or center, Rodman invented a role for himself which subverts the logic of traditional positions. His helter-skelter, full-court, full-time intensity blurs the line between defense and offense. He "scores" without scoring, keeping the ball in play until one of his teammates drops it through the hoop. . . . The battle for domination of the boards is a fascinating game within the game. Rodman's relentless, no-holds-barred, kamikaze pursuit of missed shots foregrounds rebounding and frees it from subordinate status. "The game's too easy," he says. . . . "'*tain't* basketball and '*tain't* rebounding. It's just '*tain't.*" Irreducible to anything else—a perpetual work in progress, compelling, outrageous, amoral. Rodman immerses himself in what he does, defines himself by it, stakes out new territory: percussive behavior so edgy it threatens to wreck the game that's supposed to contain itCross-dressing, cross-naming himself

(Denise), frequenting gay night clubs, going AWOL from his team, head-butting a referee, winning four rebounding titles in a row, painting his hair, dating Madonna, challenging the NBA commissioner to suspend him, bad-mouthing the men in suits who pay his salary . . . He dons the uniform, takes the paycheck, but doesn't exactly go to work. . . . The game we've taken for real disappears, and we're left to deal with the reality of Dennis Rodman in our faces.[131]

Rodman the rookie was described as a youth as much from rural Oklahoma (college) as the streets of Dallas (childhood in the Oak Cliff projects). Because of the playing style he'd developed, joining the rough-playing, bad boy Detroit Pistons of 1986 came naturally, like the sprouting of a seed that was in him all along. He was not going to throw away his shot. "We're like a hockey team, everybody wanna see us fight."[132] He more than fit; he burst into the Detroit team personality that wanted to spoil the wholesome PR fairytales painted around players like Magic Johnson, Larry Bird, and Michael Jordan. Rodman's personal psychology, no one's business but his, nonetheless manifested in wild partying, episodes of despondency, and unpredictable choices in fashion and sex. Traded from the Pistons in 1993 and dating Madonna in 1994, Rodman lived his fantasies and made his personal choices public—in hair color, clothing, sexuality—blasting off, becoming passionately self-directed, and dancing with his trickster self. Of course, he was a spark plug crucial to the Bulls' championships of 1996, '97, and '98. He's a student and a master of the game, but it was the game's connection to stardom that propelled him to outrageousness. "People don't understand, it's just not basketball that we have to deal with on this team. It's the pressure of the [bleeped bull****]. You know, I'll play the game for free, but you get paid for the [bleep] after you leave the floor. . . . This business can kiss my a**. I don't give a d*** what they think about me."[133] To make his point, he took a forty-eight-hour "vacation" in the middle of the season to let off some steam and party. No NBA player does that—yet he returns, and he competes hard. He is a warrior and a trickster and a rebel, maybe not

Dennis Rodman at his *I Should Be Dead By Now* book signing in Chicago, 2005.

a hero. In the language of Native Americans, for whom coach Phil Jackson and Rodman both have affinity, Rodman, according to Jackson, would be considered by the Ponca tribe in Oklahoma, a heyoka, a backward-walking person, a sacred clown.

Much is made of Rodman's relationship and brief romance with Madonna, and rightly so. Madonna was the marketing genius of the time, and she coached him on a sophisticated approach to marketing and branding. Just as importantly, Rodman's marketing posture was based on the cardinal trickster characteristic, rule breaking.

Rodman's transgressive tendencies have not served him as well since retiring from the NBA. Besides the scary friendship with an off-kilter, nuclear-armed dictator, Rodman has suffered from alcoholism, lost his fortune, become enmeshed in legal problems, and defaulted on child support. Hyper success can impose burdens the rest of us don't understand and that more fragile souls like Rodman's are not prepared to handle.

But jackpots are just that: a very lucky trifecta of the right mix of trickster personality traits, a talent that is recognized by whatever cultural moment that person lives in, and the ability to get away with crossing selected boundaries.

END ZONE DANCES

Calling American professional football a national religion is not much of a stretch. Within and without the game, it's rife with ritual and passionate belief. Tailgate parties are often more glorious than the game and saltier than the food in the stadium. As a $48 billion industry—not counting player, coach, and support staff salaries—clothing, hats, swag, souvenirs, faces, cars, houses, almost any product you can think of is a candidate for branding with the logo of an NFL team.[134] Coin flips, time-outs, quarterback signals, fan cheers, interview styles, and the like all have ritualistic flairs not found in the rule book. Church ministers defer to the football gods, shortening services so the congregation can get home in time to watch the game.

Are Black athletes disproportionately represented in the NFL? No doubt. Are they well-paid? They are. Are they at high risk of lifelong disability, in

particular those stemming from concussions? Yes. So are they, despite the riches and privileges, exploited? And is the game, therefore, ripe for rebellion and transgression? You bet.

A new ritual has evolved, the end zone celebratory dance. An African American cultural invention adopted by players Black, white, and brown, its genesis goes all the way back to 1965 when New York Giants end Homer Jones introduced the "spike." The spike, where the player throws the ball hard against the ground after scoring, started a wave of signifyin(g) rituals that grew more elaborate and personalized, until the NFL tried to suppress them in 2006 with a fifteen-yard penalty if the player crossed certain boundaries.

The first end zone dance in the NFL was performed on October 24, 1971, by Elmo Wright, a receiver for the Kansas City Chiefs. He'd been working on it since his junior year in college. As a star receiver, he'd spike the ball after a score, but the NCAA disallowed the spike, and Mr. Wright rechanneled his celebratory energy into a dance. After high-stepping to avoid a tackler, Wright would just continue to prance once he'd scored.

Dance squads assembled from among the players on the field to celebrate scores started with the 1983 Washington Redskins[lvii] football team, performing a group high-five. Team spirit! The first dance that showed a lot of premeditation and individual style could be attributed to Cincinnati Bengals 1988 rookie running back Ickey Woods, who performed the Ickey Shuffle. There was a lot of back and forth with the NFL folks who make the rules as to what could earn a fine and what was allowed. In other words, Homer Jones initiated a signifyin(g) dance that other players have continued, testing and breaking preset rules for over fifty years. The league could barely keep up; as they kept redrawing the boundaries, the players kept playing with them.

Of Black origin, the end zone celebration has been a source of irritation to sports announcers and, in a world of white team ownership, offers an oblique reflection of America's struggle with race. This fun-loving prankster side of the trickster has asserted a performance right by players, counter to the white establishment that controls and profits from the game. Players still maintain impossibly high standards of athletic play but add some signifyin(g) that goes

lvii Renamed the Washington Football Team in 2020.

beyond their contracts. Such celebrations engage a mass sense of fun, and one might speculate that they subconsciously revive tribal traditions that go across oceans and back centuries. And they function as a cultural stimulus that we all might find our own joyous victory dance.

Here are a few of the notable touchdown celebrations that the NFL—known then as the No Fun League—judged transgressive and earned fines and penalties:[lviii]

- Terrell Owens, a boasting signifier if there ever was one, celebrated by bringing out a Sharpie and autographing the ball he'd just scored with for the San Francisco 49ers. The NFL made a rule that you couldn't have a prop like that on your body. So New Orleans Saints wide receiver Joe Horn planted a cell phone in the padding on the goalpost. Upon scoring, he pulled it out and pretended to make a phone call.
- Owens created controversy again when after scoring he ran to the middle of the field—the Niners were in Dallas, hostile territory—and assumed a braggadocio pose. Like the Lion pouncing on the Signifying Monkey, a pissed-off Dallas Cowboy illegally tackled Owens.
- Antonio Brown, receiver for the Pittsburgh Steelers, returned a punt for a touchdown, leaped into and straddled the padded goalpost.
- Buffalo Bills wide receiver Stevie Johnson pantomimed a minuteman firing a musket, then he fell backwards, pretending to have been shot.
- Seattle Seahawks running back Marshawn Lynch jumped and grabbed his crotch as he crossed the goal line. Lynch was perhaps more notable for his laconic interview style, having fun with the media by not playing their game.
- Randy Moss of the Minnesota Vikings celebrated with a vulgar, yet trickster-esque pantomime known on social media as the "poopdown," i.e., pretending to pull down his pants and... In Super Bowl XLIX, Seattle Seahawks receiver Doug Baldwin did the same.

lviii Many of these players played for multiple teams beyond the ones cited. Examples are taken from a YouTube compilation, where seeing is believing. Savage Brick Sports, "The Best Celebrations in NFL Football History," posted November 14, 2017, YouTube video, https://www.youtube.com/watch?v=7LRsJu_mrsM.

Other touchdown celebrations that have been allowed:

- Dance moves: Detroit Lions wide receiver Johnnie Morton did the Worm; Baltimore/Cincinnati wide receiver Kelley Washington did the Squirrel; and San Francisco 49ers defensive back Merton Hanks, the Funky Chicken.
- Ezekiel Elliott, running back for the Dallas Cowboys, jumped into a giant-sized Salvation Army kettle. Yeah, it was a Christmas game.
- Wide receiver Victor Cruz of the New York Giants danced a mean Mambo.
- Fullback Mike Tolbert of the Carolina Panthers and Stevie Johnson, wide receiver for the Buffalo Bills, both danced Gangnam Style.
- Jacoby Jones (Baltimore Ravens), Travis Kelce (Kansas City Chiefs), Haywood Jeffries (Houston Oilers), Deion Sanders (multiple teams), Lance Moore (New Orleans Saints), Rob Gronkowski (New England Patriots), Zay Jones (Buffalo Bills) all displayed great moves too difficult or zany to describe.
- Chad Johnson, wide receiver for the Cincinnati Bengals, danced an Irish jig. Johnson also kneeled before a cheerleader and proposed to her after another score. Wearing number 85, at one point he legally changed his name to Chad Ochocinco. Among countless other prankish celebrations.

Chad Johnson and Antonio Brown have probably been fined more than any other players, and it was deliberate. Johnson budgeted for the fines, taking a stand for his trickster rights: "I play to have fun. I don't play for the dollar amount. Maybe that's why they [the NFL enforcers] take so much money, because they think we play for the money. Maybe they'll get the point. I play to have fun, not for the money. Come on, now. What are you going to suspend me for? Having fun?"

Some of the most intriguing are the team celebrations. Fun and play can be more than an individual's statement and collectively engaged:

- Minnesota Vikings reenact a game of leapfrog. Another time, a round of Duck Duck Goose.
- Atlanta Falcons celebrate with their signature dance, the Dirty Bird.
- Players on a few different teams cluster like a set of bowling pins for the scorer to knock down.
- Carolina Panthers bust a move, doing the Dab collectively and also in individual celebrations, leaning and nodding their heads into their forearms in rhythm.

More exciting celebrations can be found on YouTube under Sport Vines' "Best Football Touchdown Celebrations of All Times"[135] You can see back flips, gymnastics, and sexy dance moves that continue to evolve.

Players like Randy Moss, Chad Johnson, and Terrell Owens crossed enough boundaries to cause the NFL considerable heartburn and reactions that ranged from banning celebrations to drawing multiple lines in the sand as football culture and fan popularity (i.e., money) shifted and pushed more and more limits.

I highlight the National Football League because of its popularity in the US and its special relationship to the African American community. College football teams have gotten into the act as well.

In soccer, goal celebrations tend to follow every score. Soccer/football is a more multicultural, multiracial affair, so common archetypes might sing and dance and celebrate scores and victories, but discerning cultural associations with the celebrations may be more challenging. And hockey teams, populated by mostly white athletes, have gotten in on the act, as the Carolina Hurricanes perform the Storm Surge and spike the puck.

Returning to American football, these dances and short skits and outrageous antics became so popular that the NFL had to scale back the regulations in 2017 and then scale them back even further in 2019. That year, at the NFL Honors, emcee Steve Harvey announced "the best touchdown celebration of the year. Can you believe that? They're giving out an award for what y'all used to get fined for."[136]

This retreat has allowed the celebration, often as entertaining as the game itself, to flourish. And in 2020, the evolution from dastardly mischief to cel-

ebratory splendor continued. The NFL put up screens and cameras in the end zone for the players to perform their dances, to be viewed in real time and amplified for the TV audience. The Trickster cycle completes. The end zone celebratory dance, once discouraged, outlawed, and penalized, has become glorified and a part of the game's presentation, a triumph for Eshù Elégba.

Bringing the end zone dance officially into the rituals of the game follow the practice recommended by Lewis Hyde throughout *Trickster Makes This World:* Give trickster his moment. Suppressing Trickster will bring an eventual and often catastrophic release.[137] Tune in for further developments of Eshù Elégba's emergence on the sports scene.

AFROFUTURISM: FROM SUN RA TO WATCHMEN

Alondra Nelson explained Afrofuturism as a way of looking at the subject position of black people which covers themes of alienation and aspirations for a utopic future. The idea of "alien" or "other" is a theme often explored. . . . Afrofuturism involves reclaiming some type of agency over one's story, a story that has been told, throughout much of history, by official culture in the name of white power. It is for this reason that Dery says, "African-American culture is Afrofuturist at its heart."

—*Afrofuturism,* Wikipedia[138]

The whole intellectual landscape of the novel [Ralph Ellison's *Invisible Man*], which deals with the condition of being alien and alienated, speaks, in a sense, to the way in which being black in America is a science fiction experience.

—Greg Tate[139]

You still got a man, head of the Krew Kruk Klan *(sic)* sayin'
that the Black people have contributed as much to Western
civilization as the horse. So actually, since I don't consider
myself as one of the humans, I'm a spiritual being myself, I'm
sure I can contribute more than the horse. . . . I know I myself,
would never want to be God or even like God, because, God
got all these human beings on this planet, and I most certainly
wouldn't want to be responsible, or even have the disgrace
that I made them.

—Sun Ra[140]

O verwhelmed by a game that has been played all around the planet,
with Africa colonized and Africans enslaved by France, Great Britain,
Portugal, Italy, the United Kingdom, Germany, Belgium, the ancient
Greeks and Romans, and Americans—maybe a great majority of Black folks
rightfully feel that the world, within and without Africa, is against them, and
they have to get *off* the planet in order to be free. In the words of the band War,
"For you and for me, the world is a ghetto."[141] And in a trickster move of rever-
sal, Afrofuturism takes the concept of "other"—usually used in the context of
explaining racism, a phenomenon of harm and oppression—and, through the
invention of alien races and intergalactic travel, turns otherness into a fun cel-
ebration of liberation. Thus, Afrofuturism represents one of the more imagina-
tive approaches to signifyin(g), represents the utopic possibilities of multiple
worlds. Afrofuturism is about more than Eshù Elégba, but space is the place
that gives Eshù, gives that Trickster spirit room to move and to not be defined
only by opposition or by the experience of enslavement and oppression. Recall
the conception of signifyin(g) as not linear or parallel to whatever the dominant
game is, but as perpendicular: the rigged game is a line that circumvents the
planet. Afrofuturism launches perpendicularly into outer space.

Afrofuturism can be found in literature, film, and art; and in music, where
sound experimentation signifies off of tradition and employs outer space themes
in lyrics, song titles, sound, and performance. The term was coined in 1993 by
Mark Dery,[142] but its emergence dates to the 1950s. In 1954, Chicago harp great

Little Walter released "Blue Light," a pretty straightforward slow blues, until about two minutes in, when he starts using feedback and reverb and overblowing to otherworldly effect. Johnny "Guitar" Watson sluffed off his first moniker, Young John Watson, the name on the label of his single, *Space Guitar,* also from 1954. In this wild instrumental, Watson[lix] riffs on a traditional rhythm and blues background with what would later be dubbed psychedelic guitar effects. His 1957 *Gangster of Love*[143] (later covered by Steve Miller, Johnny Winter, and Sam the Sham) reads like a Signifying Monkey boast:

> Jesse James and Frank James
> Billy the Kid and all the rest
> Supposed to be some bad cats
> Out in the West.

> But when they dug me
> And my gangster ways
> They hung up their guns
> And made it to their graves.

> I robbed a local beauty contest
> For their first place winner
> They found her with me out in Hollywood
> Eating a big steak dinner.

> They tried to get her to go back
> To pick up her prize
> She stood up and told them
> "You just don't realize…

…that Watson was the original Gangster of Love.

We've observed how a personality can emphasize, in one way or another, different aspects of the Trickster archetype. Muhammad Ali demonstrated how

lix Frank Zappa was a fan and took especial note of Sun Ra's doo-wop songs.

a hero and a warrior can add great depth, complexity, and transcendent power when mixed in with trickster magic. How Dennis Rodman can glom on to the transgressive feature of the archetype, and that collectively NFL players can celebrate scoring in a way that is not playing the game but playing with the game. The most daunting challenge to the trickster, especially the ones who are not Jesus Christ, Krishna, or the Buddha, is to manifest that savior-like quality, which I translate to mean sharing a utopian vision with those whom you have chosen to serve. Which brings us to Sun Ra.

SUN RA

At the same time Young John Watson and Little Walter were taking their sig-nifyin(g) boasts into the lower stratosphere, the musician who shot farther into outer space and more deliberately founded and lived Afrofuturism was jazz great Sun Ra. Sun Ra, who made it clear to the world that "space is the syn-onym for a multi-dimension of different things other than what people might at present think it means. So I leave the word space open, like space is supposed to be, when I say space-music."[144]

Herman Poole "Sonny" Blount, who would become Sun Ra, was born in 1914, but according t0 him, he was not exactly born, but "These space men contacted me. They wanted me to go to outer space with them. They were looking for somebody who had that type of mind."[145] He met up with them while in college, and they transported him to Saturn, where he was taught things that would save Earth from doom.

This experience informed his spiritual philosophy, Thmei, based on exten-sive readings and writings and developed in partnership with Alton Abraham, whom he met in 1951. Named after the Egyptian dual goddess of truth and justice, Thmei Research was a society antidotal to dominant white narratives and intended specifically for the Black audiences of Chicago's South Side. Theosophical in its bent, Thmei's association with Egypt lent itself to Black pride. Egypt is an African culture not only more ancient than Greek democ-racy, Judeo-Christian tradition, and Islam but a culture with a government and an order that lasted five thousand years. Thmei's literature can get dense, but it offers at least three principles. Thmei presented a philosophical and spiritual

text that explicitly does not justify or allow the slavery and subjugation of Black people, or of any people.

The second principle distinguishes Thmei Research from the separatist and counterracist Nation of Islam, which was gaining in popularity at the same time. Though also a Black voice tuned for Black people, Thmei's Black nationalism, unlike the Nation of Islam, proposes and performs a post-racial future of truth, justice, and beauty for all humanity.

Thirdly, in the indeterminant mode of Eshù, Thmei made no claims of being right in their path, only that their path was different and better than its more doctrinaire fellows.

Thus we learn that Le Sony'r Ra (in 1952, he made this legal name change from Herman Blount)—through his extensive writings, his radical lifestyle, his adherence to Thmei's mythological and utopian vision, and his iconic personality—was about much more than his music. Yet it is the music we turn to as proof of his genius and the world he created, one congenial to Trickster spirit.

Though never recorded, he led a big band in Alabama for ten years. But from the early 1950s until 1982, Sun Ra and the various configurations of his big band released more record albums than just about anyone. Few of those

Sun Ra Returns to Saturn. Wood Construction by Steve Soklin. somekindofart.com

albums were insignificant. One could debate which of the first four albums—*Sound of Joy; Jazz by Sun Ra, Vol. 1* (also released as *Sun Song*); *Super-Sonic Jazz*; and *Jazz in Silhouette*—is the most wonderful. *Super-Sonic Jazz* and the USSR's Sputnik satellite both launched in 1957. Outer space was declared a real thing by President Eisenhower the following year when he made the first national address to be beamed from a satellite,[146] and various Cold War efforts were made by superpowers to explore and extend the thrust of missiles and rockets—for war, for exploration, for communication.

What if space were not only the realm for governments and corporations, but also for cultural movements? Sun Ra's space program, parallel in time but perpendicular in concept, matched those of the US and USSR. In that same year of the Sputnik launch, Sun Ra and his Arkestra changed emphasis from Thmei Research to a new culture, a new music, and most visibly, a new style of dress: space-age capes with images of ringed planets and suns, space-helmet-style headgear, moon boots, silver-lamé shirts. All of this with some element of Egyptian flavoring as well. As much an act of artistic distinction—a style of dress adopted whole cloth by George Clinton and Parliament-Funkadelic in the 1970s—Sun Ra declared it an act of creative resistance, of political agency through culture, of empowerment, that there are worlds Black people can explore as Black people and make their own.

In Sun Ra's program, the band, the musicians, the astronauts, the dancers, the music—together they comprise the spaceship—in Sun Ra's vernacular, the Arkestra—that propels us all into an outer space. As Paul Youngquist writes, "Artfully and on a plume of music, Sun Ra blasts Blackness into space."[147] These are wonderful concepts when taken in earnest and wonderful when seen as the antics of a West African Trickster god and a Signifying Monkey working through Sun Ra as their clairvoyant. Sun Ra rarely dropped his Saturnian persona, but he was hip and winked "A race without a sense of humor is in bad shape. A race needs clowns."[148]

Sun Ra demanded his bandmates meet high standards of "Precision, Orchestration, Discipline." That other jazz ensembles couldn't was grist for his signifyin(g) boasting and cutting. And though he had allegiance to and love for the Black people on the South Side of Chicago, he never agreed to

be a human being himself but identified instead as an angel—a nice trick and sideways funny boast he would regularly make. But trickster ain't no angel. Credit Sun Ra more for opening space for Trickster to roam and play than for embodying trickster traits. Like he said, he was an angel.

In March of 1956, the Sun Ra Arkestra recorded its first single of note, the ground-breaking "Super Blonde" (b/w "Soft Talk"), and they would continue to release singles into the 1980s. They put out more than thirty 45-rpm singles, signaling a singularly signifyin(g) phenomenon. Just this oeuvre of sixty tunes, all under four minutes, spans everything from classic doo-wop, Saturnian improvisations over Count Basie/Fletcher Henderson-styled big band arrangements, and rhythm and blues to the wacky "M Uck M Uck" sung by Yochanan (the Space Age Vocalist), novelty and holiday tunes, and otherworldly sounds. No musical artist before or since can match Sun Ra's idiosyncrasy or range. When you rehearse five hours a day year in and year out, diverse genres present boundaries easily crossed. Unique as their practice of self-producing, -cutting, and -selling their albums was—in the early days you had to go to their shows in order to buy a Sun Ra record—they forged the prototype for everything DIY in music since. And in a nod to trickster time travel, the Sun Ra Arkestra would release albums with songs for the future that had been recorded far in the past. For example, he moved to New York in 1961, but albums after that date frequently included recordings from Chicago's mid-fifties. By his own testimony, Sun Ra released music only when the world was ready for it. The trickster-esque time travel of his music is dizzying: different names for the ensemble, different players, different recording dates, all woven onto the same vinyl record, played then and released now.

The first three albums came out in 1957, but 1959's *Jazz in Silhouette* rightfully gets the most attention for its revolutionary hard-swinging bop band bounce and is mentioned along with Ornette Coleman's *The Shape of Jazz to Come*, John Coltrane's *Giant Steps*, Charles Mingus's *Mingus Ah Um*, Dave Brubeck's *Time Out*, Thelonious Monk's *The Thelonious Monk Orchestra at Town Hall*, and Miles Davis' *Kind of Blue* as one of the albums that made 1959 such a monumental year for jazz. It was also the year that the controversial documentary, *The Cry of Jazz*, was released.

Sun Ra played electric piano and synthesizer in a jazz setting before anyone else, and he is among the founders of electronica, his work being increasingly sampled nearly thirty years after his passing. But that musical innovation's not even the half of it. In even earlier recordings from the fifties, Sun Ra used reverb as an authoring rather than enhancing effect. Psychedelic. The most sober description of his music is given by "Alex" in the 1959 film from the South Side, *The Cry of Jazz*. Considered an early example of public art proclaiming Black pride and predicting the civil unrest that was yet to come, *The Cry of Jazz* features Sun Ra and the Arkestra and this description: "Sun Ra, among other things, fuses the snakelike bebop melodies with colors of Duke Ellington and the experimental changes of Thelonious Monk."[149] Veteran Arkestra saxophonist John Gilmore put it like this:

INTERVIEWER: Why has one of the most highly respected saxophone players in the country stayed so many years with Sun Ra?

GILMORE: Well, he was the first one to really introduce me into higher forms of music, you know, past what you might would say what Bird and Monk and the fellas was doing. I didn't think anybody was ahead of them, until I met Sun Ra, you know. And I played with him, on and off about six months. And I could read real well, I'd just come out of the army playing solo clarinet, so reading was no problem. Any of the music that he showed me, I could read it pretty well, but I didn't really understand it. I couldn't hear it, for about six months. Then one night . . . I heard it! [laughs] We were playing this number "Saturn." I'd been playing it for six months, every time we worked. But then I really heard the intervals this one night. And I said, "My gosh, this man is more stretched out than Monk. It's unbelievable that anybody could write any meaner intervals than Monk or Mingus, you know. But he does. His intervals, knowledge of intervals and harmony, very highly advanced, you know, so when I saw that, I said, 'Well, I think I'll make this the stop, you know.'"[lx]

lx *Sun Ra: A Joyful Noise*, directed by Robert Mugge (United States: MVD Visual, 1980), DVD. Gilmore (1931-1995) was an under-recognized jazz great, known to have influenced John Coltrane and many other jazz players since the fifties. Besides his talent,

And in Hal Willner's collection of various musicians' interpretations on Walt Disney themes, *Stay Awake*,[150] the Arkestra turns in a spectacular rendition of Disney's gloriously playful and silly "Pink Elephants on Parade," from the 1941 movie *Dumbo*. Sun Ra and the various configurations of the Arkestra (aka Myth Science Arkestra, Solar Arkestra, Astro Infinity Arkestra, etc.), as they moved from Chicago to New York and Philadelphia, would continue to explore and invite others to experience their relationship to infinity.

Sun Ra was an angel mainly, but at least two crucial attributes of the trickster are very strong with him. He deserves credit for inventing the communal household of hipster musicians—this was the foundation of his financial strategy for keeping a big band together—yet he was a solitary soul, as tricksters are, a loner yet a lover of the human race, with a deep and loving commitment to African Americans, in particular those living on Chicago's South Side.

Secondly, Sun Ra embodies Trickster's savior-like quality—Sun Ra's purpose was to spread love and hope and, even more so, to engage his audiences with a utopic vision. That purpose grounds his profile and motivates his significant contributions.

In the realm of the demigods, Tricksters from Raven to Loki to Eshù Elégba play a role in courses of humanity, are divine interpreters; amongst humans, it's rare for trickster types to overtly express hopes for utopia or attract a savior identity. But Sun Ra does, and he also plays the biggest trick of all, transcending the game of earthly politics by rejecting the oppressors of this planet and taking off on Rocket Number Nine.[lxi] Such an approach finesses and signifies on the conflict and struggle against racism, the fulcrum of Afrofuturism. And while that essential struggle for peace and justice on earth is so necessary, a science fiction fantasy of liberation by exodus into space can be taken at face value or employed as an alternative wellspring for creativity, for art. For art as political agency. In the next section, we learn how Sun Ra's trick comes full

he was known for his loyalty to Sun Ra and the mission of the Arkestra despite those who urged him to go out on his own.

lxi "Rocket Number Nine Take Off for Planet Venus," on Sun Ra and His Myth Science Arkestra, *Interstellar Low Ways*, Saturn, 1966. The song gets sampled, and the interstellar theme and use of number nine has been used by everyone from Jimi Hendrix and John Lennon/Yoko Ono to Lady Gaga and Janelle Monáe.

circle and gains a new narrative, a historic act of signifyin(g) nearly seventy years later in HBO's *Watchmen*.

Disruptive play is all about the trickster in politics and culture, but some readers may wonder why more political figures are not profiled and explained. Sun Ra answers this query, creating potent works in the field of culture-as-politics and offering hope, hope that music and art can transform the world. For folks like William Blake, John Milton, Langston Hughes, Cornel West, Maya Angelou, Allen Ginsberg, Jerry Garcia, and Sun Ra, really most great artists whose art has an element of good fun, pursuing such a belief, offering such utopic experiences, *is* politics. Sun Ra explained that "the real aim of this music is to coordinate the minds of peoples into an intelligent reach for a better world, and an intelligent approach to the living future. By peoples I mean all of the people of different nations who are living today."[151]

Early in his adulthood, Sun Ra was traumatized while in the care of the military, though he was a conscientious objector. This "inspired [Sun Ra] to approach music as a means of social as much as artistic expression. It brought a political edge to transforming the world, using sound as an agent of change. [Sun Ra said] 'Perhaps there is a force counter to the white one, a vitalizing power from above that might blind blank eyes and burn away difference. One whose rays might raise people above race.' A force to transform the space of segregation. . . . [I]n emphasizing creativity over antagonism, he makes culture the engine of social reform."[152]

Accepting capitalism and commerce as necessary evils, or at least necessary intermediaries, Sun Ra and his partner Alton Abraham signify on the economic system. In answer to the query "What are you selling?" Sun Ra's Black-owned record label El Saturn rejoinders with "Advertisements for Infinity." "All of my compositions are meant to depict happiness combined with beauty in a free manner. Happiness, as well as pleasure and beauty, has many degrees of existence; my aim is to express these degrees in sounds which can be understood by the entire world."[153] And to Sun Ra, record sales were incidental. He wanted to reach people to have them hear his music, but conventional marketing and promotion were anathema. Sun Ra was one of the first to adopt a do-it-yourself ethic that deliberately interfered with the mechanisms of com-

mercialism. His trailblazing made the small-label punk and indie movements possible, and bands as popular as the Grateful Dead and Pearl Jam would also break from their ornery relationships with record labels and the star-making machinery. Part of this DIY ethos, shared by Sun Ra and the Dead, Pearl Jam and Lord Buckley, was to give their art away. Once performed, it belonged to the world. Their prevailing interest was in a level of authenticity and room to move, a place to play.

Was Sun Ra a crackpot? Emphatically not. Youngquist writes, "Sun Ra deserves to be acknowledged for changing the history of jazz and arguably that of Black culture in general."[154] Even if one disregards his utopian philosophies and purposes, he founded Afrofuturism, and he built a successful career around some of the most outrageously fun, beautiful, idiosyncratic, genre-birthing ideas, musical and otherwise. Throughout his reign, over fifty different musicians played from the deck of the Arkestra, musicians of supreme talent and beauty. The Arkestra featured some of the greatest horn players in John Gilmore, Julian Priester, Marshall Allen, Pat Patrick, Farrell Sanders (to whom Sun Ra gave the nickname Pharoah—it stuck), most of whom also played percussion, which when added to drummers like Robert Barry, William Cochran, or Clifford Jarvis and bass players like Victor Sproles or Ronnie Boykins, created unique bass/drum settings as playful as they were nimble, adept, and expert. As is the music, as it was played, as it lives on through over two hundred albums.

Conservatively estimated, Sun Ra's bands worked more than fifty hours a week for well over forty years, and then beyond Sun Ra's death in 1993. They would often rehearse for over five hours and then play a five-hour gig. The Arkestra's move from New York to Philadelphia (gentrification pushed them out, and they got a good deal on a communally run home from Marshall Allen's dad) coincided with the departure of a number of key musicians. Loss of baritone sax player Pat Patrick and bassist Ronnie Boykins moved the sound into higher registers. At the same time, Sun Ra finally added a woman to the ensemble, the remarkable June Tyson. Tyson engaged the audiences and inspired the musicians with a sense of jazz and theater that expanded the reach of the band and established an Afrofuturistic vocal style, one shared with

Abbey Lincoln and Betty Carter.[lxii] Tyson's arrival signaled the extension of Sun Ra's vision to include audience participation, full embrace of space-age garb, and the addition of any number of dancers to the show, male and female, gender-varied and gender fluid.

* * * * * * * * *

Can the Afrofuturist torch, passed from Sun Ra to the likes of Jimi Hendrix; George Clinton & P-Funk; Earth Wind & Fire; Afrika Bambaataa; Dr. Octagon; Thundercat; Shabazz Palaces; and many others, sparkle any brighter and be any more salient than in Janelle Monáe's 2010 debut album, *The ArchAndroid?*[lxiii]

She is dressed in Afrofuturist garb, wearing an Egyptianized helmet molded in the shape of a space-age city. In the opening liner notes, we read her revision of the Sun Ra myth "1. That she, Janelle Monáe, is actually from the year 2719; 2. That she was snatched, genoraped and de-existed in that year— or in 21ˢᵗ Century parlance, she was kidnapped by some body snatchers after work one day, then she had her genetic code sold illegally to the highest bidder . . . and then . . . forced into a time tunnel and sent back to our era."[lxiv]

Musically, the album brings 70s soul, twenty-first-century R & B, electronica, Nuyorican, late-stage swing, and a mélange of Black genres into the Afrofuturist orbit. Monáe and Stevie Wonder have featured each other in live performances—she's signifyin(g) delightful love and appreciation, riffing off his song "Golden Lady" (from the album *Innervisions*) in "Locked Inside." Sun Ra recorded *The Nubians of Plutonia* in 1958 and 1959, where the Arkestra played an extended unearthly jam, "The Golden Lady." Are these connections conscious or just synchronicity? The main thing is, they happen. On "Mushrooms and Roses," Monáe even revisits one of Jimi Hendrix's most psychedelic outings, "1983 . . . (A Merman I Should Turn to Be)."[155] She plays

lxii The cover of Betty Carter's first album, *Out There with Betty Carter*, features a wild Afrofuturist image of Carter looking out the porthole of an all-metal Sputnik-style satellite as a US rocket ambles by.

lxiii And bless her heart for copping Sun Ra's lyrics, but we'll blow past Lady Gaga's "Venus." I think it's a nice homage, but no exemplar of Afrofuturism.

lxiv Time-travel tunnel=Trickster. Quote is from the liner notes on Janelle Monáe's album *The ArchAndroid*, Bad Boy Records, 2010.

notes and cops the feel from this majestic Afrofuturist tale of exodus to Atlantis, an escape from the ravages of this world. Hendrix sings "Not to die but to be reborn, Away from lands so battered and torn." In Monáe's concluding piece "BaBopByeYa," Monáe sings "I see beyond tomorrow, this life of strife and sorrow, my freedom calls and I must go," a direct homage to Sun Ra and Jimi in words and music. This is the perpendicular world of the Signifying Monkey, the escape from racism into outer space, or into Atlantis.

Or into terrestrial invisibility. The Marvel comic-turned-movie *Black Panther* puts CGI skin on Afrofuturism's bones, depicting the nation that abides in inner/outer space—on Earth but invisible—Wakanda. *Black Panther's* visuals and style paint a beautiful and stunning Afrofuturistic vision of a technologically advanced African society hidden in plain sight, symbolizing what racism blinds us from seeing—an apt Afrofuturist metaphor. The narrative hews more closely to Western conventions (good guy/bad guy and hero love affair tropes), and it lacks the complexity of Africa's cosmologies of gods and tricksters and creative behavior. But the Afrofuturist signatures of empowered Black people and strong female characters—especially Danai Gurira as the bodyguard and warrior Okoye, Lupita Nyong'o as rights activist and undercover spy Nakia, and Letitia Wright as engineering genius Shuri—are ably presented. *Black Panther* fulfills Sun Ra's mission, as it finds a way to share its tech and bring hope of peace and universal prosperity to the peoples of Earth.

There's Trickster magic in the nomenclature, history, and imagery of the Black Panther Party. When T'Challa takes his throne, the film signifies honor in striking similarity to the famous photo-portrait of an armed Huey P. Newton in full Black Panther Party regalia, sitting on an identically shaped rattan throne. This is deliberate and would have been considered subversive, but in 2018 the radical militancy of the Black Panther Party became acceptable in Hollywood, which made the connection to the Black Lives Matter movement. What had struck fear in white America to the point where J. Edgar Hoover's FBI assassinated, exiled, and imprisoned Panthers and other Black leaders of the sixties becomes a message of deliverance. Now it can be told: the Black Panther Party was driven by love for the Black community, and while Disney movies might frequently exalt a sanitized version of love, *Black Panther* tricks

the capitalist power of Marvel/Disney into performing an act of the kind of love that heretofore wouldn't have made the cut.

There's a trick of circumstance as well: the short life of *Black Panther's* star Chadwick Boseman. He comes to prominence portraying African American heroes like Jackie Robinson, Thurgood Marshall, and James Brown, becoming one of America's biggest movie stars. Then, after playing the African king T'Challa in *Black Panther* (as of September 2020, *Black Panther* had earned the fourth highest domestic gross of all time in the US)[156] and three of Marvel's other most popular films, he up and died, joining the gods and leaving the largest entertainment corporation, Disney, with a profound conundrum for its multibillion-dollar franchise to unknot. Some trick that.

Before he died, Boseman returned to the blues roots that made Sun Ra possible, playing the frustrated innovator Levee in the movie version of August Wilson's *Ma Rainey's Black Bottom.* His character represented the powerful artistic drive that pushed traditional blues into jazz frontiers and also the frustration born of the white record industry's theft of Black music.

Smack dab in the middle of the Afrofuturist era are the books and stories of author Octavia Butler. In a difficult and controversial act of signifyin(g), she riffs off of the sins of white men raping Black women, employing a science fiction literary device of interbreeding between extraterrestrial races (or vampires) and humans, generally in the interest of changing power relationships. She takes on the daunting task of finding ways for trickster playfulness to seep into the edifice of fragile human responses to racism and the morality strictures of science fiction. Yet she accomplishes just that in *Lilith's Brood, Kindred* (which also features time travel), and *Wild Seed* (book one of her Patternist series).

All facets of American culture are African, are European, indigenous, Latin, and Asian. But in music, Eshù Elégba is especially present. The roots of American popular music—Delta blues, Dixieland, jazz and its invention, minstrelsy, prison chants and gospel, rhythm and blues, rock and roll—are tied to Mother Africa.[lxv] Trickster glint flashes bright in the music and personalities of Bessie Smith, Louis "Satchmo" Armstrong, Duke Ellington, Betty Carter,

lxv It is also becoming more widely recognized that enslaved Africans, generally male, intermarried with Native American women, inferring a partially obscured indigenous influence on what is generally referred to as African American music.

Nina Simone, Fats Waller, Cab Calloway, Louis Jordan, Cecil Taylor, Betty Davis, Thelonious Monk, Slim Gaillard, really too many to mention.[lxvi] Fats Waller is almost always in a joking mood; Cab Calloway's an essential part of the fabric of jazz traditions, while at the same time lampooning them; Thelonious Monk's the genius whose music most sounds like the musings of a playful child. And Betty Davis affected Afrofuturist touches to her image even before Parliament-Funkadelic flipped that switch. The trickster influence in African American and Afro-Atlantic culture is immense, worthy of several volumes. I should hope that readers increase their sensitivity to Trickster energy from the gist and rhythm of these examples.

WATCHMEN 2019

HBO's nine-episode series *Watchmen* leaps to Afrofuturism's cutting edge, doing much to define our new age of popular culture. The story's fabric is woven with filaments of Ifa's divine powers, of Trickster god Eshù, and of the Signifyin(g) Monkey. Through an intricately constructed script infused with the African American literary vernacular, *Watchmen* is rife with the markings of West African and African American mythology.

Earth is at peace, but only because the powers that would otherwise be fighting each other are distracted by periodic showers of alien squids that die within minutes of raining down. Dr. Manhattan, an almost omnipotent being, takes the Trickster feat of time travel a step further by existing in multiple times simultaneously. If he represents West African cosmology, he is less Trickster/Eshu and more like Ifa, the supreme god. Yet he can't quite grab the throne. He's befuddled by a particular period of time that he cannot see, cannot decipher, and his efforts to connect to and solve this puzzle are likened to tunnels, another trickster motif.

But *Watchmen's* most profound plot points revolve around the Nostalgia pills of superhero Hooded Justice. Through this device, we bear witness to Eshù Elégba's dramatic interpretive powers to communicate with Ifa, to understand Ifa's messages, to receive Ifa's blessings. In this, *Watchmen* makes a point more profound than Marvel's *Black Panther*.

lxvi Though sexism suppressed much that we might have heard from Black women.

Will Reeves, a Black cop in early 1940s New York, approaches a news vendor who's reading an Action Comics, the one where we learn of Superman's origin. "Beats the news, huh?" "Yeah. More hopeful," replies the news vendor. "What's it about?" "A boy, a baby. His father puts him in a rocket ship and sends him to Earth just before his planet explodes." This scene ties Reeves to one of the original comic book heroes, Superman.

As a very young child he had survived the 1921 massacre of the middle-class Black community in the Greenwood neighborhood of Tulsa, Oklahoma, known as Black Wall Street.[lxvii] His father hid him in the back of a carriage, with friends who were escaping the carnage. They got away just before Will's parents were murdered and Black Wall Street ravaged. That trauma, it's similarity to the origin of Superman, and his experience of racism as a New York cop inspired him to become the first human superhero, Hooded Justice.

The other hero of the story, Reeves's granddaughter Angela Abar,[lxviii] is also a human superhero, Sister Night. She tries to protect her grandfather from the FBI, who are after him. To do this, she takes his customized pharmaceutical "Nostalgia." The pills are encoded with his memories, and thus she time-travels and relives her grandfather's life: escaping the Tulsa massacre, joining the New York police department, experiencing racist police practices, and ultimately uncovering and foiling a Ku Klux Klan plot to foment Black-on-Black violence.

lxvii The Tulsa Race Massacre occurred May 31-June 1, 1921, when a "white mob attacked residents, homes and businesses in the predominantly Black Greenwood neighborhood of Tulsa, Oklahoma. The event remains one of the worst incidents of racial violence in U.S. history . . . [n]ews reports were largely squelched, despite the fact that hundreds of people were killed and thousands left homeless." From "Tulsa Race Massacre," History Channel (website), updated April 19, 2021, https://www.history.com/topics/roaring-twenties/tulsa-race-massacre.

lxviii *Abar, The First Black Superman* is a 1977 blaxploitation superhero film directed by Frank Packard and starring J. Walter Smith, Tobar Mayo, and Roxie Young. Paraphrasing Wikipedia, s.v. "Angela Davis," last modified May 7, 2021, 12:19, https://en.wikipedia.org/wiki/Angela_Davis: *Angela* Yvonne Davis (1944-) is an American political activist, philosopher, academic, Marxist feminist, and author. She studied under the philosopher Herbert Marcuse, a prominent figure in the Frankfurt School. She joined the Communist Party and became involved in numerous causes, including the second-wave feminist movement, the Black Panther Party, and the campaign against the Vietnam War.

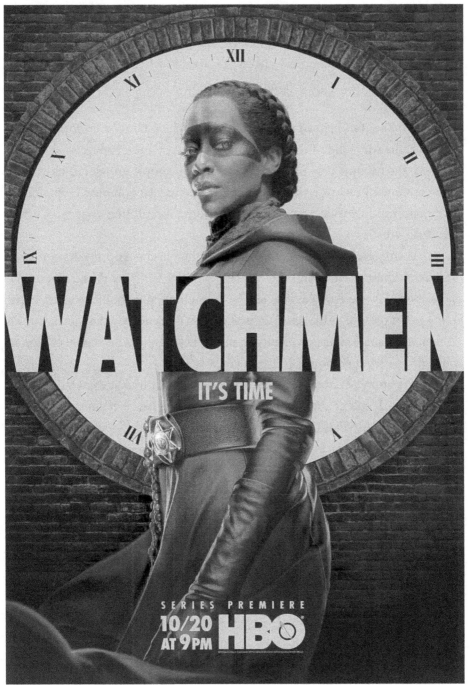

Regina King in *Watchmen* (2019), directed by Damon Lindelof.

But the pills are powerful and not meant to be taken by anyone else. Abar is hospitalized and undergoes a chemical and psychological therapy to restore her singular mind, to undo the chaos of living two lives. When she awakens in the hospital, she finds a number of cannulas and IV tubes. She gets out of bed, traces their path, expecting that they're connected to her grandfather or to medicine, but instead she discovers that she's hooked up to a sleeping elephant, the true king of the jungle. When Reeves's life is thus weaved with her past, she becomes the Signifying Monkey, a complex model of indeterminacy: complex in its weighty psychological demands; complex in its nonlinearity and time vertigo; complex in the intense moral dilemmas with which she must wrestle.

Abar struggles with multiple dual identities: Is she Angela Abar or is she "|Sister Night, the Nun with the Motherf%@!#n' Gun?"[lxix] Is she a cop or is she a mom? Is she Angela or is she her grandfather, or both at once? Is she living in the present or the past? Or is she the Signifying Monkey who, like his companion Eshù Elégba, can interpret multiple languages and connect mortals to the divine? A superpower if there ever was one.

This is pretty serious stuff. But when we think of tricksters, we see smirks and guffaws, laughter and pranks, not so serious. In fact, *Watchmen's* essential subplot of Adrian Veidt/Ozymandias provides plenty of comic relief. He plays a critical role, but as an exile, and represents an earlier generation of *Watchmen* superheroes. He's always on the verge of being arrested, imprisoned, executed, or otherwise disposed of. Funny. Before he exits, though, he gets the trickster honor of presenting a loud fart as his defense in a kangaroo court, where he is then found guilty by a herd of baby pigs.

In homage to Henry Louis Gates's comment on John Coltrane's "My Favorite Things" from *The Sound of Music, Watchmen* signifies on another Rodgers and Hammerstein musical, *Oklahoma!* Here it's performed by an all-Black cast, directed by Tessa Hurston, referencing Zora Neale Hurston, the

lxix Her inspiration was a (fictional) blaxploitation film she watched as a young girl—on VHS no less. Initially, her father, Reeves's son, won't let her watch the film and lectures her on masks. He says you can't trust people in masks because then you can't tell who's who, who's good or who's bad, what's pretend and what's real—thus connecting superhero types donning masks and the masked Ku Klux Klan.

groundbreaking Black folklorist, anthropologist, ethnographer, novelist, short story writer, and filmmaker. Juxtaposing the racial complacency of a white-bread musical set in the same state as the Tulsa massacre, and then having it performed by an all-Black cast, brings to mind the same painful juxtaposition Lord Buckley experimented with when he played the bucolic standard "Georgia On My Mind" in the background as he narrated a hateful southern lynching of a Black man.

But really, what's the biggest trick of all? Well, if you're stuck in a game you cannot win, like being enslaved or relegated to third-class citizenship, you *can* pull out one of the oldest tricks in the book: "You can't fire me. I quit!"[lxx] As Sun Ra put it, "This planet is like a prison."[157] In this variation, if the African diaspora has become a place where every day a Black person wakes up and loses, gets fired in a sense, then their best move is to quit, as in, quit Earth and become a pioneer of outer space. Or quit playacting a legitimate identity that will never be respected or free, don a mask, and seek justice as a vigilante superhero. So get away from Earth through space travel, through time travel, or by putting a costume between you and it.

Hence the motivation for Black art to move into the realms of science fiction, and even fantasy and horror. With Africa a precious but distant past, America a painful present, Afrofuturism offers a canvas that reverses contexts of Westernism and opens up to a rebirth of artistic and magical power.

While not completely dispensing with the conflict-based, good guys/bad guys Western conventions, *Watchmen* subsumes them to the more crucial, engaging, and unfinished narrative of the African American's struggle, exploring the pain of New World oppression and leaving plenty of room for trickster mischief. In a closing scene of the series, Abar is tucking her daughter into bed beneath a cartoonish poster of wild animals of the jungle. Front and center are the elephant, the monkey, and the lion.

* * * * * * * * * *

lxx The earliest instance of this phrase that I was able to find is in the beautifully titled film *It Happened Tomorrow*. The film's serendipity celebrates our purposes with its time travel theme. Directed by René Clair, Arnold Pressburger Films/United Artists, 1944.

In *Room Full of Mirrors,*[158] Jimi Hendrix sings of this imprisoning metaphor that he crashes through, his spirit bringing his true self to the fore and revealing "the whole world." The symbolic use of rooms full of mirrors (by Hendrix, in *Watchmen,* in *Us)* creates a roiling gumbo of moral indeterminacy, especially in *Watchmen,* where it is paralleled by so many reversals and betrayals of good guys and bad guys. The audience is continually teased by this signifyin(g) action of never knowing for sure who is on whose side. The big reveal is that there are notable white people, particularly in politics and law enforcement, who put on a good public face of wanting to help Black Americans but use this pose of appeasement to create a boundary that protects racist practices in general and the Ku Klux Klan in particular.

> Thinking about the black concept of Signifyin(g) is a bit like stumbling unaware into a hall of mirrors: the sign itself appears to be doubled, at the very least, and (re)doubled upon ever closer examination. It is not the sign itself, however, which has multiplied . . . we soon realize that only the signifier has been doubled and (re)doubled. . . . The difficulty that we experience when thinking about the nature of the visual (re)doubling at work in a hall of mirrors is analogous to the difficulty we shall encounter in relating the black linguistic sign, "Signification," to the standard English sign "signification." This level of conceptual difficulty stems from—indeed, seems to have been intentionally inscribed within—the selection of the signifier "Signification" to represent a concept remarkably distinct from that concept represented by the standard English signifier, "signification." For the standard English word is a homonym of the Afro-American vernacular word. And, to compound the dizziness and giddiness that we must experience in the vertiginous movement between these two "identical" signifiers, these two homonyms have everything to do with each other and, then again, absolutely nothing.[159]

The creator of the foundation story for *Watchmen,* Alan Moore, has distanced himself from the original film (*Watchmen,* 2009) of his 1987 graphic novel[160] and all other associations. Which makes it only more culturally dramatic that the HBO series from 2019, created by Damon Lindelof, signifies all over Moore's story, creating a grand reinterpretation that is faithful to its origins and at the same time expands its alternative history. Expands it to make the 1921 massacre of Black Wall Street in Tulsa core. Henry Louis Gates Jr. himself plays the Secretary of the Treasury who hands out reparations to the victims and their descendants, nicknamed as Redfordations, after President Robert Redford. This coup de force signifies all over the standard narratives by creating the context of a government dedicated to a mission of antiracism.

THE ARCHING AMEN

It is such a sad and grievous comment on the marvelous quality of playfulness that it could be translated into a racist stereotype and that racist attitudes can emerge from a failure to fully understand or value the play ethic. Just the fraction of momentous African American achievement highlighted here confirm that the now-obsolete racist stereotype of happy-go-lucky and lazy Black folks was and is beyond the pale—bigoted and deeply shameful.

Maybe the psyche that has dominated the wealth and privilege that society dispenses has been one obsessed with domination, with winning, with a phony work ethic, enmeshed in a game/system of overlapping contracts and covenants, rules and calcified roles, exclusive cultural play and contests that create de facto barriers to a chosen people, a people chosen to keep the flame of original and sacred play alive in a world that tends to suffocate it. We can understand the personalities of individuals and the personalities of cultures through archetypes whose force varies from person to person, from society to society. No one archetype need dominate. A society is most healthy when all, including Trickster, have their place at the table. And no one culture need dominate. Our society is most healthy when all cultures, including African American, have their place at the table. And that means hearing the eloquent, anguished call for justice, as well as the playful ways of the Trickster god Eshù

Elégba. In African American culture lives one of the most profound and developed manifestations of Trickster. And that is a gift.

I daily draw inspiration from Black culture. Even the small slice covered here is insufficient, yet it takes a central role. A fuller picture of the Afro-Atlantic would include profiles and histories from the Caribbean and Brazil, and my future writing on Trickster will include the contributions of those rich cultures.

In a post-COVID-19 world where the US has lost its international dominance and the undeserved and unwarranted burden of solving the world's problems—which as one of the most warlike nations in history, it certainly cannot—and as the US goes through a rebirth of its psyche, we would do well to integrate Eshù Elégba into the twenty-first century's version of the American in an America reborn.

I cannot lay claim to much more than a fan's understanding of Sun Ra the man. But when I watch the segment of the documentary film *Sun Ra: A Joyful Noise,* where he utters the quote that opens this chapter, the look of pain, the tears welling up when citing the Ku Klux Klan leader, are unmistakable. And how he fought off such racism follows not only in the next sentence of that quote but in his life. As 2020's Black Lives Matter movement created a marginally safer place for African Americans to openly share their pain, I've seen that same look of hurt many times. When President Barack Obama eulogized national hero John Lewis at his party's convention that same year, and as he and gave a thumbnail summary of the civil rights movement, he uttered the hope that "…no child in this country feels the continuing sting of racism," I saw that same look of pain and empathy, those same tears welling up.

Sun Ra has returned to Saturn, but through our experience of him, he is a living role model of how to resolve that pain and move through life as a beautiful person and an antiracist building a world without that sting. Yes, it's a struggle. And as unlikely as it might seem, playfulness and trickster awareness are part of winning it.

Sun Ra—a major jazz composer, pianist, bandleader and founder of Afrofuturism—a major voice of the twentieth century and a voice that barely caught on with a mass audience. If Sun Ra connects to the sensationally popular *Watchmen* series, and I should think that he does, that says

something. We're finally hearing a voice that's been crying to be heard, and its vision inspires.

Every culture's folklore features at least one Trickster god. West Africa's Eshù Elégba has made it to the New World and, in cultures throughout the Afro-Atlantic and beyond, triumphed, fueling some of the most immensely influential culture makers—culture makers who lift the veil that separates us from a better world.

* * * * * * * * *

In 1961, jazz singer, poet, and activist Oscar Brown Jr. released his debut album *Sin & Soul*. The lyrics to the fourth cut on the album retell the Signifyin' Monkey[lxxi] folk tale—take it, sisters, brothers, and others; may it serve you well:

> Said the Signifyin' Monkey to the lion one day
> "There's a great big elephant down the way
> Goin' round talking, I'm sorry to say
> About your mama in a scandalous way
> Yes, he's talking 'bout your mama, and your granma too
> And he don't show too much respect for you
> Now you weren't there and I sure am glad
> 'Cause what he said about your mama made me mad."
>
> CHORUS: Signifyin' Monkey, stay up in your tree
> You are always lying and signifyin'
> But you better not monkey with me.
>
> The lion said, "Yeah? Well I'll fix him
> I'll tear that elephant limb from limb"
> Then he shook the jungle with a mighty roar

lxxi "Signifyin' Monkey," on Oscar Brown, Jr., *Sin and Soul*, Upam Music Co., 1960. Other versions of the old folktale were recorded by Cab Calloway, Willie Dixon, Smokey Joe Baugh, Chuck Berry, Johnny Otis, George A. Romero and more.

Took off like a shot from a .44
He found the elephant where the tall grass grows
And said, "I come to punch you in your long nose"
The elephant looked at the lion in surprise
And said, "Boy, you better go pick on somebody your size"
The lion wouldn't listen, he made a pass
The elephant slapped him down in the grass
The lion roared and sprung from the ground
And that's when that elephant really went to town
I mean he whipped that lion for the rest of the day
And I still don't see how the lion got away
But he dragged on off, more dead than alive
And that's when that monkey started his signifyin' jive

CHORUS

The monkey looked down and said, "Ooh-wee!
What is this beat up mess I see?
Is that you, lion? Ha-ha! Do tell
Man, he whipped your head to a fare-thee-well
Give you a beating like it wasn't nothing
You supposed to be king of the jungle, ain't that some stuff?
You big overgrown pussycat, don't you roar
I'll hop down there and whoop you some more"
The monkey got to laughing and jumping up and down
But his foot missed the limb and he plunged to the ground
The lion was on him with all four feet
Ground that monkey to hamburger meat
The monkey looked up with tears in his eyes
And said, "Please, Mister lion, I-I apologize
I meant no harm, please let me go
And I'll tell you something you really need to know"

CHORUS

The lion stepped back to hear what he'd say
And that monkey scampered up a tree and got away
"What I wanna tell you," the monkey hollered then
"Is if you fool with me, I'll sic the elephant on you again"
The lion just shook his head and said, "You jive
If you and your monkey children want to keep alive
Up in them trees is where you better stay."
And that's where they are to this very day

Signifyin' Monkey, stay up in your tree
You are always lying and signifyin'
But you better not
No you better not
You are always lying and signifyin'
But you better not monkey with me.

A MILLION YEARS
OF FIFTY TRICKSTER WOMEN

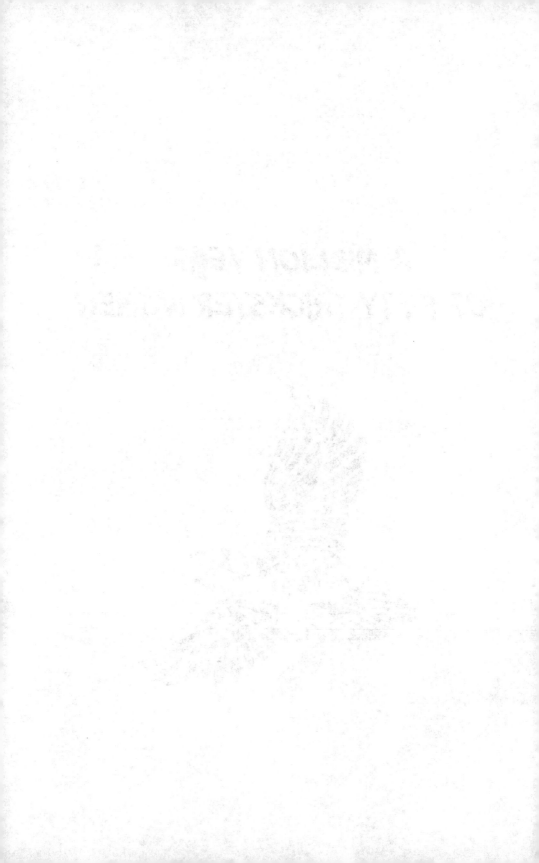

CHAPTER EIGHT

BREAKING THE CHAINS

Savior with a small s, Rescuer at least.
The Trickster Force is strong with her.
She hews to the path to liberation.
Leads. Or doesn't.
Trickster energy, Trickster Force.
Not a person, demigod or goddess.
But energy in the wilderness of wildness,
Sparking joy, hope, vision, and love.
Transforming politics, growing culture.
A collective soul-mind
Tricking power, dancing to utopia.

I s there a difference between women dressing up as men and a Trickster god literally changing sex? And back again? Is the female trickster a role she plays, a life she leads, or just a once only trick? Thus the puzzle of Trickster's gender: a riddle wrapped in a mystery inside an enigma.[lxxii] For the Trickster, gender is an enticing plaything, an opportunity for tricks. And people who are not cisgender hetero males—female, nonbinary, transgender, gay, lesbian, queer—whatever their sexual or gender identity, all are humans. And in

[lxxii] As Winston Churchill famously said about the Soviet Union, but that's another story.

175

this book, all are humans or demigoddesses or goddesses and gods, or fantasy beings. All sentients. This chapter delves into the feminine in folklore, searching for a new context that will deepen and expand the concept of trickster, searching for what happens when the female exhibits trickster behaviors we have known and discovering attributes that have been previously obscured. Gender fluidity, for our purposes, is an attitude that opens our minds to an enlarged view of Tricksters. This has to happen for Tricksters to fulfill their destiny . . . it takes all of us. So while much of the next three chapters is based in feminist theory, the door to the full inclusion of any and all sexual identities—and remembering that a human being cannot *be* an archetype—is opened wide. I do not have all the answers, so I did my best to lay out questions and possible pathways.

* * * * * * * * *

Nigerian scholar Ayodele Ogundipe writes that Esu "is certainly is not restricted to human distinctions of gender or sex; he is at once both male and female. Although his masculinity is depicted as visually and graphically over-whelming, his equally expressive femininity renders his enormous sexuality ambiguous, contrary, and genderless."[161]

Just as mainstream patriarchal societies become more receptive to and inclusive of women's contributions to culture and politics, the paradigm explodes. The collective movements, dating generally from Stonewall in 1969, towards acknowledging and accepting first gay and lesbian, then transgender and queer people led us to a twenty-first century with an increasingly accepted gender-fluid conception of humanity. Yet this has been a feature of Trickster mythology all along, where gender could be ambiguous, shifting, unknown, and bent to the causes of humor, celebration, good storytelling, and liberation. Trickster's shapeshifting nature has been waiting eternally for this.

Centuries before René Magritte and Pablo Picasso would rearrange human anatomy on their canvasses, the Greeks made figurines of the goddess of mirth, Baubo. She was commonly formed sans torso, with her face sitting atop her thighs, which put her vulva where one would expect the chin. A tricky way to present the female form.

As the story goes, Demeter—the Greek goddess of grains, agriculture, harvest, growth, nourishment, and the fertility of the earth—is in mourning over the death of her daughter, Persephone. Demeter is received by Baubo and offered the traditional comforts of wine and food, but in her grief, Demeter declines. To cheer her up, Baubo, along with Iambe, entertain her with ribald and obscene songs, meant to provide comic relief. When the songs don't quite do the trick, Baubo lifts her tunic to expose her pudendum, which also reveals Demeter's son Iacchus, who was hiding somewhere in there. This hilarious and shameless display breaks through Demeter's mood as her baby boy runs to embrace her. The goddess laughs, drinks, eats, and returns fertility to the crops.

The Latin roots for the word *pudendum*,[lxxiii] meaning vulva, is the verb *pudēre*, to be ashamed. It's how we get the word *impudent,* meaning without shame. Thus the connection and the possibility that goddess Baubo, the mirthful one, is that exceptional spirit, a female trickster, and a brave goddess free of shame. Impudent, if you will.

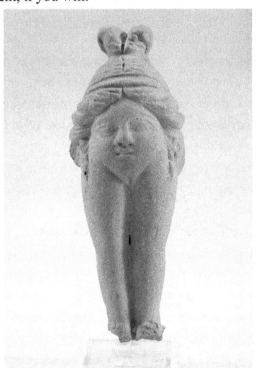

Greek terracotta Baubo figure. Hellenistic, 4th-2nd century BCE.

lxxiii When referring to a woman.

* * * * * * * * *

Lest one eschew such an inordinate focus on genitalia and sex—consider instead whether the tale of Baubo's impudence can be told the way a lewd man would, as a dirty story. Or could it be a myth that prophesizes women's liberation?

The same attributes of promiscuity and dirty jokes hold true for male tricksters. Wakdjunkaga of the Winnebago tribe, the oldest known Trickster god, is obsessed with the length and abilities of his penis. It's many feet long and can slither across a river in search of a paramour, and there is an elaborate tale that explains how it got cut down to human size. Bugs Bunny gets about as risqué as a children's cartoon dares, and Raven tales of the Northwest indigenous tribes feature recurring themes of impregnation. We are left with the dilemma of trying to sort out divine inspiration from patriarchal norms. When is it succumbing to a societal demeaning of the woman, and when is it celebrating sexuality and being playful, more in the Trickster mode?

To regain the lightheartedness of these stories, recall the hipster icon Lord Buckley's penchant for nudity. When visiting his home, one typically found the Lord, his family, and whoever else happened to be there "in the buff." This practice was less a form of debauchery and more for the sake of nudity's connection with the way we are born and with the ideal of liberation, of moving about freely in this world.

And though the case can be made for Baubo as a female Trickster goddess, and though gender-bending is common in trickster tales, Tricksters almost always appear male.

Lewis Hyde, in his seminal Trickster Makes This World,[162] addresses Trickster and gender directly, making three arguments. The first is that trickster tales come from patriarchal mythologies where almost all of the prime actors are male. He cites examples of temporary transformations to female form in order to trick an adversary or dupe. Wakdjunkaga becomes a woman and bears children for a chief as a means of getting access to good eats. Norse god Loki transforms into a mare in heat to distract an enemy stallion and then gives birth to the eight-legged horse, Sleipnir.

But Hyde proposes Baubo—role-shifting from queen to nurse to crone to entertainer—and the Japanese and Shinto sun goddess, queen, ruler and fox Amaterasu as possible female tricksters. Some note that the rulers of ancient Japan were women.[163] Japanese emperors go to Amaterasu to abdicate, an appropriate role for one who tricks power. This tradition raises the question, can tricksters govern?

What little story survives of these goddesses reveals bawdy jokes and the flashing of naked bodies—and great power. Baubo's notable Trickster magic relieves grief and suffering and, through her superpower of comic wackiness, brings fertility back to the world. The stories have become truncated, censored, and dismissed, with great loss of detail resulting. The invading Zeus-worshippers not only conquered, but their patriarchy came to dominate Western folklore and its narrative. And patriarchy has defined human cultures worldwide.

Hyde makes his second argument, that there may very well be female tricksters from cultures around the world who have been ignored or obscured. Had there been more female anthropologists before the mid-twentieth century, they might have been more likely to have gained trust with indigenous women, heard and recorded such stories.[lxxiv] Hyde contends, though, that one or two tricks, as is the case with the Chinese Fa Mu Lan or the Hebrew Bible's Rachel, do not a trickster make. But Aunt Nancy/Ananse of African American lore; Scheherazade, the Middle Eastern storyteller; Inanna, the Sumerian goddess; and the Chinese mythical creature, the Huli jing all make great Tricksters. Marilyn Jurich's *Scheherazade's Sisters*,[164] published the same year as

lxxiv "Occasionally . . . the primary trickster in African-American tales is represented by a female. . . . 'Of Molly Hare' from Virginia and 'Aunt Nancy' from the Gullah region of Georgia, the latter a variant form of Ananse, a trickster in tales from Ghana, Liberia, and Sierra Leone. Female tricksters—divine or secular—rarely appear in African, Native American or other aboriginal myths or tales. . . . [I]n the ethnographic literature trickster is represented 'as a Priapean male dominated by his sexual appetites' . . . [but] a 'peculiar bias' may exist in how the stories were collected. . . . [M]ale ethnographers of the Boasian school interviewed males, believing that male elders held 'the repository of traditional knowledge.' . . . [T] he major reason for Trickster/trickster as a male figure is the fact that society is dominated by male hierarchical structures. Trickster as a collective representation of that society would naturally be pictured as male." In Marilyn Jurich, *Scheherazade's Sisters: Trickster Heroines and Their Stories in World Literature* (Westport, CT: Greenwood Press, 1998), 44.

Hyde's book (1998), dismisses Inanna and Mexico's Matlacihuatl as Trickster gods. But later in the book (p 213), Jurich returns to Inanna's story and tells how she—with the aid of a lot of alcohol—tricks her grandfather Enki into giving her the "me." The me comprises the over one hundred divine ordinances that together make for the foundations of civilization—social institutions, religious practices, technologies, behaviors, mores—and the power that comes with them. She then distributes throughout Sumer the power held so tightly by Enki, an example of a female trickster governing and doing so more democratically. Jurich also makes the case for a trickster triumvirate of Rachel, Jacob, and Rebekah.

Even more salient are the female Coyote Tricksters of the Hopi and the Tewa, two Native American Pueblo tribes. All of these female trickster tales come out of matrilineal and/or matrilocal tribes. But of the hundreds of Coyote trickster tales, only around twenty feature a female protagonist. And the tricksters found in matrilineal groups where the women are powerful, like the Tsimshian and Tlingit of the North Pacific coast, are nonetheless male.

Motherhood makes for a regular feature in these stories, whereas family obligations are merely incidental for male tricksters. Male tricksters have an overwhelming sex drive, yet rarely procreate.

Trickster tales often seem to center on the son's individuation and renegotiation of his relationship to his mother. Hyde cites Krishna's close relationship with his mother, his dependence upon women to feed his ravenous appetite, but his refusal to assume any obligation to them. His trickery bespeaks the male trait of oscillating between connecting to and pulling away from females. The trickster wants it both ways. This characteristic of avoiding connection or familial duty so frequently associated with male behavior, the playboy if you will, makes the third argument of why an otherwise gender-fluid Trickster demigod would assume male form.

Hyde concludes his essay wondering why the mother-daughter relationship has not given rise to a companion female trickster mythology, and the best answer he can offer is a return to the first assertion, that the trickster character, though found in every culture on Earth, is significantly colored by the prevalence of patriarchal narratives. So early stages of this investigation reveal less

morally indeterminant characters but a climate of indeterminacy surrounding the trickster concept itself.

TRICKSTER HEROINES

Scheherazade's story, the through line of Arabian Nights, contains many elements of the female trickster. The king and his brother, having experienced the pain of unfaithful wives, are still unsatisfied after killing them and their lovers. King Shahrayar decides to kill all women, one at a time, by marrying a new young virgin every night and executing her the next day. Scheherazade finds a way to foil this plan. She volunteers to be the first wife but entertains the king with tales that all end with teasers. Her execution is delayed because the king so wants to know what happens next. Eventually, she brings the king enough joy (and three children) that he falls in love with Scheherazade, marries her, and abandons his intended gendercide.

In *Scheherazade's Sisters,* author Marilyn Jurich makes the crucial point that in her quest to rescue the women of the kingdom, had Scheherazade tried reasoning with the king—that one bad wife does not a gender make; or tried to prove how tender, loyal, beautiful, and moral she was, in contrast to the bad wife; or scolded him for attempting such a cruel mass murder; or bargained or bribed him with sexual favors or promises of a great family; or threatened rebellion once his subjects figured out the heinous plan; or even begged and pleaded—had she these stratagems, none would have worked. "Only a trick could succeed. Power must be tricked out of power, and the powerless have only the trick as their resource."[165]

Scheherazade presents one of the most complete portrayals of a female trickster in ancient times. We are fortunate to live in an era where a fuller expression of the female trickster may bring fortune and completion and a more distinct vision of a better, more invigorated society. But what a long, strange trip it's been.

One of the tales from Arabian Nights, "The Lady and Her Five Suitors,"[166] tells of a wife unhappy with her husband's wanderings and desirous of another lover for herself, a man who is in prison. She goes before the governor, claiming that the prisoner is her brother and sole means of support. The governor is willing to release him but requests that she come to his house to obtain the

form. Hip to his motives, the woman makes excuses and invites the governor to her home instead. This dance is repeated with other government officials, including the king, all of whom accept invitations to the woman's house, all of whom are expecting sexual favors.

Four visitors are expected; four visitors are expecting. She hires a carpenter to prepare a cupboard with four separate and locking horizontal compartments. After he propositions her, she says, hey, make me a fifth compartment.

Once completed, she challenges the carpenter to fit into a compartment he says is too small then locks him inside.

The visitors' arrivals are timed so that each interrupts the previous one. She claims the knocking on the door to be her husband and tells the wannabe paramour to hide in one of the compartments. All five suitors get locked up! Having obtained the release of her "brother," the young lovers escape while the dignitaries are left to shout for help and, after three days, covered in their own excrement, are released by the neighbors. Realizing how they've been tricked, they laugh and admire how the young woman put one over on them.[167]

As we are amused by one woman's cleverness, we are entertained by another's foolishness. Catherine, in the Grimm's fairy tale "Frederick and Catherine," bumbles and fumbles her way from one humorous catastrophe to the next, reminiscent of The Cat in the Hat. As a housewife, she absentmindedly forgets where she put their sausages, and the dog eats them. She mishandles her husband's vat of beer and causes a flood. She spills an entire sack of flour in her attempt to clean up the spilled beer. To pay for crockery from some itinerant peddlers, she directs them to where her husband has hidden gold, which they steal. She attempts to heal the earth by spreading butter in ruts on the road. Eventually, while cutting corn, she accidentally cuts off all of her own clothes and, without them, forgets who she is. She comes home and wakes her husband that night, peering in through a window, looking for Catherine. Literally, she's trying to find herself. Figuratively, she's trying to find her self.

In his own drowsy state, the husband assumes that she is indoors, sleeping next to him, and sends away his own wife, who is convinced that she is not.

She joins a band of burglars who must abandon her, as she politely shouts to their intended victims, "Good folks, have anything? We want to steal." To be rid

of her, the burglars task Catherine with picking turnips in a pastor's field. Upon discovering this tattered and bedraggled woman in a permanently confused state, the pastor runs away, frightened by a woman he believes to be the devil.[168]

While we may choose to belittle Catherine, we might also perceive her as a holy fool performing a sacred trickster function. Jurich believes that "Catherine, rather, belittles a male-engineered society that gives orders without providing adequate instruction, that relies on cheating and stealing, that is frightened by women who in their fevered and guilty imagination they assume are devils. Catherine . . . is that figure which causes chaos so as to uncover the greater chaos posing as order in the culture at large. She asks the reader to question what is normal, what is good."[169]

The women protagonists in folktales where we might find female tricksters are usually there for only a single tale, Scheherazade's tenure being a notable exception. So as a character, even in these extended stories, there is not enough material to discover more than one or two trickster attributes, and there is a difference between using a trick as a tactic or stratagem and being endowed with the full complement of archetypal gifts of trickery, mischief, and revelation. Jurich herself, who has hung her hat on the concept, wrestles with this challenge: "In trying to understand the folktale and the place of the woman character in the tale, we need to be careful and we cannot be too certain. . . . In searching for the trickstar (female trickster), I sometimes found it hard to cast her with any certainty."[170]

Thus the difficulty in sussing out those who might have multiple trickster attributes and make good examples. But there are evidence and ideas to be mined. For example, one trickster attribute includes the willingness to suffer humiliation, to play the fool, to be tricked as well as to play tricks. Few of the female characters Jurich proposes show this quality. But consider the precept of the patriarchy or any oppressive society: humiliation of the oppressed, in this case women, is a given. She already proceeds from that place and from an existence of daily humiliation. Thus she is exempted from having any sticks of dynamite blowing up in her face or anvils falling on her from a cliff.

Oppressors humiliate the oppressed. But if the model for Trickster is to be revised to integrate the female psyche, proceeding from an assumed place of

oppression does more than automatically subscribe the female trickster to this attribute. To resist the oppressor endows the female trickster with moral purpose. This throws a monkey wrench into the works, works that are built on a Trickster cycle that is a journey from moral indeterminacy to moral discovery.

Folkloric female tricksters who are often hybrids, trickster-heroines, allows for this preexisting morality. Put a pin in this perplexity.

SOCIETY REFLECTED: WOMEN IN FOLKLORE

We proceed with a review of the obstacles women face in their quest for identity and self-determination; how female tricksters are similar to tricksters as we've come to understand them; how they're different; and how female tricksters inform a revised model of tricksters and their messianic and utopian attributes.

Male tricksters would seem to act from a position not of power per se, but of the freedom power grants. They commit acts unperturbed by their own histories or by the conditions or confinements set by anyone who might have power over them, jesters being the exception. They are footloose and fancy free.

Female tricksters begin from a place where a husband or father or suitor has power over them, and thus their tales are couched in the struggle to overcome and be free of their oppressors. What cannot be ignored as we look for correspondence and correlation between male-first and female-first tricksters are the conditions of patriarchy that color the portrayals.

Typical depictions are: Old women as eccentric, befuddled, and imperceptive; young women as spiritless, dependent, and without moral conviction, subject to the will of aggressive heroes. Women whose physical beauty overshadows a lack of intellect or emotion. Independent women who are either evil witches or hateful wives. Women who are allowed happy endings only if they are beautiful, docile, and compliant.

These tales teach that women seek only marriage and wealth. They are sought after as valuable property. Women are willing to destroy other women in order to get their man. And women succeed through victimization, rescued by the prince. Fairy-tale women who win can be described as "one to yea-say the 'master,' nodding her head adorned with a diamond tiara, gloating her triumph in a swanky castle filled with designer furniture."[171]

One exception might be fairies, who can be powerful and good, but most are powerful and bad. Being ugly or homely equates with evil, power with immorality, stepmothers and bad fairies with predatory sexuality.[172] In general, the narratives' limited opportunities encourage a psychic helplessness, which sets the table for an external power like a prince to provide fortunate solutions. The women lack agency, initiative, or direction. These limited, negative, and detrimental roles created boundaries which even women authors struggled to cross, leaving little room for the female trickster to perform.[173]

Jurich recounts tales from the patriarchy invested in showing women as treacherous, evil, untrustworthy, betraying, and so forth. In the Egyptian tale "The Two Brothers" from 1200 BCE, one man resists the seduction of his brother's wife, only to be accused of it by her. In the Hausa (Nigerian) legend "The Old Woman," the title character offers room and board to a blind man, only to steal his assets and sell off his fiancée. After being caught and serving her jail sentence, the old woman returns and now uses lies to trick two armies of the same kingdom to fight each other. She then encourages thieves and beggars to exploit the carnage. A huge massacre results. In a number of these kinds of tales, the devil himself runs from villainous women who commit evils even he cannot abide.

One plotline repeated often enough to consider it a trope is the offered bargain of some combination of power, wealth, and high-status marriage if the husband or wife would only murder their spouse. Jurich's examples include "No Pity in Woman," a King Solomon version from the seventh century, and "There Are Women and There Are Women" from Armenia. Invariably, the husband refuses the atrocity that the wife is only too willing to commit.

These stories are important and instructive. They confirm the cultural milieu of a patriarchy with folktales that encourage men to justify and protect their domination of woman, whom they are taught to not trust. We must keep this in mind. And many are tales of women who do not aspire towards the attributes of the Trickster archetype that we have come to know. Humor is absent. Evil replaces moral indeterminacy. They scheme and trick only to accumulate power or get revenge.

Jurich coins the term trickstar to distinguish female tricksters, whom she considers stars, from male ones. But in our understanding of Trickster

as shape-and gender-shifter, and ultimately genderless, and as we live in a century where the proposition of gender fluidity is gaining acceptance, the term can get in the way of an understanding beyond male/female binarity. But point well taken; true female tricksters are stars who have broken through the oppressions of sexism and patriarchy. Male-centric stories where the female is conquered, disparaged, and left bereaved are vastly more common than the heroines and tricksters we're able to excavate from our patriarchal past. Tales of mistreated wives far outnumber those of henpecked husbands, and the wives' punishments are always more severe—being cast out, abused, beaten, killed, condemned, and/or enslaved.

And to our specific purposes, because women have been disempowered around the globe and throughout history, in fiction and reality, they have had to resort to trickery as a means of defense or just to improve their own lives, which both buoys and confuses the search for female tricksters. What is the difference between a human trickster imbued with the spirit of the Trickster archetype and ordinary and extraordinary people who use tricks as a strategy for overcoming their oppression? How best to address the contrast between heroines and their moral stands, more critical in the case of an oppressed group, and tricksters, most frequently described as morally indeterminate and stumbling towards moral discovery?

FEMALE TRICKSTERS SIMILAR TO MALE TRICKSTERS

Tricksters' playfulness cannot be set aside. Heroines of great gravitas like Aphrodite and Joan of Arc are just too serious. The female trickster "has a sense of humor, a sense of play. She enjoys verbal games, games of strategy, and all kinds of inventive deviations. Even when she is exposed to difficulty or danger, her ability to find amusement in the situation or to twist circumstance to her favor become significant elements in the tale . . . hopeful, pragmatic, convinced that she can turn a situation around, . . . she seeks to amuse."[174]

"The Pirate Princess,"[175] a story that migrated from Eastern Europe to Yemen, begins conventionally enough with a couple in love who, to over-come the prohibition of their marriage, plan to elope. They first escape to an island. But there the princess is observed by a merchant captain and his crew,

and he takes her for himself. After she makes him promise not to touch her until their wedding night, she plays the willing bride and sends him off to inform his family. Once he's gone, she gets his sailors drunk and absconds with their ship.

Out on the sea, she's again captured, this time by a king with whom she makes the same bargain/trick: "Do not touch me until our wedding and, for tonight, leave me with eleven of your ladies-in-waiting on 'my' ship." She gets the ladies drunk and sets sail. Stopping on an island for food, they're attacked by twelve pirates. The princess dodges massacre by promising each of the women as a bride to the pirates. They drink again in celebration, the pirates pass out, and the women kill them. These intrepid women then disguise themselves as male sailors and drop anchor in a faraway city where an heirless king has died.

That city's custom is to throw the king's crown from the palace and bestow kingship on whosever's head it finds. Of course, it lands on the head of the pirate princess "sailor," who becomes "king" and eventually reveals that she is a woman. This is one of many tales where the heroine gender-shifts or disguises herself as a man in order to make progress.

As news of her strange luck spreads, her three suitors recognize her from honorary busts that are on display throughout the region, and they come before her: the merchant, that first king, and her beloved. She restores to the merchant his treasure and the eleven ladies-in-waiting to the king. And to herself, the man she has always intended to marry.

The beauty of the story lies first in the humorous ways of the trickster pirate princess, despite the killing of the pirates (self-defense!). It's a fun story, particularly in its use of tricks to reverse the ways of power and to empower a female. Jurich contends, and this tale portends, that a true fulfillment of trickster prophecy calls for an expansion of the archetype. That it in fact relies upon the integration of the female psyche, the additional repertoire of behaviors and tricks that women bring, and their adeptness at tricking power into performing acts of love in order for society to make progress.

The princess and the prince are installed as rulers by the viziers who observe her intelligence and evenhanded exercise of power. To those she

tricked and took advantage of in order to save herself and further her purposes, she has returned their goods, undone the meanness.

Unrevised trickster mythology would have had her relinquish the throne, align with the attribute that tricksters do not seek to accumulate power. However, in this story and in the cultures that tell the tale, and possibly in a more gender-inclusive concept, the idea of a trickster who governs, as one who does not hunger for power but proves to be fair and just, should be considered. We encounter the recurring problem of parsing out whether the tale features a female protagonist who might use a trick or two as simply a tactic or whether she meets or addresses by revision more of the trickster's ten attributes. So many of these tales give insufficient character description of the woman for us to consider whether she's trickster or just tricky, but "The Pirate Princess" comes pretty close.

An irreverent tale from India, "The Cunning Dhansiri," comes even closer. Confined to a loveless arranged marriage, Dhansiri finds passion with a forbidden suitor, Sudarshan, who seeks a tryst. When he sends a messenger, an old woman, to make the proposition, Dhansiri responds and rejects angrily, yet like a trickster who can interpret and speak multiple languages, she embeds and disguises clues in her response that convey to Sudarshan her true message, the time and place where they can meet and make love.

Her father-in-law discovers the lovers together in the woods and makes his sighting public. Dhansiri devises clever alibis and tricks that perplex an informal trial convened to determine her guilt or innocence. Her maneuvers and arguments cast doubt on her father-in-law. Set free of the accusations and in a female version of the promiscuous male trickster, she is able to continue the affair with Sudarshan.

In societies where men were allowed infidelity and multiple wives and those wives were confined to homes and unhappy marriages, this tale represents an initial foray towards liberation and equality. In this setting, adultery is seen as the only conceivable way a woman could begin to make her case for equality. And in trickster fashion, it mocks power. Typically, descriptions of women who must scheme to avoid unwanted wedlock or find love outside of marriage are derogatory and condemning—the betrayer, the hag, the witch, the

shrew. But "such menacing maidens, as well as wayward wives, are engaged in a warfare where victory means self-determination."[176]

Must a female trickster also be a heroine? In Baubo and Dhansiri, we have tricksters who win but are not.

Unusual circumstances and the rules governing unusual circumstances sometimes replicate trickster conditions for a woman. Tamar, daughter-in-law of Judah (Genesis 38), is twice widowed, so not a virgin, but neither does she have any children. She seeks a life unencumbered by stigma or stereotype. Neither a wife nor a mother, thus her identity undetermined, Tamar should be free to perhaps become a fun trickster, but in this biblical era, such a woman would be discarded by the deceased husband's patriarch and robbed of any identity. Even put to death by fire. So Tamar disguises herself as a prostitute and has sex with Judah, her father-in-law. Now he and his rejection of Tamar is silenced; she can extort him based on this incestuous affair, and she has exposed the double standard that allows men infidelity but executes women for the same misdeed. And she goes on to more than a self-determined identity, she becomes a matriarch of Israel.

The Greek god Hermes presents one example of a gender-ambiguous Trickster god. Like all Tricksters, he has the gift of knowing many languages and is thus the perfect messenger for Zeus. He's a peacemaker and the "god of dreams." One mythologist, William G. Doty, takes particular note of Hermes's flexibility with gender roles. He describes him as "strikingly feminine": peacemaker, healer, the bringer of fertility, and in Crete he's the god of the carnivalesque ritual topsy-turvy event, where power relationships are, through masquerade, reversed.[177] He's a preserver of the hearth, traditionally a woman's role. He is grounded like the respected matriarch, restoring our vigor and sustaining our sense of proportion.

FEMALE TRICKSTERS DIFFERENT FROM MALE TRICKSTERS

Henry Louis Gates Jr., author of *The Signifying Monkey*, a treatise built around the West African Trickster god Eshù Elégba, is fascinated by the tricksters' moral indeterminacy, and while Jurich recognizes it and because she is on a quest to find female tricksters, she turns to female heroines who utilize tricks as stratagems, some of whom may be tricksters, some not. Jurich's title *Sche-*

herazade's Sisters: Trickster Heroines and Their Stories speaks to her intentions: shedding light on tricksters who stumble into heroism or heroines who employ tricks in their pursuit of justice or something good. And she allows for the idea of trickster rulers, of tricksters being able to govern, whereas to date the understanding is that tricksters embrace the role of mocking power and thus do not take it. The historic oppressed status of women changes the calculus, but conflating heroines and tricksters complicates the proposition. Jurich begins with the moral crusader, the "fierce woman of righteous conviction."[178] She makes her case that to reach the threshold of a utopian era, the female trickster must also be a heroine able to defeat aggressors, assume power, and govern. The folktale "Gulnara the Tartar Woman" makes this prophecy.

Gulnara's father is called upon by the khan, a descendent of Genghis Khan and the supreme leader of the Tatar tribes, to go to war against the khan's rival, Kuzlun. Gulnara is the youngest daughter, determined to protect her father and replace him on the battlefield. Her older sisters fail to step up to the task, so she dresses in a man's armor and joins the khan's nine thousand warriors. As an expert warrior archer and military strategist, she leads the troops to victory over Kuzlun, though he is not vanquished. Cowardly generals try to claim credit for her accomplishments and also falsely claim that Kuzlun is fully defeated.

Gulnara exposes the lies and the generals' failure to even understand what had happened in battle. The khan is seeking trophies of the victory, and here Gulnara's trickster cunning and knowledge uncovers Kuzlun's trick. When she shakes out the sand from her saddlebags, out come a camel, an iron anvil, and a silver birch, which transform into Kuzlun, his wife, and his daughter, respectively. Thus Gulnara secures the authenticity of her leadership.

But wait. Along with the dishonest generals, the ungrateful khan is jealous and threatened by this heroine. Together these powerful but insecure men hatch a plot to kill her. She upends the conspiracy, and they fall into the pit of poisonous snakes they'd intended for her. Finally, she returns to her tribe a triumphant savior and promises protection from any tyrannical khans. "The destruction she brings against Khan Kuzlun may be regarded as 'necessary violence,' as part of her general rebellion against all warfaring tyrants. Her recklessness and inventiveness serve the larger interests of society. She is

both revolutionary and savior. . . . Gulnara creates for the reader a sense of Utopian aspiration."[179]

This story flickers in and out of tricksterness as we have defined it. Gulnara cross-dresses to gain access to the truth (tells a lie to reveal the truth); she understands transformative magic, but she also leads an army and becomes a ruler. She is a heroine not only by her military prowess but by her ability to suffer abuse from her fellow men in armor. Jurich attributes the variants to the fact that a woman's bag of tricks is not the same as a man's.

When we open ourselves to more closely inspect femaleness in the trickster archetype, we open ourselves to feminist insight on all genders and on all actors, and on society itself: "the powerful aggressor and the helpless virgin are both victims for each is denied access to self-expression and each is, consequently, driven into madness or death."[180]

So in order to be a force for enlightenment, the female trickster must win, must be strong. As we saw in "Frederick and Catherine," the female simpleton doesn't get the last laugh or get to lead people into realization. Male tricksters, however, can advance society through foolishness: "The trickster often fails. In his failures he becomes a joke, yet in laughing at him men are set free, for 'they are laughing at themselves.'"[181]

Jurich's conception of the female trickster homes in on her defining trick: that she is a heroine who uses the wiles of the trickster to escape and transcend the stereotypes with which women are saddled and to rewrite women's roles. This is the fantastic and admirable story of heroines who employs tricks, less so of female tricksters who aspire to heroism.

The most important attribute of the female heroine-trickster is her brave campaign for social justice. Male tricksters more rarely reach that evolution, more often are perceived as incomplete stories, as unfinished business. In Robert Darnton's *The Great Cat Massacre and Other Episodes in French Cultural History,* his examples of tricksters focus on those who might defeat a villain or save a town but who decline the greatest prizes, such as those that include governing or reversing power. Instead, they favor modest rewards like fine tobacco or a new armoire. Thus, "Tricksterism expressed an orientation to the world rather than a latent strain of radical-

ism. It provided a way of coping with a harsh society instead of a formula for overthrowing it."[182]

Jurich seeks to complete this story, seeing male tricksters as works in progress, still in transition to the heroic roles female tricksters perform. She dubs them "bricoleur-transformer" types,[183] tricksters who do not seek revenge, power. or wealth, or even justice. They only wish to continue having fun.

It's worth noting that Jurich describes "Delilahs" (as in Samson and Delilah) as tricksters marked by a punishing patriarchy as traitorous and deserving of blame. Indeed, Delilah's betrayal of Samson made her name a euphemism for the explosive combination of treachery and voluptuous attractiveness. But perhaps Mae West foretold Jurich's revision. In Goin' to Town (1935), Delilah is the role she chooses to play in an upcoming opera. "I got a lot of respect for that dame. There's one lady barber that made good."

The next chapter brings tales of more trickster heroines and trickster queens, who in their dual quests for freedom from oppression and sustaining fun, stretch and fool, pierce and rearrange the very concept of trickster. Mae West most certainly had her share of fun slamming the patriarchy, and she wasn't gentle about it. She and tricksters like Yayoi Kusama, Michaela Coel, Rachel and Rebekah play gentle and rough and will continue bending and shaping trickster until we all get it.

CHAPTER NINE

TRICKSTER QUEENS

The transformer type is most often a woman. The reason for the predominance . . . seems obvious. Those who are denied fair treatment under existing systems are moved to expose inequities, challenge existing conditions, rebel from the institutions that oppress them. . . . As nurturer and protector, woman seeks to benefit those for whom she cares and tries to improve her community. In her effort to find the vital means to guarantee the wellbeing of her family and the supporting structures . . . she is likely to develop a keen moral sense. She may also find the courage to participate in actions that liberate . . . and foster change . . . More psychological and pragmatic, the female, unlike the male, has frequently had the license to oppose tyranny without suffering . . . fear of reprisal. First, her opposition can be more easily and more attractively disguised. Second, she practices her opposition and trickery in an atmosphere and environment that is far less threatening than it is for the male. No one suspects a weak and timid woman of fomenting a conspiracy, or forming a plot; nor, according to common belief, do women have intellect or reason enough to understand or care about matters in

the larger world. The woman has, therefore, "double impunity"—the fragility of her sex and the feeble-mindedness of her brain. In fact, however, because she is driven to change attitudes and systems that have handicapped her and because she also has more access to effective means of trickery . . . the trickstar transformer is a formidable figure. Her tactics are especially successful because others are caught unawares, diverted as they are from suspicion not only by her sex but by [her] . . . appeal to the expectations of men who inhabit a sexist society.

—Marilyn Jurich[184]

*T*his chapter untangles the dilemma of how the commonly accepted profile of the trickster has favored footloose and fancy-free male behavior while women were bound by the familial duties of raising children and nurturing families. But just as the demeaned and dismissed court jester is free to tell the king truths he'd rather not hear, the chauvinism that disempowers women gives the female trickster cover and relative safety from whence she can hatch schemes that transform and liberate. And her built-in morality strengthens the proposition that the trickster-heroine and female Trickster energy are good candidates for political leadership.

The transformer trickster plays savior in the sense that such tricksters will use tricks and lies to uncover the greater lies that oppress. In Disruptive Play, and also in Jurich's book, Till Eulenspiegel of Bavaria is just such a trickster; he tells lies but also speaks truth to power.[lxxv] Gresser see him as "a lone-wolf trying and often succeeding in breaking through the walls of an early capitalist society."[185] Till often does this by pranking his various employers who are exploiting his labor, cheating him of decent working conditions, a fair wage, or doable tasks.

Archetype variants occur early on. There is the hint of collectivity and breaking away from the trickster-as-loner assumption in the Biblical

lxxv Shepherd Siegel, *Disruptive Play: The Trickster in Politics and Culture* (Seattle, WA: Wakdjunkaga Press, 2018), 48-50; "Such lies as the transformer fabricates expose the greater lies of the world." from Jurich, *Scheherazade's Sisters*, 215.

tale of how Jacob and Rebekah tricked Isaac out of the birthright that by custom should have gone to his older-by-seconds twin Esau. Male tricksters work solo, so this triumvirate of tricksters—wife Rachel joins in later—all of whom play tricks, fascinates: the mother, the wife, and the aspiring patriarch.

Tricksters in their jester role speak truth. But when acting more as free agents and manipulators, especially for noble causes, tricksters lie to expose the truth (motto paraphrased from the Yes Men).

Rachel steals her father Laban's teraphim—household idols—and other sacred objects to diminish his status and increase Jacob's. She tricks Laban into not recovering the items by hiding them underneath the saddle on her camel. Fearing that he may encounter the "taint" of his daughter's feigned menstruation, she wards off his efforts at recovery with this trick, a trick and a prank that played on the edifice of Hebrew law that perhaps grew out of men's superstitions, with her own body providing the magic. Rachel's lie shows us the truth: that Jacob, working in alliance with women, with his future wife and with his mother, is the stronger man.

Rebekah, the mother, leads. It is she who concocts the plan and is determined to see it executed. Isaac had given to Esau, in her presence, the exact actions he was to take[lxxvi] in order to receive the birthright. Rebekah memorized these and passed them on to Jacob. All he had to do was follow Rebekah's instructions, including the famous disguise (animal skins to make Jacob's smooth skin feel like his hirsute brother's). He would fool his blind father, and the birthright would be his. A greater truth: God intended that Jacob should lead the Jews. And by lying in order to get to a greater truth, Jacob himself becomes a trickster.

Rebekah loved her son but also had the destiny of the Jews in mind for she overcomes Jacob's resistance to the scheme by agreeing to take on any curse that might befall Jacob for pulling off the ploy. She easily agrees to this because she knows that she is fulfilling God's will (The Lord had revealed to Rebekah during her pregnancy that her older son would serve the younger.)

lxxvi "Bring me some wild game and prepare me a delicious meal. Then I will bless you in the Lord's presence before I die." Genesis 27: 2-9.

Rachel is not so sure. She asks Jacob if it's proper for a righteous man to resort to trickery. He replies that it is, for we read (in 2 Samuel 22:27, New Living Translation): "To the pure you show yourself pure, but to the crooked you show yourself shrewd."

This parable shows the moral indeterminacy of the trickster in play, but in the greater context of the moral pursuit of political progress. And in this trickster tale, it is the influence of two women that obtain for Jacob the power to govern. The lies uncover God's greater truth: it's Jacob who must lead.

An example that sidelines the debatable word of God and clearly shows the female trickster fighting off oppression and rescuing her people is that of another Jew, Esther. She's married to the Persian king Ahasuerus, which would seem to place her in a position of power. But she's a Jew amongst Persians, in the diaspora, and an orphan, and "only" a woman, so she employs the trick that men set for themselves when they put themselves above women.

She's subservient, flattering to the monarch, and at his service with food and especially drink. She conceals her own intellect. For every decision she persuades or tricks the king into making, she credits him and his wisdom. By getting into the king's good graces, she is able to defeat his vizier Haman who is attempting to have Esther's uncle Mordecai and all Jews put to death. By saving the Jews, she tricks power into performing an act of love.

But her feats of trickster-heroine saviorism do not deliver us to utopia, only one step closer. Esther manipulates the situation so that the king decrees the execution of Haman (Esther 7:9-10), true to the limitations ancient society put on women in that era (fifth century BCE). "The transformation she effects must be imperfect. The heroine, as other human beings, must work within systems or her work and she herself will be destroyed by them. It is enough to praise what she accomplishes, defying tyranny and preventing the slaughter of innocents."[186]

A NEW MODEL: FEMALE TRICKSTERS AS SAVIORS AND UTOPIANS

For female tricksters, the tricks are always embedded in the context of their oppression, their efforts to overcome. They employ their feminine status as means for devising tricks and, ultimately and usually, acts of heroism. This

sequence contributes to the difficulty of separating trickster from heroine. Penelope, the wife of Odysseus, remains faithful throughout his twenty-year absence. To delay suitors trying to convince her that he has died, she weaves a burial shroud for her father-in-law, promising to be available once it is completed. But in the nighttime, she undoes the day's work.

Penelope plays this and other tricks to save herself for her man. And Esther to save her uncle and her people. And Rebekah her people's destiny. All achieved within the patriarchal system. Imagine what might come of the unchained and liberated spiritual force of female tricksters.

* * * * * * * * *

Huli jing are shape-shifting Chinese Trickster demigods who take many forms, most notably of nine-tailed foxes and of beautiful women. Their tales are part of the Shan Hai Jing (Classic of Mountains and Sea), which dates from perhaps as far back as the fourth century BCE and was finalized early in the Han Dynasty (206 BCE–280 CE). Huli jing can be good or bad, their appearance can presage good or bad luck. Hence the trickster attribute of moral indeterminacy. They're free spirits known to draw and captivate the unrequited love of men.[187] In a twenty-first-century update, an episode of the 2019 animated series *Love, Death + Robots* updates the myth and tells of a distinctly female trickster;[188] "Good Hunting" presents a fable where Yan, a mythical, pastoral Huli jing, struggles to survive the industrial revolution and ultimately reclaims her divinity.

Yan's a magical Trickster born of an era crowded out by the rise of technology. In China at the end of the nineteenth century, a hunter and his son, Liang, track down the Huli jing Tsiao-Jung, freeze her into human form, and kill her. The son corners her daughter, Yan, who protests their being demonized and hunted and explains that they mean humans no harm. She convinces Liang, and he helps her escape.

The animation presents this era of British colonization of Hong Kong with a semi-fictionalized turn-of-the-century steampunk look, industrial smoke in a forest of riveted steel inventions that never were but look like they could have been.

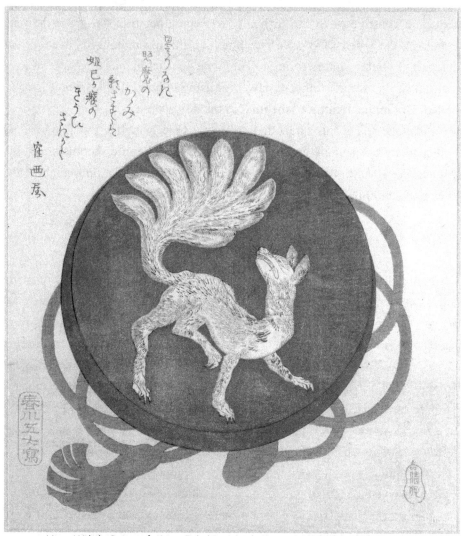

Mirror With the Design of a Nine-Tailed Fox, Harukawa Goshichi (Japanese, 1776–1831);
Woodblock print (surimono); ink and color on paper.

Liang has left rural China and found a new life as a brilliant engineer in the rapidly urbanizing metropolis. Yan has not been so lucky. She is diminished by the mechanized world that has taken over and crowded out magic. She can no longer shape-shift easily. She lives to hunt, but her efforts are frustrated by disappearing wilderness and encroaching cities. She struggles and must move to the city to survive. Liang, though, has become her friend, and he does what he can to help her, providing solace and food.

Yan survives the onslaught of industry and urbanization, but barely, and eventually resorts to prostitution, turning tricks for the British colonizers. One of her johns is the governor of Hong Kong, who can only get it up for machines, so he drugs Yan, ties her down and, in an act even more heinous than rape, has his henchmen surgeons amputate, mutilate, and turn her into a sex automaton. In rebellious fury, she kills the governor, escapes, and seeks refuge with Liang.

Liang cannot bring back her human body, but with his talent for robotic science, he redesigns her mechanisms and restores Yan to archetypal divinity, in modern form. She is once again—with a tricked-out mechanical body that does Iron Man one better—an agile and powerful Huli jing. Yan is reborn as an avenging superhero nine-tailed fox-woman who hunts down and strikes oppressors of her people, in particular those sexually assaulting young women.

In this retelling of the Trickster cycle, Yan of the rural wild grows from a pre-moral innocence to a morality born of her struggle to survive and defend herself.[lxxvii] But it's more than that. "Good Hunting" also paints a picture of how we might encounter magical and ancient archetypes in the twenty-first century. It makes a convincing proposal of a definitively female Trickster goddess who begins life as a female and completes her cycle liberated from the patriarchy but still fighting it. Yan fits the Trickster profile handily, she's a hero to other women, mythologized through animation. In her final triumph, she establishes an identity not beholden to the system that had defined her.

MAE WEST

Mae West's brand of feminism meets men on their terms and still bests them. Behold her marvels—a gutsy, Bessie Smith approach to singing; a smart mouth on par with Groucho's; an undeniably seductive beauty—and, mainly, talent. Talent to write all her own scripts, and the insistence on full artistic control of her shows and her films. West made her statement onscreen and off, as

lxxvii Anonymous were in the same moment of the cycle—the movement from an undifferentiated and amoral psyche to individuation, self-awareness, and the beginnings of order and values—when they took on Tom Cruise and the Church of Scientology. See Paul Radin, *The Trickster: A Study in American Indian Mythology* (New York: Schocken, 1956), xxiii-xxiv; Shepherd Siegel, *Disruptive Play: The Trickster in Politics and Culture* (Seattle, WA: Wakdjunkaga Press, 2018), 263-277.

iconoclast, writer, vamp, trickster, actor—she brought a fully formed persona to the world.

Her second film, *She Done Him Wrong* (1933),[189] was based on her most successful burlesque-y stage show, *Diamond Lil.* It has all the signatures of a great Mae West film: an onslaught of one-liners, sex appeal, a tight plot, bedazzled excitement, sex, humor . . . and situations that put sexual politics front and center. West's sexy portrayal of Lady Lou (née Diamond Lil)[lxxviii] simultaneously won industry praise and government censorship. *She Done Him Wrong* has the unique distinction of being nominated for Best Picture *and* provoking the Motion Picture Association of America[lxxix] into enacting a stricter and more repressive Production Code.[lxxx] West must have been doing something right in *She Done Him Wrong.*

In Lady Lou's cynical world, she lives to accrue diamonds, and she exploits men's hunger for status and wealth by dangling her irresistibility as potential wife and great lover. Lady Lou boasts, "I wasn't always rich. There was a time I didn't know where my next husband was coming from." She is surrounded by suitors who typically declare their undying love and then promise to kill her if she's ever seen with another man. By portraying male chauvinism as such a desperate loser's game, West is playing a trick, mocking men and setting them up as deserving of whatever they get. Lou's sexual power and intelligence strikes a blow for feminism in a time when confronting men's sexism meant meeting it with an equal and opposite force. It's a grand revision of the folktales recounted earlier. She never plays the subservience game.

Goin' to Town (1935) is another sly satire of male behavior—and a playbook for women to succeed in sexual politics. Mae West as Cleo Borden assumes the power traditionally held by men. In the film, she's living the saloon life as a dance hall queen late in the era of the Western cowboy. Through an engagement to a cattle rustler who is conveniently shot to death the day before their wedding, she acquires a great fortune which she spends and gambles

lxxviii For legal reasons, both the character's name and the original stage show *Diamond Lil* had to be changed. "She done him wrong" is a lyric from the closing classic Mae West performance of the folk standard "Frankie and Johnny."

lxxix In 1933, it was called the Motion Picture Producers and Distributors of America.

lxxx The Motion Picture Production Code was a set of moral guidelines for the self-censorship of content applied to most US motion pictures from 1934 to 1968.

with freely. Her newfound wealth attracts male versions of the gold digger. She crashes high society with all of the Marx Brothers' comic disrespect and lampooning, just minus the physical chaos.

She plows her way through a bevy of subservient men. The thematic text is *I like men, I like seducing them, and I even like making love with them. But I'm in charge.* She plays the suitors off of one another and gets the man she's after in the end. If the male and female parts of the characters in this movie were reversed, it would be shown in Feminism 101 as a case study of patriarchal sexism and chauvinism in film . . . which makes it brilliant satire. She plays a trick on gender roles. She didn't have to play a man in order to play *like* a man.

West delivers a prototype for twentieth-century feminism. Never shy about the power of her sexual attraction, she nonetheless employs the kinds of tricks one more likely would expect from a male character. We can be too blinded by her genius and hilarity to get it at first. Camille Paglia comments on Raquel Welch's iconic photo in the trash film *One Million Years B.C.* (1966) to make the same case, but she might as well have been discussing West:

> She simply took...the posture of confrontation, of alert-ness, of a woman, very sexy but ready to take on the world. So these...images really marked a sea change in the way women are portrayed in terms of erotic imagery coming out of Hollywood. [She] preceded feminism... in fact, to me, this embodied feminist ideals better than anything that came from the mouths of the actual leaders of the feminist move-ment. These women, Ursula Andress and Raquel Welch, they showed that they understand sexuality. And they're ready to meet men as equals."[190]

In *Going to Town*, after extended teasing, West gives one of her suitors (Ivan Lebedeff as Ivan Valadov) the heave-ho:

Ivan: Darling, I just found out it is you I am in love with. You are the only one for me after all.

Cleo: After all what?

Ivan: Oh darling, I love you. I love you. I must have you. Marry me.

Cleo: Now listen, Ivan. You're all right to play around with, but as a husband, you'd get in my hair.

Ivan: But darling—

Cleo: Besides, we're intellectual opposites.

Ivan: What do you mean?

Cleo: Well, I'm intellectual, and you're opposite.

Ivan: Let me tell you, I am an aristocrat and the backbone of my family.

Cleo: Well, your family ought to see a chiropractor.

For her ultimate caper, Mae West sings opera! (What's Opera, Doc?) And the role? Delilah.

Winslow: Do you mean to tell me that you're going to attempt Samson and Delilah?

Cleo: Say listen, I'll attempt anything once . . . and what's more, I'm gonna sing Delilah. I got a lot of respect for that dame. There's one lady barber that made good.

It is not too farfetched to see West as Delilah revised. She wreaks the same havoc on unwitting males, with the difference between them and Samson being that they asked for it. "What a trajectory. What a woman. She wasn't a product of her time, she was a product of her own imagination."[191]

CONCLUSION? OR TRICK?

"Such lies as the transformer fabricates expose the greater lies of the world."[192] The trickster persists in what appears as nonsense to a world living a lie, because her truth does make sense in an ideal society.

The male trickster comes to moral discovery through episodes of moral indeterminacy while enjoying a carefree existence. The cycle would appear to be quite different for a female trickster who has no such luxury and emerges

out of the traditional roles of protector and nurturer, of mother to her children. This maternally minded woman advances beyond her traditional roles with a moral sensibility born of a very different experience. She's raising a family, and she's motivated to protect that lifework.

As the oppressed sex, women have a greater incentive to proclaim a society liberated from sexism. The male trickster may lift the veil to give us a peek at a better society by exposing current society's inequities and lies. The female trickster, having been excluded from power, comes eager to propose new systems, proactive models, and ideas of what a better society might look like, one aligned with the ideals of a functional and loving family. "A government operating on female principles may offer opportunities for an expanded awareness of human potentiality."[193] She thus tricks power, assumes it, and transforms society to reflect the love and lessons of the nurturing family.

To build a liberated society requires freedom from history's constraints. But such aspirations are yet built on a foundation of respectful understanding of folklore and women's roles, good, bad and indeterminate. We learn from and value myths' and folktales' truths and relevance, even when we don't like what we see—just as poet Marianne Moore views poetry: "Imaginary gardens with real toads in them."[194]

Jurich excavates folklore in search of more liberated females and female tricksters and searches through existing tales for nuggets that go against the grain of stereotype. She also comments on how overt feminist revisions of tales "flattens" them. They lose their cultural vitality. A more contemporary lens views the victim as a survivor, a person of strength not weakness. In other words, revise the lens, not the tale. Better to create new, original folktales like "Good Hunting" that point the way to a liberated consciousness and a society that frees both the female victim and the male aggressor. And take note: our trickster-heroines of "Good Hunting," Mae West, and Baubo are not maternal woman. They come forth as tricksters free of the mother's responsibilities.

Props to Marilyn Jurich for finding new ways to traverse the pathways of folklore. But the dilemma remains: as morally indeterminate beings, tricksters begin their journeys with no moral pursuit. It's important to dis-

tinguish between trickery as a valid, amusing, and morally justifiable tactic for upending and breaking through patriarchy, and the acting out of Trickster attributes that lead to less predictable outcomes. Trickster journeys have been defined as the pursuit of fun. The pursuit of social justice comes later, through experience. Somewhere between the ingenuous id and the crusader for social justice lies the trickster way of being that may satisfy both male and female personae.

All that said, the treatment of women in folktales is much too frequently abusive, and they are much too often characterized as deceitful, unfaithful, vile, and sexually uncontrollable. Attributes that in a male trickster might seem frisky and fun are routinely condemned in women, and this prejudice screams out for correction so that we might get to a greater truth and recognize the power of a liberated and unjudged female trickster.

Male trickster tales feature a character, human or godlike, who simply begins. He performs unfettered. If he proves himself a fool, at least he has the political capital to waste, and if he is humiliated, it is because he invited it. The female, on the other hand, proceeds from the accurate presumption of having no political capital save her sexual gifts, which she must advertise and employ as a trick to attain some freedom to pursue self-determination, privilege, or treasure. Thus, the female trickster is thrust into heroic battles, while the male trickster more often gets to pick his.

To introduce moral indeterminacy as a defining feature of the male trickster intrigues. To do so with a female reinforces the demeaning and demon-ing slander she suffers, obscuring the novel proposition of a morally indeterminate—neither heroine nor villainess—woman who is not demonized.

One good example of this is the 1999 dark comedy *Being John Malkovich*,[195] which features many Trickster markings: tunnels, gender switching, the 'trick' of getting inside someone else's head, time travel. The film fills the room with the searing, acrid-sweet air of amorality performed without mercy by the delightfully self-dealing, id-driven, and cynical Maxine Lund (played by Catherine Keener), who's in it for the money. For the money: customers get to spend fifteen minutes inside the head of John Malkovich (played by the very real actor John Malkovich). For the sexual love: she makes love with her

business partner's wife, but only when Lund is inside John Malkovich. For the manipulation and scheming: let's see what happens if we put John Malkovich in John Malkovich's head. And for other acts of hilarious and aggressive selfishness—consequences do not matter to her. A no more negatively id-ish trickster character has graced the world since Alfred Jarry's Ubu Roi, his fictional King of Poland.[lxxxi] The beauty of the Maxine Lund character, and Keener's electric-shock performance, is in the fact that she's one nasty trickster, yet with a Mae West self-assurance, she transcends and repels any of the patriarchal labels a less woke Hollywood would have attached.

* * * * * * * * *

The world creates buffoonish tricksters who in their stumbling ways nonetheless birth consciousness, selfhood, and a balance between the individual and society. The world creates gifted and intellectual tricksters. But the world also creates heroes who use tricks as part of a grand strategy, as Prometheus does when he steals fire and sacrifices himself for the sake of humans.

More a martyred hero than a mirthful Trickster, Prometheus presents some of the same problems we find in our search for female tricksters. One origin story relates how the gods send to Earth the first woman, Pandora, as revenge for Prometheus's theft. She opens the deliberately tempting jar (popularized as a box) and proceeds to release all forms of evil and curses on humanity. Jurich considers Pandora herself to *be* the trick released on men by Zeus, rather than a willful perpetrator. But having been created without mind or morals, Pandora grows into the Trickster skin. All of the gifts the gods bestow on her—needlework and weaving; grace; shamelessness; language; clothing, necklaces, and finery; a garland crown; and a name—create an illusion that makes life bearable and inspires human achievement. From this perspective, she stands next

lxxxi Not coincidentally, John Cusack as Craig Schwartz works as a puppeteer and, when forced to get a real job, works on the 7½ floor of a building where the ceiling is only five feet high. Jarry's prototype for the Ubu plays was a puppet show he wrote at age fifteen, spoofing his chemistry teacher. Later in life, Jarry lived in an apartment with similar dimensions as Schwartz's office. See Siegel, *Disruptive Play,* 75-87.

to Prometheus as a heroine to humans and, in a real turnabout trick, Trickster to the gods.[lxxxii]

Full inclusion of female tricksters means expanding and revising the profile and concepts of the trickster universe. Why does this matter? Any conversation of an ideal society necessarily requires that sexist iniquities and abuse be resolved and transcended. If there are utopian or messianic intentions to be gained from Trickster consciousness, its feminine side needs articulation.

In dozens of folktales, women play tricks, overcome adversaries, are heroic, are predatory, are evil, are good, are murderous, have superpowers, usurp wealth, make daring rescues, and display a number of other traits that attract consideration as female tricksters. But most lack humor or the willingness to be humiliated. They struggle with moral indeterminacy, avoid scatology, and once they begin perpetrating tricks, the tables never get turned. From Gretel in *Hansel and Gretel* to other tales of female cannibalism, from "Ani Apprenticeship" of the Kabyle (Northern Algeria) to "Loon Woman" of the Wintu tribe (upper Sacramento River), we hear tales of bewitching, ensnaring, treacherous, and oversexed women. While these qualities are not exclusive to tricksterism, if they do not "surprise us with discovery or rouse our sense of mirth,"[196] they really cannot be of the trickster realm, more the bad witch. Likewise with the baba yagas, viragos and ogresses of various folklores. All that said, with the cultural waves of liberation that are upon us, the time of the female trickster free of oppression has come.

For example, I like the mirth of this tale. Kraba is a young, beautiful, brilliant, and playful Norwegian maiden. The Viking king and widower Ragnar comes to visit family in Norway and hears of her. Bound by his need to represent power, he commands that she appear before him "neither naked nor cold, neither fasting nor fed, she shall not come alone, yet no man shall attend her." His riddling requirements are meant to manifest the obvious conventions of a not-hungry, modestly dressed subject arriving with female attendants. Instead, Kraba appears before the king smelling of leeks, wearing a trout net, and accompanied by a dog. Ragnar is seduced by her sense of humor and

lxxxii Jurich, *Scheherazade's Sisters*, 197. Though tricksters may experience temporary suffering, they come out of it with laughter triumphant. Prometheus's excruciating eternity takes him out of the trickster realm and into the ouch of infinite martyrdom.

independence and proposes marriage (yawn), but it is the gleeful pranking and healthy disrespect of authority that makes Kraba a rare and enticing example of trickster.[197]

I MAY DESTROY YOU

Michaela Coel wrote, directed, produced, and acted in *I May Destroy You,* a 2020 HBO series based on a real-life rape she survived. The show bursts into a new mode of storytelling that most viewers born before the mid-eighties will find startling.[198] The setting is contemporary London and the wild life of her British West African community before, during, and after that trauma. Coel's autobiographical story may offer up the best new model, a cutting-edge picture foretelling a Trickster consciousness or climate, perhaps what we've been looking for all along.

The rape itself is both the symbol and the fact of patriarchy unhinged. *I May Destroy You* tells the story of what happens when a trickster survives rape and then engages in the necessary heroic battle to somehow beat back the debilitating pain of the injury, but trembling and oscillating between the roles of crusader, griever, lover, friend, celebrity, debtor, daughter, artist . . . she's someone who could be having a lot of fun were it not for the tormentous attack.

Arabella Essiedu, the character drawn from Coel's own life, is a rising star, an author with a successful first book. But she delays completing the draft of a second for which her publisher is becoming increasingly impatient. Out partying with friends, a stranger spikes her drink and rapes her in a men's room stall.

The trauma brings chaos. Arabella self-destructs the opportunities that come her way. She takes a lot of drugs and drink. As consciousness of her situation strikes, as the journey through trauma takes shape, she just as suddenly resolves to take no drugs at all. But for her and her friends, explicit episodes of sex continue. Scatology shows up as menstruation openly enters the narrative, and a few scenes take place while Arabella is sitting on the toilet.

A fellow writer, Zain, is sent by the publisher to help her overcome her writer's block. He becomes a consensual lover but removes his condom during sex without telling her. This act—it's called "stealthing"—certainly constitutes assault. Soon thereafter, the publisher sponsors a literary summit, where

Arabella comes to the lectern to talk about her new book but instead denounces Zain to the rather large audience as a rapist.

This happens in the very beginning of her recovery. She is still quite raw. Arabella's also influenced by the hurly-burly of social media chatter when she decides to very publicly call out Zain's transgression.

Arabella and everything around her buzzes with chaotic energy. Her in-your-face honesty and arresting style are electrifying to watch and make her an overnight social media star. Running out of funds, she gets a job with a vegan food company who pay her extra to promote their food on her Instagram, Twitter, and TikTok feeds. But hearing a spurious critique of the company, she goes on camera and pranks her employer, declaring her love for fried chicken and proceeding to eat it right under the vegan food company's logo.

She borrows money to fly to Italy to maybe resume a love affair she'd left there. The ex-boyfriend locks her out, breaks her fragile heart. She's a hot mess of moral indeterminacy and a stumbler. She is always speaking her truth, but it's truth that changes as she processes chaos and consequences, signifyin(g) on the moral or immoral constancy we expect from characters we meet on television. She's having eight trickster adventures all at once, which creates a time warp of simultaneity and a trickster universe.

One of her best friends is addicted to hookups on the gay dating app Grindr. Her best friend Terry Pritchard (played by British Nigerian Weruche Opia) is the bestest friend anyone could wish for, and this connection—they've known each other since childhood—is the one thing that holds strong and endures throughout Arabella's dangerous odyssey. They affirm their friendship regularly with a spoken oath: "Your birth is my birth. Your death is my death."[lxxxiii]

But Terry and Arabella also have a lot of fun together, traveling abroad, frolicking through London's club scene; their world teems with constant excitement. The series' soundtrack ranges from indie singers and British rappers to the latest dance R & B, Daft Punk, Nicki Minaj, the Afrofuturists Janelle

lxxxiii French historian and anthropologist Jean-Pierre Vernant comments on Pandora as a heroic symbol for all women, who carries with her the ambiguity of the human condition: "a happiness with unhappiness, a birth which also means death." Jean-Pierre Vernant, *Myth and Society in Ancient Greece*, trans. Janet Lloyd, (New York: Zone Books, 1988), 201.

Monàe and Kamasi Washington, '70s soul-funk from the Blackbyrds. *I May Destroy You*'s tastes sprawl as does its consciousness, the music as emotional as Arabella's heart; spontaneity abounds.

Though she was born in London, Arabella says, "I'm African." She speaks truth to power, but like the tricksters we've come to know, she doesn't seek to accumulate it, quite the opposite. She makes a show of losing power and influence as suddenly as she's gained it. She's scatological. She doesn't play the game but plays with the games of race, gender, and career. Is that her greatest trick?

Yet it's about more than Arabella. The actor, the character, the story, the settings all share that trickster quality of existing in two worlds simultaneously. Whether it's the gay hookup, the threesome, the rape, the transgender lover, sexual transgression is an omnipresent theme.

But so is love. All viewed through a society shaken and staked out by these Generation Z rebels who bring exhilarating behaviors, the birth throes of a liberated life. This group of sexually diverse young grown-ups have jumped into the rushing, liminal river of moral indeterminacy, swimming furiously to make it to the other side, to the ego death[lxxxiv] where they will experience moral discovery. We can propose Arabella as the mid-twenty-first-century female trickster, but what's most exciting about *I May Destroy You* is that Trickster energy and Trickster consciousness play a larger role—less about an individual and more about the social climate that ultimately leads to the proto-utopian society—not chaos, but antistructure—the glimpse of which Coel/Arabella audaciously and graphically awakens.

YAYOI KUSAMA AND YOKO ONO

It may have something to do with the grandiose ambitions of Japanese imperialism, followed by the horror of the nuclear bombing of their civilian populations. Two blazing, illuminating trickster types, both survivors, both harbingers of utopia, rise out of that horrifying inferno: Yoko Ono and Yayoi Kusama.

Kusama, born in 1929, has led a long and storied career as performance and avant-garde artist. Ten years after Kusama's 1958 journey from a con-

lxxxiv Ego Death is the name of the bar where the rape and many subsequent scenes occur.

servative family in Japan to the art scene in New York, Yoko Ono followed the same path.

Kusama paints every day. "I don't think anything or prepare before I paint."[199] Many painters will choose the same subject or landscape to paint over and over again. Kusama chooses infinity, and infinity generously agrees to pose for her. Kusama's Infinity Mirror Rooms (1958-2016) are beyond description. Words fail, though to paraphrase one art critic, they are multireflective installations that allow viewers a deep and immersive "infinity" experience.

And lo, her 1965 Infinity Mirror Room is *Phalli's Field,* a mirthful disarming of the penis, that appendage which has been part and parcel of so much oppression, reborn in a room filled with thousands of phalli, red polka dot on white, stuffed and cuddly, rendered harmless and given the chance to be part of a transformed, liberated, and playful humanity. Kusama's a wellspring of utopian hope. But one informed by having lived through the atomic bombing:

> "I remember the sacrifices during the war. . . . I don't want to ever see this happen again. People being killed and the sacrifices people made. After I die, I hope that people see that my paintings are about love and peace and spirituality. . . . This is a painting titled Footprints of the Atomic Bomb . . . This is about many people's sacrifice. And I hope it will never be repeated. I am not only talking about the bomb but war and conflict in general."[200]

In 1964, Herbert Read wrote, "Those early paintings, without definition, seemed to actualize the infinity of space."[201] It's hard to imagine a more delightful way of tricking power into performing an act of love. Her progression of twenty Infinity Mirror Rooms, begun with the transformation of the penis, concludes (for now) with the unfettered whimsy of a field of bright yellow pumpkins with vertically arranged black polka dots, *All the Eternal Love I Have for the Pumpkins* (2016). "I like pumpkins, everyone loves pumpkins. They're a source of energy."[202]

To shield herself from a world of lies, Kusama lives a utopian truth and, since 1977, goes home to an apartment in a Tokyo psychiatric asylum every evening. Not because she has to. At age ninety, she shares her excitement at having her works seen by young people. Writes Mika Yoshitake, curator of Kusama's 2017 *Infinity Mirrors* exhibit:

> *The Infinity Mirror Rooms* have prompted numerous interpretations. Some critics describe them as producing a disturbing effect in which the viewer's body virtually disintegrates into the infinitely receding reflections that surround him or her; others see the rooms as embodying a utopian challenge that addresses multiple modes of being beyond private, individual experience that remain fundamental to communal living. . . . Her installations and performances of the late 1960s involved the communal application of polka dots and the enactment of the self-styled notion of "self-obliteration" to radically connect individuals . . .[203]

"After I die, I hope that people see that my paintings are about love and peace and spirituality. This is why I am painting. . . . Infinity is infinite energy encompassing the future. I have been fighting through art to weave a new world by using my own philosophy."[204]

Hopefully, there will be a permanent installation that brings us all closer to infinity and usher us into that utopian era. Lord Buckley deployed his talent in the interest of exploring what can happen when people gather, a utopian quest. Through her art, Kusama seeks the same. Her art installations invite a communal experience and, like Buckley's intentions but through a different medium, evoke a communal experience of utopia.

* * * * * * * * *

For the woman, trickster tactics are antidotal to institutionalized demeaning. They are employed in her historic campaign to transcend prescribed roles,

to show us new ways to perceive her and the world, to give us messianic hints and clues that lead us closer to the world of a new woman, a new man, a new person, and a new society.

Yoko Ono contains a multitude of character traits, and her trickster qualities are mixed up in that multitude and require an almost clinical teasing out and distillation in order to behold them.

Yoko Ono—a woman who once wrote, "I like to fight the establishment by using methods that are so far removed from establishment-type thinking that the establishment doesn't know how to fight back." For someone whose art reflected this belief—not in her music, but in her early career as a minimalist, dada, and charter member of the Fluxus movement—and asked the simplest and most outrageously beautiful things of her audience, one can see how critics might consider her silly. What's more difficult to explain are the torrents of critical attacks she has weathered throughout her life, as artist, as musician, as wife, lover, and mother. To get to the parts of her trickster self, much of this noise must be set aside, save for the contrast between her famous husband, whose artistic output was almost always universally praised and hugely popular, and Ono, who as an artist had to struggle to find broad acceptance, understanding, and popularity. At the time of their meeting, and throughout their twelve-year relationship, John Lennon was overwhelmed by the attention and praise he received and sought escape; Yoko Ono was distraught by the lack of attention and by the criticism she received. Both of these experiences carried some personal pain yet viewed from the right angle and, from enough distance, constitute some kind of cosmic joke. The next chapter takes a closer look at Yoko Ono as trickster.

CHAPTER TEN

YOKO ONO: TRICKSTER RE-IMAGINED

Some will say she is an artist, is talented. Others will say she is a phony with absolutely no talent at all. You know what? It's all true, every single contradictory bit of it."

—Norman Seaman[205]

"Cloud Piece": "Imagine the clouds dripping, dig a hole in your garden to put them in." This is not a piece of poetry. Poetry to me is nouns or adjectives. This is verbs. And you have to do them. These are all instructions and when you just do it, then you start to understand it.[206]

It is sad that the air is the only thing we share. No matter how close we get to each other, there is always air between us. It is also nice that we share the air. No matter how far apart we are, the air links us.[207]

—Yoko Ono

"Imagine" was inspired by Yoko's *Grapefruit*. There's a lot of pieces in it saying like "Imagine this" or "Imagine that." If you get a copy of *Grapefruit* and look through, you'll see where I was influenced by her. "Imagine" could never have

been written without her. And I know she helped on a lot of the lyrics but I wasn't man enough to let her have credit for it. So that song was actually written by John & Yoko, but I was still selfish enough and unaware enough to take her contribution without acknowledging it. The song itself expresses what I'd learned through being with Yoko and my own feelings on it. It should really have said "Lennon/Ono" on that song, because she contributed a lot of that song.

—John Lennon[208]

Her perspective is Y E S. She tries stuff out that often doesn't work but sometimes does. Avant-garde artist, activist, and dada perpetuator Yoko Ono shared antics, riddles, pranks, and instructions that led folks in the direction of beauty and love, communion and peace. Never one to shy away from existential pain or hard emotions, her utopian visions are only strengthened by that holism. Looking back, we appreciate her Trickster spirit despite vacillating popularity with critics and the public. She's inspired by artists of the past who might otherwise have been neglected. She shares inspirations with contemporaries who helped her along when she was beat and whom she helped out when she was Beatled. Her art lights the future. With every reevaluation she inspires more and inspires those many generations her junior. Yoko Ono prolonged the life of dada and ensured that artists would continue to imagine, with and without mischief, the playfulness of the child, the art of the absurd, and hopes for a world at peace.

And by artist, this is what she meant: "You don't need talent to be an artist. 'Artist' is just a frame of mind. Anybody can be an artist; anybody can communicate if they are desperate enough. There is no such thing as imagination of artist. Imagination, if you are desperate enough, will come out of necessity. Out of necessity, you will start to get all kind of imagination."[209]

Assessing Yoko Ono demands some considerations. She challenges norms, not only as a woman in the male-dominated Western music and avant-garde art scenes of the sixties, where her kind of assertiveness was unwelcomed, but as a Japanese woman. Her friend, champion, and contemporary,

the Black activist and comedian Dick Gregory, put it thus: "We're not used to seeing an Asian that ain't bent over, smiling, apologetic, she never was that. When was the last time people in the press interviewed any Asian, much less an Asian woman that looked you right in the eye and answered your question and could be as belligerent with her answer as you are with your question?"[210] Whatever bad vibes surrounded Ono, whatever bad behavior she might be accused of, consider that.

And then there's that elephant in the room, her famous relationship with John Lennon, which cannot be ignored but can be put in service to Ono's mission and the fusion their connection represented. As much as possible, I bring up the dramas of her life only when they help explain how her art and her performances energized her tricksterism.

Yoko Ono rebelled against a privileged, wealthy, judgmental, and disapproving traditional family. Leaving that more secure environment, she jumped into the rapids, a life buffeted about by criticism, risk, and misfortune: she lost a custody battle for her daughter, lost her husband to assassination, endured constant criticism of her radical but uneven career in art, took on the daunting task of managing excessive wealth, became emotionally invested in how her art was reviewed and recognized, and faced many other trials. How to dig trickster out of this chaos? While chaos is the trickster's playground, succumbing to lurid and manufactured sensationalism leads us astray. Instead, distill and focus on Ono's life lived as art.

Begin with the Fluxus art movement of the 1960s and '70s. One of Ono's first major influences was composer John Cage, and he is credited with originating Fluxus concepts through his music compositions. John Cage performances were trickster-like in their indeterminacy—by design there was no design. One could not predict where a particular composition—"4:33" is four minutes and thirty-three seconds of silence—would go. Marcel Duchamp, the original dada who entered a urinal into a 1917 exhibition, was still on the scene, and he also heavily influenced Fluxus. And that moniker "art movement" was even indeterminate, as its founder George Maciunas wrote a Fluxus manifesto that was never adopted. Suffice it to say that, like dada, Fluxus artists emphasized the creative process over the finished product. Extending and

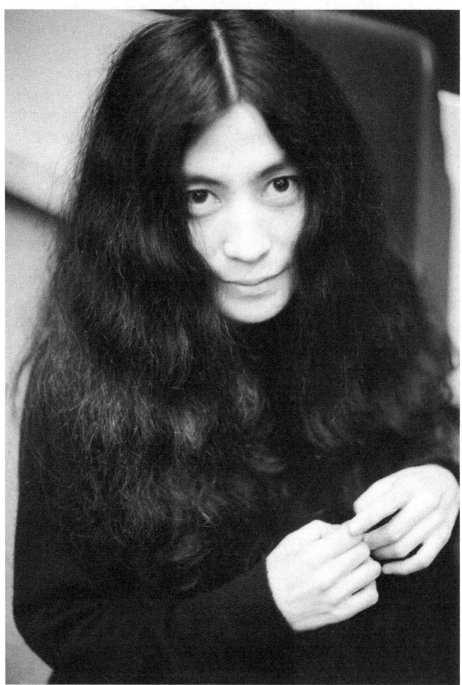

Portrait of Yoko Ono by Linda McCartney, 1968

reviving dada concepts in the sixties, Fluxus gave birth to new art forms such as intermedia,[lxxxv] conceptual art, and video art. In a nutshell, Fluxus broadened the definition of art, and Yoko Ono grew and developed in its midst.

Many well-and lesser-known artists comprised the Fluxus movement, using more modern means such as video and happenings to cross boundaries and involve audiences. Fluxus declared unlimited freedom for the artist on the premise that definitions of art were arbitrary and dispensable. Mixing it up with the essence of Duchamp, Fluxus said call anything you like Art. John Cale, John Cage, Nam June Paik, and Maciunas were notable members. But none became more famous than Ono,[lxxxvi] who deserves credit for bringing Fluxus and dada consciousness to larger audiences.

Jerry Hopkins' biography *Yoko Ono* ably summarizes much of Ono's music and her activist, minimalist, Fluxus art. But he also relies heavily on what the critics thought, often rock critics with no expertise or appreciation for the avant-garde. Further, she was subjected to the sexist realities of the time. The gossipy trash obscured Ono's intentional statements. The flak she attracted is regrettable but instructive. To understand avant-garde art, let alone tricksterism, is beyond the reach of many pop culture reporters. The groomed and siloed media machine was more about making money, scratching surfaces, and reporting trash and scandal.

These larger-than-life distractions obscure Ono's portfolio, generally of Fluxus performance art. Ono continues, echoes, and advances the statements of disruptive dada and other avant-garde artists such as Arnold Schoenberg, Kurt Schwitters, Emmy Hemmings, Andy Warhol, and many lesser-known tricksters of the movement, who cross or even erase the boundaries between art and life.

The trickster attribute of scatology is built into Fluxus. While the Latin translates to "insistent change," or "flux," Maciunas preferred the alternate definition of Fluxus, "the forceful evacuation of the bowels." His icon for the movement was a line drawing of a man bent over and breaking wind. But when pressed,

lxxxv Intermedia is 1960s art that mixed genres, like drawing and poetry, painting and theater, collage and photography.

lxxxvi Here is a list of the most notable Fluxus artists. See how many you recognize: Joseph Beuys, George Brecht, John Cale, Robert Filliou, Al Hansen, Dick Higgins, Bengt af Klintberg, Alison Knowles, Addi Køpcke, Nam June Paik, Ben Patterson, Daniel Spoerri, and Wolf Vostell.

he defined it as "a fusion of Spike Jones, vaudeville, gag, children's games, and Duchamp."[211] In a number of shows put on during her New York avant-garde phase, Ono would wire a microphone to a toilet and ensure that a few well-timed flushes were broadcast into the theater, all part of the performance.

Ono's most elegant, prankish, and hilarious nod to scatology was the ad she placed in the *Village Voice* announcing a special exhibit of her work at the Museum of Modern Art—an exhibit that did not exist, even though some disappointed museumgoers fell for the trick and showed up. In serious mode, she was protesting the lack of women artists in MOMA's catalog. In trickster mode, she is depicted holding a shopping bag with a large *F* painted on it and had the photo snapped as she approached the word *Art* in the Museum of Modern Art's sign.

HER (F)ART

In Hanover, Germany, dada Kurt Schwitters turned his own house into a work of art, calling it by a nonsense word, the *Merzbau*. He began in 1923, and for the next fourteen years, he continuously converted rooms, embellishing its architecture with his art of fantastic angles and geometry. In 1966, Yoko was living with her mate Tony Cox in a London flat in Hanover Gate. In that same spirit, Yoko wanted to turn that flat into a work of art, in her own aesthetic, which we now know, like Schwitters's, tended to favor black and white.

Lindsay Zoladz of *Vulture* captures Ono's spirit nicely: "Every image is a painting; every sound is a song. . . . Ono's early art reminds me of Yves Klein, the impish French artist whose first piece was—in his imagination—to sign his name in the sky."[212]

Ono helped to create and lead a trendy, avant-garde movement. In 1960, she hosted a series of collaborative performance art events in her New York loft, events not well attended. Yet today it's recalled as a watershed moment in performance art.

In *Grapefruit*, a compilation of notes begun in 1961[lxxxvii] and first published that same year, Ono instructs:

lxxxvii Excepting one from 1953.

PAINTING FOR THE WIND
Cut a hole in a bag filled with seeds
of any kind and place the bag where
there is wind.

-1961 summer

PAINTING TO LET THE EVENING LIGHT GO THROUGH
Hang a bottle behind a canvas.
Place the canvas where the west light
comes in.
The painting will exist when the bottle
creates a shadow on the canvas, or it does
not have to exist.
The bottle may contain liquor, water,
grasshoppers, ants or singing insects, or
it does not have to contain.

-1961 summer

PAINTING TO BE CONSTRUCTED IN YOUR HEAD
Go on transforming a square canvas
in your head until it becomes a
circle. Pick out any shape in the
process and pin up or place on the
canvas an object, a smell, a sound,
or a colour that came to your mind
in association with the shape.

-1962 spring
Sōgetsu

PAINTING TO HAMMER A NAIL
Hammer a nail into a mirror, a piece of
glass, a canvas, wood or metal every
morning. Also, pick up a hair that came

off when you combed in the morning and
tie it around the hammered nail. The
painting ends when the surface is covered
with nails.

-1961 winter[lxxxviii]

Ono's first major show, 1962 in Tokyo, was universally panned, criticized as unoriginal, and just plain disliked. But nine years later, she mounted a nationally recognized show at the Everson Museum in Syracuse, New York.[lxxxix] The Newsweek review noted that "The big world knows Yoko only as Mrs. Lennon . . . but . . . Yoko has been a presence in the American avant-garde for more than a decade . . . a crucial member of the Fluxus movement . . . she has been a continuing influence on other artists through her concerts, performances, films, paintings, and writings."[213]

Some call it conceptual, but Ono's art is best described as instructional, a slight but crucial advancement over dada; rather than just shocking the audience, it calls for participation. The piece was not complete until the audience left the position of observer and participated. Even refusal to participate, rebelling, was considered a form of participation.

"The difference between the Dadaists and Surrealists and the artists of Yoko's period, Allan Kaprow says, is that the earlier artists '. . . tended to consider the audience as whipping boys. They were intent on shocking people, where we were out to involve people. What we were doing was democratic and, I think, invitational.'"[214] Ono distinguished herself with instructional art," said Anthony Fawcett, "art that made people think, gave people things to do."[215]

So this movement of involving the audience or spectator in art in a more engaging way could be found in the humor of artists like Any Warhol—who used images of the ultra-relatable Campbell's soup cans, bananas, Mao Tse-tung and Brillo pads to make pop art—and in Claes Oldenburg's out-

lxxxviii Yoko Ono, *Grapefruit* (New York: Simon and Schuster, 1970, 2000, unnumbered) includes all four examples. Printed in conjunction with the exhibition **Y E S** YOKO ONO, Contemporary Arts Museum, Houston, July 14-September 12, 2001.
lxxxix This coincided with the release of John Lennon's *Imagine* album, which she helped produce.

sized sculptures of pencils, spoons, spades, cheeseburgers, and clothespins. Judith Malina's Living Theater pulled audience members onto the stage and involved them in the play's action. George Segal invited folks to sit inside chicken coops and rattle noisemakers. George Brecht's Motor Vehicle Sundown—perhaps the first flash mob—had participants get into their cars and follow instructions to turn headlights or radios or windshield wipers on and off, honk horns, open and close windows. Allan Kaprow did a piece where he swept the woods with a broom.[xc]

The boundary between art and life, or art and politics, is the boundary between the spectator and the participant, between the artist wanting to be observed and the artist as inspiration, as organizer and activist. Ono's approach creates space, and space for playfulness. Taking instruction means making something real. As Ono herself put it, "The conceptual reality, as it were, becomes a concrete 'matter' only when one destroys its conceptuality by asking others to enact it, as, otherwise, it cannot escape from staying 'imaginary.'"[216] When we make art part of our lives, and our lives part of our politics . . .

Ono's art, play, life gain a bigger stage in 1964. In Tokyo, she screened one of the Rock Hudson/Doris Day films and instructed the audience to look only at Day. Cut Piece, more about pain than peace and love, was first performed in 1964. Yoko sat unmoving while the audience was invited, one by one, to take scissors and cut a portion of her clothing off, until she was left naked on stage, again with no expression, no movement.

Woman shown as a demeaned and oppressed sex in both Japan and the West recurred as subtext to her otherwise playful art. Sexism, a wrong that needed righting, stood in the way of a more fully realized society. In Rape, made with Lennon, a film crew used the camera to pursue and harass (with permission) a young girl in the streets of Vienna for three days. Not only a feminist work, Rape also generalized the term, depicting how the media hounded Yoko and John. As a feminist, Yoko brought unabashed exposure and unsentimental depictions of miscarriages, rape, sex, nudity, body-conformity, and pregnancy. Yet the seriousness of how these phenomena are experienced

xc Think of it as acting out Naïve artist Henri Rousseau's painting *The Dream,* which features a couch in a jungle setting.

is never too far away from her sense of slyness and mischief that ultimately invites fun and the hope of resolving pain and suffering.

Female artists broke into the boys' club. Carolee Schneeman painted onto the bodies of dancing naked humans in Meat Joy, asserting the erotic and playful over the pornographic. Charlotte Moorman was attracting attention as the organizer of the city's annual avant-garde festival—and she would play her 'cello while sitting on the back of a man down on all fours.

Double meanings and irrepressible playfulness, signatures of trickster signifyin(g), can be detected in Ono's film Bottoms/Film No. 4, a 1967 montage of 365 close-ups of different buttocks—right, left, top, bottom. Ono's inspiration came from watching a housemaid scrub a floor: "I thought the movements her behind made were very humorous,"[217] but seen through a feminist lens, the film battles advertising that conditions us to particular body images, telling us what an attractive behind looks like. Fifty years later, Madison Avenue takes this seriously and diversifies advertisements.

Then again, maybe not so serious: Ono "also said she hoped that in fifty years or so, when people looked back at the 1960s through the films produced during that decade, they would see 'not only the age of achievements, but of laughter.'"[218]

And then there were pranks that summer of '67: dancing naked in public with Tony Cox; the old dada prank of fake news, reporting the theft of a film soundtrack to a documentary about a saint's thighbone being returned from Venice to the site of his martyrdom on the Greek island of Chios; and wrapping herself in cloth and being tied to the lion statues in Trafalgar Square.

She'd met John Lennon in 1966. By 1968, they were together and made Smile/Film No. 5, which took a high-speed filming of John breaking into a smile, one minute's worth, and showed it at a regular speed, extending the spread of John Lennon's smile to thirty minutes. This piece was clearly influenced by Andy Warhol and . . . was a lot of fun!

Ono's Water Piece, part of the 1971 Everson Museum exhibition, invited artist friends to contribute anything to do with water. She received steam engines, poems, test tubes with colored water, microphones in tanks of water, ice cubes, fish tanks, a refrigerator. One old friend, Bob Watts, sent a Volkswa-

gen convertible filled with water and fish. As if to prove that anyone can be an artist, Yoko and John's favorite submission was of a ship's compass, submitted by their driver.[xci]

Most of Ono's art is what you see is what you get, or at least what she asks you to imagine, but sometimes there are hidden meanings. Painting to Be Stepped On, one of several "Painting" instructions (Painting to See the Skies, Painting to See the Room, Painting to Be Constructed in Your Head, Painting for a Broken Sewing Machine, etc.) instructed the participants to walk on and allow others to walk on an empty canvas placed on the floor or in the street. Yoko had canvases mounted on the floor of her apartment for just this reason.

But this piece also symbolizes the persecution of Japanese Christians during Edo-period Japan, when they were subjected to Fumi-e (translation: painting to be stepped on) and forced to betray their religion by walking on paintings of Jesus and Mary. Thus Ono presents a trickster boundary between a painting born of playful instruction and one of desecration and religious oppression.[219]

THE PLAYFUL AND THE REAL

Ono explores the seam between dada and surrealism. In Half-a-Room, she furnishes a quite ordinary room with a bed, a table, chairs, a clock, a radio—but everything is painted white—and cut perfectly in half. The film Fly follows a fly as it travels up and down and all around a sleeping nude. Simple and provocative ideas played out.

Ono was already committed to feminism and fundamentally aware of racial and cultural games of domination. Once she and Lennon were together, the politics of her art became even more explicit. Absurdism and liberation politics conjoined.

She emerged as a female trickster in culture and politics. Her art migrated from the less accessible world of the avant-garde into the pop, into the political. The most famous, performed with her groom, was Bed Peace, where Yoko and John spent their two-week honeymoon in bed, a "bed-in" riffing off of

xci Other invited contributors included Bob Dylan, Jasper Johns, Dennis Hopper, Isamu Noguchi, Paul Krassner, and Spike Milligan.

the then-current form of protest, the sit-in. It's 1969, and The Beatles are still together, still the most famous people in the world, so Bed Peace brought a huge crowd of media into the couple's hotel rooms, first in Amsterdam and then Montreal. The press and much of the public was all too eager to ridicule the event, but when compared to the drivel that passes as coverage of celebrity marriages, one must ask where the ridiculous truly lies.

Like the Yippie prank of levitating the Pentagon; like the Yes Men impersonating VPs from Dow Chemical; like Marcel Duchamp painting a mustache on the Mona Lisa; or Banksy, a smiley face—Bed Peace laid down a historical marker that, looked back upon, points to a better, more playful and peaceful future.[xcii] Ono released a ninety-minute film of the event in 2012. On International Peace Day 2020, Yoko added this message: "Dear Friends, In 1969, John and I were so naive to think that doing the Bed-In would help change the world. Well, it might have. But at the time, we didn't know. . . . The film is powerful now. What we said then could have been said now. In fact, there are things that we said then in the film, which may give some encouragement and inspiration to the activists of today."[220]

When the trickster speaks truth to power, power's first reflex is to dismiss. Lennon, in Bed Peace, confronted this dynamic directly: "Yoko and I are quite willing to be the world's clowns if by so doing it will do some good. I know I'm one of these 'famous personalities.' For reasons only known to themselves, people do print what I say. And I'm saying peace. We're not pointing a finger at anybody. There are no good guys and bad guys. The struggle is in the mind. We must bury our own monsters and stop condemning people. We are all Christ and we are all Hitler. We want Christ to win. . We're trying to make Christ's message contemporary. What would he have done if he had advertisements, records, films, TV and newspapers? Christ made miracles to tell his message. Well, the miracle today is communications, so let's use it."[xciii]

xcii In 2013, singer-songwriter Jhené Aiko made a video and recorded a song that re-creates the 1969 *Bed Peace*. "Bed Peace" appears on Jhené Aiko, *Sail Out*, Def Jam Recordings, 2013. The song and video also feature Childish Gambino.

xciii *Bed Peace*, directed by Yoko Ono and John Lennon, 1969; and in Jerry Hopkins, *Yoko Ono* (London: Sidgwick & Jackson, 1987), 101. On Ono's website, http://imaginepeace.com/archives/15702, the pronoun for Christ is not capitalized.

In a further effort to promote peace, Yoko and John posted a special 1969 Christmas message on billboards in London, Paris, Rome, Berlin, Athens, Tokyo, New York, Los Angeles, Toronto, Montreal, and Port of Spain: "war is over—if you want it—happy Christmas, John and Yoko."[221] It's a beautiful expression, and it's also a trick that, like the Yes Men, tells lies to reveal a deeper truth. The wars in Vietnam, Laos, and Cambodia were far from over and did not end for another six years.[222] But the trickster in utopian mode always seeks peace, always looks to the fun that lies beyond war.

Acorn Piece followed the peak of Bed Peace. Ono and Lennon had one hundred acorns collected and mailed to world leaders, with the message that they plant an oak tree in the name of peace. These went to everyone from Haile Selassie to Richard Nixon.

Three years later, in February of 1972, Yoko and John appeared as cohosts for a week on the nationally televised Mike Douglas Show. In that same spirit of the playful meets the political, Yoko gave the national audience this instruction: "Call a stranger every day and say 'I love you'—pass this message along. By the end of the year, everybody in the world will have gotten your love. There are so many lonely people in this world, and we have to tell them we're connected."[223] To demonstrate, Yoko was given a phone while on camera. She dialed a number at random and delivered the message to an unsuspecting but lucky woman.

This same year, John was fighting deportation. In a stunt that must have made Abbie Hoffman proud, they held a press conference announcing the establishment of a new country, Nutopia: no boundaries, no passports. Under its cosmic laws, Lennon declared that "All people of Nutopia are ambassadors of the country. As two ambassadors of Nutopia, we ask for diplomatic immunity and recognition in the United Nations of our country and its people."[224] Lennon was sick and tired of playing the immigration game, so he played with the game.

Yoko attended a conference on feminism in Chicago. One friend observed that, even in the midst of this most serious struggle, Yoko's trickster charm couldn't help rising to the top. One friend commented: "Yoko really strutted her stuff, she was wearing her uniform—the beret, the hot pants, the boots.

And she had the women's rap down. In a way it was kind of cute. She came on strong, she said men were pigs, and she was wearing hot pants and talking in her little tinkly voice. A lot of the other women didn't know quite what to make of her."[225]

Tricksters Yoko and John cross and recross the boundary between playful fun and serious politics. War, racism, capitalism, and sexism were their main targets.

In her college days, Ono entered the art world with ideas, concepts, poetry, and instruction. By the mid-1960s, she'd joined Fluxus, making intermedia art, making things. But it was the later events, performances, and media that drew attention. A good example is her notorious B-side to Lennon's hit single "Starting Over." "Kiss Kiss Kiss" ended with Yoko's cries of a real or fake but very definitive orgasm. That and Cut Piece spoke to Ono's unblinking art of sexual reckoning—confront sexism and be sexual.

In reacting to critics of her music, specifically the 1971 Ann Arbor benefit concert for White Panther John Sinclair, Ono asserts the dada ethos of fast and direct connection: "Folk songs of this age, pop song is becoming intellectualized and is starting to lose the original meaning and function. Aristocrats of our age, critics, reviewed the Ann Arbor rally and criticized the musical quality for not coming up to their expectations. That was because they lost the ears to understand the type of music that was played there. That was not artsy-craftsy music. It was music alongside the idea of, message is the music. We went back to the original concept of folk song. Like a newspaper, the function was to present the message accurately and quickly."[226]

Lennon can be credited with pushing both their lives into political realms, and Ono with expanding that vision to include egalitarian relationships. She wrote the song "Woman is the N***** of the World." She quite astutely stated that "in the '60s there was a sexual revolution and everybody was all excited about it. But then it turned out to be a sexual revolution for men and not for women. And so women started to feel very resentful and . . . were used . . . for their revolution."[227] Expanding on that critique, she said that "the ultimate goal of female liberation is not just an escape from male oppression. How about liberating ourselves from our various mind trips such as ignorance, greed, masochism, fear of God and social conventions?"[228]

The couple also did a benefit at Harlem's famed Apollo Theater, held for the relatives of Black prisoners shot in the revolt at upstate New York's Attica prison. And there were many more performances, contributions, and events for progressive causes to which the couple lent their fame and talents.

If you dismiss as silly an artist's fantastic and playful ideas, you miss out on the fun, on how that kind of imagination might inform the real and the so-called serious. And the opposite might also be true. When Lennon was killed, Ono doubled down on their commitment to spreading the utopian creed of love and peace, and she did not lose her playful perspective.

She transformed into art how her partner's 1980 murder almost shattered the life she was rebuilding. On 1981's Season of Glass, an album that recalls Lennon throughout, she tries to refuse a new lover on "No No No" and follows it with a plea, "Will You Touch Me." Season of Glass faced the tragedy of Lennon's death and the persistence that brought her through her grief. On the first anniversary of his death, she made a video and shared this message worldwide: "I hope his death serves as a springboard for finally bringing sanity and peace to the world. John died in the war between the sane and the insane. He was killed by an insane act at a time he was enjoying the sanest moment of his life."[229]

YOKO AND JOHN ARE ONE

Ray Coleman's biography[230] divides John Lennon's life into two parts: "before Yoko" and "after Yoko." Which is how they looked at it too.

Ono's art influenced their collaborations. Instructions for *Bed Peace* and *Acorn Piece,* conceived by both, could easily have appeared in *Grapefruit.*

Ono's poetry and art conjured fantasies as wild as you could imagine:

> Imagine one thousand suns in the
> sky at the same time.
> Let them shine for one hour.
> Then, let them gradually melt
> into the sky.
> Make one tunafish sandwich and eat.

and

Make a hole.
Leave it in the wind.[231]

As fantastical as Ono makes her art, she is anchored in the real, embracing the dada concept of making your life your art. Yoko's creations tend to be autobiographical or to conceptually adopt the natural world (the sky, the sun, the wind) or the built world (a ceiling, a floor, a tuna fish sandwich) or to give instructions to real people engaging with the art, but no stories with made-up characters. She signifies on storytelling, tells no stories but her own.

John Lennon concocted some great characters, the likes of Day Tripper, Paperback Writer, Mr. Kite, The Walrus, the King of Marigold, the Duchess of Kircaldy, Nowhere Man, Prudence, Bungalow Bill and Sexy Sadie. His departure from this songwriting device coincided with getting together with Yoko. Final Beatles characters had a strong McCartney ring to them: Maxwell Edison, Mean Mr. Mustard, Polythene Pam…the most John-ish being more of a demigod, Sun King. All these came out in 1969, the same year as *Ballad of John and Yoko.* In other words, 1969 was the last time John was telling stories symbolically in song and the first time he and Yoko *became* the iconic story. *Plastic Ono Band* (1970) and *Imagine* (1971) affirmed that transformation. Henceforth, everything was about the reality of politics, personal and societal, and about real people, usually themselves.[xciv]

This migration from the playful to the real continued. Tricksters, as we've known them, flourish in the fertile soil of footloose and fancy-free playboy types, but following his 1973-74 eighteen-month "lost weekend" of decadent carousing in LA and New York, John renounced sexism, became a househusband, and the two became one.

Dick Gregory put it like this: "I've never seen a relationship that was as equal. They came together, they moved together. It would have been very easy for him to be just John Lennon. The press didn't want this Asian to be

xciv An interesting digression would be to discuss the most idiosyncratic song in the Beatles catalog, *Revolution 9*, which Ono, in 1968, participated in making and which was an experiment during their budding romance.

part of it, but he said, 'It's me and her. We are one.' He demanded that you not overlook her."[232]

In the midst of the seriousness of antiwar politics, Lennon's tribulations with US Immigration, and Ono's painful estrangement from her daughter Kyoko, trickster humor and mischief got sidelined. But dig through this and consider that the declaration of Lennon and Ono's union may have germinated a new edition of the trickster persona, one more inclusive of the feminine.

Tricksters don't come on as leaders, they're too busy mocking them. And like magicians, they'll employ misdirection: don't look at me, look at the trick. In a variation on that theme, once Lennon and Ono got together, their messages to the world emanated from their union, they shared credit and traveled the pathways of love, finding inspiration in each other, sharing or discarding authorship.

They midwifed the egalitarian relationship.[xcv] What had been a fantasy, what no celebrity would publicly attempt in the late sixties, they made real and thus wrote a new chapter in the book of Trickster. They crossed the boundary of the historically chauvinistic relationship and played the trick of speaking for each other, evincing the Trickster god Hermes in two-headed quicksilver indeterminacy. Of course, this irked Paul, Ringo, and George to no end in the Beatles' final days. But "[if Trickster god] Hermes is involved, after a touch of chaos comes another cosmos. Hermes is a god of luck, but more than that, he stands for what might be called 'smart luck' rather than 'dumb luck.'"[233]

The time for their shared dreams of utopia has not yet come, but on its path, the extremely public romance between Yoko Ono and John Lennon modeled the male painfully and publicly coming to terms with his sexism. Of course, John preached love and peace for a few years before meeting Yoko; it's part of what made the attraction possible. But all of the tabloidesque chatter aside, together they committed to doing what they could as simple and flawed human beings, to use their fame as a pulpit to invite the world to join them on that road to (N)utopia.[xcvi] They combined a clear-eyed assessment of

xcv Whether John and Yoko achieved an egalitarian relationship is less important than the fact that they declared it and set it up as a worthy ideal.

xcvi "What makes Yoko Ono and John Lennon so crucial to our contemporary culture," wrote Kate Millett, "is their refusal to live only in the world of art. Instead, they have

the state of the world with what could loosely be called a New Age approach to making worldwide peace:

> People think of fantasy as different from reality, but fantasy is almost like the reality that will come. Everyone creates the fantasies, so everyone creates the reality. If you look at it that way, then George Orwell will create 1984. That's the general trend of the male species, I think—creating that kind of fantasy. . . .
>
> . . . [W]e were doing commercials for peace.
>
> When we did the bed-ins, we told the reporters that and they responded, "Uh-huh, yeah, sure . . ." But it didn't matter what the reporters said, because our commercial went out nonetheless. It was just like another TV commercial. Everybody puts them down but everybody knows them, listens to them, buys the products. We're doing the same thing. We're putting the word "peace" on the front page of the paper next to all the words about war.[234]

When you consider that Lennon and Ono compelled the press to pay attention to the war in Vietnam, freedom of expression, censorship, and police brutality, when the mainstream coverage of rock stars focused on hair color, astrological sign, drugs, lovers jilted and otherwise, the usual gossip, and maybe music, it really did mark a step forward. And they were able to take on the most serious issues with an avant-garde prankster mindfulness and tap the messianic in trickster.

MORE TRICKSTER ATTRIBUTES

- **Gender Fluidity**—Ono and Lennon's first collaborative album, *Two Virgins* (1968), featured the infamous cover of the couple naked, packaged in a variation on the plain brown paper bag. The album, on the

reintegrated art with the social and political facets of life and offered us something like moral leadership through their committed pacifism. Using all the resources of their prestige and popularity, they have unceasingly protested the crimes of humanity upon itself." In Hopkins, *Yoko Ono*, 172.

Apple label, celebrated their romance. Apple's art director, John Kosh, wanted to include a jigsaw puzzle that, when assembled, reversed the couple's genitals.

- **Willingness to Accept Humiliation**—John's "clown" remark covers this quite nicely, but as a target for critics, Yoko had to carry an inordinate share of bad reviews, some of them deserved. She hated it; she wanted her art to be understood and loved, but she was willing to continue undaunted despite the fairly regular public humiliation and disrespect she endured.

- **Sexy Lonerism**[xcvii]—Ono's aristocratic family of origin came with all its pretenses of entitlement and the iciness and distancing typically associated with the upper class. In rebellion, she made her way into New York's hipster avant-garde and pursued her own sexual liberation, consorting with a bevy of lovers. But the upper-class background did give her confidence, an assumed position of power. She forged her own solitary path. As a child in occupied Japan, she was in poverty throughout World War II and was poor again as a newcomer artist in New York, strengthening her independence. She asserted her place in a man's world of art and competed successfully as a Japanese national in the West. She boldly pursued romance with a Beatle. And these successes, her American fame, only provoked a negative reaction in Japan, where she was treated as an alien.

In her solo work, she influenced both minimalist artists and ardent feminists. All of these achievements required that trickster confidence that does not depend on others.[xcviii]

xcvii "... A state of being alone embraced by mostly schizoids, weirdos, outcasts, loners, ninjas, shaolin heroes, and geeks." See Footnote 7.

xcviii In Hopkins, *Yoko Ono,* 143-144: "Yoko talked about her 'Who Has Seen the Wind?' There was something 'of a lost little girl about it,' she said, a sense of 'quiet desperation.' [Interviewer Jonathan] Cott' appreciated what Yoko was saying and himself added that "Religion, a philosopher once said, is what you do with your aloneness.. . . . or, one might add, with your pain and desperation. Yoko's music pushes pain into a kind of invigorating and liberated energy, just as a stutterer finally gives birth to a difficult word, since it existed originally at the fine edge between inaudibility and the sound of waves of dreams.'"

And lonerism can get you places. The internationalism of her "strange woman in a strange land" theme set the tone for a twenty-first century where multiracial and international artists of more varied backgrounds define the scene. Finally, given the constant affirmation of her union with John Lennon, the strength of her lonerism seems highly ironic, until it makes perfect sense.

- **Divinity**—Like Sun Ra, Jimi Hendrix, David Bowie, Janelle Monáe, George Clinton. and others, Ono entertained notions of not being of this Earth. Accepting the 1982 Grammy for *Double Fantasy* (Album of the Year), Ono shared that "John is with us here today. Both John and I were always very proud and happy that we were part of the human race who made good music for the Earth and for the universe. Thank you."[235] Also, she is clearly moved by the rapturous applause, deliverance of the recognition she'd always sought.

If John and Yoko are one, an uncanny redemptive quality to Lennon's untimely death would be that, like the West African Trickster god Eshù Elégba, Yoko from that point on walked with one leg in the world of the living and the other with the dead.

TRICKSTER: EXPANDED EDITION

The final proof of Ono's trickster force is her vulnerability. She detested humiliation, yet Trickster consciousness doesn't ask trickster to *like* such humiliation, only that she be willing to accept it as part of the package, as the price of liberation, be "willing to be the world's clowns if by so doing it will do some good."

All of the distractions of love/money/fame/art would batter, stretch, distort, and maybe ruin a soul weaker than Ono's. So much of her early work failed to garner attention, and much of the attention paid to her later work was unfriendly. She's survived that parade of distractions and come through as strong as any major sixties artist; but she's nonetheless human and subject to the beatness[236] and the beatings of the world. *Cut Piece* may have been a foretelling of her life in waiting.

Ono's body of art thus emerges as an ephemeral, flickering hologram, like the one of Princess Leia that kicks off the original *Star Wars* film, where she warns of danger and shares information vital to the survival of the rebellion. In this case, the information embedded in Princess Yoko's ART2-D2 stokes rebellious love, utopian vision, autobiographical honesty, shameless sexuality, uncomfortable pain, and a straight-faced sense of the absurd (nothing, ultimately, is taken too seriously)—in short, a trickster persona not unscathed by the torments of life in the late twentieth century. This Force is strong with her!

This survivability, this enormous strength, may be the most important contribution she makes to humans coming to terms with their own trickster tendencies. Just ask Robin Williams, Abbie Hoffman, Alfred Jarry, Hunter S. Thompson, John Lennon, Lord Buckley, Neal Cassady, Andy Kaufman, and a host of other trickster men who met sad and premature deaths. At the time of this writing, Ono is eighty-eight years old and going strong.

What, if any, is the trickster-inspired messianic message of the John and Yoko union? So many fans perceived her as a negative influence on the dream that they had come to know as The Beatles. But under the fair assumption that she was not the cause, that the band was likely to break up anyway, consider a John Lennon who'd have conformed to the low expectations the public had of sixties rock stars: infidelity, drug abuse, apolitical attitudes, immoral behavior. And consider what we got instead: the egalitarian relationship writ large, huge energy added to the antiwar movement and the politics of peace, the househusband, the wife able to manage an incredibly complex estate, a commitment to full sharing, the couple's togetherness coming first and the work second, and a second act of his musical career that fully aligned with the honesty, love, and politics of his life in the 1970s. They were not unique in this; they'd joined a broad movement towards social and sexual justice. But they were in the vanguard.

* * * * * * * * * *

Despite their tendencies to play with gender, trickster tales are often told from a male perspective and are custom fit to a male psychology, a psychology

of the philandering playboy if you will. Patriarchy and the male orientation of trickster legends mean that we find far fewer examples of female-centric tricksters. Such folklore is hidden, perhaps made extinct, or has yet to be written as we enter a more gender-just age. If there is a collective unconscious, a fountain not made by the hands of man, it would be a source unencumbered by the prejudices and the -isms from which we struggle to free ourselves. So when a strong female like Ono assumes a trickster persona, it may be harder to recognize, it may bring to light previously unnoticed trickster attributes, a revised profile. It may augur a new chapter in the world's folklore.

For such a famous figure, if we can see through all that swirls and surrounds Ono's art and life, the mist, smoke, and spittle of the critiques that bother her, as well as the accolades that please, we discover an overlooked trickster attribute, a form of equanimity. If art invites audience participation, and the art succeeds if the audience is willing, and the art succeeds if the audience refuses, this births a new trickster attribute: I am what I am and your reaction to it makes me what I am and puts a shared process into motion no matter what that reaction is. Equanimity, the less erratic side of moral indeterminacy, is found embedded in tantalizing and irresistible connection.

Like all tricksters, Ono dances on boundaries: between Japan and the US and England; between music and art; between art and life; between lonerism and union; between protest politics and utopian dreams; even between the living and the dead.

FUTURE GAMES

TIME TRAVEL, THE POGO STICK OF PHILOSOPHY

Time travel offends our sense of cause and effect—but maybe
the universe doesn't insist on cause and effect.

—Edward M. Lerner[237]

Bill: How's it going? I'm Bill, this is Ted. We're from the future.

Socrates: Socrates.

Ted: [whispering to Bill] Now what?

Bill: I dunno. Philosophize with him![238]

I n 1895, H.G. Wells's *The Time Machine* captured the popular imagination and set the tone for our infinite fascination with time travel. Its attendant gadgetry kept the nerdier fans busy, while others were distracted by the possible and impossible science of it. But the idea of time *travelers* and time travel's effect on human nature carries the most significance and intrigue. The time traveler, like a cosmic pogo sticker, bounces in and out of moments, performs from a place of detachment yet also influence. Uprooted from the present, the personality of the time traveler may seem cavalier, not responsible or bound to the consequences of their actions. But the Pogo Stick Thesis is that

time travelers, in their ability to witness, digest, and consider the failings of the past and the promise of the future, can shed light on a more playful, hopeful, and less time-bound society.

The well-worn but amusing tropes of time travel appear frequently. Among the plethora are Interstellar, Peabody's Improbable History (with his trusty Wayback Machine), A Christmas Carol, Hot Tub Time Machine, Planet of the Apes, Time Bandits, The Terminator, Marge Piercy's feminist take Woman on the Edge of Time, Heroes, Rip Van Winkle, Pan's Labyrinth, Quantum Leap, Galaxy Quest, Donnie Darko, The Avengers, The Twilight Zone, 12 Monkeys, Back to the Future, A Wrinkle in Time, Slaughterhouse Five, Midnight in Paris, Looper, Run Lola Run, Star Trek, A Connecticut Yankee in King Arthur's Court, and Dr. Who, to name just a few.

J.K. Rowling duly restates it in her Harry Potter novel, *The Prisoner of Azkaban.* In Alfonso Cuarón's film version, Harry and Hermione depart the present, make daring rescues, then show up back in their classroom at Hogwarts. Harry allays suspicions, with tongue in cheek, "Honestly, Ron, how can somebody be in two places at once?"

And Jimi Hendrix sings of being a million miles away and at the same time right here.[239] Lighthearted spins on a person multiplying by time-traveling into their own past. Time travel is fun! Might it foment a particular attitude or converge on a particular personality type? HBO's *Watchmen* tries to form an answer to this in its portrayal of Doctor Manhattan, an almost omnipotent being who lives in multiple times simultaneously and so adopts a curiously passive attitude towards altering events and history—he's learned *not* to intervene. There are streaks of the Trickster god in him, that time travel, as part of his very being, connects him to the world's past, present, and future while at the same time detaching him and thus renders his responses to people and their dramas impassive. Though he doesn't laugh, he senses the mutation of human history on Earth as one big cosmic joke. Great suffering, great laughter.

Time travel is an attribute of the rule-breaking Trickster archetype. The Trickster archetype has been with us since at least the times of the Huli jing, Jacob, and Wakdjunkaga. The Trickster takes many forms but is defined by

playfulness, and C.G. Jung describes Tricksters as typically having these qualities: "his fondness for sly jokes and malicious pranks, his powers as a shape-shifter, his dual nature, half animal, half divine, his exposure to all kinds of tortures, and—last but not least—his approximation to the figure of a saviour. . . . In his clearest manifestations, he is a faithful copy of an absolutely undifferentiated human consciousness."[240]

Two examples are particularly instructive and demonstrate the lighthearted approach of the trickster who substitutes fun for power.

In *King Lear*, the *Godfather* of its time, Shakespeare exposes the folly of power through a play about how it slips away. *Lear's* Fool matches elusive power with a taunting dance of his own. He represents Lear's conscience, but Lear ignores him. The Fool makes Lear's madness worse, drives him crazy. Time is the Fool's theme. He dances on the story's mushrooming graves and uses his power of prophecy to make a critique of priests, brewers, nobles, squires, usurers, tailors, bawds, and whores.

By definition and decree, the Fool has not power, but vision. And in that vision, sees power as madness. Shakespeare further endows this uncanniest of characters with time-travel abilities. Does that embolden and allow him to mock power without hesitation or fear? In his final lines, the Fool invokes "The prophecy Merlin shall make, for I live before his time," suggesting his ability to travel from Lear's eighth century BCE to Merlin's 500 CE.

Then suddenly he vanishes. The Fool provokes by his very absence. Freed from Lear's endgame, freed of time's bonds, the Fool drifts out of the play and into another era.

Lear's Fool has the privilege of speaking truth to power but wields none in the conventional/institutional sense. In mythology and folklore, Tricksters are simply born powerful, or they obtain power through trickery, not imperial conquest. In his comic retelling of King Lear, Christopher Moore discovers the Fool's divine potentiality, lonerism and detached uprootedness: "The fool's number is zero, but that's because he represents the infinite possibility of all things. He may become anything. See, he carries all of his possessions in a bundle on his back. He is ready for anything, to go anywhere, to become whatever he needs to be. Don't count out the fool . . . simply because his number is zero."[241]

Shakespeare's political wisdom is that power is a fool's game, and it takes a Fool to reveal this. Through the depth of Lear's characters and the device of time travel, Shakespeare offers a narrow, hopeful, shimmering lifeline to a world that trades the time-bound exercise of power for the more lighthearted and fun life that time travel inspires. The Fool points to a future of possibility. Though bound by the trappings of the court jester, time travel is his trump card, his prophetic transcendence of power.

What about the more liberated Trickster character, Bugs Bunny? In 1944's *The Old Grey Hare,* Bugs and his foil Elmer Fudd time-travel to the year 2000, where, in their creaky twilight years, the comic antagonists play out their eternal routine. Eh, what's up, prune-face?" hails old Bugs, who is suffering from lumbago.

In a tour de force of phony sentimentality, Bugs fakes a mortal wound when shot by Elmer's Buck Rogers Lightning-Quick Rabbit-Killer. Bugs whips out a scrapbook he'd apparently been keeping, and we time-travel again, back to their first chase as infants. After reenacting the "What's up, doc? I'm looking for a little baby bunny. What's he look like, doc? He looks . . . just like you!" routine (see Marx Brothers in chapter three), the chase ensues but is suddenly halted. Baby Bugs says, "Uh-oh, time for little babies to have afternoon nap." The two curl up together and snooze. "Okay, nap over," declares Bugs, and the chase resumes.

Sure, it's a typical smart-aleck gag, but it also means Bugs's creators are traveling back to their own infancies—lighthearted, childlike and broadly playful. Which is where our psyches first encounter Trickster.

Bugs Bunny stewards the ethos of time-traveling tricksterism. He does not lack compassion, but he also refuses to take anything seriously. He remains detached; he floats above situations and, like a time traveler, gains the perspective of the long view. Consider the play of animals, of cartoon characters, and of infant and toddler humans and how adults who can recall and relive their childhood frolics refresh their psyches by time-traveling back and forth from their own early childhood to the present.

If we entertain this notion of time-traveling tricksters roaming around the past and the future, then why do they do it? Not to accumulate power, but its opposite. We cannot dissolve power with power, but Tricksters, like the Fool,

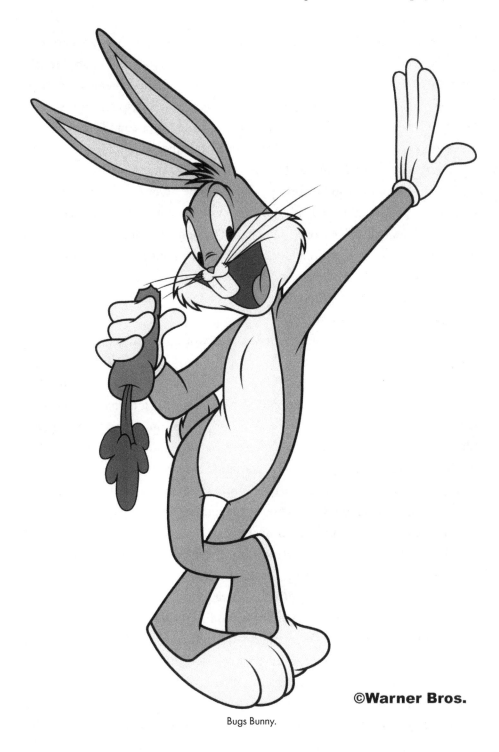

Bugs Bunny.

©**Warner Bros.**

like Bugs, can mock it and nudge us towards a society where the power of play prevails over the play of power. Where time is the X factor that shuffles the linearity of human progress and opens us to a time-mashed, dreamward view.

The absurdist Alfred Jarry was the rare human who aspired to this state. He seemed to spring forth fully formed. His creations—poems, The Ubu Cycle plays, essays like "How to Construct a Time Machine," and fiction, especially *The Exploits and Opinions of Doctor Faustroll, 'Pataphysician*—confound efforts at a developmental theory. His style can be described as scenic; everything is happening at once. Dialogue emerges from the scenery, starts to make sense, but then dissolves back into hallucination. Unbound by time, Jarry invented modern art even though it was born years after he died. Time travel yields these insights, a panoramic view of the past and a prospective hope for the future. Taking multiple moments in all at once can yield a vision where the fluidity of time dissolves the bonds of power.

But how does this play out in the real world, a real world of waning playtimes?

Take this example. A woman testifies: "I am glad that I own a gun because when that man tried to break into my house, it was that gun that protected me and my baby." It's hard to dispute this mother's position and essential role. She is bound in time by the trauma of this difficult moment. But time-traveling tricksters, taking nothing seriously, are untethered from the present moment and, just as certainly, fulfill the role—through their antics, through humor, tricks, laughter, and lightheartedness—of imagining a world where such threats do not occur. An even more grim example is the story Viktor Frankl tells in *Man's Search for Meaning*[242] of Holocaust prisoners whose souls survived by retaining humor in the midst of genocide. Time travel is a psychic crowbar (when the pogo stick is in the shop) that liberates us from the present and allows a more playful perspective on even the most distressing of life's ordeals.

We all face events that tie us mightily to a moment in time. The tragic loss of a loved one. The witness, participation, or victimization of war or of crime. Falling in love. Celebrity. Moments destined for history. But time travelers have a special relationship with time, history, and circumstance. Their detachment from events brings a perspective that stokes the imagining of possible

futures. Dystopian visions reify the bonds of power, violence, repression, and force. Utopian visions break them. While time travel initially liberates from the present, it ultimately presents the prospect of liberation from all bonds. The message of the time traveler carries a meaningfulness deeper than the phenomenon itself.

In the 2016 film *Arrival*,[243] Dr. Louise Banks (played by Amy Adams) experiences a stunning version of time-travel affecting events, and there is a thriller aspect to how she delivers the blessings of an extraterrestrial race. But the film also lays out how time travel can affect personality and perspective. Dr. Banks's character seems detached from her peers as she persists in following a vision and approach to loving the aliens that only she seems to understand. She learns that she will give birth to a wonderful daughter who will die young of a rare disease; that the aliens arrived to bring the nations of the world together by tossing them a puzzle, a puzzle that challenges them to replace power and conflict with sharing; and that the aliens' language is shared with Earthlings so that they can fulfill a prophecy of returning the favor three thousand years hence. Though we've described time travel as loosening the bonds to the present, Dr. Banks actually helps make stronger and deeper connections between nations, and with her soon-to-be husband and the father of her child. This serious film, devoid of pranks and gags, nonetheless delivers insight into the political value of the time-travel fantasy and a profile of the savior aspect of time-traveling tricksters, in this case a woman. We now catch glimpses of the trickster's redemptive power.

Perhaps a more on-point depiction of tricksters and time travel can be found in the comedy classic from 1989, *Bill & Ted's Excellent Adventure*.[244] It's absolutely fitting that a late-eighties version of a comic trickster in film would come to us in the form of Southern California stoner dudes, where we see Keanu Reeves's iconic portrayal of Ted "Theodore" Logan, stumbling through trickster episodes with his best friend Bill S. Preston, Esq., played by Alex Winter. The film gleefully exploits dumb for some very good laughs, not much different from the wanderings of Winnebago Trickster Wakdjunkaga. In fact, it turns out that Bill & Ted's kind of dumb talk is the same language the alien masters of the universe use while guiding the social progress of living beings through their

primary tool, time travel. Like the West African god Eshù Elégba, Bill & Ted have one foot in this world, 1988's San Dimas, California, and another in the world of the gods: Socrates, Abraham Lincoln, Sigmund Freud, Genghis Khan, Napoleon, Billy the Kid, Joan of Arc, and Ludwig van Beethoven. If Ted flunks his high school history course, his father is going to send him to the place that strikes terror in the hearts of antiwar tricksters—military academy. So their supposed quest is to put together a history report. Very funny.

Bill & Ted are tricksters in the purest sense of interpreting messages from other worlds, in this case the historic past. They tell their classmates what these historical figures would think of San Dimas, California, circa 1988, though just as Bill & Ted live in the moment and are thus chronically forgetful, the filmmakers forgot to put that part in the film.

The Trickster cycle begins with moral indeterminacy, in this case declared with the oft-repeated line "Party on, dude!" We're never quite sure how the tale might evolve into some level of moral discovery, yet the *Bill & Ted's Excellent Adventure* hews to that path. Each little episode features some display of slapstick pratfalls, generally in the clumsy category, that are endearingly executed.

The cleverness is in the structure. There is this constant tug-of-war between the silly-but-sturdy plot of our un-heroes trying to pass their history exam and the gags and pranks that constantly threaten to derail their mission, making the story a delightful example of the power of slapstick to upend narrative and challenge reality. Bill & Ted are in a constant state of forgetting what it is they're supposed to be doing and why.

Bill & Ted decide to buckle down and be more disciplined, but then princesses from medieval England show up with Rufus (George Carlin), their time-traveling chaperone, to distract them. The attractive princesses and Bill's stepmom signal trickster promiscuity, and trickster's hunger for good food is satisfied by little plastic cups of chocolate pudding.

Anyway, in a hilarious turn of events, their mediocre absolutely terrible metal band, the Wyld Stallyns becomes the basis of a future civilization. The final scene reveals that destiny and why passing the history exam and thus keeping the band together matters so much to the world. Rufus announces the trickster savior has come: "Eventually your music will help put an end to war

Alex Winter and Keanu Reeves in a scene from 1989's *Bill and Ted's Excellent Adventure.*

and poverty. It will align the planets and bring them into universal harmony, allowing meaningful contact with all forms of life, from extraterrestrial beings to common household pets. And it's excellent for dancing."

As ridiculous as the premise may seem, this otherwise slight film completes the Trickster cycle as Bill & Ted stumble into moral discovery. And that Wyld Stallyns becomes the basis of a future civilization aptly summarizes the trickster's case for governance.

Rufus's summation can be understood on three levels: First, only a utopian idiot would believe that an untalented and puerile metal band could bring peace, prosperity, and love to the universe; such dreamers are ridiculed. Second, as unlikely as it seems, this possibility somehow does save the universe and, in its silliness, tricks power into performing acts of love. Tricksters are both unknowing stumblers and save-the-world schemers. Bill & Ted tickle us into being open to what may seem to be silly ideas. And third, the film, with its upbeat, hilarious conclusion, makes a mockery of the present, an age where the great preponderance of prognosticating Western art anticipates only dismal and devolved dystopias. *Bill & Ted's Excellent Adventure* gives these grim scenarios a healthy poke in the eye.

The tricksters of folklore and mythology tend to wander alone. They reveal truth, often through mockery. They do not take power seriously. They cross boundaries, including the boundaries of time. Their tricks confound time. Time travel frees them from the bindings of temporality, of current events. Like a pogo stick bouncing onto different moments, a trickster will connect the dots to form themes and give perspective and visions that break the cycles of power and oppression.

There are more books and films using time travel than you can shake a pogo stick at. Watch for the ones that throw trickster into the mix.

CONCLUSION

WHO IS TO BLAME FOR 2020?

A prank should have a resonance and a ring to it. It should
speak of the higher aspirations of human activity. It should go
far beyond the limitations one would expect it to have. That's
what pranks are all about: the unexpected—the element of
surprise transposed onto some kind of poignant act . . .

—Mark Pauline[245]

The strong rule the weak, and the clever rule the strong.

—Boyd Rice[246]

To those who might doubt a theory of archetypes, their influence on
political progress, and how powerful culture is in determining poli-
tics, just consider the grip that the Warrior had on a significant seg-
ment of US society in the early decades of the twenty-first century, folks
who wo believed that all conflict had to be resolved with force. Dialogue not
welcome. The Warrior as a personality type, the resultant infatuation with
toxic masculinity.

Sean Hannity hosts a flagship show for one of the most popular cable
news networks and addresses a right-wing base. He speaks in the raw terms
of the Warrior, one who lives for the fight, who lives to win. There is no loyal

opposition, only enemies. Whether it's the Warrior energy of the NFL, QAnon (what could be more heroically masculine than rescuing the country from pedophiles?), or the tragic and inane faux heroism of domestic terrorism, and everything in between, an American cult has decided that lawfulness, dialogue, negotiation, and peaceful resolution—the principles of democracy—take a backseat to fighting for what they believe is their entitlement . . . to the point of insurrection. For them, democracy left the station a long time ago.

The Trump administration played many dishonest tricks on the American people, but that does not make him a trickster. When assessing the Tricky Dick-ness[xcix] of Donald Trump's coterie, we certainly find amorality, but amorality in the pursuit of power. In an authentic Trickster cycle, moral indeterminacy opens the door to mischief, but mischief chiefly in the interest of having fun, never in the interest of power, malice or greed. In every resonant case of trickster folklore, when faced with power, the trickster mocks it. Trump's Tricky Dick-ness trickery was usually carried out as a toxic mix of prejudice, clownishness, and self-dealing. He played that old fascist not-a-trickster trick of stoking angry xenophobia and racism on the one hand while with the other, robbing the American people through tax cuts for the rich. Robin Hood in reverse, and the oldest trick in the book. Such behavior mocks democracy and worships power. It utterly fails as a worthy exemplar of the Trickster archetype.[c]

In the aftermath of a US president who embodied the Clown dressed up as a Warrior willing to play tricks, who tapped and amplified the strained Warrior voice of aggrieved white men, how are we as a society to make room for true Trickster and not this perversion? Tricks have been co-opted by dishonest warriors and the vox populi has become suspicious of anyone and anything that is not straightforward and somber.

It's time for another kind of government, but will it be in a humorless liberal doctrine that suppresses Trickster spirit and ultimately fails again? This is

xcix A reference to disgraced president Richard Nixon.

c Kali Holloway gives a great example of a trick played on the American people that has no connection whatsoever to the antics of the Trickster: "That's the trick of American violence: It's labeled so only when it threatens to upset the violence of America's white supremacist hierarchical order." Kali Holloway, "The Violence Didn't Start with the Protests," *The Nation* (June 29/July 6, 2020), 11.

the pendulum swing that makes Americans dizzy and clouds third options. At one end, racist, sexist, xenophobic populism and authoritarianism that stoke hatred and violence, a misappropriation of Warrior energy. At the other, a socially engineered state that governs a public judged incapable of handling freedom, an overdose of the otherwise nurturing Mother, suppressing triggers and free expression, intimidating independent thinkers for fear of losing their jobs, protecting us from harshness and politically incorrect thought—kind of like photoshopping cigarettes out of old movies.

It's time for Tricksters to have their say in the matter.

The case for Trickster, the "let's have fun" utopian, is underrepresented, yet it is key to cutting the Warrior down to size. Trickster opens the way to a visionary, evolving society, not to dominate, but to perform a subtle governing function, humorously limiting the Mother, the Child, the Magician, the Hero, the Warrior, the Lover, and so forth, just enough so that all voices are heard.

MEANING AND PURPOSE

We can turn to contemporary satirists who fearlessly mock power from whichever political wing it comes: Jon Stewart, Tom Wolfe, Joseph Heller, Samantha Bee, Mindy Kaling, Keegan-Michael Key and Jordan Peele, Tom Lehrer, Dave Chappelle, Aziz Ansari, Ricky Gervais, Sarah Silverman, Amy Poehler, Kristen Wiig, Chris Rock, Steve Coogan, Bill Maher, Issa Rae, Maria Bamford, John Oliver, Stephen Colbert. These satirists, though they may animate the trickster in all of us, are entertainers—writers, stand-up comedians, actors, TV hosts—not activists. Their import is to be found in their fame only to the extent of the influence they have in awakening a general public to get active and bring Trickster spirit into the public commons. Lord Buckley, the most famous person to have never become famous, exhorted us all to become artists. As does Yoko Ono. And artists go through the artistic process, gain insight, and share those insights in the public commons, in performance, in the dive bar, in government, in the streets, or at the kitchen table. Art and politics meld: Artist activism, street theater, pranks and tricks that reveal truths.

Here's an example: During the COVID-19 crisis, when folks in the neighborhood would walk down the street wearing their mask and being careful to

stay socially distanced, they were acting out the caring Mother. In a good way! When others would refuse to mask up and socially distance, we observed a caricature of bravery in the mold of the Warrior. When from a safe distance, a person would unmask and somehow find something funny in all this and perform it, that's Trickster.

Taking that a step further, consider the possibility that COVID-19 is the trickster virus. Rich nations are pooling their resources and giving vaccinations to poorer nations. They have to if the virus is to be brought under control. Such an initial gesture redistributes a little bit of wealth on a global scale. What if the mechanics of this gesture catches on and the flow of wealth and resources to developing nations continues and increases? Then COVID-19 will have tricked power into performing the greatest possible act of love.

* * * * * * * * *

Let's recapitulate the Trickster cycle with some final examples. Recall our first question: what is play? We need to better proportion rationalist thinking, that something matters only because it fulfills an "important" purpose, that everything from animal behavior to economic policy must be explained through purpose. This misses the forest for the trees. Fixation on purpose crowds out the joy of existence, which has meaning, but not purpose.

Cultural anthropologist and anarchist thinker David Graeber (1961-2020) makes reference to an inchworm playing around on stalks of grass; ants who mount fake war games; birds who entertain themselves in flocks—apparently all just for fun. He wrestles this issue to the ground:

> An analysis of animal behavior is not considered scientific unless the animal is assumed . . . to be operating according to the same means/end calculations that one would apply to economic transactions. . . . [A]n expenditure of energy must be directed toward some goal, whether it be obtaining food, securing territory, achieving dominance, or maximizing reproductive success... ethologists have boxed themselves into a

world where to be scientific means to offer an explanation of behavior in rational terms—which in turn means describing an animal as if it were a calculating economic actor trying to maximize some sort of self-interest . . . That's why the existence of animal play is considered something of an intellectual scandal . . . even when it is acknowledged, the research more often than not cannibalizes its own insights by trying to demonstrate that play must have some long-term survival or reproductive function. . . .

Let us imagine a principle . . . of ludic freedom. Let us imagine it to hold that the free exercise of an entity's . . . capacities will . . . tend to become an end in itself. . . . Evolutionary psychologists claim they can explain—as the title of one recent book has it—"why sex is fun." What they can't explain is why fun is fun. . . . I'm not . . . saying that . . . a play principle as the basis of all physical reality—is necessarily true. I would just insist that such a perspective is at least as plausible as the weirdly inconsistent speculations that currently pass for orthodoxy, in which a mindless, robotic universe suddenly produces poets and philosophers out of nowhere. . . . [I]t gives us ground to unthink the world around us. [247]

I'm recalling an ongoing debate I used to have with my colleagues in public education, colleagues who would champion the arts. To avoid budget cuts, to keep their programs afloat in hard times, they would make the argument that teaching the arts—music, ceramics, painting, drama, and other electives—was still important, even in an age of obsessive testing and emphasis on science and math. The arts were important because students did better in math and science and reading and were better socialized when they also participated in the arts. And then maybe these colleagues would roll out a study or two. In other words, they conceded the point by making the argument that their subject areas, the arts (and now you can start substituting "play" for "the arts")

were important only because they supported achievement in *other subjects* that were decreed important.

And I'd challenge these folks, using music as an example, saying, "You mean that if music *didn't* improve math scores, then you would agree that it should be eliminated from the school's offerings?" Well, of course not. So I'd add, "Music and play are intrinsically valuable, self-justifying. If you must attach a value, say that music is important because it is beautiful, or play is important because it is fun. I prefer to not justify either."

Music and play are important as first principles. Ask any infant or toddler. Why do you think that some of the rock bands of the sixties went out of their way to play free concerts? They did so to demonstrate that making money was not the purpose of their show. There was no purpose beyond having fun and feeling alive and doing so communally: let's see what can happen when people gather. These gatherings were meaningful, but without any articulation of purpose. Like play.

So if we can rewind to square one, to a world before purpose, and consider that play and playfulness are first principles, they exist for the same reason life-forms exist, for the fun of being alive, we come to very different perspectives on the social, economic, spiritual, and political behavior of all animals, including humans. Lives full of meaning, but not necessarily purpose. Which brings us to that second question: what happens when a grown-up retains the ability to be playful in the way they were as children?

From the crazy wisdom of the RE/Search folks, we get more nuggets from the compulsive prankster Boyd Rice. He's known best for presenting First Lady Betty Ford with a skinned sheep's head. This nonsensical prank came out of a rather spontaneous serendipity—"at the local supermarket . . . I'd always look at the meat section, especially all this meat I couldn't imagine any tasteful use for: skinned sheep's heads, big hoofs, snouts, etc. I'd always think, 'There must be *something* I can do with this."[248] So he picked up a sheep's head, then noticed that the First Lady was in town and made his way through the handshake line to present Mrs. Ford with the sheep's head. Some obscure and ridiculous connection with abortion rights was inferred, as there was a demonstration going on at the time. Anyway, Rice got within about six feet of Mrs. Ford before the Secret Service led him away.

He and his cohorts would redesign the high school display cases, replacing trophies with raw meat. His town of Lemon Grove in San Diego County (population around 25,000) had a famous statue of a huge lemon; it was big news when Boyd and his teenage crew painted nonsense graffiti on it: *dada, Krishna,* and a sad face, ☹. Graffiti in and of itself, not a big deal; but Lemon Grove's big lemon was sacred, and thus its violation ruptured order in the small community. Which gave the prank poignancy and made it more fun.

He developed complex relationships with the vice principal of his high school and the local police, who were bemused and confused. Their mantras to young Rice were "you're in trouble" and "we're disappointed." Meanwhile, Rice was living a truth that predicted *The Matrix* movie franchise, a truth we struggle to know, a door a trickster unlocks with magical pranks:

> You realize that everything is completely fictional and completely made-up; that it's only real for people because everybody's in agreement . . . but you don't have to agree. It's like the whole world is completely imaginary; all the values aren't in things but in people's heads. People project those values onto things, but the values aren't in those things. The fact that people are collectively imagining the same values at the same time props up the whole system. . . .
>
> Imagination is the starting place for the whole world. Everything in the world came out of someone's imagination. People divide everything into "fantasy" and "reality" but everything that's real once existed in the imagination before it existed in the real world. You can take away the imaginary values that people project onto things and substitute your own imaginary values.[249]

And Rice's pranksterism joins a long and ancient tradition. In *Scheherazade's Sisters,*[250] Marilyn Jurich writes:

> Bakhtin suggests still other therapeutic effects of folk humor since such humor refuses prohibition or submission and ridi-

cules authority, it triumphs over fear and brings strength, reassuring us with a way into the future that can be trusted. Such a view agrees with that expressed by Koepping, who holds that just as the carnival figure issues protest and serves as a commentator on the absurd, so too does the trickster attempt to create "a counter Universe." More than a figure that urges the audience to consider alternative political structures, more Utopian in nature, the trickster, according to Koepping, performs a philosophical function.

The grown-up who has retained the ability to be playful as they were in childhood is going to encounter and represent Trickster. Trickster magic encourages a Play Society. The case disruptive play makes is that the mockery of power, the pursuit of fun, the prank that opens the doors to imagining a different world, can augur a cultural psyche that reflects all archetypes.

But instead we find ourselves beholden to the Warrior persona, a false idol if you will, worshiped for too long and too timidly challenged. Our challenge is to free ourselves from Warrior strong-man primate dominance.

CULTURE AND POLITICS

Lewis Hyde's *Trickster Makes This World* teaches us that suppression of Trickster energy will ultimately lead to an explosive release that can get out of hand. Well into the twenty-first century, animating Trickster is a necessary but dangerous lift. Drowning in misinformation, how are we to tell the difference between lies that expose the truth and lies that corrupt, hurt, and betray? What's the difference between a good prank and a bad one?

In a December, 2020 RE/Search online event celebrating their publication *Pranks!*, trickster John Law was asked what to do about the pseudo-reality of bigoted right-wing pranking—from QAnon, on the internet, in 4chan and 8kun/8chan[ci]—that's giving pranks a bad name. Law replied that you are a prankster for the just cause "by having a pure heart. Otherwise, you're a sadist,

ci "8kun, previously called 8chan, Infinitechan or Infinitychan, is an imageboard website composed of user-created message boards. The site has been linked to white supremacism, neo-Nazism, the alt-right, racism and antisemitism, hate crimes, and

not a prankster." Mischief, love, and fun should be easy to distinguish from mischief, hate, and sadism.

We now return to the third question that has driven this exploration: what happens when a playful grown-up gets involved in culture and politics?

A great example of the child's playfulness in contemporary culture comes to us from filmmaker and director Taika Waititi of New Zealand. With the innocence of Andy Kaufman and a strong streak of satire, Waititi's films deflate adult-ism with playful takes on vampires and documentaries (*What We Do in the Shadows,* 2014) and the allure of Adolf Hitler to little boys and girls in prewar Germany (*Jojo Rabbit,* 2019). With *Thor: Ragnarök* (2017), Waititi expands Marvel's superhero universe with generous helpings of comedy. Even though classic Trickster god Loki is a main character in *Thor* and *The Avengers,* Waititi's more about having a good laugh than depicting a true trickster. He manages to advance the sluggish Marvel plotlines and still make a film that is as much a comedy as an action adventure. Loki, though he vacillates between unreliable, morally indeterminate ally and power-hungry schemer, still falls short of portraying a true Trickster god, who would mock power but not seek it. Talents like Sun Ra and Waititi remind us of the larger world of play that encompasses trickster. They both create playful worlds for others, including tricksters, to join.

Hewing closer to the political implications of tricksters is the pure-hearted prankster Sacha Baron Cohen. Cohen's politics veer in a number of directions, but his guiding light is less a specific policy platform and more having his antennae up for the most mockable displays of pea-brained power. Though he adopts a trickster persona for his invented roles—Ali G, Borat Sagdiyev, Brüno Gehard, and Admiral General Aladeen—his moral commitment is evident from his background.

He studied history at Christ's College, Cambridge, with a focus on antisemitism. He wrote his undergraduate dissertation on the American civil rights movement. He draws inspiration from Peter Sellers for his style of adopting various guises and characters, and he studied the art of the clown with master-clown Philippe Gualier in Paris. Using techniques that riff off

multiple mass shootings. The site was known for hosting child pornography. "Wikipedia, s.v. "8chan," last modified May 8, 2021, 13:26, https://en.wikipedia.org/wiki/8chan.

of the chestnut TV show *Candid Camera* (on and off the air 1948-2014), Cohen's subjects, often political figures, would not suspect that Ali G was a made-up character, and Cohen could score satiric points, oblique and direct. His first major film, *Borat: Cultural Learnings of America for Make Benefit Glorious Nation of Kazakhstan* (2006) was a mockumentary that used this character Borat, an East European version of a hillbilly, to satirize American culture, sexism, racism, homophobia, antisemitism, and jingoism.

In Showtime's *Who is America?,* Cohen would interview conservative politicians, advocates, and talk show hosts in the guise of adopted characters like Erran Morad, supposedly an Israeli anti-terrorism expert. He shared absurd proposals like "Kinderguardians," where children ages three to sixteen would be armed with guns, this to Philip Van Cleave, president of the Virginia Citizens Defense League, and the TV audience would witness the dupes taking take these things seriously. Cohen tells lies to reveal the truth.

In January 2020, Cohen pretended to be a right-wing country singer and got onstage at a gun rights demonstration in Olympia, Washington. The rally was held in opposition to the March for Our Lives movement spurred by the Stoneman Douglas High School shooting. Protected by his own security from being attacked or thrown off stage or having the power cut, he sang a song and encouraged the small crowd to sing along, with lyrics that called for injecting liberals, CNN, the World Health Organization, Barack Obama, Hillary Clinton, Dr. Anthony Fauci, Bill Gates, and people who wear protective masks with the "Wuhan Flu." The bit was later used in his Borat sequel, *Borat Subsequent Moviefilm* (2020).

In a 2019 speech to the Anti-Defamation League, Cohen for the first time appeared publicly as Sacha Baron Cohen, not as one of his characters. He gave us a peek into his comedic technique, offering a simple lesson on the power of the pranking trickster: "When Borat was able to get an entire bar in Arizona to sing 'Throw the Jew down the well,' it did reveal people's indifference to antisemitism. When—as Bruno, the gay fashion reporter from Austria—I started kissing a man in a cage fight in Arkansas, nearly starting a riot, it showed the violent potential of homophobia. And when—disguised as an ultra-woke developer—I proposed building a mosque in one rural commu-

 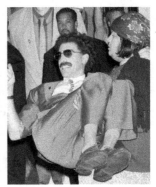

as Ali G, 2002	Sacha Baron Cohen as himself, 2016	As Borat, 2006

nity, prompting a resident to proudly admit, 'I am racist against Muslims'—it showed the growing acceptance of Islamophobia."[251]

Cohen's moral compass works quite well. He portrays bumbling, bigoted, and ignorant pranksters, a funhouse mirror reflection of a hapless trickster lost and confused by lies in a swirl of moral perversion and indeterminacy. When he finally takes off the mask, as in this speech, he completes his performance of the trickster journey to moral discovery.

UTOPIAS AND MESSIAHS, MEANING AND PORPOISE

Our best hopes come with the understanding that American society is in a liminal state. In anthropological terms, liminality means that one is in the middle state of a rite of passage, no longer having the previous status, but not yet arrived in the status of that passage's completion. It's a vulnerable and volatile time, one when an authoritarian version of the Warrior can take hold. Or a rigid liberal doctrine. But it's also an opportunity for Trickster to light the way towards utopia, for the mockery of power to have greater influence, such that other human traits rise to the surface.

> In the liminal state[,] symbols of birth and death, of sexual reversal and social dissolution abound. . . . these symbols . . . whereby nakedness represents both birth and death and the liminal hut both womb and tomb—focus on the creation of a society that, in its lack of status and hierarchy, in its intimacy and

simplicity, appears to be the antithesis of normal social order. This communitas, however, is in some sense the great symbol of liminality itself, for . . . it reveals the hidden depths of social order, its true center. Thus the movement outside . . . is in fact a movement inside, a movement disclosing the inner cohesion of society even as it makes available to society those forces of contradiction and anomaly which ordinarily seem to lie outside its scope.[252]

* * * * * * * * *

In Yoko Ono's documentation of her 1969 Bed Peace with husband John Lennon, from their bed in their honeymoon suite, they engage in a conversation with comedian and activist Tommy Smothers, who is distraught by the ways of war, politics, and commercialism:

Smothers: [Politicians] have no opinions, except the little tidbits they've been given, no open dialogue, and then the politicians in turn, equate how they're going to react and what they're going to vote for based on the polls, which were based on lack of information to begin with.

Ono: That's terrible, but that's no reason to give up. That's even more reason to find a way. You know, you have to do that. And there's no space, no time for negative thoughts. Listen, we're gonna make it, that's all. We have to make it.

Smothers: We have to make it. It's like being dropped in the middle of the ocean, and there's eight hundred miles, and you know you're not gonna to swim it. But you don't just drown, you start swimming, even though it's hopeless.

Lennon: You don't know, you're gonna come across a log or you're gonna come across a—

Smothers: A porpoise that'll pick you up, maybe.

Lennon: Okay, well, believe in porpoise, then, believe in porpoise. [253]

So, maybe meaning and porpoise, but not purpose.

Go ahead, laugh.

Because tricksters just want to have fun. Describing enslaved African Americans as happy-go-lucky just demonstrates the ignorance of racism and can lead people into even deeper and more harmful racist beliefs and actions. Yet Afro-Atlantic culture gives voice to a collective consciousness with the potency of Eshù Elégba, able to celebrate, joke, and laugh in the face of oppressed status. Eshù Elégba nurtures the soul that leads to just political action. In the throes of oppressive husbands, kings, and lovers, female tricksters must employ tricks, clever but not fun, because they're fighting off abuse. Yet the woman's triumph gives birth to the radical notion of tricksters' capacity for governance.

We know that an archetypal model can be adopted en masse; we see it in groups of warriors, be they the military, a sports team, or domestic terrorists. Though it's a more difficult fire to light, the idea promoted here is trickster-ism as an energy amongst groups, a collective playful movement and a more broadly embraced personality profile, instead of pinning hopes on a charismatic leader. Elections matter, but movements prevail. We're all leaders, all artists, all catalysts, and the idea of society being a place with a hearty helping of fun, carnival, celebration is as old as trickster tales themselves. In older times, a tribe might turn to a shaman as a trickster leader:

> Another type of transformer whose influence it is difficult to assess is the shaman. Here he is represented by Nasreddin Hodja. This trickster has already been cast as "wise fool" . . . one whose responses are related to mystical thought. The Hodja's statements Leeming regards as profound and the Hodja himself as "the wounded-wounder"—Hodja as a savior, one who discards the old consciousness in order to bring forth new ways of understanding. Certainly, these are large claims for this folktale character. How significant and far-reaching are the exhortations of a sage, how compelling his behavior to induce, instruct, even invent the lives of others is never a closed question. In fact, in "Nasr-ed-Din Hodja in the Pulpit," the Hodja himself demonstrates how tricky it is to believe in

a self-proclaimed shaman. In this tale, Nasr-ed-Din refuses to impart wisdom to his congregation[254]

The tale ends with the shaman exhorting the people to not elevate him, but to be each other's teachers. What's being proposed here is Trickster energy distributed widely.

Humanity has always realized that the scope of simple and entertaining folk-tales can have broad implications. In his discussion of the West African Trickster god Ananse, usually taking the form of a spider, Pelton describes three thematic groupings of trickster tales: The first concerns Ananse himself. The second, Ananse's role in shaping the physical world. And the third, how Ananse has affected human society.[255] Thus we have a taxonomy for understanding Trickster.

We communicate in the written word and around the fire with stories. With stories we make our points. And stories need characters. So far, the numerous characters of this book have helped to make the point of social progress through a broader understanding and embrace, however transient, with the Trickster. But the ultimate gift of Trickster is to be found in a single character, and that character is society itself. When Trickster is more broadly understood, we discover the energy of a collective movement towards a better world, towards a more fun world achieved through the revelations of prankishness. The clever trick power into performing acts of love—however abstract that may seem in this moment—that's the point. Believe in porpoise!

ABOUT THE AUTHOR

Shepherd Siegel playfully trains his lens on politics and culture to suss out the Trickster element as it has shown up, tickled society, and then just as quickly disappeared. His diverse academic background—degrees in music, career and technical education, special education, administration; and studies in anthropology—equip his scholarly pursuits. His activism grows out of visions born in the bohemian counterculture of the San Francisco Bay Area. His presentations and talks have established him as a reliable and entertaining public intellectual on the subject of tricksters in politics and culture.

He has a varied history as an activist, writer, musician, researcher and prankster. He's written over 30 peer-reviewed and other journal articles, a textbook that enjoyed two editions *(Career Ladders: Transition from High School to Adult Life),* and the award-winning *Disruptive Play: The Trickster in Poli-*

tics and Culture (Wakdjunkaga Press, 2018), of which *The Seattle Times* said, "Siegel's writing bursts with color and life." *Kirkus Reviews* wrote "Siegel's thesis is philosophically provocative and original....combining intellectual rigor with a bracing optimism." Born in Chicago, Siegel has lived the longest in the Bay Area and Seattle, where he now resides.

Find the Index to *Tricking Power* and connect with Shepherd Siegel at www.shepherdsiegel.com

SELECTED BIBLIOGRAPHY

WORDS

Coleman, Ray. *Lennon: the Definitive Biography*.)New York, NY: Harper Perennial; Revised, Updated, Subsequent edition, 1993).

Dale, Alan. *Comedy Is a Man in* Trouble (Minneapolis: University of Minnesota Press, 2000).

Darnton, Robert. *The Great Cat Massacre and Other Episodes in French Cultural History* (New York: Vintage, 1985).

Dery, Mark. "Black to the Future: Interviews with Samuel R. Delany, Greg Tate, and Tricia Rose," In *Flame Wars: The Discourse of Cyberculture* (Durham, NC: Duke University Press, 1994).

Dickerman, Leah, and Brigid Doherty. *Dada: Zurich, Berlin, Hannover, Cologne, New York, Paris*. Washington,, D.C.: National Gallery of Art, in association with D.A.P./Distributed Art Publishers, 2005.

Dover, K.J. *Aristophanic Comedy*. Berkeley: University of California Press, 1972

The 50 Best Trash Talk Lines in Sports History. Bleacher Report. Archived from the original on December 18, 2013. Retrieved July 10, 2020 from http://bleacherreport.com/articles/1238737-the-50-best-trash-talk-lines-in-sports-history/page/51

Frankl, Viktor E. *Man's Search for Meaning: An Introduction to Logotherapy* (London, UK: Hodder & Stoughton, 1959).

Gates, Henry Louis, Jr. and Cornel West, *The African-American Century: How Black Americans Have Shaped Our Country* (New York: The Free Press, 2000).

Gates, Henry Louis, Jr., *The Signifying Monkey: A Theory of African American Literary Criticism* (Oxford: Oxford University Press, 1988).

Graeber, D. (2017, April 05). What's the Point If We Can't Have Fun? Retrieved January 28, 2021, from https://thebaffler.com/salvos/whats-the-point-if-we-cant-have-fun.

Greenfeld, K.T. (Author), *Muhammad Ali: The tribute* (p. 9). NY, NY: Sports Illustrated Books/Time.

Gresser, Hannelore. "Till Eulenspiegel, The Controversial German Trickster." Thesis for Children's Literature, Suffolk University, Boston, MA.

Herskovits, Melville J. *Dahomey: An Ancient West African Kingdom,* Vol. II, (New York: J.J. Augustin, 1938).

Hill, M. (2009, January). *The Spread of Islam in West Africa: Containment, Mixing, and Reform from the Eighth to the Twentieth Century.* http://spice.stanford.edu/

Hopkins, Jerry. *Yoko Ono.* London, England: Sidgwick & Jackson, 1987.

Hyde, Lewis. *Trickster Makes This World* (New York: Farrar, Straus and Giroux, 1998).

Jurich, Marilyn. *Scheherazade's Sisters: Trickster Heroines and Their Stories in World Literature.* Westport, CT: Greenwood Press, 1998.

Kusama, Y., Yoshitake, M., Chiu, M., Dumbadze, A. B., Sutton, G., & Tezuka, M. (2017). *Yayoi Kusama: Infinity mirrors.* Munich, Germany: DelMonico Books/Prestel.

Mailer, N. (1973). *Existential errands.* New York: New American Library. In Henry Louis

Ono, Yōko. *Grapefruit.* New York, New York: Simon and Schuster, 1971.

Ono, Y., Lennon, J., & Sheff, D. (2000). *All We Are Saying: The last major interview with John Lennon and Yoko Ono.* New York, NY: St. Martin's Griffin, pp. 38-39

Pelton, Robert D. (1989). *The trickster in West Africa: A study of mythic irony and sacred delight.* Berkeley, CA: University of California Press.

Radin, Paul, *The Trickster: A Study in American Indian Mythology.* New York: Schocken, 1956.

Rattray, Robert Sutherland (1930). *Akan-Ashanti Folk-Tales; coll. & translated by R.S. Rattray, illustr. by Africans of the Gold Coast Colony.* Oxford: Clarendon.

Rodman, Dennis, and Tim Keown. Bad as I Wanna Be. New York, NY: Dell Publishing, 1997.

Sarofeen, Kyle. "Drew 'Bundini' Brown: Boxing's Greatest Hype Man." Hannibal Boxing. Hannibal Boxing Media, Retrieved May 26, 2020. https://hannibalboxing.com/bundini-brown-boxings-greatest-hype-man/.

Siegel, Shepherd. (2018). *Disruptive play: The trickster in politics and culture*. Seattle, WA: Wakdjunkaga Press.

Stallybrass, Peter, and Allon White, *The Politics and Poetics of Transgression* (Cornell University Press: Ithaca, New York, 1986).

Sutton-Smith, Brian. *The Ambiguity of Play.* (Cambridge, Massachusetts: Harvard University Press, 1997).

Szwed, John F. *Space Is the Place: the Lives and Times of Sun Ra.* Durham, NC: Duke University Press, 2020.

Tate, Greg. *Cult-Nats Meet Freaky-Deke*. 10 Jan. 2020, www.villagevoice.com/2020/01/10/cult-nats-meet-freaky-deke/. Originally published December 1986.

Thompson, Robert Farris. *Flash of the Spirit: African and Afro-American Art & Philosophy* (New York: Vintage, 1983).

Trager, Oliver., *Dig Infinity!: The Life and Art of Lord Buckley*. New York: Welcome Rain, 2001.

Vale, V., & Ballard, J. G. (eds.)(2010). *Pranks!* San Francisco, CA: RE/Search Publications.

West, Cornel. *The Cornel West Reader* (New York, NY: Basic Civitas Books, 1999),

Wideman, John Edgar. "Playing Dennis Rodman." *The New Yorker*, April 29, 1996.

Youngquist, Paul. *A Pure Solar World: Sun Ra and the Birth of Afrofuturism.* Austin, TX: University of Texas Press, 2016.

MOVING PICTURES AND MUSIC

Arrested Development. Mitchell Hurwitz, creator. The show ran on Fox from 2003-2006, and on Netflix, 2013, 2018, and 2019.

Arrival. Denis Villaneuve (director). Heisserer, E., & Chiang, T. (2016). *Arrival* [Film]. United States; Paramount Pictures.

Being John Malkovich. Kaufman, Charlie. United States: Astralwerks, Gramercy Pictures, Propaganda Films, Single Cell Pictures, 1999.

Bill & Ted's Excellent Adventure. Film. United States: De Laurentiis Entertainment Group (DEG), 1989.

Black Panther. Ryan Coogler (dir.). Milano: Walt Disney studios home entertainment, 2019.

Borat Subsequent Moviefilm. Jason Wollner (dir.), Sacha Baron Cohen, Maria Bakalova. Amazon Studios, 2020. https://www.primevideo.com/dp/0O2UR0DET7Q8BLWJVZL7G5WXZ4.

Brazil, dir. Terry Gilliam (Los Angeles, CA: Embassy Pictures, 1985) film.

Butch Cassidy and the Sundance Kid. Goldman, William.

The Cry of Jazz. DVD. United States: Grove Press Film Division, 1959.

Dolemite [Motion picture on DVD]. Moore, R. R. (Writer), & Martin, D. (Director). (1975). US: Comedian

"Good Hunting," in *Love, Death + Robots,* Season 1, episode 8. directed by Oliver Thomas, adapted script by Philip Gelatt, based on a story by Ken Liu, March 15, 2019, Red Dog Culture House. Viewed on Netflix.

The *Great Buster: A Celebration.* Cohen Media Group, 2018. And https://en.wikipedia.org/wiki/Buster_Keaton. Retrieved September 15, 2019.

The Great Dictator. Charlie Chaplin.

Hot Tub Time Machine, dir. Steve Pink (Los Angeles, CA: Metro-Goldwyn-Mayer, 2010) film.

I May Destroy You, Michaela Coel, Creator. June 7-August 24, 2020.

Interstellar, dir. Christopher Nolan (Hollywood, CA: Paramount Pictures, 2014), film.

Keaton, Buster.

One Week. Joseph M. Schenk Productions,. Davenport, IA: Eastin-Phelan, 1920.

The Playhouse. Joseph M. Schenk Productions, 1921.

Steamboat Bill, Jr. Buster Keaton Productions; Joseph M. Schenk Productions, 1928.

Three Ages. Buster Keaton Productions, 1923.

The Last Dance [Video file]. Hehir, J. (Director). (2020, April 19). https://www.espn.com/watch/player/_/id/bd425095-a59f-4f46-91f4-f7d6e211913a/bucketId/33331

Lewis, Jerry.

The Bellboy. Lewis, Jerry. Jerry Lewis Pictures; Paramount Pictures, 1960.

The Nutty Professor. Lewis, Jerry. Paramount Pictures; Jerry Lewis Films, 1963.

Marx Brothers.

Animal Crackers. Paramount Pictures, 1930.

The Cocoanuts. Paramount Pictures, 1929.

Duck Soup. Mankiewicz, Herman J., Bert Kalmar, and Harry Ruby, Paramount Pictures, 1933.

*Horse Feathe*rs. Paramount Pictures, 1932.

Monkey Business. Paramount Pictures, 1931.

A Night at the Opera (1935). Thalberg, Irving G., George S. Kaufman, and Morrie Ryskind. Metro-Goldwyn-Mayer, 1935.

Ono, Yoko (Director). (2012, June 22). BED PEACE starring John Lennon & Yoko Ono (1969) [Video file]. Retrieved December 10, 2020, from https://www.youtube.com/watch?v=mRjjiOV003Q.

Richard Pryor: Live in concert [Motion picture on DVD]. Margolis, J. (Director), & Pryor, R. (Writer). (1979). United States: See Theater Network / Special Event Entertainment.

Roots of Black Music in America [CD]. Samuel Charters (Producer). (Folkways, FA 2694, 1972).

Rocket Number Nine Take Off for Planet Venus. Vinyl recording. Sun Ra and His Solar Arkestra. *Interstellar Low Ways*. Chicago, IL: Alton Abraham, 1960.

The Strong Man. Langdon, Harry.

Sun Ra: A Joyful Noise. DVD. Dir. Robert Mugge, United States: MVD Visual, 1980.

Sun Ra. [Le Sun Ra; Herman Poole "Sonny" Blount; Le Sony'r Ra]

Interstellar Low Ways. Ra, Sun. *Sun Ra and His Myth Science Arkestra.* Vinyl recording. Saturn, 1967.

Jazz in Silhouette. Sun Ra and his Arkestra, Vinyl recording. El Saturn Studio, Illinois: Alton Abraham, 1959.

The Nubians of Plutonia. Sun Ra and His Myth Science Arkestra. Vinyl recording. Evidence, 1966.

Outer Spaceways Incorporated. Sun Ra. Vinyl recording. New York, NY, 1968.

Sound of Joy. Sun Ra and the Arkestra. CD. Chicago, IL: Delmark Records, 1957.

Space is the Place. Sun Ra. CD. Streeterville Recording Studio, Chicago, IL: Alton Abraham, 1972.

We Travel the Space Ways. Sun Ra and his Myth Science Arkestra. *We Travel the Space Ways.* CD. Evidence, 1967.

Un Chien Andalou. France: Luis Buñuel-Salvador Dali, 1928.

Watchmen, Damon Lindelof, Creator. Nine Episodes. HBO, October 20-December 15, 2019.

West, Mae.

Goin' to Town. Emanuel Cohen Productions, 1935.

My Little Chickadee. West, Mae, and W. C. Fields. Universal Pictures, 1940.

Night after Night. Paramount Pictures., 1932.

She Done Him Wrong. Paramount Pictures, 1933

ENDNOTES

1 "You Should Read This: Poetry As Insurgent Art by Lawrence Ferling-hetti," The World Remains Mysterious: The Writing of Cat Rambo, December 4, 2012, http://www.kittywumpus.net/blog/2014/12/04/you-should-read-this-poetry-as-insurgent-art-by-lawrence-ferlinghetti/.

2 "A Lost 'Little Boy' Nears 100: Poet and Publisher Lawrence Ferling-hetti," Passevite, March 28, 2019, https://www.passevite.net/a-lost-little-boy-nears-100-poet-and-publisher-lawrence-ferlinghetti/.

3 Brian Posehn, "'Grandpa Metal' Official Video," directed by Jack Bennett, premiered July 24, 2020, on YouTube, https://youtu.be/IL_TbdT4hbY.

4 *Hollywood*, directed by Daniel Minahan, season 1, episode 2, "Hooray for Hollywood: Part 2," released May 1, 2020, on Netflix.

5 Cornel West, *The Cornel West Reader* (New York: Basic Civitas Books, 1999), xvi.

6 Alan Dale, *Comedy Is a Man in Trouble* (Minneapolis: University of Minnesota Press, 2000), 135.

7 *Monkey Business*, directed by Norman McLeod (United States: Paramount Pictures, 1931), film.

8 Robert D. Pelton, *The Trickster in West Africa: A Study of Mythic Irony and Sacred Delight* (Berkeley, CA: University of California Press, 1989), 50-51.

9 Tom Robbins, "In Defiance of Gravity: Writing, Wisdom, and Fabulous Club Gemini," *Harper's Magazine*, September 2004, 57-61.

10 "Stumblin' In" on Suzi Quatro, *If You Knew Suzi...*, E.M.I. Electrola Studios, Cologne, Germany, 1978. Words and Music by Nicky Chinn and Mike Chapman, Copyright © 1979 by Chinnichap Publishing, Inc. and Careers Music, Inc.

11 Fraser Brown and Michael Patte, "From the Streets of Wellington to the Ivy League: Reflecting on a Lifetime of Play," *International Journal of Play* 1, no. 1 (March 2012): 6-15.

12 Brian Sutton-Smith, *The Ambiguity of Play* (Cambridge, MA: Harvard University Press, 1997), 214-231.

13 Paul Radin, The Trickster: A Study in American Indian Mythology (New York: Schocken, 1956), xxiii-xxiv.

14 Shepherd Siegel, *Disruptive Play: The Trickster in Politics and Culture* (Seattle, WA: Wakdjunkaga Press, 2018), 41-44.

15 Lewis Hyde, *Trickster Makes This World* (New York: Farrar, Straus and Giroux, 1998).

16 V. Vale and J.G. Ballard, eds., *Pranks!* (San Francisco: RE/Search Publications, 2010), 5.

17 Vale and Ballard, *Pranks!*, 34.

18 Louis Menand, "Change Your Life: The Making of the New Left," *New Yorker*, March 22, 2021, 53.

19 Oliver Trager, *Dig Infinity!: The Life and Art of Lord Buckley* (New York: Welcome Rain, 2001), 231.

20 Trager, *Dig Infinity!*, 5.

21 Buckley, in Trager, *Dig Infinity!*, 9.

22 Folklore designates special powers to such sons.

23 In Trager, *Dig Infinity!*, 57.

24 Trager, *Dig Infinity!*, 280.

25 Richard Buckley, *Hiparama of the Classics* (San Francisco: City Lights, 1980), 14-17.

26 Richard Buckley, *Hiparama of the Classics* (San Francisco: City Lights, 1980), 2.

27 Albert Goldman, in Trager, *Dig Infinity!*, 134.

28 Trager, *Dig Infinity!*, 312.

29 Jerry Garcia, in Trager, *Dig Infinity!*, 221.

30 Laurie Buckley, in Trager, *Dig Infinity!*, 81-82.

31 Trager, *Dig Infinity!*, 153.

32 Trager, *Dig Infinity!*, 91.

33 Charles Tacot, in Trager, *Dig Infinity!*, 92.

34 In Trager, *Dig Infinity!*, 84.

35 Paul Radin, *The Trickster: A Study in American Indian Mythology* (New York: Schocken, 1956), xxiii-xxiv.

36 "Absolutely Sweet Marie," on Bob Dylan, *Blonde on Blonde*, CBS, 1966.

37 Joseph Jablonski, "Swinging Stirrups: Announcing the Formation of the Knights & Ladies of Lord Buckley," *Arsenal*, no. 4 (1992). And in Trager, *Dig Infinity!*, 364.

38 Trager, *Dig Infinity!*, 367.

39 Robin Williams, in Trager, *Dig Infinity!*, 79.

40 Lady Buckley and Lord Buckley, Jr, "Rare 1992 TV Interview," interview by Skip E. Lowe, *Skip E. Lowe Looks at Hollywood*, posted to YouTube on May 22, 2017, retrieved March 8, 2021, https://www.youtube.com/watch?v=SNX-FDeoEjs&t=183s.

41 Bill Crow, *From Birdland to Broadway: Scenes from a Jazz Life* (New York: Oxford University Press, 1992). And Trager, Dig Infinity!, 86.

42 Trager, *Dig Infinity!*, 103.

43 Albert Goldman in Trager, *Dig Infinity!*, 58.

44 Richard Buckley, "The Religious History of Álvar Nuñez Cabeza de Vaca," in *Hiparama of the Classics* (San Francisco: City Lights, 1980), 31-34.

45 Trager, *Dig Infinity!*, 95.

46 Alan Dale, *Comedy Is a Man in Trouble* (Minneapolis: University of Minnesota Press, 2000), 219.

47 James Agee, "Comedy's Greatest Era," in *James Agee: Film Writing and Selected Journalism* (New York: The Library of America, 2005), 16. The essay first appeared in the September 3, 1949, issue of LIFE magazine.

48 Dale, *Comedy Is a Man in Trouble*, 3.

49 Dale, *Comedy Is a Man in Trouble*, 3-4.

50 Besides the Buster Keaton films themselves, the documentary *The Great Buster: A Celebration*, directed by Peter Bogdanovich (New York: Cohen Media Group, 2018); and Wikipedia, s.v. "Buster Keaton," retrieved September 15, 2019, https://en.wikipedia.org/wiki/Buster_Keaton are primary sources.

51 Buster Keaton: *The Art of the Gag*, edited and narrated by Tony Zhou (Every Frame a Painting, 2015), https://vimeo.com/146442912.

52 R. Bruce Elder, *Dada, Surrealism, and the Cinematic Effect* (Waterloo, Ontario: Wilfrid Laurier University Press, 2015), 623.

53 James Agee, "Comedy's Greatest Era," in *James Agee: Film Writing and Selected Journalism* (New York: The Library of America, 2005), 9-10.

54 Alan Dale, *Comedy Is a Man in Trouble* (Minneapolis: University of Minnesota Press, 2000), 11.

55 *The Twilight Zone*, directed by Norman Z. McLeod, season 3, episode 13, "Once Upon a Time," aired December 15, 1961, on CBS.

56 Dale, *Comedy Is a Man in Trouble*, 139.

57 "AFI's 100 years…100 stars: The 50 Greatest American Screen Legends," American Film Institute website, accessed January 2, 2020, https://www.afi.com/afis-100-years-100-stars/.

58 *Monkey Business*, directed by Norman McLeod (Los Angeles: Paramount, 1931), film.

59 James Agee, "Comedy's Greatest Era," in *James Agee: Film Writing and Selected Journalism* (New York: The Library of America, 2005), 10.

60 *Duck Soup*, directed by Leo McCarey (Los Angeles: Paramount, 1933), film.

61 *Duck Soup* (1933).

62 Peter Stallybrass and Allon White, *The Politics and Poetics of Transgression* (Ithaca, NY: Cornell University Press, 1986), 1-26.

63 Dale, *Comedy Is a Man in Trouble* 132. Dale's quotes within his quote are from C.L. Barber, *Shakespeare's Festive Comedy: A Study of Dramatic Form and Its Relation to Social Custom* (Princeton, NJ: Princeton University Press, 1959), 7, 30, 36-57.

64 Dale, *Comedy Is a Man in Trouble*, 136.

65 Dale, *Comedy Is a Man in Trouble*, 159.

66 Dale, *Comedy Is a Man in Trouble*, 151-152.

67 Dale, *Comedy Is a Man in Trouble*, 153.

68 Walter Woolf King as star tenor Rodolfo Lassparri.

69 Dale, *Comedy Is a Man in Trouble*, 97.

70 Dale, *Comedy Is a Man in Trouble*, 94-95.

71 Lewis Hyde, *Trickster Makes This World* (New York: Farrar, Straus and Giroux, 1998), 100-107.

72 Shepherd Siegel, *Disruptive Play: The Trickster in Politics and Culture* (Seattle, WA: Wakdjunkaga Press, 2018), 277.

73 J.D. MacDonald, *Dress Her in Indigo* (New York: Lippincott, 1969), 114.

74 In homage to *The Cocoanuts?*

75 Shawn Levy, *King of Comedy: The Life and Art of Jerry Lewis* (New York: St. Martin's Press, 1996), 73.

76 Alan Dale, *Comedy Is a Man in Trouble* (Minneapolis: University of Minnesota Press, 2000), 193-194.

77 Joan Howard Maurer and Norman Maurer, *The Three Stooges Book of Scripts: Volume II* (Secaucus, NJ: Citadel, 1987), 9.

78 *Butch Cassidy and the Sundance Kid*, directed by George Roy Hill (Los Angeles: Twentieth Century Fox, 1969), film.

79 *Hot Tub Time Machine*, directed by Steve Pink (Los Angeles: Metro-Goldwyn-Mayer, 2010) film.

80 Dale, *Comedy Is a Man in Trouble*, 43.

81 Siegel, *Disruptive Play*, 277-286.

82 Dale, *Comedy Is a Man in Trouble*, 54.

83 Craig Brown, *Hello Goodbye Hello: A Circle of 101 Remarkable Meetings* (New York: Simon and Schuster, 2012), 314.

84 *Brazil*, directed by Terry Gilliam (Los Angeles: Embassy Pictures, 1985), film.

85 K.J. Dover, *Aristophanic Comedy* (Berkeley, CA: University of California Press, 1972), 41.

86 Henry Louis Gates Jr., *The Signifying Monkey: A Theory of African American Literary Criticism* (Oxford: Oxford University Press, 1988), 5.

87 Further readings on Eshù Elégba include Robert Farris Thompson, *Flash of the Spirit: African and Afro-American Art and Philosophy* (New York: Random House, 1983); Robert D. Pelton, *The Trickster in West Africa: A Study of Mythic Irony and Sacred Delight* (Berkeley, CA: University of California Press, 1989); and Shepherd Siegel, *Disruptive Play: The Trickster in Politics and Culture* (Seattle, WA: Wakdjunkaga Press, 2018).

88 Henry Louis Gates Jr. and Cornel West, *The African-American Century: How Black Americans Have Shaped Our Country* (New York: The Free Press, 2000), xv.

89 *Richard Pryor Live on the Sunset Strip*, directed by Joe Layton (United States: Columbia Pictures, 1982), film.

90 *Richard Pryor: Live in Concert*, directed by Jeff Margolis (United States: Special Event Entertainment, 1979), film.

91 Henry Louis Gates Jr. and Cornel West, *The African-American Century: How Black Americans Have Shaped Our Country* (New York: The Free Press, 2000), xv.

92 Bruce Jackson, *Get Your A** in the Water and Swim Like Me: Narrative Poetry from the Black Oral Tradition* (Cambridge: Harvard University Press, 1974), 164-165.

93 Bruce Jackson, *Get Your A** in the Water and Swim Like Me*, 172.

94 Gates, *The Signifying Monkey*, 7.

95 Gates, *The Signifying Monkey*, 113.

96 Gates, *The Signifying Monkey*, 7.

97 Geoffrey H. Hartman, *Criticism in the Wilderness: The Study of Literature Today* (New Haven: Yale University Press, 1980), 272.

98 Robert D. Pelton, *The Trickster in West Africa: A Study of Mythic Irony and Sacred Delight* (Los Angeles: University of California Press, 1980), 164, 143.

99 Gates, *The Signifying Monkey*, 24-25.

100 Václav Havel, "Never Hope Against Hope," *Esquire*, October 1, 1993, 68.

101 *Dolemite*, directed by D'Urville Martin (United States: Dimension Pictures, 1975), film.

102 *Akan-Ashanti Folk-Tales, collected and translated by Robert Sutherland Rattray and illustrated by Africans of the Gold Coast Colony* (Oxford: Clarendon, 1930).

103 Gates, *The Signifying Monkey*, 54.

104 Robert D. Pelton, *The Trickster in West Africa: A Study of Mythic Irony and Sacred Delight* (Berkeley, CA: University of California Press, 1989), 9-10.

105 "Room Full of Mirrors" on Jimi Hendrix, *Rainbow Bridge*, Electric Lady Studios, 1970.

106 *The Original Kings of Comedy*, directed by Spike Lee (New York: 40 Acres and a Mule Filmworks, 2000), film.

107 Quoted in Henry Louis Gates Jr. and Cornel West, *The African-American Century: How Black Americans Have Shaped Our Country* (New York: The Free Press, 2000), 113.

108 Greg Tate, "Cult-Nats Meet Freaky-Deke," *The Village Voice*, originally published December 9, 1986, www.villagevoice.com/2020/01/10/cult-nats-meet-freaky-deke/.

109 Margari Hill, "The Spread of Islam in West Africa: Containment, Mixing, and Reform from the Eighth to the Twentieth Century," *Stanford Program on International and Cross-Cultural Education*, January 2009, https://spice.fsi.stanford.edu/docs/the_spread_of_islam_in_west_africa_containment_mixing_and_reform_from_the_eighth_to_the_twentieth_century.

110 *Roots of Black Music in America*, compiled by Samuel Charters, Folkways Records, 1972, compact disc.

111 Gates and West, *The African-American Century*, 99-100.

112 Jeff Tweedy, "Racial Injustice in the Music Industry" Wilco website, July 8, 2020, https://wilcoworld.net/racial-injustice-in-the-music-industry/.

113 Richard Hoffer, "Introduction," *Sports Illustrated Muhammad Ali* 1942-2016: The Tribute (New York: Sports Illustrated Books/Time, June 6, 2016), 9.

114 Norman Mailer, quoted in Gates and West, *The African-American Century*, 232.

115 *Da 5 Bloods*, directed by Spike Lee (United States: Netflix, 2020), film.

116 "30 of Muhammad Ali's Best Quotes," *USA Today*, updated June 5, 2016. Retrieved July 9, 2020, https://www.usatoday.com/story/sports/boxing/2016/06/03/muhammad-ali-best-quotes-boxing/85370850/.

117 Zack Pumerantz, "The 50 Best Trash Talk Lines in Sports History," *Bleacher Report*, June 29, 2012, retrieved July 10, 2020,http://bleacher-report.com/articles/1238737-the-50-best-trash-talk-lines-in-sports-history/page/51.

118 This one is from Quotefancy, https://quotefancy.com/quote/869906/Muhammad-Ali-I-m-young-I-m-handsome-I-m-fast-I-m-pretty-and-can-t-possibly-be-beat-They Retrieved May 19, 2021.

119 Kyle Sarofeen, "Bundini Brown: Boxing's Greatest Hype Man," *Hannibal Boxing Media*, posted November 27, 2017, https://hannibalboxing.com/bundini-brown-boxings-greatest-hype-man/.

120 Gulla Geechee Cultural Heritage Corridor Commission. https://gullah-geecheecorridor.org/thegullahgeechee/ Retrieved May 19, 2021.

121 Yomi Kazeem, "Africa Meant A Lot to Muhammad Ali—He Meant Even More to Africa," *Quartz Africa* (website), June 5, 2016.

122 Victor Mather, "Ali's Least Memorable Fight," *New York Times*, June 5, 2016.

123 *The Last Dance*, episodes 3 and 4, directed by Jason Hehir, aired April 26, 2020, on ESPN.

124 Ben Morris, "The Case for Dennis Rodman, Part 1/4 (a)-Rodman v. Jordan," Skeptical Sports Analysis (website), August 3, 2011, https://skepticalsports.com/the-case-for-dennis-rodman-part-14-a-rodman-v-jordan/.

125 Dennis Rodman and Tim Keown, *Bad as I Wanna Be* (New York: Dell Publishing, 1997), 12-14.

126 Michael Silver, "Rodman Unchained: The Spurs No-Holds-Barred Forward Gives New Meaning to the Running Game," Sports Illustrated, May 29, 1995, https://vault.si.com/vault/1995/05/29/rodman-unchained-the-spurs-no-holds-barred-forward-gives-new-meaning-to-the-running-game.

127 Chris Ballard, "Draymond Before Draymond: The Complicated Legacy of Dennis Rodman," *Sports Illustrated*, June 6, 2018, https://www.si.com/nba/2018/06/06/dennis-rodman-basketball-legacy-north-korea-draymond-green-warriors.

128 Michael Silver, "Rodman Unchained: The Spurs No-Holds-Barred Forward Gives New Meaning to the Running Game."

129 Wikipedia, s.v. "50 Greatest Players in NBA History," retrieved July 13, 2020, https://en.wikipedia.org/wiki/50_Greatest_Players_in_NBA_History#List.

130 Craigh Barboza, "Remember When Dennis Rodman Put on a Wedding Dress and Claimed to Marry Himself?" CNN, November 3, 2020, https://www.cnn.com/style/article/remember-when-dennis-rodman/index.html.

131 John Edgar Wideman, "Playing Dennis Rodman.," *The New Yorker*, April 29, 1996, 94-95.

132 *The Last Dance*, episodes 3 and 4, directed by Jason Hehir, aired April 26, 2020, on ESPN.

133 *The Last Dance*, episodes 3 and 4, directed by Jason Hehir, aired April 26, 2020, on ESPN.

134 Transparency Market Research, *Licensed Sports Merchandise Market to reach US $48.17 Billion by 2024 -A New Research Report by Transparency Market Research, October 20, 2016*, https://www.prnewswire.com/news-releases/licensed-sports-merchandise-market-to-reach-us4817-billion-by-2024---a-new-research-report-by-transparency-market-research-597749011.html.

135 Sports Vines Land, "Best Football Touchdown Celebrations of All Times," posted February 3, 2016, YouTube video, https://www.youtube.com/watch?v=CubV2ausTRs.

136 NFL Rush, "Baker Mayfield & Ninja Present Best Celebration Award! 2019 NFL Honors," posted February 2, 2019, YouTube video, https://www.youtube.com/watch?v=036URDRnuBA.

137 Lewis Hyde, *Trickster Makes This World* (New York: Farrar, Straus and Giroux, 1998).

138 Wikipedia, s.v. "Afrofuturism," accessed July 28, 2020, https://en.wikipedia.org/wiki/Afrofuturism.

139 Greg Tate in Mark Dery (Editor), *Flame Wars: The Discourse of Cyberculture*. "Black to the Future: Interviews with Samuel R. Delany, Greg Tate, and Tricia Rose," (Durham and London: Duke University Press, 1994), 208.

140 *Sun Ra: A Joyful Noise*, directed by Robert Mugge (United States: MVD Visual, 1980), DVD.

141 "The World Is a Ghetto," track 2, side 2 on War, *The World Is a Ghetto*, Avenue Records, 1992.

142 Dery, "Black to the Future," 180.

143 "Gangster of Love," single by John Watson, Keen Records, 1957.

144 Quoted in John Szwed, *Space Is the Place: The Lives and Times of Sun Ra* (Durham, NC: Duke University Press, 2020), 382.

145 Szwed, *Space Is the Place*, 29.

146 Cary O'Dell, "President's Message Relayed from Atlas Satellite--Dwight D. Eisenhower (December 19, 1958)," Library of Congress, 2012, https://www.loc.gov/static/programs/national-recording-preservation-board/documents/EisenhowerSpaceMessage.pdf.

147 Paul Youngquist, *A Pure Solar World: Sun Ra and the Birth of Afrofuturism* (Austin, TX: University of Texas Press, 2016), 134. And many of the ideas in this paragraph are inspired by and borrowed from Youngquist.

148 Szwed, *Space Is the Place*, 236.

149 *The Cry of Jazz*, directed by Edward O. Bland (United States: Grove Press Film Division, 1959), film.

150 Sun Ra and His Arkestra, "Pink Elephants on Parade," track 9a on *Stay Awake*, A&M Records, 1988.

151 Album liner notes from *Jazz by Sun Ra, Vol. 1*, Transition, 1957.

152 Paul Youngquist, *A Pure Solar World: Sun Ra and the Birth of Afrofuturism* (Austin, TX: University of Texas Press, 2016), 16, 31, 40.

153 Sun Ra, *The Immeasurable Equation: The Collected Poetry and Prose*, compiled and edited by James L. Wolf and Hartmut Geerkan (Wartaweil, Germany: Waitawhile, 2005), 447.

154 Youngquist, *A Pure Solar World*, 99.

155 "1983 . . . (A Merman I Should Turn to Be)" on Jimi Hendrix Experience, *Electric Ladyland*, Reprise Records, 1968.

156 Tim Dirks, "All-Time Box Office Top 100." Filmsite (website), accessed on 05/21/2021 https://www.filmsite.org/boxoffice.html.

157 Szwed, *Space Is the Place*, 364, 100.

158 "Room Full of Mirrors" on Jimi Hendrix, *Rainbow Bridge*, Electric Lady Studios, 1970.

159 Henry Louis Gates Jr., *The Signifying Monkey: A Theory of African-American Literary Criticism* (Oxford: Oxford University Press, 1988), 49-50.

160 Alan Moore, Dave Gibbons, and John Higgins, *Watchmen* (New York: DC Comics, 1987).

161 Ayodele Ogundipe (presumed to be the same person as Molara/Omolara Ogundipe, the Yoruba feminist scholar). Esu Elegbara: Chance, *Uncertainly In Yoruba Mythology*, (Malete Nigeria: Kwara State University Press, 2012), 97.

162 Lewis Hyde, *Trickster Makes This World* (New York: Farrar, Straus and Giroux, 1998), 335-343.

163 Hyde, *Trickster Makes This World*, 177-180; Emiko Jozuka, "Centuries Ago, Women Ruled Japan. What Changed?" WTOP News, April 27, 2019, https://wtop.com/asia/2019/04/centuries-ago-women-ruled-japan-what-changed/.

164 Marilyn Jurich, *Scheherazade's Sisters: Trickster Heroines and Their Stories in World Literature* (Westport, CT: Greenwood Press, 1998).

165 Jurich, *Scheherazade's Sisters*, xvi-xvii.

166 Jurich retells the tale as "The Young Woman and Her Five Lovers."

167 Jurich, *Scheherazade's Sisters*, 34-36.

168 Jurich, *Scheherazade's Sisters*, 38-39.

169 Jurich, *Scheherazade's Sisters*, 39-40.

170 Jurich, *Scheherazade's Sisters*, 234, 235.

171 Jurich, *Scheherazade's Sisters*, 230.

172 Jurich, *Scheherazade's Sisters*, 229.

173 Jurich, *Scheherazade's Sisters*, 228.

174 Jurich, *Scheherazade's Sisters*, 23.

175 Jurich, *Scheherazade's Sisters*, 170-172.

176 Jurich, *Scheherazade's Sisters*, 10-11.

177 William G. Doty, "A Lifetime of Trouble-Making: Hermes as Trickster," in *Mythical Trickster Figures: Contours, Contexts, and Criticism*, eds. William J. Hynes and William G. Doty (Tuscaloosa: University of Alabama Press, 1993), 46-65; Peter Stallybrass and Allon White, *The Politics and Poetics of Transgression* (Ithaca, NY: Cornell University Press, 1986); The Oxford Classical Dictionary, s.v. "Hermes," Herbert Jennings Rose and Charles Martin Robertson (Oxford: Clarendon Press, 1977), 502-503.

178 Jurich, *Scheherazade's Sisters*, 58.

179 Jurich, *Scheherazade's Sisters*, 59.

180 Jurich, *Scheherazade's Sisters*, 230.

181 Robert D. Pelton, *The Trickster in West Africa: A Study of Mythic Irony and Sacred Delight* (Berkeley, CA: University of California Press, 1989), 9-10.

182 Robert Darnton, *The Great Cat Massacre and Other Episodes in French Cultural History* (New York: Vintage, 1985), 33, 34, 59.

183 Darnton, *Great Cat Massacre*, 217.

184 Marilyn Jurich, Scheherazade's Sisters: *Trickster Heroines and Their Stories in World Literature* (Westport, CT: Greenwood Press, 1998), 225.

185 Hannelore Gresser, "Till Eulenspiegel, The Controversial German Trickster," thesis for children's literature (Boston: Suffolk University, c. 1970), 9.

186 Jurich, *Scheherazade's Sisters*, 236.

187 Wikipedia, s.v. "Huli jing," last modified May 12, 2021, 05:22, https://en.wikipedia.org/wiki/Huli_jing.

188 *Love, Death + Robots*, season 1, episode 8, "Good Hunting," directed by Oliver Thomas, adapted script by Philip Gelatt, based on a story by Ken Liu, aired March 15, 2019, on Netflix.

189 *She Done Him Wrong*, directed by Lowell Sherman (United States: Paramount Pictures, 1933), film.

190 "Interview: Camille Paglia," Lürzer's International Archive, June 2014, https://www.luerzersarchive.com/en/magazine/interview/camille-paglia-155.html.

191 Claudia Roth Pierpont, in *American Masters*, season 34, episode 2, "Mae West: Dirty Blonde," directed by Julia Marchesi and Susan Rosenthal, aired June 16, 2020, on PBS.

192 Jurich, *Scheherazade's Sisters*, 215.

193 Jurich, *Scheherazade's Sisters*, 226.

194 "Poetry," Marianne Moore, Academy of American Poets, retrieved January 10, 2021, https://poets.org/poem/poetry.

195 *Being John Malkovich*, directed by Spike Jonze (United States: USA Films, 1999). Screenplay by Charlie Kaufman.

196 Jurich, *Scheherazade's Sisters*, 50.

197 Jurich, *Scheherazade's Sisters*, 160.

198 Another HBO series, 2019's *Euphoria*, adopts a similar revolutionary style.

199 Interview with Melissa Chiu, in Mika Yoshitake and Alexander Dumbadze, *Yayoi Kusama: Infinity Mirrors* (Munich: DelMonico Books/Prestel, 2017), 166.

200 Interview with Melissa Chiu, 168.

201 Herbert Read, statement for Kusama: Driving Image Show, Castellane Gallery, New York, 1964, Beatrice Perry Papers, New York.

202 Yoshitake, *Yayoi Kusama: Infinity Mirrors*, 169.

203 Yoshitake, *Yayoi Kusama: Infinity Mirrors*, 14. See also Claire Bishop, Installation Art (London: Routledge, 2005), 90; Jo Applin, Yayoi Kusama: Infinity Mirror Room—Phalli's Field (London: Afterall Books, 2012), 80-81.

204 Yoshitake, *Yayoi Kusama: Infinity Mirrors*, 168.

205 Norman Seaman, in Jerry Hopkins, *Yoko Ono* (London: Sidgwick & Jackson, 1987), 251.

206 First Quote: John Lennon and Yoko Ono, Imagine: *The Story of the Making of the Album* (London: Universal Music Ltd., 2018), 30; John & Yoko: Above Us Only Sky, directed by Michael Epstein (United Kingdom: Channel 4, 2018), film.

207 Second Quote: from Lisson Gallery brochure '67 y.o. and in the 1970 calendar, part of Plastic Ono Band, *Live Peace in Toronto* (Toronto: Bag Productions, 1969).

208 *John & Yoko: Above Us Only Sky*, directed by Michael Epstein (United Kingdom: Channel 4, 2018), film.

209 Hopkins, *Yoko Ono*, 155. This quote is taken from a time when she'd not yet mastered English grammar.

210 Hopkins, *Yoko Ono*, 116.

211 George Maciunas, in Hopkins, *Yoko Ono*, 45.

212 Lindsay Zoladz, "Yoko Ono and the Myth That Deserves to Die," *Vulture, New York* magazine, May 13, 2015, www.vulture.com/2015/05/yoko-ono-one-woman-show.html.

213 Douglas Davis, in Hopkins, *Yoko Ono*, 155.

214 Hopkins, *Yoko Ono*, 27.

215 Anthony Fawcett, in Hopkins, *Yoko Ono*, 60.

216 Yoko Ono, "The Word of a Fabricator," compiled in Jon Hendricks, "Anthology: Writings by Yoko Ono," in *YES Yoko Ono*, Alexandra Munroe, et al, (New York: Harry N. Abrams, 2000), 285. This essay was originally published in Japanese as "Kyoko*sha no gen" in SAC Journal no. 24, May 1962. Translation by Yoko Ono, 1999.

217 Yoko Ono, in Hopkins, *Yoko Ono*, 64.

218 Hopkins, *Yoko Ono*, 65.

219 Kathryn Rattee, Melissa Larner, Rebecca Lewin, and Alexandra Munroe, "Why War? Yoko by Yoko at the Serpentine," essay in *Yoko Ono: To the Light* (London: Koenig Books, 2012), 25-39.

220 *Bed Peace*, directed by Yoko Ono and John Lennon (United Kingdom: Bag Productions, 1969), film, retrieved December 10, 2020, https://www.youtube.com/watch?v=mRjjiOV003Q.

221 *John & Yoko: Above Us Only Sky*, directed by Michael Epstein (United Kingdom: Channel 4, 2018), film.

222 US involvement ended in 1973, but the civil wars in Laos and Cambodia continued into 1975.

223 Hopkins, *Yoko Ono*, 167.

224 Hopkins, *Yoko Ono*, 169-170.

225 Hopkins, *Yoko Ono*, 185.

226 Hopkins, *Yoko Ono*, 161.

227 Hopkins, *Yoko Ono*, 213.

228 Hopkins, *Yoko Ono*, 161.

229 Hopkins, *Yoko Ono*, 233.

230 Ray Coleman, *Lennon: The Definitive Biography*, revised, updated, subsequent edition (New York: Harper Perennial, 1993).

231 Yoko Ono, "Tunafish Sandwich Piece" and "Painting for the Wind," in *Grapefruit* (New York: Simon and Schuster, 1970, 2000), unnumbered.

232 Hopkins, *Yoko Ono*, 116.

233 Lewis Hyde, *Trickster Makes This World* (New York: Farrar, Straus and Giroux, 1998), 138.

234 David Sheff, *All We Are Saying: The Last Major Interview with John Lennon and Yoko Ono* (New York: St. Martin's Griffin, 2000), 38-39.

235 "John Lennon gana el Grammy póstumo -Double Fantasy 1982" posted September 25, 2018, YouTube video, https://www.youtube.com/watch?v=2HejWy8MXug.

236 Shepherd Siegel, *Disruptive Play: The Trickster in Politics and Culture* (Seattle, WA: Wakdjunkaga Press, 2018), 142-143, for a riff on Jack Kerouac's various definitions of beat.

237 Edward M. Lerner, 5quotes.info, accessed March 31, 2021, https://5quotes.info/quote/186082.

238 *Bill & Ted's Excellent Adventure*, directed by Stephen Herek (United States: Orion Pictures, 1989), film.

239 "Voodoo Chile," on Jimi Hendrix, *Electric Ladyland*, Reprise, 1968.

240 C.G. Jung, in Paul Radin, *The Trickster: A Study in American Indian Mythology* (New York: Schocken, 1956), 195, 200.

241 Christopher Moore, *Fool: A Novel*, (New York: Harper, 2009), 138.

242 Viktor E. Frankl, *Man's Search for Meaning: An Introduction to Logotherapy* (London: Hodder & Stoughton, 1959), 35, 63-64.

243 *Arrival*, directed by Denis Villeneuve (United States: Paramount Pictures, 2016), film.

244 *Bill & Ted's Excellent Adventure*, directed by Stephen Herek (United States: Orion Pictures, 1989), film.

245 V. Vale and J.G. Ballard, eds., *Pranks!* (San Francisco: RE/Search Publications, 2010), 17.

246 Wikipedia, s.v. "Boyd Rice, last modified April 13, 2021, 13:24, https://en.wikipedia.org/wiki/Boyd_Rice#cite_note-5.

247 David Graeber, "What's the Point If We Can't Have Fun?" *The Baffler*, January 2014, https://thebaffler.com/salvos/whats-the-point-if-we-cant-have-fun.

248 V. Vale and J.G. Ballard, eds., *Pranks!* (San Francisco: RE/Search Publications, 2010), 18.

249 Vale and Ballard, *Pranks!*, 29, 34.

250 Marilyn Jurich, *Scheherazade's Sisters: Trickster Heroines and Their Stories in World Literature* (Westport, CT: Greenwood Press, 1998), 37.

251 Sacha Baron Cohen, "Keynote Address at ADL's 2019 Never Is Now Summit on Anti-Semitism and Hate) (speech, Anti-Defamation League, November 21, 2019), https://www.adl.org/news/article/sacha-baron-cohens-keynote-address-at-adls-2019-never-is-now-summit-on-anti-semitism.

252 Robert D. Pelton, *The Trickster in West Africa: A Study of Mythic Irony and Sacred Delight* (Los Angeles: University of California Press, 1980), 34.

253 *Bed Peace*, directed by Yoko Ono and John Lennon (United Kingdom: Bag Productions, 1969), film.

254 Jurich, *Scheherazade's Sisters*, 219-220.

255 Pelton, *The Trickster in West Africa*, 30.

A free ebook edition is available with the purchase of this book.

To claim your free ebook edition:

1. Visit MorganJamesBOGO.com
2. Sign your name CLEARLY in the space
3. Complete the form and submit a photo of the entire copyright page
4. You or your friend can download the ebook to your preferred device

Morgan James
BOGO™

A **FREE** ebook edition is available for you
or a friend with the purchase of this print book.

CLEARLY SIGN YOUR NAME ABOVE

Instructions to claim your free ebook edition:
1. Visit MorganJamesBOGO.com
2. Sign your name CLEARLY in the space above
3. Complete the form and submit a photo
 of this entire page
4. You or your friend can download the ebook
 to your preferred device

Print & Digital Together Forever.

Snap a photo

Free ebook

Read anywhere

CPSIA information can be obtained
at www.ICGtesting.com
Printed in the USA
JSHW041919260522
26409JS00003B/4

9 781631 957307